Master Drawings

Master Drawings

from the Achenbach Foundation for Graphic Arts
The Fine Arts Museums of San Francisco

Robert Flynn Johnson

Joseph R. Goldyne

The Fine Arts Museums of San Francisco Richard Burton, S.A.

This catalogue has been published in conjunction with the
exhibition *Master Drawings from the Achenbach Foundation for
Graphic Arts* at the California Palace of the Legion of Honor.
This exhibition and catalogue have been made possible by
generous grants from the Graphic Arts Council; the National
Endowment for the Arts, a Federal agency; and Richard
Burton, S.A., Geneva, the publisher.

Cover: Henri de Toulouse-Lautrec, *Au cirque: Cheval pointant*,
1899 (detail). Cat. no. 71

ISBN 0-88401-045-7
Library of Congress Catalogue Card No. 85-70503

Master Drawings from the Achenbach Foundation for Graphic Arts
was designed by Jack Werner Stauffacher of The Greenwood
Press, San Francisco. Editing by Jeanne D'Andrea, Los Angeles.
Production management by Ann Heath Karlstrom, The Fine Arts
Museums of San Francisco. Type is Kis-Janson. Photocomposition,
color separations, printing, and binding by BCK Graphic Arts, S.A.,
Geneva, Switzerland.

To our parents,
who first instilled in us a love of art.
R. F. J.
J. R. G.

Contents

Foreword

In the late sixties the Achenbach Foundation for Graphic Arts occupied one gallery at the end of a wing in the California Palace of the Legion of Honor. Library and reading alcove, offices, storage, matting, and framing were jammed into a thirty-by-forty foot area. Prints and drawings were exhibited in an adjoining thirty-by-forty foot room with a ceiling twenty feet high. Even then, E. Gunter Troche, the curator in charge of the Achenbach, felt the work space was too crowded and the gallery ceiling too high for displaying the relatively small-scaled prints and drawings. It is a pity that Dr. Troche did not live to see the department expand to occupy almost an entire wing, which is three times larger than the original space and includes exhibition galleries more compatible with the scale of works of art on paper. This wonderful expansion was made possible by the generosity of the William G. Irwin Charity Foundation.

The next major growth period in the department occurred under the guidance of the present curator in charge, Robert Flynn Johnson. The publication of these *Master Drawings* attests to the growth of the collection under his stewardship in the last ten years. In a period in which drawings have appreciated dramatically, growing scarce as well as costly, it has taken a nimble curator to acquire advantageously. Bob Johnson has been just that. Drawing on all his curatorial skills while inflation was eroding his purchase funds, he bought against the trends of fashion. To do this requires a wide-ranging knowledge of the field, the taste and the eye to spot the unusual, not to mention the capability and the energy to roam the galleries here and in Europe in the quest.

This period has been further marked by the happy accident of friendship between Bob Johnson and his collaborating author, Dr. Joseph Goldyne. Bob Johnson readily acknowledges the value of this bond, finding in Goldyne an artistic intellect, a scholar, and a colleague to share the passion for collecting. Such a friendship is rare enough under any circumstance, but to have it occur in a city not overly blessed with collectors is the Museums' and San Francisco's good fortune.

Ian McKibbin White
Director of Museums

Acknowledgments

This catalogue was first proposed three years ago as a means to make better known the master drawings of the Achenbach Foundation for Graphic Arts. Acquisitions in recent years have increased the significance of this part of the collection and inspired the idea for an exhibition to celebrate both this publication and the collection that it represents.

The Graphic Arts Council of the Achenbach Foundation for Graphic Arts, under the leadership of two successive chairmen, George Poole and Stuart Coyne, enthusiastically embraced the initial project. The Council's generous financial grant was crucial to the publication of this catalogue. We are also grateful for two grants from the National Endowment for the Arts, a Federal agency, for conservation of the drawings and for the exhibition itself.

In 1971 the Western Regional Paper Conservation Laboratory was established by Roy Perkinson in the space adjacent to the Achenbach Foundation for Graphic Arts, to serve as a center for the research and treatment of works of art on paper, and as a training center for conservators. Since 1976 it has been headed by Robert Futernick, whose dedication, expertise, and close working relationship with the Achenbach have assured the highest quality of care for the collection. Thanks are due to Mr. Futernick and Debra Evans for the examination, media identification, and conservation of the works of art presented in the exhibition. Conservators Pauline Mohr and Janice Schopfer also provided helpful assistance to the project, as did Niccolo Caldararo, Conservation Technician.

Ann Karlstrom, the Museums' Publications Manager, coordinated the production of the catalogue with patience, cooperation, and professionalism. Jeanne D'Andrea, who edited the manuscript, improved the text without compromising the meaning and tone intended by the authors. We were fortunate to have a multilingual typist, Ursula Egli, who also directed her attention to the accuracy of foreign terms and titles. Deborah Bruce provided indispensable assistance in checking the many bibliographical references in the entries and proofreading the text. Any mistakes or omissions are, however, the responsibility of the authors. James Medley is to be commended for producing the fine color photography, and particularly for having worked within a severely curtailed time limit. Jack Werner Stauffacher of The Greenwood Press produced the handsome design for the catalogue.

Maxine Rosston, Assistant Curator, has been of invaluable assistance to me in the initial editing of my essay entries. I am extremely grateful to her for undertaking this sometimes thankless task. Judith Eurich, Curatorial Assistant, researched provenance, bibliography, and exhibition history for each entry. She also brought together into a cohesive form for the publication department this information, the text from the two authors, and the media identification from the paper laboratory. In addition, she supervised the photography of the works of art. Without her special dedication to this project, the catalogue would not have become a reality. She, therefore, has my deepest appreciation.

Many people have been helpful in various ways in assisting me to bring this publication to completion. In particular I wish to thank Patricia Allderidge, Adelyn Breeskin, James Dearden, Toni DeVito, Lorenz Eitner, Albert Elsen, Hal Fischer, Lloyd Goodrich, F. Whitney Hall, Evelyn Joll, Robert Kashey, Karen Kevorkian, Lamar Leland, Margaretta Lovell, Stefanie Maison, Dwight Miller, Charles S. Moffett, Alfred Moir, John Morton Morris, Ronald Pickvance, Philip Pouncey, Debra Pughe, Miklos Rajnai, Anthony Reed, Martin Reymert, Sally Robertson, Charles Ryskamp, Mrs. Hanns Schaeffer, Thomas K. Seligman, Jean Pierre Selz, Peyton Skipwith, Stephen Somerville, Julian Stock, Sean Thackrey, Elizabeth Tower, David Tunick, Nicholas Turner, Andrew Wyld, and David and Constance Yates.

The appreciation and understanding of old master and nineteenth-century drawings is a journey, not a destination. I am particularly grateful to several individuals who were especially helpful and encouraging to me along the way: DeWitt and Patricia Hardy, the late A. Hyatt Mayor, Richard S. Teitz, Tom Freudenheim, Victor Carlson, John and Paul Herring, Bruce Livie and Angelika Arnoldi, Roy Davis and Cecily Langdale, and R. E. Lewis.

Among the private collectors of my acquaintance who have formed significant drawing collections during the past thirty years, no one has had as great an influence on me as David Daniels. It is David's emphasis on the quality of a work over the reputation of an artist that has given me confidence to follow my own instincts.

In evaluating and measuring the importance or worth of a drawing, it is important to have colleagues whose taste and knowledge you trust and whom you can easily consult. Sven Bruntjen is one of the individuals who has filled that role for me, combining connoisseurship with a healthy sense of humor. His advice has always been insightful and straightforward.

This catalogue has been a collaborative effort. I wish to acknowledge the contributions of my coauthor, Joseph R. Goldyne, to the success of this project. One of the great pleasures of living in the Bay Area over the past decade has been the opportunity to become a friend and colleague of Joseph's. From the first day we met in the spring of 1975, we recognized our mutual interest in and love of drawings. Over the years I have turned instinctively to him for advice and counsel. My respect for his knowledge made him an obvious choice as coauthor of this publication. It was decided at the outset that, rather than have each of us write all the entries on a particular nationality, we would divide the one hundred works equally according to those drawings that interested each of us the most. The selection of the works and the evolution of the entries has been marked by lively discussion and intellectual interchange between the authors, which has been the most rewarding aspect of this project.

R. F. J.

The Correspondence of Creativity

The artist does not draw what he sees, but what he must make others see.[1]

– Edgar Degas

Drawings have often been called the chamber music of art. The intimate nature of the drawing medium gives its necessary limitations appeal and strength. In most drawings, the diminutive scale of the work and the delicate nature of the medium will demand thoughtful attention from the viewer. A. Hyatt Mayor observed that "this intimacy of drawings explains why they are the last works of art that one comes to appreciate. Any painting jumps at you from across the room as no drawing can... a wallful of drawings cannot overpower like a gallery of paintings...."[2]

Consequently, except for monographic exhibitions of popular artists such as Leonardo, Holbein, and Picasso, drawings generally appeal only to a specialized audience of connoisseurs, artists, and collectors. In the subjective world of art, however, attempting to gauge quality and worth through attendance figures is a fool's pursuit. The symphony, for example, remains a more popular form than chamber music. Such popularity does not make it superior, only different.

Painting, sculpture, and printmaking emphasize elements of premeditation and revision in execution that do not occur in most drawings. A major characteristic of drawing, by contrast, is that it displays the visual evidence of artistic process. It is frequently the method by which artists first investigate, develop, and correct their work in other media. A drawing is more often created as a means to an end than an end in itself. Aline Saarinen wrote that "no other art form is quite as revealing of the artist's temperament and special preoccupations. No other art form pulls the spectator into so intimate and personal a relationship with the artist at the moment of creation. Looking at a drawing is a sort of visual eavesdropping."[3]

An artist's drawings can be seen as a form of diary. To study them is like reading the notes or correspondence of an author rather than his published writings. Except for finished works made on commission, as gifts, or with intent to sell, most drawings are not created with a consciousness of making art. Only later do they take on aesthetic lives of their own. The spontaneity of drawing allows opportunities for exploration, creativity, and expression not found in more premeditated forms of art. This element of chance-taking, however, explains why there are substandard drawings by even the greatest artists. Sir Kenneth Clark observed that "we have plenty of evidence how carelessly Leonardo could draw when his mind was wandering."[4]

If artists of the past could see the majority of their paintings, sculptures, and prints displayed in museums today, they would probably condone the exhibition of these "completed" works of art. In the case of drawings, however, they could quite possibly object to the display of personal and "unfinished" products of their aesthetic imaginations. It is just this unguarded immediacy, inherent in most artists' drawings, that makes them so appealing.

The drawings in this volume range over four hundred years and nine nationalities. Their purposes are varied: they include highly finished drawings, architectural studies, academic exercises, copies, preliminary drawings for paintings and prints, and finally drawings made simply for their own sake.

If the role of art is not to communicate but to convey a shared experience, then the artists presented here have completed their task. It is now up to the viewer to exercise his knowledge and taste in order to complete the artistic dialogue begun in these one hundred master drawings.

Robert Flynn Johnson
Curator in Charge
Achenbach Foundation for Graphic Arts

1. *Robert Goldwater and Marco Treves, eds., Artists on Art* (New York: Pantheon Books, 1972), p. 308.
2. A. Hyatt Mayor, "The Flexibility of Drawings," in *Vassar College Centennial Loan Exhibition* (Poughkeepsie: Vassar College, 1961), pp. xv-xvi.
3. Aline B. Saarinen, "The Delight of Drawings," in *Vassar College Centennial Loan Exhibition*, pp. xvii-xviii.
4. Jean J. Seznec, "Drawings and the Man of Letters," in *One Hundred Master Drawings* (Cambridge: Harvard University Press, 1949), p. xiii.

Introduction

I

The Achenbach Foundation for Graphic Arts, which is the prints and drawing department of The Fine Arts Museums of San Francisco, is the largest collection of works of art on paper in the Western United States. It consists of more than one hundred thousand European and American prints, posters, and illustrated books from the Renaissance to the present day. In addition, the Achenbach Foundation boasts an outstanding collection of Ukiyo-e and modern Japanese prints and drawings, as well as a representative collection of Indian miniature paintings. The drawing collection numbers over two thousand works, which are predominantly European and American in origin. The growing stature of this important cultural resource is all the more remarkable because the Achenbach Foundation for Graphic Arts was not established until 1948 and no regular purchase funds for works on paper became available until 1964.

Prints and drawings departments in museums are like cultural "icebergs." Conservation requires that works of art on paper should be exhibited only for limited periods of time. Thus only a very small portion of a collection can be visible at any given time and the rest is "submerged" in storage boxes. To make our Museums' collection of European and American old master and nineteenth-century drawings known to a wider public, a selection of our finest works has been assembled in this volume. It will stand as a permanent record of the strength and diversity of this aspect of our collection and of the generosity of those donors and benefactors who made it possible.

The drawings in this volume range from the early sixteenth century to the year 1900, with the exception of a few works created during the first years of this century that are essentially nineteenth-century in character. This is the third in a series of catalogues on different aspects of our drawing collection. The first two were *Four Centuries of French Drawings* (1977) and *Russian Theater and Costume Designs from The Fine Arts Museums of San Francisco* (1980). In the planning stage are publications devoted to our collection of twentieth-century drawings and to our Indian miniature paintings and drawings.

II

The earliest acquisitions of drawings by the Museum came about more through fortuitous circumstances than by an organized plan of action. The most notable works donated during this early period were a drawing by a follower of Quesnel (cat. no. 39) that entered the collection in 1927 and the masterful sheet attributed to Domenico Beccafumi, acquired in 1932 (cat. no. 3). In 1947 the California Palace of the Legion of Honor under the leadership of its director, Thomas Carr Howe, held a major loan exhibition of French nineteenth-century drawings. This exhibition, organized by Agnes Mongan of the Fogg Art Museum, Harvard University, marked a turning point in the appreciation of master drawings in San Francisco. The museum boldly acquired from the exhibition the superb Seurat drawing study for *La parade de cirque* (cat. no. 70) for the then staggering sum of four thousand dollars. The intervening thirty-seven years have amply confirmed the wisdom of that purchase.

In 1948 the Achenbach Foundation for Graphic Arts was established by Moore and Hazel Achenbach as a gift to the City of San Francisco. Their magnificent and broadly conceived gift of graphic art was housed in the San Francisco Public Library before its transfer to the California Palace of the Legion of Honor in 1950. Moore Achenbach was not primarily interested in drawings. However, he had acquired the Cogswell Collection *en bloc*, one of the earliest collections of old master drawings formed by an American. In an article on early drawing collections in America, Jacob Bean compared the Cogswell Collection to the Bowdoin Collection in Maine:

Considerably more encyclopedic, at least in the range of the attributions, was a group of some four hundred drawings brought together by Joseph Green Cogswell, first Superintendent of the Astor Library, who had traveled abroad with George Ticknor and studied at Göttingen in 1817. Cogswell's collection, which contained interesting seventeenth century drawings and sheets hopefully attributed to Dürer, Watteau, and Boucher, was sold at auction in London in 1938 but returned to America and is now in the California Palace of the Legion of Honor.[1]

Many of the optimistic attributions of the drawings, like those of other early collections, have had to be revised. Nevertheless, the Cogswell Collection contained a number of fine sheets, notably drawings by Pier Francesco Mola (cat. no. 13) and Jusepe de Ribera (cat. no. 37).

The first curators of the Achenbach Foundation, Dr. Alfred Neumeyer and later Irene Lagorio, were occupied primarily with the organization and exhibition of the prints in the collection. In 1956, however, Dr. E. Gunther Troche, former Director of the Germanisches Nationalmuseum of Nürnberg, Germany, became the Curator in Charge of the Achenbach Foundation. Until his death in 1971,

Dr. Troche systematically organized and expanded the collection through wise purchases and the encouragement of donations. Two of Dr. Troche's purchases included in this volume are the notable rococo fantasy by Johann Wolfgang Baumgartner (cat. no. 30) and the Jean-François Millet charcoal (cat. no. 64). Undoubtedly the most important drawing purchase of Dr. Troche's tenure, however, was the purchase in 1967 of the collection of the French dealer and collector Georges de Batz. Numbering over one hundred ninety-five drawings, it contained important eighteenth- and nineteenth-century French and Italian drawings, including significant works by Giovanni Domenico Tiepolo (cat. nos. 19 and 20), Gabriel de Saint-Aubin (cat. nos. 46, 47, 48), Louis-Léopold Boilly (cat. nos. 51, 52), and Théodore Chassériau (cat. no. 54).

In 1969 the Museums received a magnificent gift of important nineteenth- and twentieth-century American and European paintings and drawings from the collection of Dr. T. Edward and Tullah Hanley. Included among the drawings were works of William Blake (cat. no. 73) and Thomas Eakins (cat. no. 92) as well as what is possibly the Museums' best-known drawing, Paul Gauguin's *L'arlésienne, M^{me} Ginoux* of 1888 (cat. no. 59).

After the death of Gunther Troche, the Achenbach Foundation came under the stewardship of Fenton Kastner from 1971 to 1975. In consultation with Dr. Phyllis Hattis, a visiting scholar from Harvard University who was cataloguing the French drawing collection, the Achenbach acquired several fine drawings, notably a superb Fragonard self-portrait (cat. no. 42) and a bizarre late drawing by Jacques-Louis David (cat. no. 56).

The American Bicentennial was celebrated at our Museums in 1976 by the exhibition of the superlative collection of American paintings and drawings formed by Mr. and Mrs. John D. Rockefeller 3rd. Two years later it was announced that the majority of works from the collection were to come to our Museums as the single greatest gift of art in the Museums' history. This gift included works on paper from the late eighteenth through the twentieth century. Some of the highlights of this collection include a rare Audubon watercolor (cat. no. 89) and two Winslow Homer watercolors, including the pensive *Burnt Mountain* of 1892 (cat. no. 94).

Over the years the single greatest source of funding for the purchase of drawings has been the acquisition endowment bequeathed by Moore and Hazel Achenbach in 1964. Without this small but reliable source of income,

many fine drawings as well as prints would have been lost. Other funding sources utilized in the acquisition of drawings have been the Margaret and Roscoe Oakes Fund, the Mildred Anna Williams Fund, the Elizabeth Ebert and Arthur W. Barney Fund, the William H. Noble Bequest Fund, the Joseph M. Bransten Memorial Fund, and the Mrs. Alexander de Bretteville Fund.

To be entrusted by collectors with gifts of drawings from their own collections is a serious responsibility that encompasses preservation, research, publication, and display. Some of the other significant donors of master drawings to our Museums have included Joseph M. Bransten, Katherine Caldwell, Mr. and Mrs. Sidney M. Ehrman, Ludwig Emge, George Hopper Fitch, the Goldyne family, Mr. and Mrs. Frederic Hellman, Osgood Hooker, Archer M. Huntington, Grace Hamilton Kelham, Ruth Haas Lilienthal, and Elizabeth S. Tower.

III

Since 1975 the aim of the Achenbach Foundation has been to develop its drawing collection in its historical strengths of Italian seventeenth- and eighteenth-century and French eighteenth- and nineteenth-century drawings, while also recognizing the need to acquire works in previously neglected areas. In this century earlier generations of American collectors and curators tended to have fine but somewhat predictable taste in their acquisition of drawings: works of the Italian High Renaissance, followed by Rubens, Rembrandt, Watteau, Boucher, Fragonard, Canaletto, Guardi, members of the Tiepolo family, Goya, and concluded by the great French masters of the nineteenth century. This refined taste was exemplified by the great collector and teacher Paul Sachs who introduced several generations of future directors and curators to the importance of drawings in his famous museum course at Harvard University. Although perfectly valid in its day, this aesthetic no longer functions for most individuals. The ever-growing scarcity of important drawings in the art market and the often astronomical prices that those few works command have demanded a reevaluation among all but the wealthiest curators and collectors of what constitutes a "master drawing." This reevaluation of necessity has by no means had negative consequences. On the contrary, artists, periods, and even nationalities previously deemed "minor" are receiving belated but well-deserved evaluation and recognition. Twenty-five years ago it would have been a rare occurrence to include drawings by artists such as Carletto Caliari, Adolph von Menzel, Edme

Bouchardon, or Thomas Couture in a catalogue of this type, nor would one have included a work by an Englishman other than Blake, Turner, or Constable, or a drawing by *any* American artist.

Today the challenge to be met by the modern museum curator in the area of acquisitions is to balance those necessary, expensive, "retrospective" purchases of rare and sought-after drawings by great masters with the daring and often problematic "anticipatory" purchases of works by artists, some of whom have been dead for hundreds of years, whose aesthetic merits for various reasons have not yet been fully understood or appreciated. In this arena, the absence of a large price tag with its comforting reassurance of confirmed importance leaves the work to be appreciated on its own merit. Fashion, beauty, rarity, condition, and art historical significance are the main factors that determine the value of a work of art. Amazingly, fashion continues to exert the greatest gravitational pull on curators and collectors, while beauty is often overlooked or downgraded.

The Achenbach Foundation continues to make both "retrospective" and "anticipatory" acquisitions. Recent "retrospective" purchases have included drawings by Rembrandt (cat. no. 29), Giovanni Battista Piazzetta (cat. no. 15), and Canaletto (cat. no. 9). Drawings that fit a more "anticipatory" mode have included drawings by Francesco Fontebasso (cat. no. 10), Pieter Quast (cat. no. 28), Philipp Veit (cat. no. 34), and Richard Dadd (cat. no. 79). It is ultimately impossible to predict how the reasoned but still subjective aesthetic judgments of today's acquisitions will be judged in the future.

Drawings are the closest tangible evidence of the artist in the act of creation. The insight they give into the process of art makes them an invaluable part of a museum's holdings. The Achenbach Foundation for Graphic Arts plans to continue to maintain its collection of drawings as one of the most popular and vital components of The Fine Arts Museums of San Francisco.

Robert Flynn Johnson

1. Jacob Bean, "Introduction," *100 European Drawings in The Metropolitan Museum of Art* (New York: The Metropolitan Museum of Art, 1964), p. 9.

Note to the Reader

Works in the catalogue are divided into national schools, as indicated at the top of each text page, and arranged alphabetically by artist's name within each school. For the French school, which has the largest number of works, there is an additional division by century.

Dimensions appear in both inches and millimeters, height before width. No work is reproduced larger than actual size. Only the sheet is illustrated (except for cat. no. 1, where decorated border is shown); support mounts are not shown, although inscriptions and stamps on the mounts are recorded in the text.

Initials at the end of each entry indicate authorship, and notes appear together at the end of the catalogue.

Catalogue

1. Giovanni Francesco Barbieri (Il Guercino) *Cento 1591-1666 Bologna*

Saint John the Evangelist Meditating the Gospel, ca. 1645-1650

Pen and brown ink on laid paper; 8¾ × 7⅞ in.
(222 × 200 mm). Mounted to a decorated border (Lugt
2858c, heirs of Benedetto and Cesare Gennari).
Inscribed in brown ink at lower left: *IN PRINCIPIO
ERAT VERBVM*, and at upper right: *10.P.*

PROVENANCE: Heirs of Benedetto and Cesare Gennari,
Bologna (Lugt 2858c); Earl of Gainsborough; private
collection(s); Sotheby's, London, 27 June 1974, lot 26,
p. 16, repr. p. 46; Yvonne Tan Bunzl, London,
1976.
BIBLIOGRAPHY: G. C. Bertala and Stefano Ferrara,
Catalogo Generale... Pinacoteca Nazionale di Bologna...,
vol. 3 (Bologna, 1973), no. 520 (reversed copy); Yvonne
Tan Bunzl, *Old Master Drawings and French Drawings of
the 19th Century* (Leicester and London: Raithby,
Lawrence & Co., Ltd., 1975), no. 18, repr.
EXHIBITIONS: California Palace of the Legion of Honor,
The Fine Arts Museums of San Francisco, *Recent
Acquisitions*, 1977; idem, *Masterworks from the Achenbach
Foundation for Graphic Arts*, 1981.

As we near the end of the twentieth century it seems
remarkable that exceptional drawings by Guercino still
are obtainable, for they have been sought by great
collectors and admired by artists since the famous
Bolognese painter's own time. Guercino was unusually
prolific and his drawings often were copied, especially in
the eighteenth century when his particularly felicitous
sense of linear design and modeling was perpetuated by
artists such as Francesco Bartolozzi and Benjamin West.
Even Giovanni Battista Piranesi did etched copies of
Guercino drawings.

Guercino's compelling manner derived largely from
the styles of Annibale and Ludovico Carracci. The
Carracci established a strong academic tradition that
provided the foundation for Guercino's lyrical
refinements of delineation and modeling–refinements
that give his drawings a memorable, bittersweet quality.

In our drawing, Saint John the Evangelist meditates
on the inspired splendor of the opening passage of his
gospel: *In principio erat verbum* (in the beginning was the
word). The artist accords his contemplative subject a
genteel rendering in which lines, and occasionally dots,
are used to create smooth transitions from light to
deep shadow. This line-and-dot manner of modeling is
consistent with a date in the mid- to late 1640s.

It was surely the quality of this drawing together with
the appeal of its subject that accounted for the etched
copy, in reverse, by Francesco Curti (1603-1670). The
Museums' drawing also was engraved by Domenico
Bonaveri and a good copy of the drawing, now in the
Royal Library at Windsor Castle, was engraved by
Francesco Bartolozzi (1725-1815) who thought it to be
the original.[1]

Saint John the Evangelist is illustrated here with the
decorated mount that identifies it as part of that group of
works inherited by the artist's family.

J. R. G.

Achenbach Foundation for Graphic Arts purchase, 1976.2.19

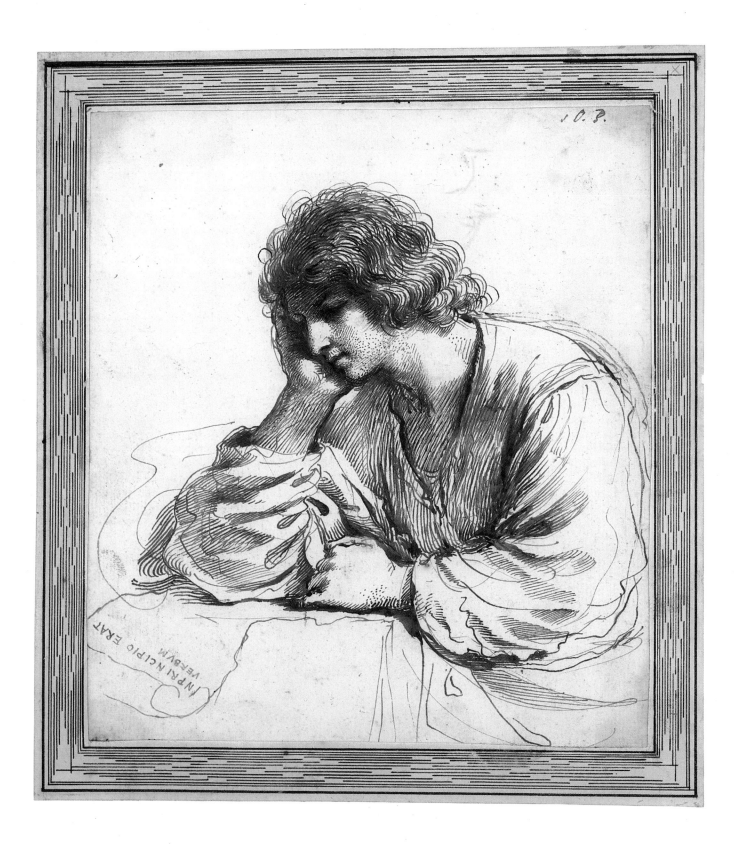

2. Giovanni Francesco Barbieri (Il Guercino) *Cento 1591-1666 Bologna*

A Kneeling Nun, ca. 1635

Black chalk with traces of white chalk heightening on laid paper; 15¾ × 11¾ in. (400 × 299 mm). Collector's stamp on verso: Sir Robert Witt (Lugt Supplement 2228b).

PROVENANCE: Earl of Gainsborough; Sir Robert Witt, (Lugt Supplement 2228b), London, 1951; Thomas Carr Howe, San Francisco, 1951-1981.
EXHIBITION: California Palace of the Legion of Honor, The Fine Arts Museums of San Francisco, *Recent Acquisitions, Part I*, 1983.

Caricature played a more frequent role than most of us realize in the graphic careers of many Italian artists. Leonardo, Bernini, the Carracci, Mola, della Bella, Canaletto, the Tiepolos, the Gandolfi, and other Italian masters produced caricatures and caricaturelike drawings, proof that there must be respite from high purpose and that humor sustains the spirit as much as nobly directed effort.

A truly brilliant and devoted draftsman, Guercino is understandably revered and collected primarily because of the delicacy and emotion captured in his serious works (see cat. no. 1). In such exercises as *A Kneeling Nun*, however, he creates what we may call a kind of proto-caricature. An early inscription on an album of Guercino caricatures now at Princeton University comments on the artist's talent for this genre: *One of his particular gifts was making certain portraits that our painters call caricatures, a genre in which he was one of those few gifted with the vivacity and intelligence that this sort of thing requires; and he stands among the very best....*[1]

Classical caricature most frequently exploits the face, exaggerating features with comic intent. One cannot be certain that the depiction of the kneeling nun had such intention, but judging from the range of Guercino's types, this effort strongly suggests an inclination toward the humorous and provides additional evidence of the scope of the artist's passion for drawing.

Guercino worked with stunning facility whether the medium he used was precise or crude. In drawing the Museums' *A Kneeling Nun*, he rapidly fashioned the image with a blunt chalk stick. Eschewing frankly farcical caricature, he achieves impact chiefly from the stolid countenance of the plump kneeling nun and from her depiction as a mound of draperies with rosary beads.

A Kneeling Nun would appear to date from the earlier half of Guercino's career, probably about 1635.
J. R. G.

Gift of Mr. and Mrs. Thomas Carr Howe in honor of Elizabeth S. Tower, 1981.2.38

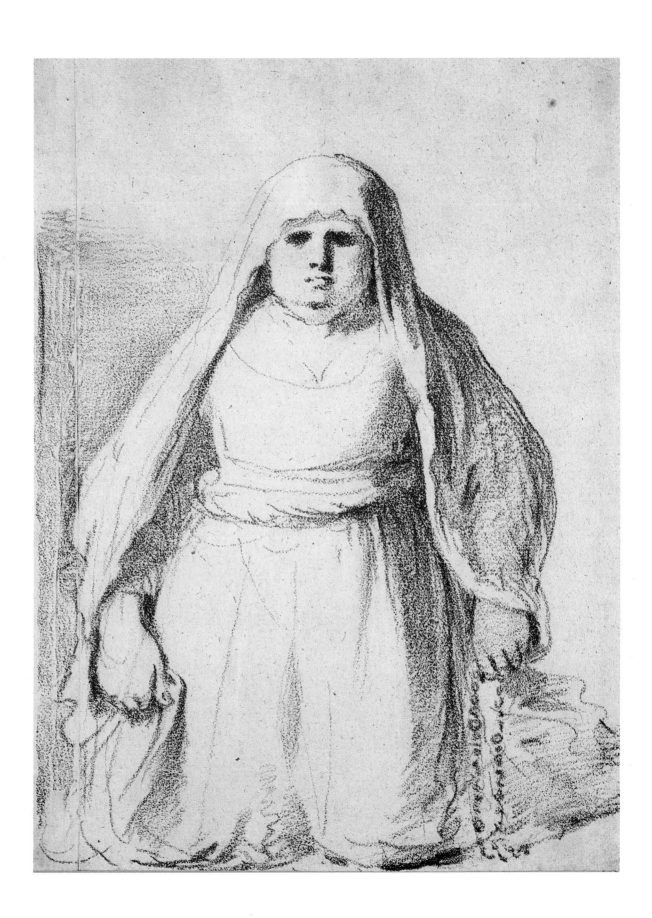

3. *Attributed to* Domenico Beccafumi *Valdibiena 1486-1551 Siena*

The Descent from the Cross

Pen and brown ink with brown and gray washes on laid paper; 14¾ × 11 in. (372 × 280 mm). Inscribed in brown ink along lower right edge: *D. Builfumi micarino Cavato Del libro di Vasari.*

PROVENANCE: Giorgio Vasari, Florence; Pierre Crozat, Paris; Gabriel Huquier, Paris; O'Hara, Livermore, and Arthur Baken, San Francisco; California Palace of the Legion of Honor purchase.

BIBLIOGRAPHY: Pierre-Jean Mariette, *Description sommaire des dessins des grands maîtres d'Italie, des Pays-Bas, et de France du Cabinet de feu M. Crozat*, (Paris, 1741), p. 7; Hans Tietze, "A Drawing by Beccafumi in San Francisco", *The Pacific Art Review* 2 (1942): 7-9; Licia Ragghianti Collobi, *Il Libro dei Disegni del Vasari*, vol. 1 (Florence: Vallecchi Editore, 1974), p. 133; vol. 2, fig. 411.

EXHIBITIONS: Mills College Art Gallery, Oakland, *Old Master Drawings*, exh. cat., 1937, no. 4, repr. (also Portland Museum of Art, 1938); Pomona College Art Gallery, Claremont, *Mannerism*, 1963; California Palace of the Legion of Honor, San Francisco, *Old Master Drawings*, 1966; John and Mable Ringling Museum of Art, Sarasota, *Master Drawings*, 1967; University Art Museum, Berkeley, *Master Drawings from California Collections*, Juergen Schulz, ed., 1968, no. 29, p. 36, repr. p. 106; University of Notre Dame, Indiana, *The Age of Vasari*, 1970, no. D5 (also State University of New York, Binghamton, 1970); California Palace of the Legion of Honor, The Fine Arts Museums of San Francisco, *Masterworks from the Achenbach Foundation for Graphic Arts*, 1981.

This may be one of the best-known drawings in Northern California. It was published for the first time by Tietze in 1942, and it has been chosen for many exhibitions. Clearly, some of the interest in the drawing results from the fact that its provenance begins with the famous sixteenth-century artist, historian, and collector Giorgio Vasari (d. 1574). Indeed, Vasari writes of some sheets by Beccafumi in his own collection (*Lives* [London, 1913] vol. 6, p. 250), and the great eighteenth-century French collector Mariette mentions in his notes for the magnificent Crozat auction of 1741 that in the sale there was a *Deposition* by Beccafumi (see bibliography). The San Francisco *Descent* was purchased in the Crozat sale by the connoisseur Huquier. Owned subsequently by a series of unrecorded collectors, it was ultimately acquired by the Museums through the James D. Phelan Bequest Fund.

Although he was a Sienese, Beccafumi's drawings reveal a host of Florentine and Roman sources as well, and his fusion of these sources often produced works of eccentric originality. But despite the expected eccentricities, the unusual style revealed in the *Descent from the Cross* has convinced some contemporary scholars that the drawing is not by Beccafumi.

The composition reveals a linear technique that seems to be inspired by the Florentine mannerist Rosso and a use of wash reminiscent of the Roman school. Philip Pouncey, however, has suggested that the drawing may well be Northern, and the Master of the Egmont Album was suggested some years ago by Julian Stock. The draftsmanship that characterizes *The Descent from the Cross* conveys an unusually successful sense of compositional fluidity and dramatic illumination, and whoever the artist, scholars agree that this work is a special achievement. While several other suggestions regarding attribution have been advanced, the preponderance of extra-stylistic circumstantial evidence in favor of Beccafumi necessarily places the burden of proof on scholars who refute his authorship.

J. R. G.

James D. Phelan Bequest Fund, 1932.4

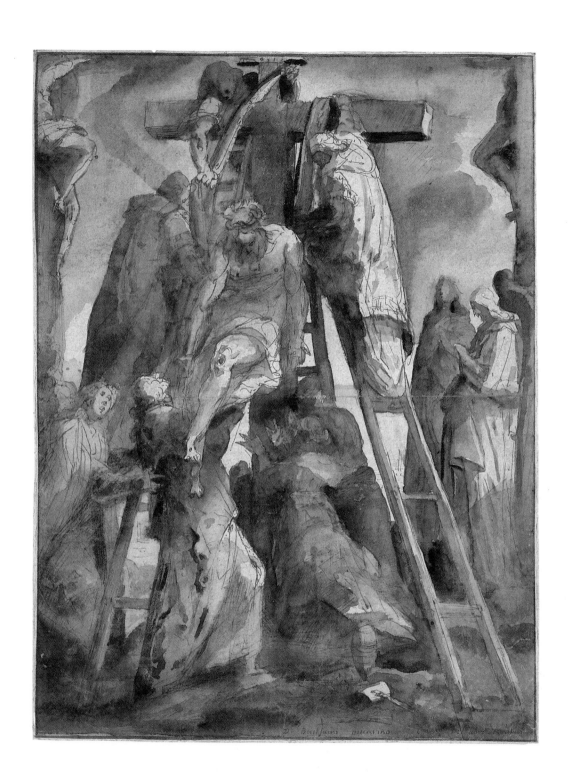

4. Stefano della Bella *Florence 1610-1664 Florence*

Marine Battle, ca. 1634

Pen and brown ink with brown wash on laid paper; 5⅛ × 8¼ in. (130 × 211 mm). At lower right the collector's dry stamp of Benjamin West (Lugt 419).

PROVENANCE: Benjamin West (Lugt 419); Sir Thomas Lawrence, London; Dr. Ludwig A. Emge Collection. EXHIBITIONS: University of California, Santa Barbara, *Regional Styles of Drawing in Italy: 1600-1700*, exh. cat., Alfred Moir, ed., 1977, no. 24, p. 46, repr., p. 47; California Palace of the Legion of Honor, The Fine Arts Museums of San Francisco, *Recent Acquisitions, 1977-1978*, 1978.

An important printmaker as well as a consummate draftsman, Stefano della Bella possessed one of the most skilled and playful hands in the history of Italian drawing. He lived at a time when graphic art had a large international audience, and he was virtually the exact contemporary of two other preeminent draftsmen-printmakers, the Genoese painter Giovanni-Benedetto Castiglione and Rembrandt van Rijn (see cat. no. 29). Despite the abundance of native Italian talent around him, Stefano was most strongly influenced by the French artist Jacques Callot (see cat. no. 38), whose genius was akin to his own, and like Callot he prepared many drawings as studies for his celebrated prints.

The works of Stefano della Bella only recently have become a serious focus of collecting. This is not because they lacked the approbation of scholars and connoisseurs but rather because they were in relatively abundant supply. Now diminished, that supply was a testament to the artist's prodigious output and thus to the critical role that drawing played in his thought and life. For artists like Stefano, drawing was akin to breathing—a continual, almost involuntary activity.

The fine sheet exhibited here, one of several drawings by the artist in our collection, is a preparatory study for an etching of a marine engagement.[1] Dating to about 1634, the year in which the related print—one of a suite of eight marines—was published, the drawing seems to provide for the basic composition as well as for some of the figures that appear in the etching. It is enlivened by a brown wash, which has not been translated into etched lines.

Not surprisingly, this work was in the collection of Benjamin West (1738-1820). The American artist's graphic sensibilities and those of numerous English collectors of the eighteenth century inclined toward the suave curvilinearity of stroke and the deft application of wash characteristic of Baroque artists such as Stefano della Bella and Guercino (see cat. nos. 1 and 2). In fact, there are drawings by West that clearly imitate the work of these artists.

J. R. G.

Gift of Dr. Ludwig A. Emge, 1971.17.1

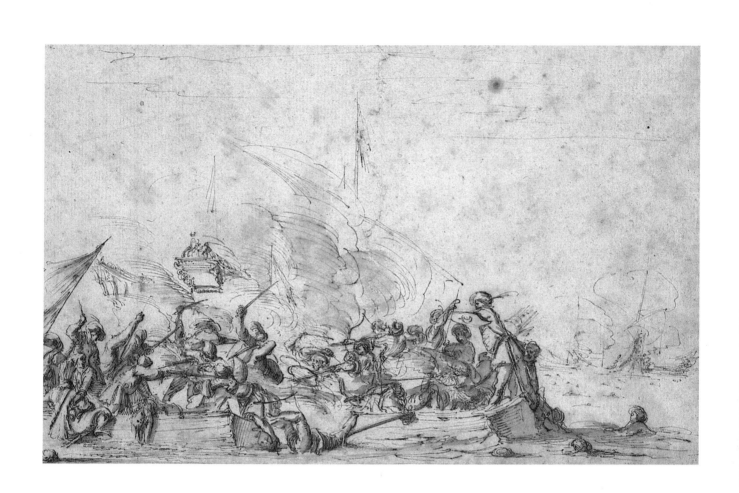

5. Giuseppe Galli Bibiena *Parma 1696-1756 Berlin*

Design for a Castrum Doloris to the Holy Roman Emperor, Leopold Joseph, after 1711 but before 1740

Pen and brown ink and gray wash with traces of graphite underdrawing on laid paper; 20⅜ × 13⅜ in. (517 × 340 mm). Inscribed in brown ink at lower center (in a cartouche on the monument): *Anno / 1681 Spronij. Sac/ro R. Ungar. Anno / 1690. Augustali Imp/eriali Corona, Augustae, Vind. inaugurata Coronam/Utramque Sacratiorem ef/fecit. Castissimi Connumij/Nobiles fructus fuere/preter filias Archid: Sept / ac / LEOPOLDUM. JOSE / PHUM. immaturo fato/raptum. Augusti f.f. / JOSEPHUS et CAROLUS / QUANQUAM illos seu felia / tas, seu ipsa Virtus enixa / nisi de hac Matre constaret,* and on verso in brown ink: *J...ice Elles (n or v)era / Terza Parte.*

PROVENANCE: Christie's, London, 10 July 1973, lot 15; H. Shickman Gallery, New York; Achenbach Foundation for Graphic Arts purchase.
BIBLIOGRAPHY: Giuseppe Galli Bibiena, *Architectural and Perspective Designs*, part 5 (New York: Dover Publications, 1964), pl. 2.
EXHIBITIONS: California Palace of the Legion of Honor, The Fine Arts Museums of San Francisco, *Selected Acquisitions, 1977-1979*, 1979-1980, checklist, no. 7; idem, *Masterworks from the Achenbach Foundation for Graphic Arts*, 1981.

The great architectural books of the eighteenth century provided not only an opportunity to display scholarship but also to communicate the dreams of noted artists and architects. Giuseppe Galli Bibiena was such a dreamer, and he became the most outstanding inventor of a remarkable family of artists and set designers. As a boy of twelve, Giuseppe was taken to Barcelona by his father, Ferdinando (1657-1743), the first of eight Bibienas associated with theatrical design. There Ferdinando received the first of his many foreign commissions, and when Giuseppe was only sixteen the family moved to Vienna to reside at the local court. Ferdinando in time became famous, and when he later went blind, Giuseppe inherited his father's court position as chief decorator.

The Fine Arts Museums are fortunate to have acquired recently a finished drawing by Giuseppe. Such sheets rarely appear on the market, and because the drawing is certainly among those preparatory studies for two engraved plates included in Bibiena's magnificent volume *Architetture e Prospettive* of 1740, it is an especially interesting and desirable addition to the collections.[1]

The drawing represents a cross section of a *castrum doloris* (literally, a castle of sadness), a temporary monument erected to the memory of a royal person or to another prominent figure. The inscription on the design dedicates the sumptuously embellished structure to the Emperor Leopold Joseph, who was born in 1678 and died of smallpox in Vienna in 1711. He was named King of the Romans or successor designate to the Empire in 1690, and from 1705 until his death he served as Holy Roman Emperor. With the passing of Leopold Joseph the Habsburgs were deprived of the Spanish succession.

It seems unlikely that this drawing was done by Giuseppe soon after the emperor's demise, for when the artist arrived in Vienna in 1712 he was but sixteen years old. Most probably it was executed closer to the time of publication of the *Architetture* in 1740. That volume contains two engravings by Andreas Pfeffel of *castra doloris* that reveal a virtually one-to-one relationship with our drawing.[2] The engravings, however, are shown in full section and our pen and wash study is conceived in cross section.

The beauty of the Museums' drawing by Giuseppe Galli Bibiena is largely achieved by techniques of brown delineation and gray wash that produce a shimmering image not unlike the magical renderings of Canaletto executed in similar fashion. This way of drawing, combined with the sheer magnificence of the forms and textures that are depicted, creates an object-conception as fully revealing of the Rococo possibilities inherent in the later Baroque as any actual work of architecture or sculpture.

J. R. G.

William H. Noble Bequest Fund, 1979.2.3

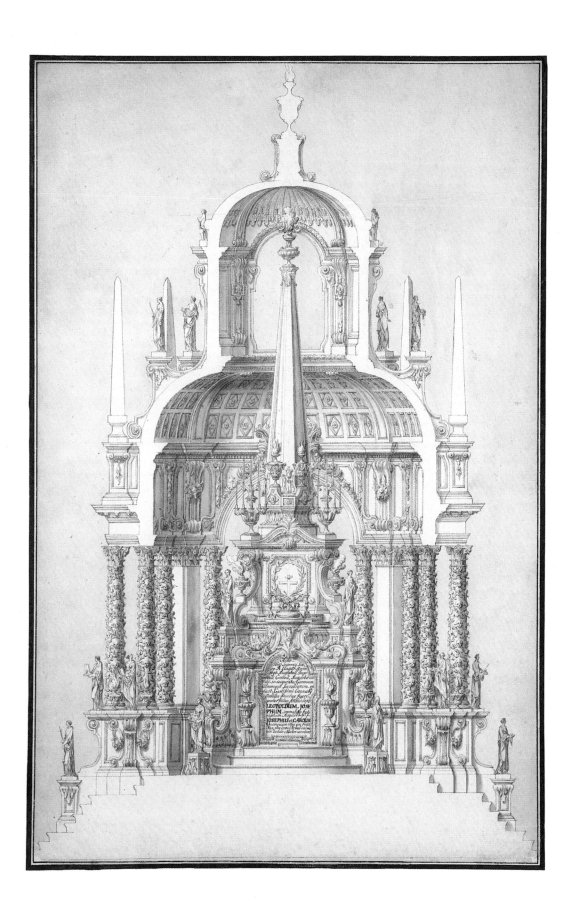

6. Pietro Buonaccorsi (Il Perino del Vaga) *Florence 1501-1547 Rome*

Landscape with a Ruin and Study of Arms, ca. 1517

Pen and brown ink on laid paper; 7½ × 6⅜ in. (191 × 162 mm). The collector's stamp of Charles Eggiman (Lugt 530) at lower right. Inscribed on paper mount at lower left: *Bull Killer, Sacrifice of Lystra*, and at lower right: *Klinkosch sale, Vienna, lot 694, April 1889 as Raphael.*

PROVENANCE: A. Freiherr von Lanna; Count Gelozzi; Klinkosch sale, Vienna, April 1889, lot 694 (as Raphael); Charles Eggiman (Lugt 530); H. Shickman Gallery, New York, 1968; Sotheby's, London, 2 July 1984, lot 7.
EXHIBITION: H. Shickman Gallery, New York, *Old Master Drawings*, 1968, no. 23b.

Vasari tells us that Raphael, after viewing examples of Perino del Vaga's drawing, declared "that among all the young men that he had known, Perino would attain to the highest perfection in that art."[1] Whether or not this exact incident occurred, Perino's is certainly one of the most celebrated names in the small, privileged circle of lesser talents trained by Raphael.

At the age of fifteen, in 1515, Perino began an apprenticeship in Raphael's atelier, and the Museums' drawing by him provides specific evidence of the influence of Raphael.[2] The two arms, holding an axe handle, are based on the arms of the bull killer in a cartoon of 1515/1516 by Raphael, now in the Victoria and Albert Museum, London. The cartoon, depicting the

Sacrifice after the Healing of the Cripple at Lystra, is taken from the *Acts of the Apostles* (xiv, 8-15). Not only is Perino's composition of the same passage based on a cartoon by Raphael but his style of rendering also pays homage to the beauty and delicacy of Raphael's draftsmanship. The precocity Vasari referred to is well substantiated by this sheet that must date to about 1517. The landscape with ruins, though freely rendered, also possesses elements favored by Raphael, such as the receding colonnade and ascending staircase on the right (for example, in the cartoon for the tapestry depicting the *Death of Ananias* and the *Fire in the Borgo*, Stanza dell'Incendio, Vatican Museums).

Perino del Vaga matured to become one of the leading fresco painters of the first half of the sixteenth century and received commissions from Genoa and Tuscany as well as Rome. His drawings for these projects were usually true working sketches, lacking the finish displayed in the passage of arms copied after his renowned master and featured on the Museums' early sheet.

One way to appreciate this rare look at a document from the circle of Raphael is to view it as the effort of an unusually gifted teenager, smitten by the excitement and challenge of working for one of the most famous artists and personalities of his time.

J. R. G.

Achenbach Foundation for Graphic Arts purchase, 1984.2.38

7. Carletto Caliari *Venice 1570-1596 Venice*

Bearded Man Wearing a Ruff, ca. 1590

Black, brown, red, and white chalk on blue-green laid paper; 11¼ × 7⅞ in. (300 × 200 mm). Inscribed with brown ink on verso: *490 Lapis*, and collector's stamp: H. Marignane (Lugt 1343a).

PROVENANCE: Zaccaria Sagredo, Venice; Maurice Marignane, Paris; Hubert Marignane, Paris (Lugt 1343a); Hans Calmann, London; Charles E. Slatkin Galleries, New York, 1960; David Daniels, 1960; Sotheby's, London, 25 April 1978, lot 12; Achenbach Foundation for Graphic Arts purchase.

BIBLIOGRAPHY: H. Tietze and E. Tietze-Conrat, *The Drawings of the Venetian Painters* (New York: J. J. Augustin, 1944), no. 235, p. 58; Edoardo Arslan, *I Bassano*, vol. 1 (Milan, 1960), pp. 239, 263; vol. 2, pl. 294; A. Ballarin, "Introduzione a un catalogo dei disegni di Jacopo Bassano–II," *Studi di storia dell'arte in onore di Antonio Morassi* (Venice: Alfieri, 1971), pp. 145-147, no. 33.

EXHIBITIONS: Seiferheld Galleries, New York, *Bassano Drawings*, 1961, no. 11, repr.; Museum of Art, Rhode Island School of Design, Providence, *Seven Centuries of Italian Art*, exh. cat. (as Bassano), 1967; The Minneapolis Institute of Arts, *Selections from the Drawing Collection of David Daniels*, exh. cat. by Mary Lee Bennett and Agnes Mongan, 1968, no. 1 (as Bassano), repr. (also The Art Institute of Chicago, 1968; Nelson Gallery-Atkins Museum, Kansas City, 1968; Fogg Art Museum, Harvard University, 1968); Yale University Art Gallery, New Haven, *Sixteenth Century Italian Drawings: Form and Function*, exh. cat. by Edmund Pillsbury and John Caldwell, 1974, no. 50, repr.; Los Angeles County Museum of Art, *Old Master Drawings from American Collections*, exh. cat. by Ebria Feinblatt, 1976, no. 54, p. 50, repr.; California Palace of the Legion of Honor, The Fine Arts Museums of San Francisco, *Recent Acquisitions, 1977-1978*, 1978; idem, *European Drawings from the Achenbach Foundation for Graphic Arts*, 1979; idem, *Selected Acquisitions, 1977-1979*, 1979-1980, checklist, no. 16; idem, *Masterworks from the Achenbach Foundation for Graphic Arts*, 1981.

This striking portrait head was attributed to Leandro Bassano when it was published by Bennett and Mongan in 1968 as part of the Daniels collection. The attribution followed the one proposed in the initial publication of the drawing (with nine similar sheets from the Marignane collection) by the Tietzes in their pioneering work of 1944.[1] Subsequent independent research by Alessandro Ballarin and W. R. Rearick strongly suggests that all of these portrait heads, now widely dispersed, are the work of Carletto Caliari.[2]

Carletto was the son of one of the true geniuses of Venetian painting, Paolo Veronese. To further his training, his father placed him in the workshop of Jacopo Bassano where drawn and painted portraits were produced continually. All of the portrait sheets once in the Marignane collection display linear as well as textural characteristics associated with the draftsmanship of the Bassano circle.

Carletto lived a tragically short life and yet was able to work for a time as one of his late father's three artistic heirs. These heirs of Paolo Veronese, or the "Haeredes Paoli" as they wished to be known, chose to work as a team and enjoyed an unusual degree of harmony in their production of paintings. Therefore, except when there is documentary evidence to make an attribution to one or the other, it is really not possible to distinguish Carletto's paintings from those of his uncle Benedetto or his brother Gabriele.

Similar problems exist with the drawings of the Caliari family. Although the portrait heads we have discussed are surely by one hand, attributing them with absolute assurance to one of the group of the "Haeredes" may be impossible. Evidence is strong, however, for an attribution to Carletto because of their Bassano-like coarse softness and because several of the chalk sheets are portrait studies for the painting *Venetian Ambassadors Dispatched to Pavia* (Sala del Maggior Consiglio, Palazzo Ducale, Venice). At least this would seem to rule out the Tietzes' earlier attribution to Leandro Bassano, for the painting is a documented late effort by the "Haeredes," and almost certainly the young Carletto supplied the drawn portraits for painterly translation by Benedetto and Gabriele.[3]

Perhaps more significant for the casual viewer than the matter of attribution is the fact that these colored chalk drawings are among the earliest pastel studies and that *Head of Bearded Man with a Ruff* is one of the handsomest of the series.

J. R. G.

Elizabeth Ebert and Arthur W. Barney Fund, 1978. 2.21

8. Domenico Campagnola *Padua or Venice 1500-1564 Padua*

Hilly Landscape with Woman and Donkey

Pen and brown ink on laid paper; 9⅝ × 15⅛ in.
(246 × 383 mm). Inscribed on verso: *motfias*.

PROVENANCE: Aldo Caselli, 1968; Esther S. and
Malcolm W. Bick, Longmeadow, Massachusetts;
Sotheby's, London, 2 July 1984, lot 14.
BIBLIOGRAPHY: refer to exh. cat. *Italian Drawings,
Selections from the Collection of Esther S. and Malcolm
W. Bick*. (New Hampshire: Hopkins Center,
Dartmouth College, 1971), no. 3.
EXHIBITIONS: Dartmouth College, Hopkins Center,
New Hampshire, *Italian Drawings, Selections from the
Collection of Esther S. and Malcolm W. Bick*, exh. cat.,
1971, no. 3, repr.

Campagnola was born of German parents in Venice
and was adopted by the artist and engraver Giulio
Campagnola, from whom he received his earliest
instruction.[1] Domenico, however, was most powerfully
influenced by Titian, whose studio he entered at an
early age and whom he is said to have assisted on the
frescoes in the Scuola del Santo, Padua, in 1511.[2] A
precociously talented artist who emulated both teachers,
Campagnola's early landscape drawings, of 1517 to 1520,
often have been confused with those of Giulio and
Titian. Indeed, although Domenico's reputation as a
landscape draftsman was known as early as 1537 from the
writings of M. A. Michiel,[3] the attribution problem of
these drawings is so great that the Tietzes stated that
"we wish to emphasize the odd fact that almost no
drawings exist that are verified beyond doubt and
universally accepted by an artist to whom hundreds of
drawings have been attributed."[4]

Based on a comparison with other landscape drawings
that are generally accepted as Domenico Campagnola,
the finely executed, panoramic drawing in the
Achenbach Foundation can be placed among those
identified by scholars as belonging to his later style.[5]
This style is characterized by a greater emphasis on
expansive vistas and receding space, the reduction of
figures to a secondary role, and a crisp, controlled
surface of pen-and-ink lines and hatchings. Domenico's
background as an engraver explains the tightness of
execution in most of these drawings.

Two characteristics of Domenico's landscape style
that are present in our sheet are the abundance of
sharply defined yet simply rendered trees and the
appearance of rustic farm buildings in the middle
distance. First seen in the work of Giulio Campagnola,
these invented elements were later elaborated and
routinely used by Domenico to enrich the landscape
detail. Domenico's landscape style stressed the
schematic usage of these devices as opposed to
naturalistic observation. Mrs. Fröhlich-Bum pointed
out that "Campagnola draws trees not to be climbed,
houses not to be dwelt in."[6]

Domenico Campagnola was one of the first Italian
artists to view landscape as an end in itself and not
simply as a backdrop for religious, mythological, or
allegorical subject matter. His landscape drawings are
the best known works in his later style, and they did
much to popularize the Venetian landscape style of
Titian and Giorgione among both his Italian compatriots
and Northern artists. Pieter Brueghel the Elder was
influenced by them as were the Carracci and other
Bolognese artists.[7] In the early eighteenth century, the
great French draftsman Antoine Watteau was inspired
to make free copies in red chalk of the twenty-three
Domenico Campagnola drawings owned by his friend
Baron Crozat.[8] Examples of this series of Watteau
drawings are in The Metropolitan Museum of Art, The
Art Institute of Chicago, and the Achenbach Foundation
for Graphic Arts (see cat. no. 49).

R. F. J.

Achenbach Foundation for Graphic Arts purchase, 1984.2.39

9. Giovanni Antonio Canal (Il Canaletto) *Venice 1697-1769 Venice*

View of the Arch of Constantine and Environs, Rome, late 1750s or early 1760s

Pen and brown ink with gray wash over traces of graphite underdrawing on laid paper; 8 × 12½ in. (203 × 316 mm). On verso in graphite: an architectural sketch.

PROVENANCE: Dr. J. F. Reber, Lausanne; Lynven, Inc., New York, 1984.

Although his reputation and fame are associated primarily with magical views of Venice and London, Antonio Canaletto probably began his celebrated career as a painter of *vedute* (views or townscapes) in Rome, in 1719. The young man had come to Rome as his father's assistant to paint theater sets, and the libretti of two Scarlatti operas record father and son as scene painters for productions staged in 1720. There are, however, no known Canaletto views of Rome of this period, though some scholars feel certain they must exist in an as yet unrecognized youthful style. That the artist abandoned the theater for the painting of views is not surprising, given his talent and his maturation at a time when Italy was the focus of the *grand tour*. That splendid introduction to the cultural world away from home, which had become *de rigueur*, especially for privileged and affluent young English travelers, generated a great demand for memorabilia. And travelers eager for a pictorial record of the topographical wonders experienced on their visits to Venice and Rome could secure no more vivid a memory than one or more of Canaletto's *vedute*–colorful paintings suited for gilded frames in the great rooms of England's patrician homes.

Because no one surpassed Canaletto as a view painter and draftsman, he was a very busy and prolific artist. Indeed, he was so besieged by commissions for Venetian subjects that with the exception of the nine-year period between 1746 and 1755, most of which was spent in England, the painter hardly left Venice.

Our Roman view, therefore, probably was drawn in Venice, for as James Byam Shaw noted recently, the drawing is a late work–from the late 1750s or early 1760s–and there is no contemporary evidence that Canaletto returned to Rome after 1720.[1] Nevertheless, the fact that the composition is not a *capriccio* (real buildings grouped in an imaginary way), but rather a rendering of the view as it appeared at the time, suggests to some that the artist may have drawn it on site. Perhaps the most plausible explanation, given the lack of specific evidence of a later stay in Rome, is Byam Shaw's proposal that the elements of the view are based on a painting like one at Shrublands Park, Ipswich, by or attributed to Canaletto's contemporary Pannini.[2] Wherever it was executed, this sparkling drawing provides excellent evidence of the magical results attained by Canaletto's technique and style. Essentially, his best painted and drawn works achieve two goals: the illusion of topographic detail and a sense of brilliant light. It is undoubtedly his discovery of how to craft the quality of flickering light by juxtaposing brown ink lines and passages of gray wash that makes his corpus of drawings among the most memorable eighteenth-century graphic achievements.

J. R. G.

Roscoe and Margaret Oakes Fund and Achenbach Foundation for Graphic Arts purchase, 1984.2.9 r-v

10. Francesco Fontebasso *Venice 1709-1769 Venice*

Male Nude Floating Upward, His Arms Outstretched; A Bust of a Young Woman, ca. 1735-1740

Pen and brown ink with gray wash over black chalk underdrawing on laid paper; 15 × 10½ in. (381 × 267 mm). Inscribed in brown ink at upper right: *51*.

PROVENANCE: Stephen Spector, New York, 1960; David Daniels, 1960; Sotheby's, London, 25 April 1978, lot 40.

EXHIBITIONS: The Art Museum, Princeton University, *Italian Drawings in the Art Museum*, exh. cat. by Jacob Bean, 1966, no. 98, p. 57; Heim Gallery, London, *Baroque Sketches, Drawings and Sculptures*, 1967, no. 67, p. 15; The Minneapolis Institute of Art, *Selections from the Drawing Collection of David Daniels*, exh. cat. by Mary Lee Bennett and Agnes Mongan, 1968, no. 17, repr. (also The Art Institute of Chicago, 1968; Nelson Gallery-Atkins Museum, Kansas City, 1968; Fogg Art Museum, Harvard University, 1968); National Gallery of Art, Washington, D.C., *Venetian Drawings from American Collections*, exh. cat. by Terisio Pignatti, 1974, no. 86, p. 42, repr. (also Kimbell Art Museum, Fort Worth, 1974-1975; The Saint Louis Art Museum, 1975); California Palace of the Legion of Honor, The Fine Arts Museums of San Francisco, *Recent Acquisitions, 1977-1978*, 1978; idem, *Selected Acquisitions, 1977-1979*, 1979-1980, checklist, no. 20.

Francesco Fontebasso was one of the distinguished followers of Sebastiano Ricci (1659-1734), an inventor whose drawings and paintings led the way for most eighteenth-century Venetian artists. But if Ricci himself was able to clarify the potential of Venetian art, his work was never able to fulfill it. That became the task of his followers, such as the Tiepolos (see cat. nos. 17-20) and Piazzetta (see cat. no. 15).

As Michael Levey observed, lesser lights such as Fontebasso were more likely to establish a recognizable style in their drawings than they were in their paintings.[1] And since Venetian draftsmanship has received considerable attention in recent decades because of its beauty and lighthearted invention, Fontebasso may now be a better-known draftsman than a painter. Best known of his drawings are those examples characterized by rapid cursive outlines and by shading established with ladders of multiple, parallel strokes. The artist received his early training in Bologna, and Bolognese seventeenth-century draftsmanship is the foundation for such works.

The study attributed to Fontebasso in the collection of The Fine Arts Museums offers another style of rendering, more open and painterly, seemingly more indebted to Ricci. The sheet was a page from a ledger book that was intact as late as the 1920s. Four of the drawings are now at Princeton, three at the British Museum, and several at The Metropolitan Museum of Art. Still others appeared on the Paris art market. Terisio Pignatti recently presented a good review of the problems inherent in attributing these leaves to Fontebasso, even if they are assigned to the artist's youth in Bologna.[2] He concludes his discussion by referring to the old inscription on one of the ledger-page drawings now in The Art Institute of Chicago: "Ercole Graziani Bolognese." Graziani (1688-1765) was a follower of the important and charming painter Donato Creti. The attribution to Fontebasso may soon fall should further investigation substantiate Pignatti's critical observation.

J. R. G.

Achenbach Foundation for Graphic Arts purchase, 1978.2.22

11. Pier-Leone Ghezzi *Rome 1674-1755 Rome*

Doctor Fossambroni, ca. 1729-1730

Pen and brown ink on laid paper; 10⅝ × 7⅞ in.
(271 × 199 mm). Inscribed with brown ink on verso: *Le Medecin fossambroni*. Inscribed in graphite at upper right corner of paper mount: *4 or 21*.

PROVENANCE: Richard Neville Neville, Paris, 1763; Second Baron Braybrooke; descended through family to Rt. Hon. Lord Braybrooke; his sale, Sotheby's, London, 10 December 1979, lot 21, repr.; David Tunick, Inc., New York.

Although he was primarily a portrait and genre painter and a draftsman, Pier-Leone Ghezzi was also a religious painter, a printmaker, and a designer of festival architecture, tapestries, and jewelry. His patrons included Pope Clement XI and members of the Roman aristocracy. He is chiefly remembered today, however, as the first professional caricaturist in the history of art. In hundreds of sardonic and incisive pen-and-ink drawings, Ghezzi portrayed every stratum of Roman society in the first decades of the eighteenth century. Many of his caricatures have been carefully inscribed to identify the personages depicted, an invaluable aid to the historical and aesthetic understanding of these works. Because the subjects of his wit ranged from the highest levels of the papal court through leading artists, musicians, and intellectuals of the day to common tradesmen and even beggars, Ghezzi's caricatures act as a visual document of that era. There are large collections of his works in European museums (of particular significance are those in the Fondo Ottaboni Latino of the Vatican Library, the Gabinetto Nazionale delle Stampe, Rome, the Cabinet des Dessins in the Louvre, and the British Museum).

Most of Ghezzi's caricatures have come down to us bound in eighteenth-century volumes. *Doctor Fossambroni* comes from a collection of 152 Ghezzi drawings contained in two volumes; inscriptions on the albums indicate that they were acquired in Paris in 1763 by Richard Neville Neville. Inherited by Neville's only son and heir, the second Baron Braybrooke, they remained in the possession of the family until they were dispersed at auction in 1979.[1] Through comparison with Ghezzi drawings of the Fondo Ottaboni Latino, Antonella Pampalone concludes that the drawings from the Lord Braybrooke albums were executed between 1720 and 1730 and are replicas by Ghezzi of drawings now in the Vatican.[2]

The pathetically senile *Doctor Fossambroni* smiles out at us, oblivious to the dog relieving himself on his right leg, while a young boy to the right looks on with surprise. With a combination of hilarity and pathos Ghezzi has thoughtfully commented on the travail of growing old. In the version of *Doctor Fossambroni* in the Vatican (Ottob. Lat., 3115, F.122), Ghezzi has noted that the doctor died on 23 December 1729 at more than ninety years of age. The Achenbach Foundation for Graphic Arts owns another Ghezzi caricature, *Monsieur de la Grenelay*, 1749, from an album once in the collection of the Duke of Wellington.

R. F. J.

Achenbach Foundation for Graphic Arts purchase, 1980.2.32

12. Ottavio Leoni *Rome ca. 1578-1630 Rome*

Portrait of Franco Tenturcine, 1624

Black, red, and white chalk on blue-gray laid paper; 9¼ × 6⅜ in. (235 × 162 mm). Numbered and dated in brown ink at lower left and center: *304 setenbre/1624*; in brown ink on verso: *62/S. Franc. Tenturcine.*

PROVENANCE: G. Moratieca, Paris; F. Kleinberger & Co., New York; John S. Newberry, Jr.; Nathan Chaikin; Esther S. and Malcolm W. Bick, Longmeadow, Massachusetts; Sotheby's, London, 5 July 1976, lot 17, p. 9, repr. p. 26; H. Shickman Gallery, New York, 1976; Achenbach Foundation for Graphic Arts purchase.

BIBLIOGRAPHY: *Fifty Drawings from the Collection of John S. Newberry, Jr.*, exh. cat. (Detroit: The Detroit Institute of Arts, 1949), no. 26, p. 20; *Italian Drawings, Selections from the Collection of Esther S. and Malcolm W. Bick*, exh. cat. (New Hampshire: Hopkins Center, Dartmouth College, 1971), no. 20, repr.

EXHIBITIONS: California Palace of the Legion of Honor, The Fine Arts Museums of San Francisco, *Recent Acquisitions, 1977-1978*, 1978; idem, *European Drawings from the Achenbach Foundation for Graphic Arts*, 1979; idem, *Selected Acquisitions, 1977-1979*, 1979-1980, checklist no. 38.

At the beginning of the seventeenth century in Italy, Ottavio Leoni established himself as a popular and prolific portraitist. He worked for several courts, including that of Pope Gregory XV. Leoni's insightful series of portraits, which chronicles the society of his era, may be compared with the contemporaneous portraits of Anthony van Dyck and with those of Hans Holbein the Younger who portrayed the court of Henry the Eighth a century earlier.

Leoni delineated the sitter's features in black chalk with white chalk highlights on blue paper. In a few cases, such as our drawing, further highlights in red chalk were added. Leoni usually placed the figure in the center of the paper, gazing out at the viewer in a straightforward, frontal pose. That the heads are usually highly finished while the body and clothing are more sketchily drawn suggests that these drawings were executed during the course of a single sitting. Leoni's portrait drawings and prints convey psychological observation, clarity, and a touch of flattery, and they made him a famous and sought-after artist.

The portrait of *Franco Tenturcine* is from a series of over four hundred portrait drawings that range in date from 1615 to 1629. These inscribed drawings bear a number and a month at the lower left and are dated at the lower center. In most cases they also bear the name of the sitter on the verso. The numbering of the drawings, for example, the *304* over the month of September on our sheet, undoubtedly refers to the order in which they were executed. A portrait of Conte Filippo Spinola in the National Gallery of Canada is inscribed *302 setenbre 1624* and a portrait of Cardinal Francesco Barberini in the British Museum numbered *305* also bears the date *setenbre 1624*.[1] The lowest recorded number on a drawing is 6, on a portrait dated January 1615, in the Hamburg Kunsthalle. The highest number from the series appears to be *434*, on a drawing dated September 1629, in The Pierpont Morgan Library, New York.[2] Such precise inscriptions could only have been done by the artist himself or someone in close contact with him. It is thought that these numbered portraits formed part of the enormous collection of Leoni drawings once owned by Prince Borghese. According to P.-J. Mariette, they were sold in an album at the sale of M. D'Aubigny in Paris in 1747.[3]

R. F. J.

Elizabeth Ebert and Arthur W. Barney Fund, 1978.2.25

304
settembre

1624

13. Pier Francesco Mola *Coldrerio 1612-1666 Rome*

Conversion of Saint Paul, ca. 1656

Pen and brown ink with brown wash and red chalk on laid paper; 10⅝ × 15 in. (269 × 382 mm). Signed at lower left: *Mola*, and inscribed on mount at right by a somewhat later hand: *Mola al Giesu in Roma*, and on verso the Cogswell number: *190*.

PROVENANCE: Joseph Green Cogswell Collection (no. 190); Mortimer Leo Schiff, New York; Moore S. Achenbach, 1939; gift to Achenbach Foundation for Graphic Arts.

BIBLIOGRAPHY: George S. Hellman, *Original Drawings by the Old Masters: The Collection formed by Joseph Green Cogswell, 1786-1871* (New York: privately published, 1915), no. 107, p. 99; Walter Vitzthum, *Il barocco a Roma*, in *I disegni dei maestri* (Milan: Fratelli Fabbri, 1971), p. 17; Jacob Bean, in "Reviews," *Master Drawings* 10, no. 4 (1972), p. 386, pl. 54.

EXHIBITIONS: California Palace of the Legion of Honor, San Francisco, *Italian Master Drawings from the Cogswell Collection*, 1959; San Jose State College, *Old Master Drawings*, 1960; Dallas Museum of Fine Arts, *Old Master Drawings*, 1961; Mills College Art Gallery, Oakland, *Old Master Drawings*, 1962; San Francisco State College, *Old Master Drawings*, 1963; California Palace of the Legion of Honor, San Francisco, *Old Master Drawings*, 1966; Pomona College Art Gallery, Claremont, *The Baroque*, 1966; Norman MacKenzie Art Gallery, University of Saskatchewan, Regina, Saskatchewan, *A Selection of Italian Drawings from North American Collections*, exh. cat. by Walter Vitzthum, 1970, no. 47, p. 56, repr. p. 151; University of California, Santa Barbara, *Regional Styles of Drawing in Italy: 1600-1700*, exh. cat. ed. Alfred Moir, 1977, no. 8, p. 21, repr., p. 23; California Palace of the Legion of Honor, The Fine Arts Museums of San Francisco, *Masterworks from the Achenbach Foundation for Graphic Arts*, 1981.

As the son of an architect, Pier Francesco Mola had many advantages during his artistic training. At the age of four, he was taken to Rome, and there he eventually apprenticed to Prospero Orsi and the Cavaliere d'Arpino. This auspicious beginning seems to have been furthered by training in the shops of Albani and Guercino in Bologna, either before or after a stint in Venice. Having been exposed to this impressive array of Baroque talent in the north, the artist returned to Rome where he then associated with Pietro da Cortona, Pietro Testa, Gaspard Dughet, and Nicolas Poussin. Mola apparently was held in high esteem by his peers for he was elected president of the Academy of Saint Luke in July 1662.[1]

Beyond the quality of exposure provided by his broad-based training, Mola was very fortunate in his own considerable ability. As a draftsman, therefore, he was able to forge a style that creatively integrated the many facets of his artistic education. His style is not easily described, although it combines a relatively crude, Roman linearity with a Bolognese sensitivity to the effect of wash and a Venetian delight in rapidly established effects. Though his drawings lack Guercino's polish and Cortona's supple structure, they are often strangely successful creations–vibrant, feisty sketches, and not the least bit self-conscious. It is as if the artist were having second thoughts about his forms almost as soon as they appeared. Such a draftsman was able to produce true working sheets, for, unlike his Bolognese contemporaries, he was constitutionally unable to dwell on crafting a drawing for its own sake.

The little-known *Conversion of Saint Paul* in the Museums' collection is one of Pier Francesco Mola's most important extant drawings, and it is a preparatory study for his fresco on the right-hand wall of the Ravenna Chapel of Il Gesù in Rome.[2] The three studies across the bottom of the sheet are for the prisoner in the right foreground of the painter's companion fresco at Il Gesù, *Saint Peter Baptizing in Prison*. The Museums are also fortunate to have Giovanni Battista Gaulli's glorious oil sketch for the ceiling of this queen of Roman baroque churches.

J. R. G.

Achenbach Foundation for Graphic Arts, 1963.24.141

14. Jacopo Negretti (Il Palma Giovane) *Venice 1544-1628 Venice*

Recto: Studies of the Transfiguration, Saint John the Baptist, 1611
Verso: Horsemen in Combat

Pen and brown ink and brown wash on laid paper; 14⅜ × 10¼ in. (364 × 260 mm). Inscribed in brown ink possibly by the artist: *1611 a na[t?] ivi[tat?] i fibrari* (1611 in the year of Christ's birth, February). Interpretation of this inscription is by Dottoressa Stefania Mason Rinaldi. Inscribed in black ink on verso by a later hand: *Palma*, and in brown ink: *G.P.no:117*.

PROVENANCE: Padre Sebastiano Resta, the Borghese Album (see verso: G.P. no. 117); Le Chevalier Marchetti, 1701; Lord Somers; Hubert Marignane, Paris (Lugt 1343a); Thomas Agnew & Sons, Ltd., London; Achenbach Foundation for Graphic Arts purchase.
BIBLIOGRAPHY: *Dessins Italiens du XVᵉ au XVIIIᵉ Siècle de la Collection H. de Marignane*, exh. cat. (Monte Carlo, 1966).
EXHIBITION: California Palace of the Legion of Honor, The Fine Arts Museums of San Francisco, *Recent Acquisitions*, 1981.

Palma Giovane, son of the painter Antonio Palma and great-nephew of Palma Vecchio, became the leading Venetian painter and draftsman of the late sixteenth and early seventeenth centuries. Palma's ability was recognized early by Guido Ubaldo, Duke of Urbino, who was impressed with his copy of a painting by Titian. Under the Duke's patronage, Palma spent eight years studying and working in Rome, returning to Venice in 1568. In Venice his principal influences were the paintings of Titian and Tintoretto. As a draftsman, however, the artist can be understood best by studying the relationship of his style to that of Tintoretto and Veronese. While these artists were unquestionably greater painters, Palma's draftsmanship often showed comparable talent. His ability was well noted by his peers, and it is not surprising that today there is renewed appreciation of Palma's drawings as important expressions of Venetian mannerism.

Palma drew with frenzied short arcs that establish his form and figures. He had a virtuoso ability to complement those rapid linear notes with deftly integrated passages of wash, which modeled and enhanced his compositions and communicated a convincing sense of movement.

On the recto of the Museums' previously unpublished double-sided sheet are a transfiguration and several studies for compositions with the figure of Saint John. On the verso are two mounted warriors in combat. The composition of the Museums' *Transfiguration*, which the artist elaborated with wash, is certainly related to that of the painting by Palma now in the Galleria d'Arte Antica, Udine, a painting that was once in the now demolished church of Santa Barbara dei Conti della Torre di Valassina.[1]

A tireless composer, Palma would often treat many variations of the same motif in separate drawings. A virtually identical composition of the *Transfiguration*, for example, with variations in the poses of the figures, is the subject of the recto of a drawing by Palma in a private San Francisco collection. Neither drawing is identical to the painting, and it is difficult to speak of sequence. It is obvious, however, that because Ivanoff and Zampetti, in agreement with Ricci, date the painting at Udine to about 1585-1590, the probable autograph date of 1611 on our drawing would exclude the possibility of its being preparatory for the Udine *Transfiguration*.[2]

What is clear from this and other subjects for which multiple related drawings exist is that Palma usually drew for enjoyment and graphic exercise, rather than for fastidious specific preparation.

J. R. G.

William H. Noble Bequest Fund, 1979.2.27 r-v

15. Giovanni Battista Piazzetta *Venice 1682-1754 Venice*

Bust of a Girl Holding an Apple

Black chalk with white chalk heightening on blue-green laid paper faded to tan; 15¾ × 11⅝ in. (400 × 295 mm). At lower right is the blind stamp of the Winslow Ames collection (Lugt 2602b).

PROVENANCE: G. Fenwick Owen; his sale, Sotheby's, London, 16 February 1949, lot 24; Colnaghi, London, 1949; Mr. and Mrs. Winslow Ames, Saunderstown, Rhode Island, 1949 (Lugt 2602b); to their daughter and son-in-law, Mr. and Mrs. Lee Littlefield; Wildenstein & Co., New York.

BIBLIOGRAPHY: Terisio Pignatti, *Disegni antichi del Museo Correr di Venezia*, vol. 1 (Venice: Neri Pozza, 1980), cited on p. 29, repr. fig. 25.

EXHIBITIONS: William Rockhill Nelson Gallery of Art, Kansas City, Missouri, *The Winslow and Anna Ames Collection of Drawings*, checklist, 1955; Jewett Arts Center, Wellesley College, Massachusetts, *Eighteenth-Century Italian Drawings, a Loan Exhibition*, exh. cat. by J. Cox-Rearick, 1960, no. 44, repr., pl. 16 (also Charles E. Slatkin Galleries, New York, 1960); Museum of Art, Rhode Island School of Design, Providence, *Drawings from the Collection of Mr. and Mrs. Winslow Ames*, 1965, no. 71; Wadsworth Atheneum, Hartford, *One Hundred Master Drawings from New England Private Collections*, exh. cat. by F. W. Robinson, 1973, no. 29, p. 72, repr. p. 73 (also Hopkins Center, Dartmouth College, Hanover, New Hampshire, 1973; Museum of Fine Arts, Boston, 1973-1974); National Gallery of Art, Washington, D.C., *Venetian Drawings from American Collections*, exh. cat. by Terisio Pignatti, 1974, no. 61, p. 34, repr. (also Kimbell Art Museum, Fort Worth, 1974-1975; The Saint Louis Art Museum, 1975).

Except for his early studies in Bologna, Giovanni Battista Piazzetta spent his entire life in his native city of Venice. There he became one of the most illustrious artists of his day, excelling as a painter, draftsman, and book illustrator.

Among Piazzetta's most memorable works is a series of large, intense heads, carefully delineated in black chalk with white heightening. These album sheets were made as independent works of art to be sold to collectors.[1] Our widely published drawing from this series is in a remarkable state of preservation. Terisio Pignatti said of it: "Our sheet has a wonderful quality of freshness; it was made from life, and was drawn with dense, short strokes to produce the reflections of light and shade."[2] However, as is true of a large number of Piazzetta drawings, the paper that once was blue-green has been transformed to a tone of tan by time and exposure to light.

Although he often portrayed youths holding objects, such as fruit, jingle rings, or flowers as props, the meaning Piazzetta intended for these drawings is unclear today. Otto Benesch was the first to suggest that they could have been designed as part of a series on the five senses.[3] The apple in our sheet would suggest the sense of taste. Then again, the scene might represent an amorous proposition to the girl through an offered and accepted apple.

Piazzetta was an inspired teacher. Among his pupils, Giulia Lama, Giuseppe Angeli, Antonio Marinetti, Francesco Polazzo, and Domenico Maggiotto often followed the style of the master so closely that their works frequently have been confused with authentic Piazzettas. This is especially true of the drawings, which were often copied as academic exercises.

By the end of the century Piazzetta's large drawings of heads had stimulated the English artist Joseph Wright of Derby (1734-1797) to execute a similar series of drawings. These in turn inspired a famous series of mezzotint portraits by the Irishman Thomas Frye (1710-1762).

R. F. J.

Achenbach Foundation for Graphic Arts purchase, Bruno and Sadie Adriani, Ludwig A. Emge, Ruth Haas Lilienthal, Roscoe and Margaret Oakes, and Lucie Stern Funds, 1983.2.7

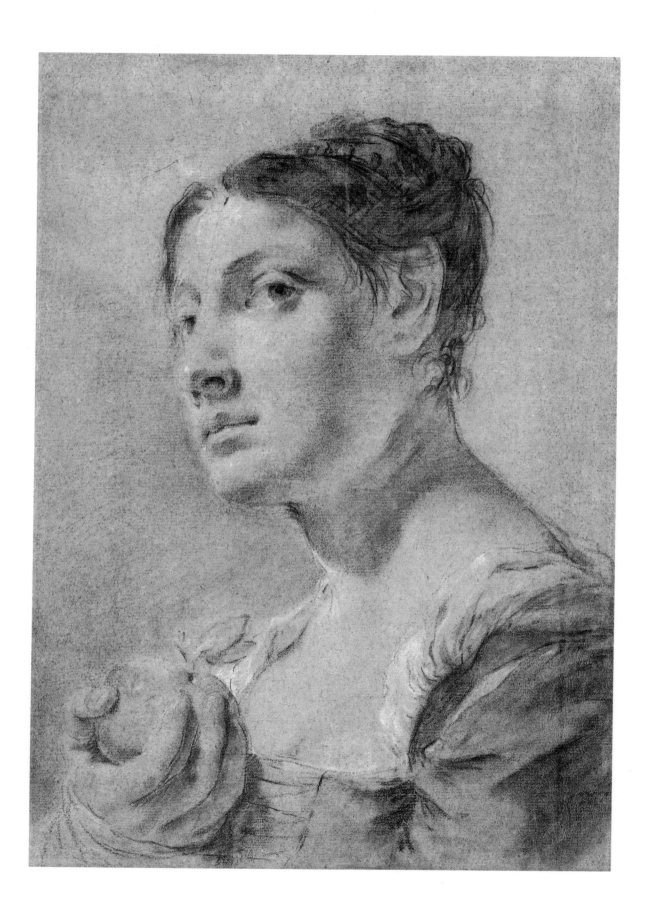

16. Bernardo Strozzi (Il Capuccino Genovese) *Genoa 1581-1644 Venice*

Temperance, early 1620s

Black chalk with white chalk heightening on gray-blue laid paper; 9¼ × 6⅞ in. (235 × 177 mm). Inscribed on verso in blue ink: *186*.

PROVENANCE: Joseph Green Cogswell Collection (no. 186); Mortimer Leo Schiff, New York; Moore S. Achenbach, 1939; gift to Achenbach Foundation for Graphic Arts.
BIBLIOGRAPHY: George S. Hellman, *Original Drawings by the Old Masters: The Collection formed by Joseph Green Cogswell, 1786-1871* (New York: privately published, 1915), no. 97.
EXHIBITIONS: California Palace of the Legion of Honor, San Francisco, *Italian Master Drawings from the Cogswell Collection*, 1959; University of California, Santa Barbara, *Regional Styles of Drawing in Italy: 1600-1700*, exh. cat. ed. by Alfred Moir, 1977, no. 67, p. 108, repr.

Some of the more exciting developments in seventeenth-century Italian pictorial art took place in cosmopolitan Genoa, and painters such as Luca Cambiaso, Giovanni Castiglione, Alessandro Magnasco, Domenico Piola, and Bernardo Strozzi are indelibly associated with the artistic culture of the city often called *La Superba*.

Because there were few mature Genoese painters working in their native city at the beginning of the seventeenth century, foreign artists were encouraged to come to the prosperous seaport. This "internationalism" proved a stylistic catalyst for much of the native painting that was to emerge, and Strozzi is an excellent example of an important Genoese artist whose creativity was affected by multiple external influences.

The principal historical accomplishment of the mature Strozzi was to revitalize Venetian painting, and he took the first step in that direction as a young artist in Genoa where he developed a style influenced primarily by Sienese art. Ordained a Capuchin about 1597, he had left the cloister by 1608, and in 1610 and 1611 he was the pupil of the Sienese mannerist Pietro Sorri. Strozzi was powerfully affected by the brief appearance at Genoa of the Sienese Ventura Salimbeni in 1610, as well as by the imported paintings of Francesco Vanni. Strozzi also was very attentive to the spellbinding brushwork of Anthony van Dyck, the young virtuoso from Flanders who stayed in Genoa for various periods between 1621 and 1627.

In the 1620s Strozzi's painting reflected the brush style of van Dyck as well as that of his native Genoese teacher Giovanni Battista Paggi, but Strozzi's genius lay in his ability to integrate the numerous influences on his art into a manner that sparkles with technical brilliance and decorative flair without abandoning the sense of seriousness imparted by his religious convictions.

Unfortunately, like other artists who reveled in the application of paint, Strozzi seems to have done little drawing. Certainly, sheets by him are rare and there are very few drawings given securely to him in North American collections. The attribution of the Museums' drawing of *Temperance* to Bernardo Strozzi was first made by Professor Röttgen in November 1971 and was independently suggested by Philip Pouncey in 1983, while the identification of the allegorical figure as that of Temperance was provided by Sylvie Beguin of the Louvre.[1] A notation, "Salimbeni", on the verso of the paper to which the drawing is laminated, reflects an earlier and very understandable attribution to the Sienese painter whose work figured importantly in Strozzi's early development.[2] Other candidates have included Francesco Vanni and Giovanni Spinelli, a Neapolitan artist, but on carefully considering the evidence provided by the drawing, the attribution of Röttgen and Pouncey seems most convincing.[3]

Though the charming depiction is redolent of Sienese mannerism in its pose and structure, it lacks the relatively suave stature of the figures drawn by Vanni and Salimbeni. Instead, *Temperance*, delineated with purposeful agitation and modeled to establish sculptural richness, also tries to incorporate a lesson from van Dyck, namely the clipped arcs establishing the eye sockets and the simply formed mouth. This stylistic amalgam is at once uncomfortable and energetic, and it points strongly toward Strozzi. Because of the hint of van Dyck's influence, one would have to date the drawing to the early 1620s, although consideration only of the dramatic borrowing from Salimbeni might have encouraged an earlier date.[4]

J. R. G.

Achenbach Foundation for Graphic Arts, 1963.24.125

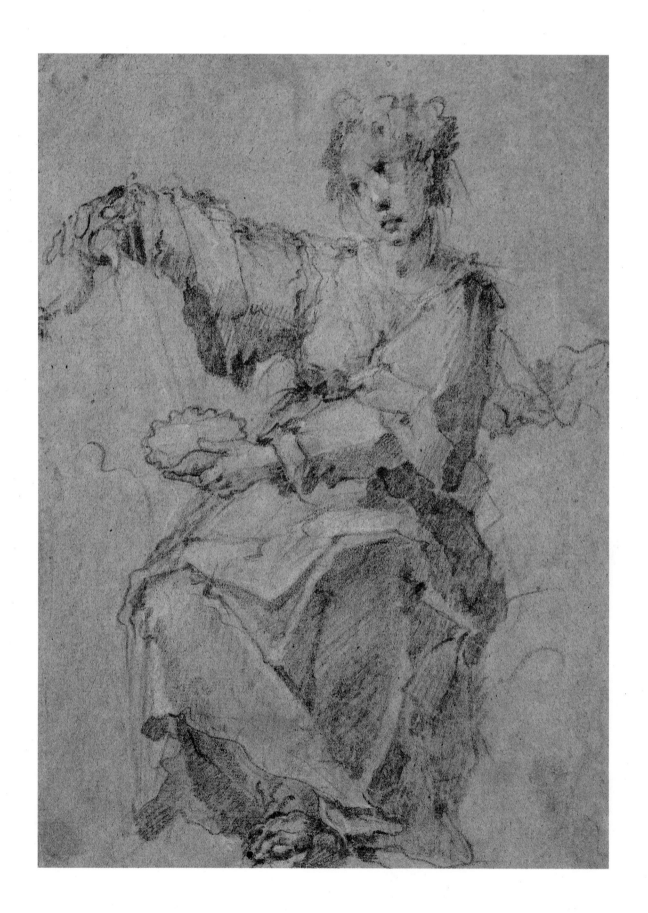

17. Giovanni Battista Tiepolo *Venice 1696-1770 Madrid*

The Crucifixion, ca. 1753-1754
Verso: Sketch, Upper Half of Body of Christ Crucified

Pen and brown ink with ink wash with traces of black chalk on thick textured paper; 14⅜ × 10⅛ in. (365 × 257 mm).

PROVENANCE: Prince Alexis Orloff, Leningrad; sale, Galerie Georges Petit, London, 29 April 1920, no. 97, repr.; Marquis de Biron; M. Knoedler, Paris; W. W. Crocker, Burlingame, California; Mrs. Diana Crocker Redington, Pebble Beach, California; Augustus Pollack.
BIBLIOGRAPHY: *Catalogue des tableaux anciens... dessins per G. B. Tiepolo composant la collection de son excellence feu le Prince Alexis Orloff* (Paris: Galerie Georges Petit, 1920), no. 97, repr.; D. von Hadeln, *The Drawings of G. B. Tiepolo*, vol. 2 (Paris: the Pegasus Press; New York: Harcourt, Brace & Co., 1928), pl. 96, repr.; George Knox, "The Orloff Album of Tiepolo Drawings," *Burlington Magazine* 103 (1961): 275, no. 57.
EXHIBITIONS: California Palace of the Legion of Honor, San Francisco, *Old Master Drawings*, 1966; John and Mable Ringling Museum of Art, Sarasota, *Master Drawings*, 1967; University Art Museum, Berkeley, *Master Drawings from California Collections*, exh. cat. ed. by Juergen Schulz, 1968, no. 56-56v, p. 61, repr. pp. 138-139; California Palace of the Legion of Honor, San Francisco, *G. B. Tiepolo and Family*, 1970; Fogg Art Museum, Harvard University, *Tiepolo*, exh. cat. by George Knox, 1970, no. 59, repr.; Los Angeles County Museum of Art, *Old Master Drawings from American Collections*, exh. cat. by Ebria Feinblatt, 1976, no. 60, p. 52, repr.

The Crucifixion makes an ideal introduction to Giambattista Tiepolo's achievement as a draftsman, and it may help us to understand why he is considered the single, greatest Venetian artist of the eighteenth century. Giambattista did not invent the kind of line and wash style in which he worked. That combination of techniques was similarly employed by Sebastiano Ricci and was practiced in Venice even in the sixteenth and seventeenth centuries by Paolo Veronese and Palma Giovane (see cat. no. 14). Giambattista, however,

brought heightened drama to the depiction of his subjects, and he perfected his pen and wash technique to be able to articulate his novel conceptions. An artist who was in demand internationally, he prepared for his grandly scaled paintings by continually thinking on paper.

In the Museums' splendid *Crucifixion*, one of ninety-six superior Tiepolo drawings that were part of the Orloff Album sold in Paris in 1920, we see a special mid-career attempt to bring a new dignity and pathos to one of the greatest yet most common Christian subjects. Giambattista's unique composition is dominated by the effects of viewpoint and rapidly stated gesture. Moreover, its sense of tension is achieved not by detailed facial expressions but by establishing through perspective that the event is uncomfortably close to the viewer. This is accomplished by the low viewpoint as well as by placing a semicircular barrier of observers behind the crosses and by using wash to unite the crowd with the central event. The method certainly reduces depth, but it also brings into play a powerful light from the left that illuminates one of the two figures at the foot of the central cross (probably the two Marys). It also marks the noble and reverential bowing gesture of the horse on the right. Technically impressive is the density the artist has given this scene while maintaining the transparency of his washes. Thus in *The Crucifixion* Giambattista has done what he does in his best pen and wash works–he unites a rapid, linear conception with a bravura tonal sweep of remarkable power and depth.

Based on its relationship with drawings that are preparatory to datable paintings, George Knox has suggested that *The Crucifixion* was executed about 1753-1754.[1] He also notes two related paintings of the subject in Saint Louis and Vierhouten, the authorship and dates of which are disputed. Nevertheless, Knox concludes correctly that, based on the existence of the San Francisco drawing, at least the conception of the Saint Louis picture must be ascribed to Giambattista.[2]

J. R. G.

Achenbach Foundation for Graphic Arts purchase, 1963.25 r-v

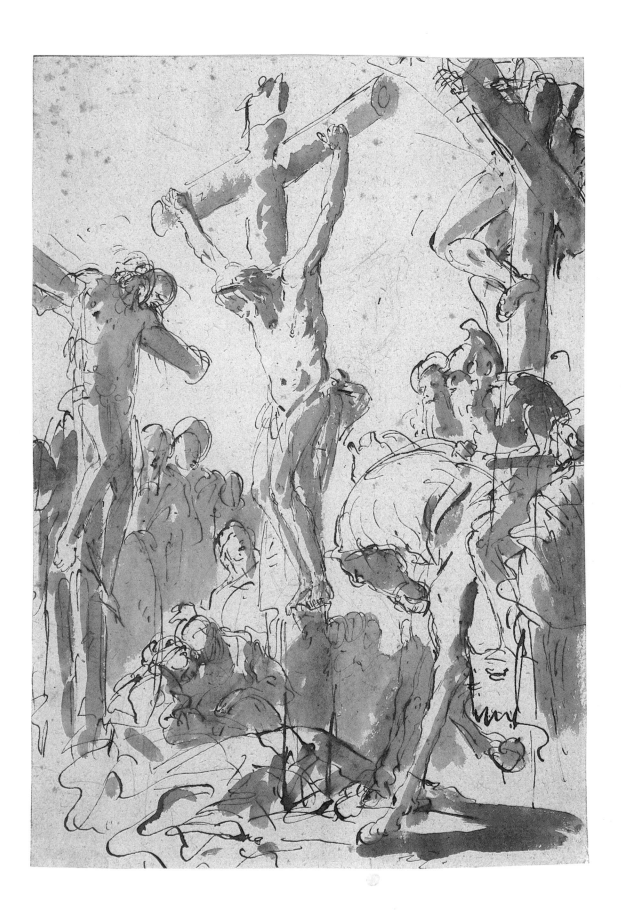

18. Giovanni Domenico Tiepolo *Venice 1727-1804 Venice*

The Head of an Old Man, ca. 1770

Red chalk with traces of white chalk heightening on blue laid paper; 10¾ × 8⅞ in. (272 × 226 mm).

PROVENANCE: Armand Louis de Mestral de Saint Saphorin (1738-1806); Nathan Chaikin; Osgood Hooker; gift to Achenbach Foundation for Graphic Arts.
EXHIBITIONS: California Palace of the Legion of Honor, The Fine Arts Museums of San Francisco, *G. B. Tiepolo and Family*, 1970; Fogg Art Museum, Harvard University, *Tiepolo*, exh. cat. by George Knox, 1970, no. 92, repr.; University Art Museum, Berkeley, *Master Drawings: Materials and Methods*, 1972; Birmingham Museum of Art, *The Tiepolos: Painters to Princes and Prelates*, exh. cat. by E. F. Weeks, 1978, no. 62, repr. p. 91 (also Museum of Fine Arts, Springfield, Massachusetts, 1978); California Palace of the Legion of Honor, The Fine Arts Museums of San Francisco, *Masterworks from the Achenbach Foundation for Graphic Arts*, 1981.

As the preeminent genius of eighteenth-century Venetian art, no figure deserves more credit than Giovanni Battista Tiepolo for raising the Rococo from the realm of dense decoration to the lofty level of inspired fantasy. But Giambattista or G.B., as he is affectionately called by today's admirers, created problems for later students by training a remarkably talented son who was capable of vacillating between superb mimicry and independent creation. It is unfair, however, to refer to Domenico as a mimic, for he so absorbed his father's artistic lessons that when required he could become an extension of Giambattista's creative spirit. This adaptability permitted them to work together as though they were one. It was a rare instance of successfully aligned filial sensibilities contributing to art of great merit.

The compelling head in our collection was included by George Knox in the Tiepolo bicentenary exhibition at the Fogg Museum in 1970 and was attributed to Giambattista.[1] It is here ascribed to his son Giovanni Domenico, and to examine that change one becomes involved in the challenging problems of connoisseurship presented by certain drawings of the Tiepolo family. This is not to imply that the styles of Giovanni Battista and Domenico are often confusing. On the contrary, the two styles usually are readily discernible. But the chalk drawings can be problematic, as are some of the paintings of the Tiepolo family.

In the better-known pen and wash works, the web of line can be visually isolated from the transparent passages of wash, and identification is often immediately apparent (see cat. no. 17). But the chalk sheets, structured by rapid little passages of line and shading, can be harder to dissect. Furthermore, the chalk method was one that son learned from father with uncanny precision.

In our drawing, the density of chalk application appears greater than one expects in the more open chalk sketches of Giambattista. This makes texture and linear variety more apparent, suggesting the approach of Domenico, whose hand was more cautious than his father's. It should be noted, however, that the Achenbach work hovers closer to Giambattista's style than most of Domenico's chalk sketches and that attribution to son as opposed to father is based on very subtle aspects of draftsmanship.

The drawing, which was definitely the model for one of Domenico's etched series of heads (*Raccolta di Teste*, ser. 1, no. 22) must date to about 1770.[2]

J. R. G.

Gift of Osgood Hooker, 1961.38

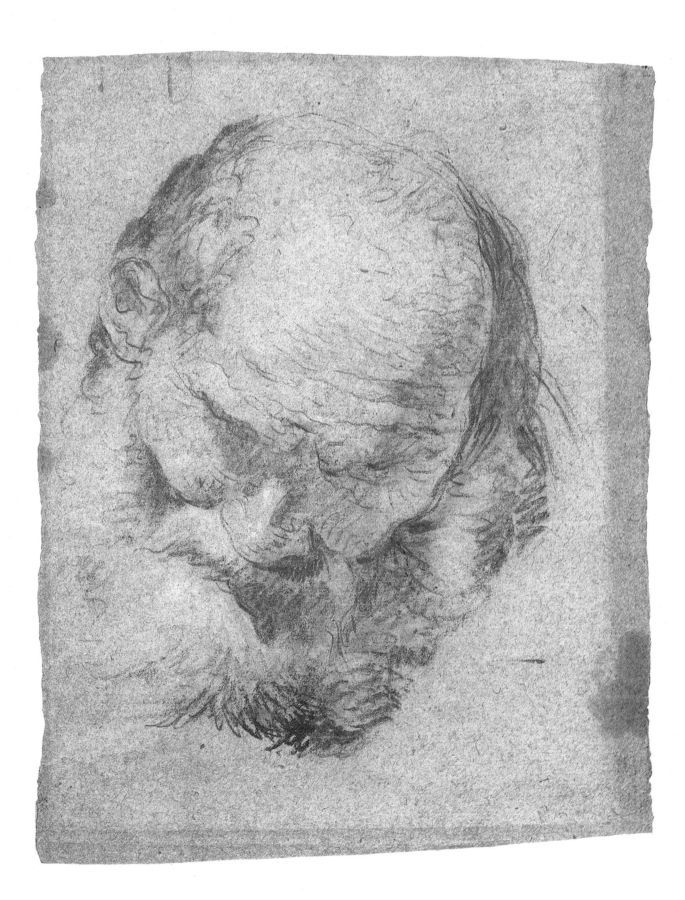

19. Giovanni Domenico Tiepolo *Venice 1727-1804 Venice*

Punchinello Series: Punchinello's Children Begging for Treats, ca. 1800

Pen and brown ink and brown wash over charcoal underdrawing on laid paper; 13¾ × 18½ in. (355 × 470 mm). Numbered *17* in brown ink at upper left corner of margin and signed at lower right: *Dom.º Tiepolo f.*

PROVENANCE: Sotheby's, London, 6 July 1920; Colnaghi, London, Richard Owen, Paris, 1920; Austin Mitchell, New York; Georges de Batz Collection.
BIBLIOGRAPHY: James Byam Shaw, *The Drawings of Domenico Tiepolo* (London: Faber and Faber, 1962), p. 52, note 3.
EXHIBITIONS: Musée des Arts Décoratifs, Paris, *Tiepolo Drawings from the Collection of Richard Owen*, 1921; California Palace of the Legion of Honor, San Francisco, *De Batz Collection: Old Master Drawings*, 1968; idem, *G. B. Tiepolo and Family*, 1970; Indiana University Art Museum, *Domenico Tiepolo's Punchinello Drawings*, exh. cat. by Marcia E. Vetrocq, 1979, no. 3, p. 42, repr. (also Stanford University Museum of Art, 1979; The Frick Collection, New York, 1980); California Palace of the Legion of Honor, The Fine Arts Museums of San Francisco, *Masterworks from the Achenbach Foundation for Graphic Arts*, 1981.

Punchinello is a character of Neapolitan origin, who was first introduced on the stage by the actor Silvio Fiorillo about 1600. Alternately lazy, greedy, cruel, sly, and humorous, Punchinello became a famous character in the *commedia dell'arte* during the seventeenth and eighteenth centuries. His traditional white suit with a ruff, tight trousers, conical hat, and black mask with its long, beaked nose clothed a hunchbacked body with a prominent paunch.

The French artist Jacques Callot had created a famous series of etchings of Punchinello over a century earlier, but it was undoubtedly Domenico's illustrious father Giambattista who first inspired him to explore this subject.[1] Count Algarotti, in a letter of 1761 to Jean Mariette, mentions Punchinello drawings by Giambattista.[2] In 1762 Domenico completed two Punchinello paintings before the family departed for Madrid.

At the end of his career, Domenico incorporated scenes from the daily life of Punchinello in his fresco decorations for the family villa at Zianigo. A date of 1797 appears in the ground-floor room devoted to this series.[3] James Byam Shaw speculates that about 1800 the elderly Domenico, pleased by the impression that the Punchinello frescoes had made on neighboring families, was inspired to produce the magnificent series of 104 Punchinello drawings entitled *Divertimento per li regazzi* (Entertainment for Children) for his young visitors.[4] From such simple inspiration this last great work of Domenico Tiepolo was created.

This series on the life and times of Punchinello is comprised of four main categories: *Scenes of Childhood and Family Life* (our sheet is one of these); *Scenes of Rural Labors and Entertainments*; *Scenes of Venetian Occupations, Entertainments, and Encounters with the Law*; and *Scenes of Travel and Mythological Adventures*.[5] Although many episodes in the life of Punchinello are illustrated, the series has no plausible narrative. The uniformly large sheets are executed in golden brown bistre ink and wash over black chalk underdrawing.

Punchinello's Children Begging for Treats (numbered 17 in the series) shows us an attractive woman dispensing treats to an excitedly grasping throng of young Punchinellos. To the right, an adult Punchinello wearing a ragged, patched cloak makes a supervisory gesture. Marcia E. Vetrocq has recently pointed out that in the *Divertimento* Domenico created works that illustrate comparable scenes in the homes of different social classes.[6] Thus our sheet, with its party for children of humble origin, can be contrasted with the drawing *The Birthday Party*[7] (present location unknown), which depicts a similar celebration in upper class surroundings. Domenico's treatment of genre subjects often borders on social satire, an interest that links his work with other artist-commentators of the eighteenth century, including William Hogarth, Pietro Longhi, and Francisco Goya.

R. F. J.

Achenbach Foundation for Graphic Arts purchase, Georges de Batz Collection, 1967.17.134

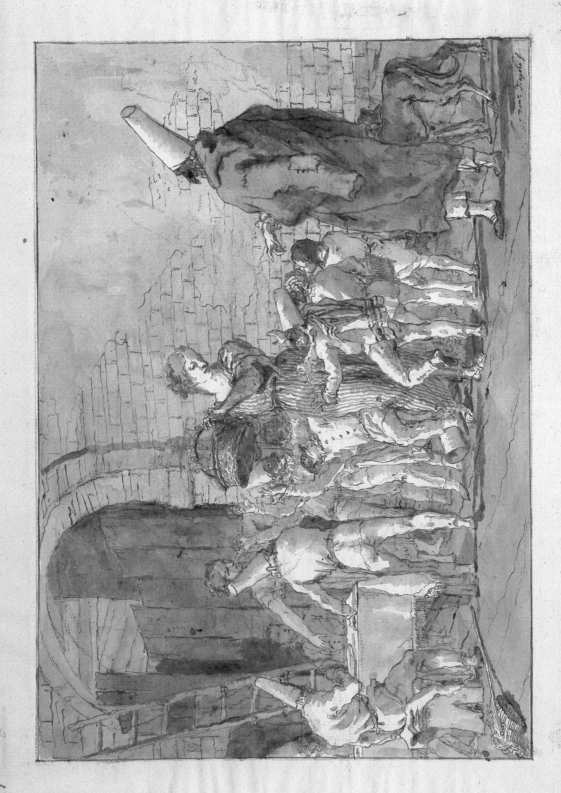

20. Giovanni Domenico Tiepolo *Venice 1727-1804 Venice*

Punchinello Series: La Furlana, ca. 1800

Pen and brown ink and brown wash over charcoal underdrawing on laid paper; 13⅞ × 18½ in. (358 × 470 mm). Numbered *31* in brown ink at upper left corner of margin.

PROVENANCE: Sotheby's, London, 6 July 1920; Colnaghi, London; Richard Owen, Paris, 1920; Austin Mitchell, New York; Georges de Batz Collection.
BIBLIOGRAPHY: James Byam Shaw, *The Drawings of Domenico Tiepolo* (London: Faber and Faber, 1962), p. 52, note 3.
EXHIBITIONS: Musée des Arts Décoratifs, Paris, *Tiepolo Drawings in the Collection of Richard Owen*, 1921; California Palace of the Legion of Honor, San Francisco, *De Batz Collection: Old Master Drawings*, 1968; idem, *G. B. Tiepolo and Family*, 1970; Indiana University Art Museum, *Domenico Tiepolo's Punchinello Drawings*, exh. cat. by Marcia E. Vetrocq, 1979, no. 20, p. 76, repr. (also Stanford University Museum of Art. 1979; The Frick Collection, New York, 1980); idem, *Masterworks from the Achenbach Foundation for Graphic Arts*, 1981.

La Furlana is numbered 31 in Domenico Tiepolo's last major project of 104 spectacular Punchinello drawings entitled *Divertimento per li regazzi* (Entertainment for Children). One of three dance subjects in the series,[1] La Furlana refers to the lively traditional folk dance of the Veneto, named for its origin in the Friuli region.[2]

In a clearing with dwellings in the distance, a small band plays while townsfolk and Punchinellos in various stages of ecstasy perform the Furlana. Tiepolo has cropped the figures radically on both sides of the composition and has directed the most frenzied dancers outward to leave a vacant middle ground. This produces a sense of almost spinning centrifugal force in the composition. In contrast, the broad expanse of sky on the left, the setting sun, and the thin shadows cast by the dancers give the scene a curious languor.

Domenico's *Divertimento* series has a curious history. The early whereabouts of the series is unknown, and only on 6 July 1920 at a Sotheby auction in London was the set described as "one hundred and two carnival scenes with many figures," made available by an anonymous seller.[3] The lot was purchased by the firm of Colnaghi for £610 and was later sold intact to Richard Owen. In 1921 Owen exhibited the series for the first and only time at the Musée des Arts Décoratifs, Paris. After the exhibition the drawings were sold individually. The collector Janos Scholz recalls that in New York, in 1935, a Punchinello sheet from this series could have been acquired for thirty-five dollars.[4]

Drawings from the series are now among treasured possessions of many public and private collections throughout the world. Prior to the sale of these drawings, Richard Owen had the great foresight to photograph the series. His photographs are the only complete documentation of Domenico's *Divertimento per li regazzi*. At the time of the 1979 exhibition of drawings from this series the locations of 26 of the 104 sheets were still unknown.[5]

R. F. J.

Achenbach Foundation for Graphic Arts purchase, Georges de Batz Collection, 1967.17.133

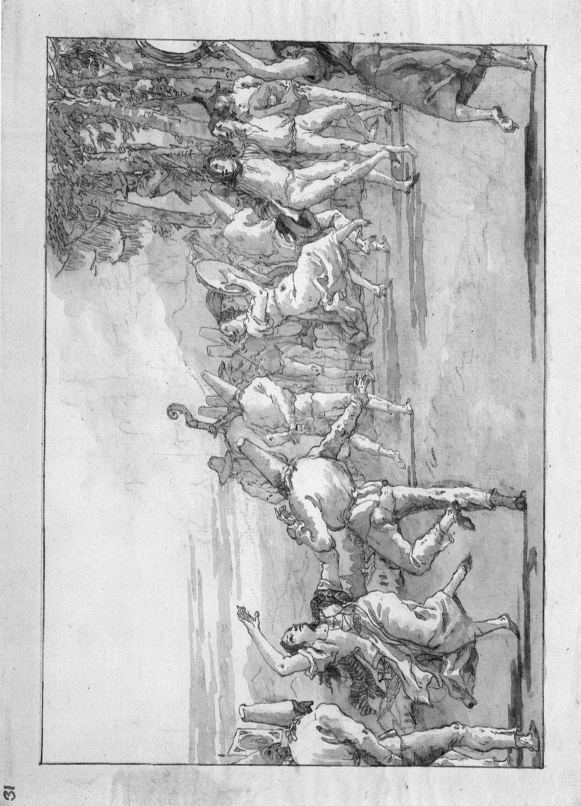

21. Workshop of Pieter Brueghel the Elder *Brueghel ca. 1528-1569 Brussels*

The Beekeepers

Pen and brown ink on laid paper; 8⅛ × 12½ in.
(206 × 316 mm). Inscribed in brown ink at lower left: *dije
den nest Weet dije Weeten dijen Rooft dij heeten*, and at lower
right: *P.BR.156(7)*. The collector's stamp of E. J. Otto
(Lugt 873b) is on verso at lower left.

PROVENANCE: Verstolk van Soelen; Grand Duchess
Sophie of Sachsen-Weimar; E. J. Otto (Lugt 873b);
C. G. Boerner & Co., Dusseldorf, 1966; Sotheby's,
London, 4 December 1969, lot 16, repr.; Robert Lehman;
Robin Lehman; John and Paul Herring & Co., New York.
BIBLIOGRAPHY: C. G. Boerner & Co., *Handzeichnungen
vor 1900* (Dusseldorf, October 1966), no. 14, pl. 9.
EXHIBITIONS: California Palace of the Legion of Honor,
The Fine Arts Museums of San Francisco, *Selected
Acquisitions, 1977-1979*, 1979-1980, checklist, no. 14, repr.
cover; idem, *Masterworks from the Achenbach Foundation
for Graphic Arts*, 1981.

This exceptional display of draftsmanship can be seen
in a number of works very close in style and quality to
drawings by Pieter Brueghel the Elder. Most of these
are landscapes and they occasionally appear in two or
more versions. The Achenbach work is an almost
identical copy of Brueghel's own drawing (in the
Kupferstichkabinett, Berlin)[1] which measures
203 × 309 mm, but it obviously has been trimmed slightly
at the right. The date, following Brueghel's signature, is
cut off after MDLXV. Charles de Tolnay has suggested
that the drawing be dated to 1567 or 1568. The
Achenbach sheet probably corresponds to the size of the
original before it was damaged. Whoever inscribed our
copy on the right did not attempt to reproduce
Brueghel's characteristic signature but simply initialed
it P.BR. By coincidence, the inscribed date on our
drawing also is damaged and the last digit in Arabic
numerals is missing. K. E. Simon has suggested that the
final number could only be seven, making the date 1567,
which coincides with de Tolnay's dating of the
original.[2] Except for the signature and date, the only
other obvious difference between the two drawings is
the spelling of "Rooft," with two o's in the inscribed
proverb in our drawing as opposed to only one in the
original. The subject matter has been copied sensitively,
nearly line for line, but the execution of our drawing is
slightly harder, with more contrast than in the original.
Another copy of this Brueghel drawing, probably of a
later date, is in the British Museum.[3] It is, however,
more coarsely drawn than the Achenbach version and
lacks the proverb and any date or signature.

Because of its high degree of finish and its subject,
men toiling in nature, this composition can be associated
with two other late Brueghel drawings: *Spring*, dated
1565 (Albertina, Vienna), and *Summer*, dated 1568
(Kunsthalle, Hamburg). Like those works, which were
made into engravings, *The Beekeepers* surely was designed
as a model for a print, although the project never was
carried out. The reason for creating a copy as precise as
our drawing is problematical. Possibly it was intended
as a working drawing for an engraver while Brueghel
retained the original. The most logical explanation for
our copy, however, is that more than one of Brueghel's
patrons desired the original, and a second version of the
drawing was commissioned to satisfy that demand. The
degree of finish in the work, even to the inclusion of the
inscribed proverb on the left, supports this theory. It is
obvious that our drawing was made in Brueghel's studio
using the original as a model. Brueghel's sons Pieter
Brueghel the Younger and Jan Brueghel are known to
have made copies of their father's work, but they would
have been too young to have made a copy commissioned
during the 1560s. The specific authorship of the drawing
will probably never be fully ascertained.

On the edge of a village, three beekeepers arrange
beehives while a boy sits above in the branches of a tree.
The meaning of this scene is clarified by the inscription,
which is translated: "He who knows the nest, knows it;
he who robs the nest, has it."[4] It is a well-known
Netherlandish proverb meaning only the active man gets
the profit. A painting by Brueghel of 1568 *The Peasant
and the Birdnester* (Kunsthistorisches Museum, Vienna)
illustrates the same proverb but shows the boy actually
robbing a nest. In our composition the passivity of the
beekeepers who have the hives but not the bees is
contrasted with the activity of the youth who climbs
the tree to steal the bees. K. Bostrom has noted another
contrast: the wariness of the beekeepers in their awkward
protective clothing and the aggressiveness of the youth
who goes after the bees in his simple clothing.[5]
According to Bostrom the boldness of the young thief
is shown through the symbol of a mandrake root
growing in the foreground. Superstition held that this
rare plant grew under scaffolds and it was called "scaf-
fold child" or "scaffold man." The presence of the
mandrake points to a bad end for the youth in the tree.[6]

Although it is a workshop copy, this drawing reflects
Brueghel's artistic genius. In *The Beekeepers* he has created a
scene rich in its depiction of nature and of man's activities in
his environment, using his subject to illustrate elaborately
the inscribed proverb with multiple levels of meaning.
R. F. J.

*Achenbach Foundation for Graphic Arts purchase and William
H. Noble Bequest Fund, 1978.2.31*

22. Gillis Neyts *Ghent 1623-1687 Antwerp*

View of a City with Ruined Arch, ca. 1660-1670

Pen and brown ink on laid paper; 5½ × 4¼ in.
(140 × 108 mm). Signed at lower right: *G. Nyts. f.*

PROVENANCE: William Valentiner; Hans Schaeffer;
Schaeffer Galleries, New York.

Gillis Neyts became a master in the Antwerp Guild in
1647 and eventually distinguished himself as a painter,
draftsman, and etcher. With the spirit of a miniaturist,
he evolved several stylistic approaches to landscape.
View of a City with Ruined Arch is constructed with
tiny, spicular strokes, and these fine lines are massed
in parallel groups to create the illusion of detail.
Accordingly, not much real definition is achieved except
to distinguish the character of the skyline. Rather,
Neyts uses his little marks to build texture and depth,
suggesting the presence of great detail and atmosphere.
In addition, he populates his compositions with small
figures who busy themselves traversing the landscape.
In the Museums' work, the charming figures, including
fishermen and a dog, are seen near the bank of a river.
The figures, like the birds in the sky, provide graphic
accents that enliven the scene and heighten the appeal of
the view taken from the bottom of a low hill surmounted
by an arch.

Looking at the Museums' drawing, one can
appreciate that its technique is derived largely from
Neyts's work as an etcher. The sheet is also reminiscent
of the etched compositions of Bartholomeus Breenbergh
(1599-before 1658), who did a series of bridges and
arches depicted from similar viewpoints. Certainly,
Neyts was familiar with the etchings of Breenbergh,
who had been attracted to Italy early in his career, and
the Museums' drawing by Neyts, like other sheets by
him, has an unmistakably Italianate feeling. The horizon
with its windmill and tapered towers, however, is
definitely Northern in character, and it is probable that
the city depicted is Antwerp.

There are many other kinds of drawings by Neyts;
some employ considerable wash and others feature
watercolor.[1] Certain sketches must have been inspired
by the drawings and watercolors of the Antwerp painter
Lucas van Uden (1595-1673), while others display
techniques related to those of the important Haarlem
landscape artist Cornelis Vroom (1591-1661). Neyts's
most memorable efforts, however, are the light brown
ink drawings, such as the Museums' beautiful example,
accomplished almost entirely with line. These attain
a delicacy of feeling and a sense of atmospheric
perspective that are rare even among the works of the
many gifted Flemish and Dutch landscape draftsmen
who were active in the seventeenth century.

Neyts's works are signed more frequently than dated,
and it is therefore difficult to be precise about the date of
our drawing.[2]

J. R. G.

Achenbach Foundation for Graphic Arts purchase, 1984.2.44

23. Ferdinand Bol *Dordrecht 1616-1680 Amsterdam*

The Return of the Prodigal Son, ca. 1640

Pen and brown ink on laid paper; 5¼ × 7 in.
(142 × 180mm). On mount at lower right the collector's
stamp of Dr. C. R. Rudolf (Lugt 2811b).

PROVENANCE: Dr. C. R. Rudolf, London (Lugt
2811b): Sotheby Mak van Waay sale, Amsterdam, 18
April 1977, lot 105 as Samuel von Hoogstratten; David
Tunick, Inc., New York; Achenbach Foundation for
Graphic Arts purchase.
BIBLIOGRAPHY: Otto Benesch, *Neuentdeckte Zeichnungen
von Rembrandt, Jahrbuch der Berliner Museen* 6 (1964), p. 147
ff., fig. 42; Otto Benesch, *Collected Writings*, vol. 1
(London 1970), p. 268, fig. 248; Otto Benesch, *The
Drawings of Rembrandt*, vol. 4 (London: Phaidon, 1973),
no. A40a, fig. 1105; Werner H. Sumowski, *Drawings of
the Rembrandt School*, vol. 1 (New York: Abaris, 1979),
no. 206x, p. 346.
EXHIBITIONS: California Palace of the Legion of Honor,
The Fine Arts Museums of San Francisco, *Recent
Acquisitions*, 1977; idem, *European Drawings from the
Achenbach Foundation for Graphic Arts*, 1979; idem,
Masterworks from the Achenbach Foundation for Graphic Arts,
1981.

From the time Rembrandt was in his late twenties until
he was about forty-five, he was the most sought-after
teacher in the Netherlands (see cat. no. 29).[1] In 1675 a
younger contemporary, the German artist and art
historian Joachim von Sandrart wrote that Rembrandt's
"home in Amsterdam was crowded with countless
young people from leading families who came there for
instruction and tuition, each paying him an annual
fee of one hundred guilders.[2] Sandrart clearly knew
Rembrandt and was recalling Amsterdam during the
years 1637 to 1641, when the younger man resided there.
We now know that during his career as a painting
master, Rembrandt had more than thirty significant
disciples among the many students who worked briefly
with him.[3]

Not all of these disciples were particularly gifted, but
there was sufficient talent among the best of them to
cause three centuries of confusion about the attributions
of many works. Ferdinand Bol was among Rembrandt's
exceptionally talented followers. He received his basic
training in Dordrecht, possibly from Jacob Gerritsz
Cuyp and then from 1636 to 1640 (age twenty to twenty-
four) studied with Rembrandt.[4] During the 1640s,
Rembrandt and Bol probably worked as colleagues, and
Bol's production clearly shows the association. From
the 1650s, however, the younger man's style began to
show the influence of Bartholomeus van der Helst and
certain Flemish masters. In 1669, the year of Rembrandt's
death, Bol's second marriage, to a wealthy woman,
allowed him to give up painting.

The Fine Arts Museums are fortunate to possess two
drawings now securely attributed to Ferdinand Bol by
Werner Sumowski (see also cat. no. 24).[5] *The Return of
the Prodigal Son* is the most Rembrandtian work by Bol
imaginable, and it provides one with a fine example of
the kind of work that Rembrandt's best pupils could
execute when within their teacher's reach. Indeed, Otto
Benesch's catalogue raisonné included this drawing
with works attributed to Rembrandt.[6] Benesch's
hesitancy seems well founded, and his reservations have
been reinforced with stylistic comparisons and
arguments by Sumowski that appear to be sufficiently
convincing to establish the author as Ferdinand Bol.

The Return of the Prodigal Son, which illustrates Luke
15:20, offers one passage that would have been especially
problematic had it been cut from the rest of the sheet. It
is the figure of the woman (wife or servant) at the door
on the extreme right. She is so like the figures of
Rembrandt of the late 1630s and early 1640s that the
additional information provided by the rest of the sheet
is essential to make the attribution to Bol. This problem
should be kept in mind when considering the
connoisseurship of drawings by Rembrandt and his
followers, for frequently the scholar is given only the
remaining fragments of a drawing from which to make
an attribution.
J. R. G.

Elizabeth Ebert and Arthur W. Barney Fund, 1977.2.6

24. Ferdinand Bol *Dordrecht 1616-1680 Amsterdam*

Bearded Old Man with Beret, ca. 1640

Gray wash with black chalk and incised transfer lines on laid paper; black chalk for transfer on reverse; 5 × 4⅛ in. (127 × 103 mm). On verso at lower left the collector's stamp of Sir Charles Greville (Lugt 549). Large crown-shaped watermark in central area of paper.

PROVENANCE: Sir Charles Greville (Lugt 549); Earl of Warwick; his sale, Sotheby's, 17 June 1936, lot 128; J. Theodor Cremer; his sale, Sotheby Mak van Waay, Amsterdam, 17 November 1980, lot 62, repr. p. 118; Richard Day Ltd., London; Achenbach Foundation for Graphic Arts purchase.
BIBLIOGRAPHY: Werner H. Sumowski, *Drawings of the Rembrandt School*, vol. 1 (New York: Abaris, 1979), no. 143ˣ· (same model appears in two prints by Bol: Hollstein, vol. 3, no. 7, p. 21, and no. 10w, p. 24).
EXHIBITION: California Palace of the Legion of Honor, The Fine Arts Museums of San Francisco, *Recent Acquisitions*, 1981.

Ferdinand Bol was one of the closest followers of Rembrandt, and he is best known as a painter of Rembrandtesque portraits. *Bearded Old Man in a Beret* is a drawing by Bol, copied from one of his own paintings and executed in Rembrandt's manner. The painting, now at Buckingham Palace, formerly was thought to be by Rembrandt. The drawing is one of a few chalk portraits by Bol still extant that pays tribute to Rembrandt's style of portraiture.[1]

In the eighteenth century, and even until quite recently, this is the kind of drawing that would have been prized by some as a Rembrandt. But recent scholarship, particularly by Werner Sumowski, has illuminated both our perception of the pervasive influence of this revered artist and the remarkable talent of some of his followers. Because Ferdinand Bol was one of Rembrandt's most gifted followers, it should not be surprising that stylistic studies have prompted students to increase the canon of Bol's accepted works, just as they have necessitated diminishing the number of works that are securely attributed to Rembrandt himself.

Bol continued to work under the tenacious precedent of Rembrandt's style even after his apprenticeship from about 1636 to 1640, but *Bearded Old Man with Beret* was probably executed about 1640.
J. R. G.

William H. Noble Bequest Fund, 1980.2.46

25. Johannes Bronkhorst *Leyden 1648-1727 Hoorn*

Study of Lepidopterans (Five Adults and a Caterpillar)

Watercolor with gum glaze additions on laid paper;
5¼ × 7¹⁵⁄₁₆ in. (132 × 178 mm). Numbers *1* through *6*
inscribed in graphite above the insects.

PROVENANCE: Morton Morris & Co. Ltd., London.

Natural history painting in seventeenth-century
Holland is a rich and wondrous category of pictorial art
that is not well known to the general public. Even
scholars often neglect this delightful area that has made
significant contributions to art and science.

The most famous of the exponents of this genre in
seventeenth-century Holland was undoubtedly the
independent and strong-willed Maria Sibylla Merian
(1647-1717). A contemporary of Bronkhorst and German
by birth, Merian left her husband after some years of
marriage to join a religious sect called the Labadists and
eventually moved to Holland to live at the sect's castle
in Friesland. Merian was a brilliant observer and became
the first naturalist to study the metamorphosis of certain
insects. Her travels to South America to record flora and
fauna as well as her book *Insects of Surinam* each could
claim a lengthy dissertation.[1]

Not nearly as fascinating a personality as Merian,
Johannes Bronkhorst was an equally unlikely candidate
to be a natural history artist. He was taken to Haarlem
after the death of his father in 1661 and apprenticed to his
mother's cousin, a pastry cook. In 1670 he settled in
Hoorn where he remained a pastry cook, married, and
began to draw. From the beginning his subjects were
primarily birds and insects. Bronkhorst was very prolific
and many of his works are in Dutch collections.

The Museums' lovely assembly of lepidopterans may
have been one of many leaves in a book of butterflies
and moths.[2] The creatures were undoubtedly numbered
by the artist to permit reference to a descriptive listing
that would have accompanied the illustrations. Bronk-
horst has distributed his insects to feature their wings
and color. He also has paid particular attention to the
texture of the wings and has glazed them to add to the
realism of the depiction. In German sixteenth-century
art and in earlier seventeenth-century Dutch art,
accurate depictions of insects and other fauna served to
prepare for paintings. But such beautifully balanced
studies as those of Bronkhorst were probably done for
instruction or simply for the pleasure of doing. These
were often gathered together as manuscript books
and became more common in the later eighteenth and
nineteenth centuries as talented amateurs were
encouraged to practice painting animals and plants.

Though they are not truly art in the service of science
as are many of Maria Sibylla Merian's works, Bronk-
horst's compositions reflect that newfound fascination
with the world of nature that Dutch artists felt almost
honor bound to render as truthfully as possible. This
approach, in itself, reflected the new scientific spirit that
flourished in the Netherlands in the seventeenth century.
J. R. G.

Achenbach Foundation for Graphic Arts purchase, 1984.2.45

26. Jan van Goyen *Leyden 1596-1656 The Hague*

River Landscape with Farm Buildings, Bridge, and Three Boats, 1651

Black chalk and gray wash on laid paper; 4½ × 7¾ in. (114 × 196 mm). Initialed and dated at lower right: *VG 1651.*

PROVENANCE: Mrs. A. L. Snapper; Sotheby's, 5 October 1961, lot 78; H. E. Blake; Schaeffer Galleries, New York.
BIBLIOGRAPHY: Hans Ulrich Beck, *Jan van Goyen*, vol. 1 (Amsterdam: Van Gendt, 1972), no. 245, p. 88.
EXHIBITION: California Palace of the Legion of Honor, The Fine Arts Museums of San Francisco, *Recent Acquisitions, Part I*, 1983.

The relatively flat landscape characteristic of much of Holland is shown most poetically in Dutch paintings and drawings of the seventeenth century. Together with Esias van de Velde and Pieter Molijn, Jan van Goyen was one of the first artists to interpret this austere topography. His early pastorals of the 1620s record the cold light and windswept skies of his native country with remarkable facility, and this is the kind of subject that occupied him for the rest of his life. Understandably, the unaffected style of van Goyen's numerous paintings and drawings has endeared him to generations of Dutch connoisseurs and collectors, but today his appeal as one of the finest landscapists of the century is universal.

Van Goyen's many sketchbook sheets tell us that he was always drawing and that drawing was very important to his development as a painter. The Museums' *River Landscape with Farm Buildings, Bridge, and Three Boats* of 1651 was sketched rapidly in chalk and then modeled with pale gray wash.[1] Van Goyen's works do not reveal themselves as dramatic statements of light and shade. Rather, they require a longer look to fathom their beguiling content. In *River Landscape* the artist takes pains to indicate reflections in the water, smoking chimneys, rowing figures, and vegetation along the reinforced embankment. All of these details are noted in this quick sketch, reconsidered and united by a session with the brush, probably at a slightly later time.

As his hand dashed about the sheet, additional pressure applied darker flecks of chalk for accents. The overall effect of van Goyen's technique is a silvery vision of his experience that can stand on its own as a work of art.

J. R. G.

Achenbach Foundation for Graphic Arts purchase, 1981.2.5

27. Marten van Heemskerck *Heemskerck 1498-1574 Haarlem*

Joseph and Potiphar's Wife, 1566

Pen and brown ink on laid paper affixed to thicker papermount; 8⅛ × 10¼ in. (208 × 261 mm). Signed and dated in brown ink at lower right: *M. Heemskerck 1566.* Collector's stamp on verso of mount: Sir Robert Witt (Lugt Supplement 2228b).

PROVENANCE: Sir Robert Witt, London (Lugt Supplement 2228b); William Mansur Hume.
EXHIBITIONS: California Palace of the Legion of Honor, San Francisco, *Old Master Drawings,* 1966; John and Mable Ringling Museum of Art, Sarasota, *Master Drawings,* 1967; University Art Museum, Berkeley, *Master Drawings from California Collections,* exh. cat. ed. by Juergen Schulz, 1968, no. 68, p. 70, repr. p. 152.

Marten van Heemskerck may be more intriguing to art historians than to lovers of drawings for his eclectic style and his surprisingly widespread influence. The artist was a pupil of Jan van Scorel from 1527 to 1529. In 1532 he traveled to Rome where he remained until the end of 1536, when he returned to Haarlem.

Van Heemskerck's stay in Rome provided a visual experience that profoundly affected the rest of his career.[1] He seems to have been most moved by the art of Giulio Romano, one of Raphael's most important disciples.[2] In fact, certain frescoes in the Vatican that Heemskerck studied were completed by Giulio only shortly before the Dutch artist's arrival.

Heemskerck turned frequently to the Old Testament for important themes. These inspired his drawings that often were created to be engraved for publishing projects, but their choice almost certainly had greater significance. As Stechow wrote, "The books of the Old Testament were searched by many of the outstanding adherents of the Protestant faith, but also by many independent Catholics, not so much for typological parallels–that is prefigurations of the facts of the New Testament–as for great paradigms of faith and moral excellence, which were seen in terms of a universal and even sometimes of an anticlerical creed."[3] A particularly active force in the promulgation of these thoughts and beliefs was Dirck Volkertsz Coornhert (1522-1590), a philosopher, poet, and engraver who was also a pupil of Marten van Heemskerck as well as the engraver of many of his master's compositions.[4]

Joseph and Potiphar's Wife, the earliest Dutch drawing in the collection of The Fine Arts Museums, illustrates an episode from the text of Genesis 39:12 that inspired two engravings after Heemskerck. The earlier, included in a series of six prints on the Life of Joseph, dates to 1549 or 1550.[5] The later engraving, included in a series illustrating the Ten Commandments, dates to the later 1560s and apparently is derived from the Museums' drawing.[6]

The fastidious technique of the Museums' sheet is decidedly Northern, though the scowling wife of Potiphar and the mimicking griffins that support the chair are derived from the monumental figure style of Giulio Romano.[7] Thus this study reflects something of the range of Heemskerck's artistic exposure and is a document of the business of print publishing–a preparatory sheet rendered to provide easy translation by the engraver's tool.

J. R. G.

Gift of William Mansur Hume to the California Palace of the Legion of Honor in memory of his father, George E. Hume, 1952.81

28. Pieter Jansz Quast *Amsterdam 1605 or 1606 - 1647 Amsterdam*

A Skater, ca. 1640

Graphite on vellum; 7¾ × 5⅞ in. (196 × 147 mm).
Inscribed in brown ink at upper right: *45*.

PROVENANCE: Sotheby Mak van Waay, Amsterdam,
16 November 1981, lot 12, repr. p. 49.
EXHIBITION: California Palace of the Legion of Honor,
The Fine Arts Museums of San Francisco, *Recent
Acquisitions, Part I*, 1983.

Pieter Quast was one of the most prolific and spirited
Dutch artists of the early seventeenth century. His
paintings, drawings, and prints concentrated on the
depiction of peasant genre in the tradition of Adriaen
Brouwer and Adriaen van Ostade. Quast's works are
noted for their wit, savagery of caricature, animated
draftsmanship, and high degree of finish.

Quast was born in Amsterdam in 1605 or 1606.
Unfortunately nothing more is known about him until
his marriage in 1632 to Annetije Splinters. The couple
moved to The Hague within the next two years, as
Quast was made a member of the Guild of Saint Luke in
that city in 1634. By 1643 Quast was back in Amsterdam
where he died in 1647. Despite the gaiety of his art, he led
a rather unhappy life, unfortunately married and
constantly in legal trouble.[1] Unlike other artists of the
period who maintained second professions for their
livelihoods, Quast depended solely on his art and,
therefore, was always in debt. His attempt to break his
engagement to Annetije had failed, and he was legally
ordered to marry her by the Directors of Marital
Affairs.[2] The financial and emotional setbacks of his life
may account in part for the savagery with which he used
his art to mock the human species.

In addition to his paintings, Quast's drawings must
have been sought after in his lifetime, since so many

large, highly finished, signed works exist.[3] He
specialized in drawings on vellum, employing black
chalk, leadpoint, or graphite. *A Skater* is one of a group
of forty-six drawings of single figures, similar in size and
medium, that were sold at auction in Amsterdam in
1981.[4] Originally they must have formed a sketchbook
as each drawing is numbered in ink in the upper right
corner. In addition, a number of these drawings are
dated and signed or initialed in leadpoint. The dates
range from 1638 to 1640. Since a drawing numbered 33 in
the series carries the date 1640 as does another drawing in
the series numbered 46, it is safe to assume that the
Achenbach sheet (numbered 45) also was done in 1640.[5]

The subjects of these drawings are elegantly attired
figures in both Dutch and oriental costumes as well as
coarsely dressed low-life types. The animated gestures
of many of the figures identify them as actors. Like Jan
Steen and Leonard Bramer, Quast was knowledgeable
about contemporary Dutch theater and based many of
his compositions on theatrical themes.[6] In addition,
Quast was directly influenced by the etchings of the
French artist Jacques Callot (1592-1635), particularly by
his actor series of 1621, *Balli di Sfessania* (Lieure 379-402),
and his dwarf series of 1622, *Varie Figure di Gobbi* (Lieure
279, 407-426).

Despite the grotesque nose and elongated chin of the
skater's face, there is an overall effect of naturalism in
our drawing. This characteristic trait of Dutch
seventeenth-century art is especially evident in the
gliding motion of the figure as he leans, hands behind
his back, and moves forward balanced on one skate.
R. F. J.

Achenbach Foundation for Graphic Arts purchase, 1982.2.53

29. Rembrandt Harmensz van Rijn *Leyden 1606-1669 Amsterdam*

Bearded Old Man with a Wide-brimmed Hat, 1633-1634

Pen and brown ink on brown laid paper, gray wash addition by a later hand; 5 × 4 in. (128 × 103 mm). The drawing appears to have been cut along the lower edge at an earlier time. There are remnants of an ink margin along all edges of the drawing. On verso signed in brown ink at lower left: *Rembrand f/5 : 5.00/6.4*, above the collector's stamp of J. de Vos Jr. (Lugt 1450).

PROVENANCE: Ploos van Amstel (Lugt 3002); J. de Vos Jr. (Lugt 1450); J. Q. van Regteren Altena; F. Koenigs; Paul Cassirer; Colnaghi, London, 1979; Shanaugh Fitzgerald Ltd., London, 1981.
BIBLIOGRAPHY: Otto Benesch, *The Drawings of Rembrandt*, vol. 2 (London: Phaidon, 1973), no. 225, p. 63, fig. 263; *Old Master Paintings and Drawings*, exh. cat. (London: Colnaghi, 1979), no. 62, repr.
EXHIBITIONS: Rijksmuseum, Amsterdam, *Rembrandt Tenoonstelling*, 1932, no. 235; M. H. de Young Memorial Museum, The Fine Arts Museums of San Francisco, *Rembrandt, Selected Prints and Drawings*, 1982-1983; California Palace of the Legion of Honor, The Fine Arts Museums of San Francisco, *Recent Acquisitions, Part I*, 1983.

With respect to connoisseurship, Rembrandt's graphic activity during his early Amsterdam years (1632-1640) is better documented than that of any other period in his prolific artistic life. There are more extant drawings from this time as well as more sheets with his autograph signature and/or dates in his hand. This is essential to bear in mind, because recent scholarship has made us more aware than ever of just how many talented pupils were capable of approaching Rembrandt's remarkable style. This *Bearded Old Man in a Wide-brimmed Hat* is characteristic of a group of drawings that fall within the well-understood nucleus of authentic figure studies done during the 1630s.

The old Jewish men and women of his neighborhood, as well as local actors and beggars, provided the subjects of these studies from life. Subtle gestures and expressions rather than ideal postures and beauty were the concerns of the artist, and such figures as this man provided him with an inexhaustible supply of real characters for his painted and etched biblical narratives. Perhaps the most impressive thing about such apparently simple, rapid works by Rembrandt is their revelation of both awesome facility and profound humanity.

J. R. G.

Roscoe and Margaret Oakes Fund, 1981.2.3

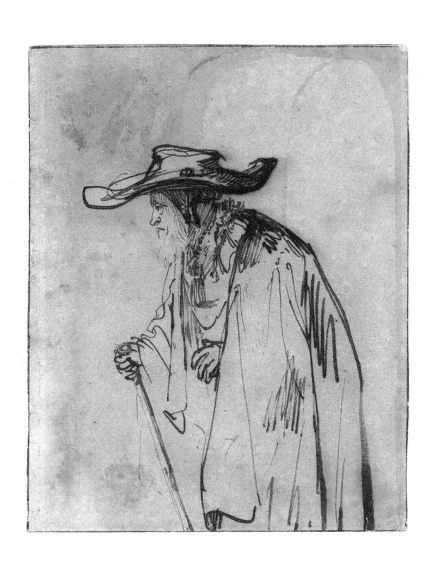

30. Johann Wolfgang Baumgartner *Kufstein 1712-1761 Augsburg*

Elementum Terrae (Allegory of Earth), ca. 1750

Ink, wash, and graphite with white and blue gouache heightening on blue-gray laid paper; 19½ × 27½ in. (486 × 686 mm). Paper scored with stylus for transfer in areas corresponding to red chalk used for transfer on reverse (except in areas of saint and entourage in upper center). Paper pieced before drawing was begun. Inscribed in graphite at lower left: *108(f?)* and at upper right: *A68*.

PROVENANCE: L'Art Ancien, Zurich, 1969.
EXHIBITIONS: John and Mable Ringling Museum of Art, Sarasota, *Central Europe, 1600-1800*, 1972, no. 66; Montgomery Art Gallery, Pomona College, Claremont, *18th Century Drawings from California Collections*, exh. cat. by David W. Steadman and Carol M. Osborne, 1976, no. 4, p. 8, repr. p. 9 (also E. B. Crocker Art Gallery, Sacramento, 1976); California Palace of the Legion of Honor, The Fine Arts Museums of San Francisco, *European Drawings from the Achenbach Foundation for Graphic Arts*, 1979.

Johann Wolfgang Baumgartner exemplifies the soaring, exuberant splendor of South German Rococo at its finest in his highly finished drawings, paintings, and frescoes. A native of the Tyrol, Baumgartner first was trained as a glass painter in Salzburg. In 1733 he settled in Augsburg, and there he became a leading painter and draftsman. Baumgartner is best known for his fresco decorations in churches, particularly those at Gertshofen and Eggenhausen near Augsburg.[1] He also is known for the hundreds of rococo designs he made for the engravers of Augsburg, then a major publishing center for the decorative arts.

The Museums' phantasmagoric drawing *Elementum Terrae* (Allegory of Earth) was created by Baumgartner about 1750 as a design for an engraving produced by the Klauber brothers, the first Catholic publishing house in Augsburg. The Klaubers specialized in engravings issued in sets of four, with each subject personified by a saint.[2] This drawing would have been used as a design for a set of the four elements. The only significant change between the drawing and the finished print is that another saint has been substituted in the upper central portion of the composition. In our drawing, a saint, thought to be Saint Rosalia of Palermo, protector against earthquakes and plagues, floats heavenward with

a look of prayerful ecstasy, assisted by a group of angels. In the finished print the equally appropriate Saint Alexius has replaced her and is surrounded by a slightly different array of angels. Inscribed on the plate is the legend: "S. ALEXIUS Patronus contra terrae motus" (S. Alexius opposed to the moving earth).

Beneath the hovering figure of Saint Rosalia in our drawing, a landscape filled with rich allegorical allusions unfolds. In the lower central portion of the drawing, a female figure representing Terra presides. Her crown of towers symbolizes inhabited lands and the waterfalls and foliage around her stand for wilderness. The basket of fruit, sheaf of grain, and gardener's tools surrounding her are usually associated with the personification of agriculture.[3]

The landscape is divided into two sections. To the right of the figure of Terra is a representation of the earth in its natural state, dominated by a towering, craggy rock formation. On the far right, a man climbs a tall ladder to pick some wild fruit from a tree. Below, four men using pickaxes and a windlass engage in mining. In the foreground, metal objects engraved with the symbols of the planets signify forces governing the earth.

To the left of Terra is the earth, cultivated and built upon by man. Dominating this side of the drawing is a fantastically constructed rococo fountain, featuring an allegorical sculpture of Hercules and Antaeus to illustrate the conflict between the good and evil aspects of earth. To the far left, framed by an elaborate arch, buildings set within formal gardens stretch into the distance. Below, a man harvests orderly rows of grapes as another hauls the vintage to a winepress. Various farm implements, representing cultivation, lie in the foreground.

The benign character of Terra, represented on both sides of the composition, is shattered by her unstable aspects, demonstrated by the earthquake in the center that destroys buildings and terrifies men, women, and children. Deliverance from this danger is in the hands of Saint Rosalia. In this bravura display of rococo draftsmanship, Baumgartner has created a devotional image of a truly surreal nature that is nevertheless true to an age of fanciful ornamental excess.

R. F. J.

Achenbach Foundation for Graphic Arts purchase, 1969.31

31. Barbara Regina Dietzsch · *Nuremberg 1706-1783 Nuremberg*

A Dandelion (Taraxacum officinale) with a Tiger Moth, a Butterfly (Lycaenid sp.), a Snail, and a Beetle

Gouache on vellum; 11¼ × 8¼ in. (285 × 210 mm).

PROVENANCE: Stanley-Clarke; Eyre and Hobhouse Ltd., London.
BIBLIOGRAPHY: *A Cabinet of Natural Curiosities*, exh. cat. (London: Eyre and Hobhouse Ltd., 1983), no. 10, repr.

London and Nuremberg were the chief centers of botanical illustration in the eighteenth century, and at Nuremberg one of the most illustrious names associated with this genre was Dietzsch. But more than one Dietzsch painted flora and fauna: Barbara's father, Johann Israel, her brother, Johann Christoph, and her sister, Margareta, all were employed by the Nuremberg court. The family's work was collected in the Netherlands and England as well.

Botany was an important aspect of medical training until the later nineteenth century, and physicians of the time, like all biologists, were concerned primarily with description and classification. Furthermore, as medicine represented a marriage of many fields, it was not unusual for a physician to be a patron of the arts, especially when these arts served to enhance the appreciation of natural history. Thus it was that Dr. Christoph Jocob Trew (1695-1760), who had a deep interest in botany and bibliography, enthusiastically supported botanical art in Nuremberg, making the city an important center for work such as that of the Dietzsch family. Although their art seems to present the natural world theatrically, it does so to focus on the beauty and wonder of natural structure and color, without mythical or religious symbolism. These concerns were shared by leading natural philosophers of the day and, as works inspired by this new emphasis, the jewel-like gouaches of the Dietzsches reflect a fascinating period in the history of science.

Because all four Dietzsches treated similar subject matter and commonly chose to present their compositions against a black background, attribution is a challenge. All were competent to execute detailed and dramatic renditions of common flowers, fruits, and vegetables, and many examples can be studied at Bamburg and at the Fitzwilliam Museum, Cambridge.

There are studies similar to ours by various members of the Dietzsch family in the Broughton collection at the Fitzwilliam Museum, and several others have appeared in the London trade during the past few years.[1] The study in the Broughton collection is tentatively attributed to Margareta. Based on a comparison of the two sheets and on the observation that works securely attributed to Barbara Regina are more meticulously rendered, it appears likely that she is the author of our gouache.

J. R. G.

Purchase, gift of the Museum Society Auxiliary, 1984.2.8

32. Adolph von Menzel *Breslau 1815-1905 Berlin*

Study of a Tree, ca. 1885-1890

Graphite on wove paper; 7⅛ × 4½ in. (183 × 112 mm). Initialed in graphite at lower left: *A. M.*

PROVENANCE: Galerie Arnoldi-Livie, Munich, 1978. EXHIBITIONS: California Palace of the Legion of Honor, The Fine Arts Museums of San Francisco, *Recent Acquisitions, 1977-1978*, 1978; idem, *Selected Acquisitions, 1977-1979*, 1979-1980, checklist, no. 40.

Adolph von Menzel was one of the most gifted German draftsmen of the nineteenth century. His career spanned more than seventy years, from his first commission in 1833 until his death in 1905. He produced many virtuoso drawings in a variety of media, including designs for wood blocks, watercolors, and drawings in ink and colored chalk as well as in his preferred medium, graphite. Menzel made his early reputation in Germany with four hundred designs for Kugler's *Life of Frederick the Great* (1840-1842) and with his elaborate, carefully composed paintings on the same subject. His paintings of the 1850s that deal with contemporary life gained increasing recognition in England and in the rest of Europe during the 1860s. In France, Edgar Degas praised his work and even made copies from memory of two of Menzel's paintings.[1]

Beginning in the 1880s, Menzel turned to drawing as his chief means of expression, viewing it not as a means to an end but as an end in itself. His earlier drawing style utilized a sharp, almost silverpointlike pencil line, and this gave way in the 1860s to the use of black chalk and soft carpenter's pencil. Through skillful use of stumping he achieved a great range of gray tonalities in his increasingly expressive drawings.

This powerfully composed study of a tree can be dated to the late 1880s, on the basis of similar studies[2] and Menzel's manner of initialing the drawing.[3] The dramatic closeup of the tree coupled with its bold cropping has produced a work of startlingly modern conception. Menzel's restless energy is occasionally seen in the accidental lines his pencil made as it skipped across the paper.[4] An example of this in our sheet is the straight line across the center of the tree trunk.

In 1907 Theodor Heuss summed up the importance of the artist's draftsmanship in *Menzel as Architect*: "His whole temperament as a man and an artist, that is to say, his way of seeing the world as an artist, lies in the point of his pencil. This is the language that he uses to tell of the nature of the world."[5]

R. F. J.

Achenbach Foundation for Graphic Arts purchase, 1978.2.9

33. Gerhardt Wilhelm von Reutern *Gute Rösthof bei Walk 1794-1865 Frankfurt*

Anne Lies Stamm and Anne Kathring

Pen and black ink on wove paper; 6⅛ × 8½ in.
(156 × 216 mm). Inscribed and dated by the artist in blue
ink: *Anne Lies Stamm. Anne Kathring./W den 31 (6?)
J. beendigt. den 26 (H.?) D.*

PROVENANCE: Galerie Fischer-Kiener, Paris, 1977;
Hazlitt, Gooden & Fox, London, 1978.
EXHIBITIONS: Galerie Fischer-Kiener, Paris, *Gerhardt
Wilhelm von Reutern*, exh. cat., 1977, repr.; Hazlitt,
Gooden & Fox, London, *Gerhardt Wilhelm von Reutern*,
exh. cat. by Stefanie Maison, 1978, no. 13, p. 15, repr.;
California Palace of the Legion of Honor, The Fine Arts
Museums of San Francisco, *Selected Acquisitions, 1977-
1979*, 1979-1980, checklist, no. 49; idem, *Masterworks
from the Achenbach Foundation for Graphic Arts*, 1981.

Gerhardt Wilhelm von Reutern was born in 1794, into an
aristocratic Saxon family. His early education took him
to Saint Petersburg and then to Dorpat University
where he first received artistic instruction from the artist
Carl August Senff (1770-1838). Von Reutern joined the
Russian army in 1811 to fight Napoleon's forces. In the
battle of Leipzig in October 1813 he suffered a severe
wound of the right shoulder, which necessitated
amputation of his right arm. After recovering his health,
von Reutern went about the demanding task of
developing his artistic talents with his left hand. During
his convalescence in Weimar in 1814, he met and became
a friend of the poet Goethe, a relationship that lasted
until Goethe's death in 1832. Goethe wrote of von
Reutern in 1831: "Nature has given him a splendid
talent, and art and nature have formed him."[1] An
important influence on von Reutern in the 1820s was
the artist Ludwig Emil Grimm (1790-1863). The two

men worked together in Willingshausen, in Hesse,
where our drawing was made.[2] In 1837 von Reutern was
appointed court painter to the Russian Imperial family.
He settled in Frankfurt am Main in 1844 and spent the
remaining twenty-one years of his life there.

Although the drawings made in Willingshausen about
1826-1827 include some still lifes and landscapes, most
of them are sharply defined portrait drawings in ink.
The double portrait of Anne Lies Stamm and Anne
Kathring is essentially two drawings in one.[3] It is an
understated, yet faithful, recording of the features
of two local women. At the same time, however, it is
a subtly disturbing drawing. The identical clothes,
scarves, and bonnets of the two women (it is only the
number of undone buttons that differentiates the two
costumes), the curious linking of the two by the gesture
of one woman resting a hand on the other's shoulder,
and the almost picture-cutout features give this draw-
ing an unusually obsessive quality. Intense, sharply
delineated portraits were characteristic of German
draftsmanship in the early nineteenth century. At his
best, as he is here, Gerhardt Wilhelm von Reutern can
be compared with Carl Philipp Fohr, Peter Cornelius,
Johann Friedrich Overbeck, and Julius Schnorr von
Carolsfeld as a master of this style of drawing.

There is very little recent literature on von Reutern.[4]
The catalyst for the current interest in him was
the exhibition and sale of a group of drawings and
watercolors in Paris in the summer of 1977.[5] In 1978 a
large portion of those drawings, including our sheet, was
exhibited in London with an accompanying catalogue by
Stefanie Maison.[6]

R. F. J.

Achenbach Foundation for Graphic Arts purchase, 1978.2.44

34. Philipp Veit *Berlin 1793-1877 Mainz*

Study for "Die beiden Marien am Grabe," ca. 1847

Brush and gray ink and graphite on wove paper; 3½ × 4⅞ in. (89 × 125 mm). Red collector's stamp at lower right: *GE* (Gustave Engelbrecht, Lugt 1148).

PROVENANCE: Gustave Engelbrecht, Hamburg (Lugt 1148); M. Christian Humann, New York; Sotheby Parke Bernet, New York, 30 April 1982, lot 118; Colnaghi, New York.

Philipp Veit and his brother, Johannes, were artists of the German Nazarene School. The name *Nazarenes* (i Nazareni) originally was applied mockingly by the Italians and was given to artists associated with the Brotherhood of Saint Luke (Lukasbrüder). This ascetic, quasireligious order was established in Vienna in 1809 by the painters J. Friedrich Overbeck (1789-1869) and Franz Pforr (1788-1812). They found baroque and rococo religious art decorative and impious and chose instead to draw their inspiration from early Italian art and German Renaissance painting, which they saw as "the way of truth." When Overbeck and Pforr moved to Rome in 1810, they were joined by a group of artists of similar beliefs who were already living there. These included Peter von Cornelius, Carl Philipp Fohr, Julius Schnorr von Carolsfeld, Joseph Fuhrich, and the two Veits.

The association of Philipp Veit and his brother with the Nazarenes is especially interesting because of their family history. Their parents' marriage represented a merger of two of the most prominent Jewish families. Simon, their father, was heir to one of the preeminent banking institutions in Germany, and Dorothea, their mother, was the daughter of Moses Mendelssohn, the most famous European Jew of the eighteenth century

and the leading philosopher of the Enlightenment. Their cousin was the renowned composer Felix Mendelssohn-Bartholdy. After their mother divorced Simon Veit and married Friedrich von Schlegel, one of the principal aesthetic philosophers of German Romanticism, she chose to educate her two sons in the Catholic faith, and they eventually were baptized as was their cousin Felix. These conversions reflect the liberal yet profoundly problematic religious changes that beset Europe in the early nineteenth century.

In 1829 Veit was called to become the director of the Städelschen Kunstinstitut in Frankfurt am Main, and in 1854 he took the position of director of the Städtischen Galerie in Mainz.

The small, exquisitely finished drawing of the *Two Marys at the Grave*, in the collection of The Fine Arts Museums, is a study for a painting of the same title in the Nationalgalerie, Berlin.[1] One should note that Veit rarely pursued such refined modeling in his drawings. It is probable, therefore, that this little work was intended as a gift, for it is really a finished grisaille miniature. Most of Veit's drawings are sketches that reflect the influence of Raphael and Dürer as painters rather than imitate their respective styles of draftsmanship.

The stark contrast of delicately modeled and detailed figures against an almost empty sky is effective in concentrating one's attention on the contemplative postures and meditative expressions of the two Marys. Such compositions not only pay homage to Italian and German artistic precedent, they prefigure the languid contours of the English Pre-Raphaelites.

J. R. G.

Achenbach Foundation for Graphic Arts purchase, Bruno and Sadie Adriani and Ruth Haas Lilienthal Funds, 1983.2.8

35. Melchior Lorch *Flensburg ca. 1527 - after 1583 Copenhagen*

The Prophet Jeremiah Exhorts the King of Judah and Other Kings to Submit to Babylon, 1552

Pen and brown ink, brown and gray wash, and traces of black chalk on laid paper; 10¼ × 15½ in. (259 × 395 mm). Monogrammed and dated in brown ink on balustrade at lower right; at lower left collector's stamp: Comte J. P. van Suchtelen (Lugt 2332). Inscribed on verso: *Jeremia 27.*

PROVENANCE: Comte J. P. van Suchtelen, Saint Petersburg (Lugt 2332); Thomas Carr Howe, San Francisco.

EXHIBITIONS: California Palace of the Legion of Honor, San Francisco, *Old Master Drawings*, 1966; idem, *Masterworks from the Achenbach Foundation for Graphic Arts*, 1981; The Art Museum, Princeton University, *Drawings from the Holy Roman Empire, 1540-1680*, exh. cat. by Thomas DaCosta Kaufmann, 1982, no. 13, p. 62 repr. (also National Gallery of Art, Washington, D.C., 1983; Museum of Art, Carnegie Institute, Pittsburgh, 1983).

In 1966 the auction of a group of wonderfully strange costume drawings, collected by the seventeenth-century author and diarist John Evelyn, reawakened the art world to the peripatetic Danish draftsman Melchior Lorch.[1] The schematized style of these costume drawings by Lorch probably reflected his intention to use them in making a series of woodcuts.

The rare and exciting drawing by Lorch in the collection of The Fine Arts Museums reveals a totally different style of draftsmanship. Predating the costume series by about twenty years, *The Prophet Jeremiah Exhorts the King of Judah and Other Kings* is a spectacle of delicate detail, consuming space in *horror vacui* much like the earlier historical works of Albert Altdorfer. Also reminiscent of Altdorfer is the stageset Jerusalem, full of Northern architectural fancy.

This drawing, dated 1552, was recently published by Thomas Kaufmann who stresses its strictly Germanic qualities despite the artist's trip to Italy in 1551.[2] He also proposes that the subject matter may refer to contemporary events. In 1552, Duke Maurice of Saxony and other German princes, already in conflict among themselves, joined forces and went to war against the Catholic emperor Charles V. Later that year, a treaty was signed with the German rulers ending their hostilities against the emperor but not resolving their own dangerous rivalries.

At the time, the Roman Church was referred to derisively as a "Babylon" by the Lutherans, and the passage of Jeremiah that the drawing refers to deals with the Prophet's plea to the Kings of Judah, Sidon, Tyre, Moab, and Edom to submit to Nebuchadnezzar, King of Babylon. Thus Kaufmann convincingly suggests that Lorch, a committed Protestant, may have chosen this rare subject matter for a drawing as a private appeal to the German nations to make peace among themselves and submit to the emperor before a worse fate befell them.

J. R. G.

Achenbach Foundation for Graphic Arts purchase, 1965.53

36. Mariano José María Bernardo Fortuny y Carbó *Réus 1838-1874 Rome*

Italian Woman, 1858

Watercolor over graphite underdrawing on wove paper;
10 × 4⅞ in. (255 × 126 mm). Inscribed in graphite at upper
left: *Fortuny*, and inscribed on verso: *Etude par Fortuny/
Ecole de chigi/Roma 1858/M Ta [fui ?].*

PROVENANCE: M. H. de Young Family, 1941.
EXHIBITIONS: National Gallery of Art, Washington,
D.C., *Italian Drawings 1780-1890*, exh. cat. by Roberta
J. M. Olson, 1980, no. 80, p. 194, repr. p. 195 (also The
Minneapolis Institute of Arts, 1980; California Palace of
the Legion of Honor, The Fine Arts Museums of San
Francisco, 1981; Grey Art Gallery, New York
University, New York, 1981).

One true measure of artistic fame is that more than one
nation claims an artist as part of its cultural heritage. So
it is with Mariano Fortuny y Carbó, who is as often
referred to as an Italian as he is a Spaniard. Fortuny
spent most of his career in Italy, although he was born
and educated in Spain. Yet despite his long residences
in Rome and Naples and his penchant for travel, he
continued to create an art that was essentially Spanish in
character.

Fortuny was orphaned at an early age and was largely
self-taught. Following his art training in Barcelona, he
received a stipend to study in Rome in 1857. While in
Barcelona, in 1860, he undertook a commission that
entailed several trips to Morocco that were inspirational

to his art. In 1866 Fortuny visited Paris, where he studied
with Jean-Léon Gérôme and Jean-Louis Ernest
Meissonier.

Fortuny thrived on the use of virtuoso brushwork and
brilliant color harmonies, although as Robert Rosenblum
stated, "Despite his swift and glittering touch, the mark
of a dashing personal calligraphy, Fortuny's paintings
are clearly based on the same Realist premises as the more
glossy, brushless descriptions of fact by Gérôme,
Meissonier...."[1] Fortuny was an influential artist who
displayed great promise when his career was cut short by
death at the age of thirty-six.

Fortuny's brilliant mastery of the watercolor medium
is referred to in contemporary accounts of the artist.[2] The
diminutiveness of the Achenbach sheet is compensated
for by the solidity of the figurative composition made up
of broad washes in a spare but still painterly manner. His
inclusion of a shadow and the skillful use of the natural
white of the paper has created an illusion of bright, direct
sunlight. The disarming simplicity of this watercolor
links it to the figure paintings of women by Camille
Corot, which Fortuny could have known at this time. It is
in these confident, glowing watercolors that the greatest
impact of Fortuny's talent is felt. From the inscription on
the verso it appears that Fortuny executed this watercolor
in Rome, in 1858, while in the atelier of Chigi.
R. F. J.

*Achenbach Foundation for Graphic Arts, gift of the M. H. de
Young Family to the M. H. de Young Memorial Museum,
41.1.5*

37. Jusepe de Ribera *Jatiba ca. 1590-1652 Naples*

Study of a Man with Upraised Hand (Orator?), ca. 1629-1630

Pen and brown ink on laid paper; 7⅝ × 5½ in.
(195 × 140 mm). Inscribed in graphite on verso:
Spagnoletto, and in brown ink: *Spagnoletto* and *195*.

PROVENANCE: Joseph Green Cogswell Collection
(no. 239); Mortimer Leo Schiff, New York;
Moore S. Achenbach; gift to the Achenbach
Foundation for Graphic Arts.
BIBLIOGRAPHY: G. S. Hellman, *Original Drawings by the
Old Masters: The Collection formed by Joseph Green Cogswell
1786-1871* (New York: privately printed, 1915), no. 255,
pl. LX; D. Fitz Darby, "Ribera and the Wise Men,"
The Art Bulletin 44 (1962): 279-307.
EXHIBITIONS: Pomona College Art Gallery, Claremont,
California, *The Baroque*, 1966; Norman Mackenzie Art
Gallery, University of Saskatchewan, Regina,
Saskatchewan, *A Selection of Italian Drawings from North
American Collections*, exh. cat. by Walter Vitzthum, 1970,
no. 39, p. 50, repr. p. 143 (also Montreal Museum of Fine
Arts, 1970); The Art Museum, Princeton University,
Jusepe de Ribera, Prints and Drawings, exh. cat. by
Jonathan Brown, 1973, no. 16, p. 164, fig. 43,
p. 194 (also Fogg Art Museum, Harvard University,
1974); Los Angeles County Museum of Art, *Old Master
Drawings from American Collections*, exh. cat. by Ebria
Feinblatt, 1976, no. 222, p. 210, repr.; California Palace
of the Legion of Honor, The Fine Arts Museums of San
Francisco, *Masterworks from the Achenbach Foundation for
Graphic Arts*, 1981.

Jusepe de Ribera was one of the principal heirs to the
aesthetic legacy of Caravaggio. In Italy he was known as
Lo Spagnoletto, an appropriate nickname for he was born
a Spanish subject and remained one all his life. Almost
his entire career as a painter was spent in Naples, but
because many of his outstanding works were sent to
Spain he can be considered as important for Spanish art
as for Italian painting, and, indeed, he had a strong
influence on Zurbarán, Velázquez, and Murillo.

As the most illustrious painter working in Naples
during the first part of the seventeenth century, Ribera
advanced Caravaggio's generalized realism by staging
his own gripping, pictorial dramas, rich with the
dazzling dermal topography and texture revealed by

light falling on aged and suffering bodies. Certainly, he
was moved to paint poignantly what he saw of the flesh
as a way of communicating what he felt of the soul.

Unlike Caravaggio, by whom there are no known
drawings, Ribera was an active graphic artist who
created a small corpus of exciting, often eccentric prints
as well as a large number of drawings. Unfortunately,
his drawings were neglected for almost two centuries.
In the last twenty years, however, several scholars,
including Michael Mahoney and Jonathan Brown, have
done much to advance our knowledge about Ribera as
a draftsman. Brown prepared a very complete entry
on the Achenbach Foundation's *Study of a Man with
Upraised Hand*, one of eight Ribera drawings belonging
to The Fine Arts Museums.[1] Noting that it is "a
paradigmatic example of Ribera's pen style in the late
1620s" displaying his "unique graphic mannerisms,"
Brown judges the drawing "one of Ribera's most
spontaneous and witty creations in any medium."[2]

The viewer, perhaps expecting more finesse in a
seventeenth-century Italian drawing, must recall that
the Neapolitan tradition was one of spirited, tough
draftsmanship. This development is in large part a
result of Ribera's influence. The iron gall ink that he
employed helped to project a certain coarse bravura, but
it also has been responsible for the destruction of many
of his sheets over the centuries. Many of those extant
are in precarious condition because of the continuing
corrosive action of the acidic ink, and they require
proper conservation.

Walter Vitzthum suggested that *Study of a Man with
Upraised Hand* might be related to Ribera's portraits
of philosophers, but there is no conclusive evidence
to support the theory.[3] Whatever its intention might
have been, the gesture and assured gaze of the man
coincidentally recall those two commanding figures
of ancient sculpture, which the artist could not have
known, *L'Arringatore* (the Orator), an Etruscan bronze
found at Lake Trasimene and now in the Archaeological
Museum in Florence, and the Roman *Augustus of
Primaporta*, excavated in 1863 and now in the Vatican
Museums.

J. R. G.

Achenbach Foundation for Graphic Arts, 1963.24.615

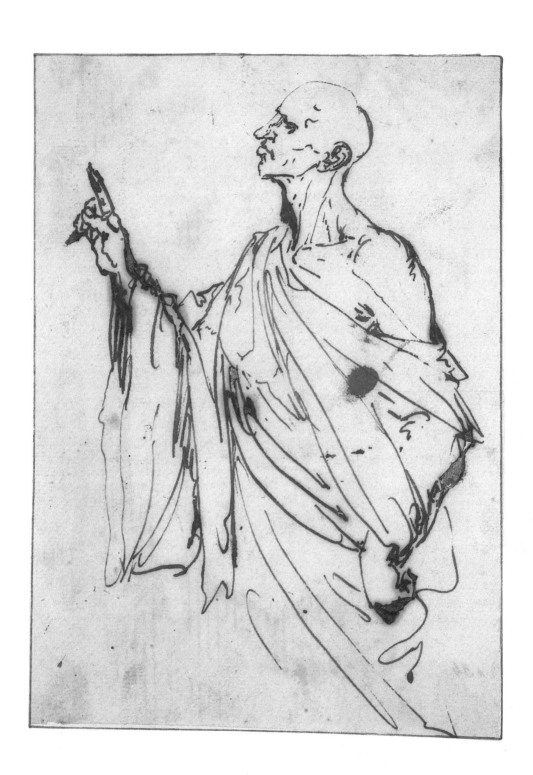

38. Jacques Callot *Nancy 1592-1635 Nancy*

Two Studies of a Standing Man, ca. 1621

Red chalk on laid paper; 3⅝ × 4⅝ in. (92 × 117 mm).
The collector's stamps at lower right of Sir Joshua
Reynolds (Lugt 2364) and Nathaniel Hone (Lugt 2793).
On verso in brown ink: *94*, and in red ink: *A 963*.

PROVENANCE: Sir Joshua Reynolds (Lugt 2364);
Nathaniel Hone (Lugt 2793); H. Shickman Gallery,
New York; Christian Humann, New York; Sven
Bruntjen, Woodside, California.
EXHIBITIONS: H. Shickman Gallery, New York, 1968,
no. 76; Museum of Art, Rhode Island School of Design,
Providence, *Jacques Callot, 1592-1635*, 1970, exh. cat.,
no. 60, repr.; California Palace of the Legion of Honor,
The Fine Arts Museums of San Francisco, *Recent
Acquisitions, Part I*, 1983.

A mere passage by a master can reveal its author as
indisputably as does a finished work. Though it over-
simplifies the challenge of attribution, this observation
can be demonstrated by considering works such as the
delightful little sketch by Jacques Callot in our
collection.

Though Callot's marvelous drawings are little known
in this country, his greatness as a printmaker is well
appreciated. Indeed, his reputation as a graphic artist
has never waned among *cognoscenti*, and during his
lifetime as well as afterward, his etchings of comic
characters and beggars have been among his most
popular prints. Examples of his beggar subjects were

even in the collection of Rembrandt who emulated them
in some of his own early prints. Callot worked in Rome
between 1608 and 1611 and was employed in Florence
between 1612 and 1620. These two centers provided
the artist with ample opportunity to observe the
idiosyncracies of individuals as well as the behavior and
movement of crowds. Eventually Callot's excellence
brought him employment by some of the great figures of
his period such as Cosimo II de Medici, Louis XIII of
France, and the Infanta Isabella of Spain.

The wonder of the Museums' drawing by Callot is its
success at animation, which is achieved by a few lines
and simple shading. The little man with a plumed cap
bends forward, his left hand held to his cheek in a
gesture of disbelief and his right arm bent at the elbow;
he may be wearing a mask. This is probably one of
thousands of such sketches, produced and originally
retained by the artist as a resource for composing his
prints. Certainly, it tells of its creator's facility and
visual intelligence as assuredly as a far more ambitious
work.

Undoubtedly associated with one of his many
celebrations of the *commedia dell'arte*, such as the *Three
Italian Comedians* of about 1618-1620 or the *Balli di
Sfessania*, after 1621, our little drawing was probably
executed either sometime before or shortly after Callot's
return to Nancy, France, in 1621.[1]

J. R. G.

Achenbach Foundation for Graphic Arts purchase, 1982.2.56

39. Circle of François Quesnel *Edinburgh 1543-1619 Paris*

Portrait of a Lady, ca. 1600

Black, red, and brown chalk on laid paper; 12 × 8¼ in.
(315 × 213 mm).

PROVENANCE: Archer M. Huntington; gift to the
California Palace of the Legion of Honor.
BIBLIOGRAPHY: Regina Shoolman and C. E. Slatkin,
Six Centuries of French Master Drawings in America (New
York: Oxford University Press, 1950), p. 16, pl. 9;
Phyllis Hattis, *Four Centuries of French Drawings* (San
Francisco: The Fine Arts Museums of San Francisco,
1977), no. 7, p. 45, repr. p. 46; Robert Flynn Johnson,
"Masterpieces of French Drawing," in Denys Sutton,
ed., "The Fine Arts Museums of San Francisco,"
Apollo (1980): 130-137, no. 1, repr. p. 130.
EXHIBITIONS: Mills College, Oakland, *Old Master
Drawings*, 1937, no. 18; Golden Gate International
Exposition, San Francisco, *Master Drawings*, 1940, no. 26,
repr.; California Palace of the Legion of Honor, San
Francisco, *Vanity Fair*, 1942, no. 25; The Denver Art
Museum, *Masterpieces of French Art from The Fine Arts
Museums of San Francisco*, checklist by Denys Sutton,
1978 (also Wildenstein & Co., New York, 1979; The
Minneapolis Institute of Arts, 1979); California Palace of
the Legion of Honor, The Fine Arts Museums of San
Francisco, *Masterworks from the Achenbach Foundation for
Graphic Arts*, 1981.

Early French portrait drawings present a host of
problems for the art historian and connoisseur, because
there is little documented material for constructing a
foundation of authentic examples by major artists for
comparison. Further complicating the task of attribution
is the standardized structure of these drawings. A rather
rigorous approach to delineating features and modeling
was taken by almost all the artists of a certain circle. To
the uninitiated it might even seem that the only major
change in the century between the activity of Jean

Clouet (ca. 1485-1541) and François Quesnel (1543-1619)
or Daniel Dumonstier (ca. 1574-1646) is one of costume.[1]

Today we realize that the major court artists were
surrounded and followed by other talents who per-
petuated their mode of presentation. It is, therefore, not
unlike the case of the royal portraits by Velázquez,
which were copied to produce versions for other
members of the king's extended family. Some of the
artists who produced these copies, such as Juan del
Mazo, were fine painters in their own right.

Portrait of a Lady in the collection of The Fine Arts
Museums illustrates the predicament of attributing a
French Court portrait. Early in this century the drawing
was thought to be a likeness of Gabrielle d'Estrées (1573-
1599), mistress of Henri IV, by Daniel Dumonstier.[2]
Subsequently, it was proposed that the likeness was that
of Marie de Medici (1573-1642), wife of Henri, and the
attribution was changed to François Pourbus the
Younger (1569-1622), Marie's court painter. Neither of
these attributions is secure, nor has the identification of
the sitter been established convincingly.

In her catalogue of the Museums' French drawings,
Phyllis Hattis broadly identified the artist as a follower
of Jean Clouet and further suggested the names of
François Quesnel the Elder (1543-1619) and Nicolas
Quesnel the Elder (?-1632) as possible authors of the
sheet.[3] Whoever the artist, Hattis's dating of the work
to about 1600 is certainly correct. But in accordance with
a commitment to that date, it would seem more
reasonable to place the drawing in the circle of the
Quesnels or of Dumonstier, who were active in the late
sixteenth and first decades of the seventeenth century.
This writer finds that the elongated eyes,
characterization of the mouth, soft modeling, and
stylized presentation of the sitter place the *Portrait of a
Lady* in the greater circle of François Quesnel.
J. R. G.

Gift of Archer M. Huntington, 1927.226

40. Edme Bouchardon *Chaumont-en-Bassigny 1698-1762 Paris*

Design for a Token for the Royal Treasury, 1737

Red chalk on laid paper; 8 × 8 in. round
(203 × 203 mm). Lettering in design: *DECET/ESSE/
PERENNEM/TRESOR ROYAL/1738.*

PROVENANCE: Adrian Ward-Jackson, London.
BIBLIOGRAPHY: H. Bouchot, "Bouchardon dessinateur
de médailles," *L'Art* 32 (1885): 214; A. Roserot,
"Edme Bouchardon, dessinateur," *Réunion des Sociétés
des Beaux-Arts des Départements* (1895): 588; F.
Mazerolles, "Les dessins de Médailles et de Jetons
attribués au sculpteur Edme Bouchardon," *Réunion des
Sociétés des Beaux-Arts des Départements* (1898): 349; A.
Roserot, "Edme Bouchardon, dessinateur," *Réunion des
Sociétés des Beaux-Arts des Départements* (1910): chap. 9;
Winslow Ames, "Bouchardon and Company," *Master
Drawings* no. 4 (1975): 379.
EXHIBITION: California Palace of the Legion of Honor,
The Fine Arts Museums of San Francisco, *Selected
Acquisitions, 1977-1979*, 1979-1980, checklist, no. 10.

Edme Bouchardon, one of the most renowned sculptors
of his age, was also an accomplished, prolific draftsman
and a designer of medals and tokens. Erwin Gradmann
has written that "Bouchardon was a sculptor who
rivalled Rodin in fertility as a draftsman. His pre-
liminary sketches, most of them in red chalk, clearly
reveal the Baroque force and profusion of ideas of this
master."[1] Bouchardon emphasized clarity in his
modeling through the use of sharply defined contours.
The austere beauty of his drawings led contemporary
connoisseurs such as Mariette and Cochin to consider
him "the best draughtsman of the century."[2] Today
the somewhat cool and analytical character of
Bouchardon's drawing is not appreciated as fully in an
age more attuned to the voluptuous eighteenth-century
draftsmanship of artists such as Boucher and Fragonard.

In 1736, Monsieur de Maurepas appointed Bouchardon
official designer of tokens and medals to the king. He
emained in this post until his death in 1762. The office
was worth 1,000 livres a year, and the holder had to
execute all commissions assigned to him. The subjects
(*corps de devise*) and their Latin mottos (*légendes*) were
selected by the Académie des Inscriptions et Belles-
Lettres, and the designs were subject to the academy's
confirmation and then final approval by the king.

For every major event of the reign, a commemorative
medal was designed and struck. The date, in Roman
numerals, referred to the time of the event rather than to
the date of the medals' execution, which was often
many years later. A more predictable but arduous task
was the creation of tokens (*jetons*). There were at least
ten projects a year for tokens, including le Trésor Royal,
les Parties Casuelles, la Chambre aux deniers, and
l'Extraordinaire des guerres. In addition, every magis-
trature of the Prévôté des Marchands de Paris was
entitled to a token. These had to be ready for distri-
bution on New Year's Day of the year inscribed
on the tokens in Arabic numerals. For example, our
study for the token for the Royal Treasury, dated 1738,
was drawn in 1737 and minted later that year. In creating
this design, Bouchardon referred to preparatory studies
for his sculptures of river gods for the fountain of the
Rue de Grenelle.[3] The allegorical meaning of the
inscription, DECET ESSE PERENNEM (may it flow
forever) is clear in its reference to the future fiscal well-
being of the monarchy.

In designing medals and tokens, Bouchardon was
plagued by overwork, repetitious commissions,
unwarranted revisions, and the necessity of dealing with
a restricted format. It is to his credit that most of these
designs display imagination and energy and that
they retain the supreme confidence of line that made
Bouchardon one of the great draftsmen of the eighteenth
century.

R. F. J.

Achenbach Foundation for Graphic Arts purchase, 1978.2.32

41. François Boucher *Paris 1703-1770 Paris*

Minerva, ca. 1754

Black chalk with white chalk heightening on thick textured tan laid paper; 14 × 7¾ in. (356 × 196 mm). Signed in brown ink at lower right: *f. Boucher*. Collector's stamp on verso of backing: Franz Pokorny (Lugt 788 and 2036).

PROVENANCE: Franz Pokorny, Vienna (Lugt 788 and 2036); Axel Beskow Galleries, Los Angeles; California Palace of the Legion of Honor purchase.
BIBLIOGRAPHY: Regina Shoolman and C. E. Slatkin, *Six Centuries of French Master Drawings in America* (New York: Oxford University Press, 1950), p. 62, pl. 35; Thomas C. Howe, *Handbook of the Collections, California Palace of the Legion of Honor* (San Francisco: California Palace of the Legion of Honor, 1960), p. 61, repr.; Pierre Rosenberg, *Mostra di disegni francesi da Callot a Ingres* (Florence: Olschki, 1968), no. 17, p. 10; Pierre Rosenberg, *French Master Drawings of the 17th and 18th Centuries in North American Collections* (Art Gallery of Ontario, 1972), p. 136; Alexandre Ananoff, *François Boucher (Peintures)*, with Daniel Wildenstein, 2 vols. (Lausanne and Paris: Bibliothèque des Arts, 1976), no. 431/3, fig. 1238; Phyllis Hattis, *Four Centuries of French Drawings* (San Francisco: The Fine Arts Museums of San Francisco, 1977), no. 32, p. 71, repr. p. 75.
EXHIBITIONS: American Federation of Arts, Monterey Peninsula Chapter, Carmel, *Third Annual Collectors' Show*, 1964, no. 5; California Palace of the Legion of Honor, San Francisco, *Old Master Drawings*, 1966; John and Mable Ringling Museum of Art, Sarasota, *Master Drawings*, 1967; Royal Academy, London, *France in the Eighteenth Century*, 1968, no. 97, fig. 144; National Gallery of Art, Washington, D.C., *François Boucher in North American Collections: 100 Drawings*, exh. cat. by R. S. Slatkin, 1973, no. 71 (also The Art Institute of Chicago, 1974); California Palace of the Legion of Honor, The Fine Arts Museums of San Francisco, *French 18th Century Drawings from the Permanent Collection*, 1977; idem, *European Drawings from the Achenbach Foundation for Graphic Arts*, 1979; idem, *Masterworks from the Achenbach Foundation for Graphic Arts*, 1981.

The depiction of the nude was a chief preoccupation of the great rococo artist François Boucher. At his worst, Boucher reduced the human body to a voluptuous but numbing uniformity, in the numerous allegorical and mythological compositions that were his forte. These nudes tend to be idealized artistic inventions, useful in Boucher's decorative formulae but ultimately devoid of eroticism or even vitality.

When Boucher chose to draw from life, however, the results were often startling in their vigorous execution and their sensuality. The freshly observed *Study of Minerva* is just such an example of Boucher's draftsmanship at its best. It was executed about 1754 as a study for the famous painting *The Judgment of Paris*. Along with *The Visit of Venus to Vulcan, Cupid and Captive*, and *Venus and Mars Surprised by Vulcan*, the painting formed a series on the loves of Venus. The paintings were commissioned for Louis XV; after his death Louis XVI had them removed because he considered them immoral.[1] The series is now in the Wallace Collection, London.

Although the figure in this drawing was a study for Minerva, the Goddess of Wisdom, Boucher has modeled her softly rounded form in a powerfully realistic manner. The broad, painterly use of black chalk with white heightening allowed the artist to concentrate on the internal modeling and weight rather than the exterior contour and shape of the figure. The baroque sensuality of the drawing and his penchant for back views of female nudes reveal Boucher's debt to the art of Peter Paul Rubens. Sir Kenneth Clark stated that "it was Rubens who inspired...Boucher. He was a master of the Baroque and the bottom is a Baroque form, harmonizing with the clouds and garlands of late-Baroque decoration. These decorative considerations certainly influenced Boucher and Fragonard when they so frequently depicted the nymphs of antiquity... lying on their fronts, and leaning their elbows on a cushion or convenient cloud...."[2]

Boucher unfortunately lived to see the virtuoso splendor of his art swept aside by changing fashion in the 1760s, a change that favored an art committed to moral principles. Nevertheless, in a keenly observed and unselfconscious drawing such as this, Boucher justified the praise of Edmond and Jules de Goncourt, who wrote that "he manages to give life and substance, on a mere sheet of paper, to the charms of the most delightful nudity."[3]

R. F. J.

James D. Phelan Bequest Fund, 1931.14

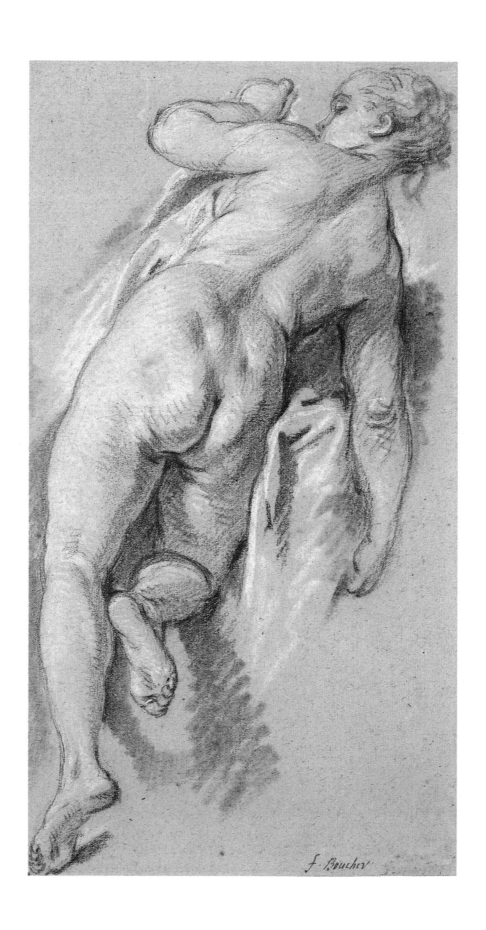

42. Jean-Honoré Fragonard *Grasse 1732-1806 Paris*

Artist in the Studio, ca. 1774

Red chalk on laid paper; 15⅛ × 19⅛ in.
(382 × 486 mm). Inscribed on mount in graphite at
lower left: *Boucher dans la Prison de St.-Lazare,* and at
lower right: *B.* Numerical notation on verso: no. *6/4/25f.*
Mountmaker's dry stamp in lower right corner
overlapping mount: FR (François Renaud; Lugt
Supplement 1042). Collector's stamp of Cailleux at
lower right.

PROVENANCE: François Renaud (Lugt Supplement
1042); Jacques Onésime Bergeret de Grandcourt; René
Fribourg; Sotheby's, London, 16 October 1963, no. 532;
Cailleux, Paris.
BIBLIOGRAPHY: Alexandre Ananoff, *L'œuvre dessiné de
Jean-Honoré Fragonard (1732-1806),* vol. 4 (Paris: F. de
Nobele, 1968), no. 1313, fig. 735; Jean-Luc Bordeaux,
"Un musée français en Californie", *Connaissance des arts*
299 (January 1977): repr. in reverse, p. 38; Phyllis
Hattis, *Four Centuries of French Drawings* (San Francisco:
The Fine Arts Museums of San Francisco, 1977), no. 51,
p. 92, repr. p. 95; Robert Flynn Johnson, "Masterpieces
of French Drawing," in Denys Sutton, ed., "The Fine
Arts Museums of San Francisco", *Apollo* (1980): 130-
137, no. 3, repr. p. 130.
EXHIBITIONS: Centre International de Paris, Galerie
Cailleux, Port Maillot, Paris, *VIIᵉ biennale internationale
des antiquaires,* 1974; National Gallery of Art,
Washington, D.C., *Drawings by Fragonard in North
American Collections,* exh. cat. by Eunice Williams, 1978,
no. 29, p. 86, repr. on cover (also Fogg Art Museum,
Harvard University, 1979; The Frick Collection, New
York, 1979); California Palace of the Legion of Honor,
The Fine Arts Museums of San Francisco, *Masterworks
from the Achenbach Foundation for Graphic Arts,* 1981.

No artist better represented the extravagant frivolity of
the Parisian demimonde at the end of the eighteenth
century than Jean-Honoré Fragonard. Of this enor-
mously talented, industrious artist working within a
society in fatal decline, John Canaday wrote, "There
was nothing Frago[nard] could not do, except rise
above the society of gallant caprice in which he moved
with such zest." [1]

Artist in the Studio is a stunning example of
Fragonard's draftsmanship and versatility. Its subject
matter differs from the artist's usual preference for park
scenes, mythological stories, and upper-class flirtations.
In its humble subject, economy of means, and warmth

of human feeling this drawing reveals Fragonard's debt
to Rembrandt, whose art he admired and occasionally
copied. This drawing has a complex composition with a
profusion of details, yet Fragonard's directness of
observation conveys a mood of relaxed intimacy. Eunice
Williams wrote of this drawing, "The contrast between
the completeness of the scene–an interior space with
consistent light source, a still-life of objects and simple
furnishings–and the broad, spontaneous manner of
sketching is typical of Fragonard's intelligent and
confident approach to chalk drawing in the 1770s." [2]

Because of an inscription on the lower edge of the
sheet, "Boucher dans la Prison de St.-Lazare," for
many years the subject of the drawing was thought to be
Boucher d'Argis, a lawyer and administrator who was
guillotined during the Revolution. This identification is
contradicted by the earlier stylistic dating of the drawing
and the fact that, as Jean Cailleux has pointed out,
d'Argis was imprisoned at l'Abbaye not Saint-Lazare. [3]
The drawing, in fact, appears to be a self-portrait of the
artist working in his studio. This identification is
confirmed by comparing the features and expression
with those of another self-portrait drawing in the
Hinzelin Collection, Paris (P. Lamy, "Le vrai visage de
Fragonard," *Bulletin de la Société de l'Histoire de l'Art
français,* 1960, pp. 79-81) and the fact that the artist is
drawing with his left hand. [4] The emotional rapport
between Fragonard and the woman in the drawing
points to her as his wife, Marie Anne Gérard, whom he
married in 1769.

In a cluttered studio containing a globe, pictures, and
bulging portfolios, Fragonard pauses from his drawing
to converse with his wife. In their slightly awkward
poses, Fragonard has movingly conveyed a scene of
unselfconscious domestic tranquility. The revelation of
self in this drawing is unexpected in an artist best known
for his artifice.

The provenance of this drawing lists several important
connoisseurs who were contemporaries of Fragonard.
They were François Renaud, a well-known mount-
maker and restorer, and Jacques Onésime Bergeret de
Grandcourt, a friend and patron of Fragonard who
sponsored the artist's second trip to Italy in 1773-1774.
In the twentieth century it was in the distinguished
collections of René Fribourg and Jean Cailleux.
R. F. J.

Achenbach Foundation for Graphic Arts purchase, 1975.2.13

43. Jean-Honoré Fragonard *Grasse 1732-1806 Paris*

Woman with a Parrot, 1780s

Counterproof from red chalk with graphite additions and brown ink reinforcement on laid paper; 13⅞ × 9⅛ in. (354 × 234 mm). Inscribed in same brown ink on verso at lower left: *Frago...D.* Mountmaker's dry stamp in lower right corner overlapping drawing and mount: FR (François Renaud; Lugt Supplement 1042). Collector's stamp at lower left corner of mount: J.P.H. (J.P. Heseltine, Lugt 1507).

PROVENANCE: François Renaud (Lugt Supplement 1042); F. R. Mailand sale, 4 April 1881, no. 58 (according to Heseltine collection catalogue, 1900); A. Piat sale, Hôtel Drouot, 22-24 February 1897, no. 650, listed as *La jeune femme à l'oiseau*, attributed to Fragonard; J. P. Heseltine, London (Lugt 1507); E. Gimpel and Wildenstein, New York, 1913; William H. Crocker, New York; Mrs. Henry Potter Russell; bequest to the California Palace of the Legion of Honor.

BIBLIOGRAPHY: R. Portalis, *Fragonard* (Paris, 1889), p. 305; *Drawings by François Boucher, Jean-Honoré Fragonard and Antoine Watteau in the Collection of. J.P.H.* [Heseltine] (London, 1900), no. 6, p. 43, repr.; Alexandre Ananoff, *L'œuvre dessiné de Jean-Honoré Fragonard (1732-1806)*, vol. 1 (Paris: F. de Nobele, 1961), no. 187, p. 99, fig. 73; Phyllis Hattis, *Four Centuries of French Drawings* (San Francisco: The Fine Arts Museums of San Francisco, 1977), no. 53, p. 93, repr. p. 97.

EXHIBITIONS: National Loan Exhibition, 1909-1910, London, no. 89; Galerie Georges Petit, Paris, *Catalogue de Dessins de l'Ecole française du dix-huitième siècle, provenant de la Collection Heseltine*, 1913, no. 34, p. 21, repr.; E. Gimpel and Wildenstein Gallery, New York, *Exhibition of Paintings and Drawings by Fragonard*, 1914, no. 30; National Gallery of Art, Washington, D.C., *Drawings by Fragonard in North American Collections*, exh. cat. by Eunice Williams, 1978, no. 55, p. 138, repr. (also Fogg Art Museum, Harvard University, Cambridge, 1979).

This beguiling work is a counterproof (French, *contre-épreuve*), an impression taken from a drawing by moistening a piece of paper, placing it against the drawing, and rolling the two through a press under considerable pressure. The result is that a mirror image of the chalk work is transferred to the moistened paper. There were several purposes to such a method. The most obvious was to make two drawings from one so that the artist could keep a version as a record; another was to provide two salable works. In any case, Fragonard appreciated the delicacy of these *contre-épreuves* and certainly gave some as gifts.

Because the monotype recently has been called the "painterly print," the related technique employed to make a counterproof might tempt one to refer to it as a "printerly drawing."[1] Both monotype and counterproof hover in an "intermedia" region, and each method produces unique, unrepeatable results.

On the basis of style and dress *Woman with a Parrot* has been dated to the 1780s, when the artist did many autobiographical and familial subjects. The bird, misidentified as a parakeet and a macaw in earlier literature, appears to be a cockatoo, for its erect crest is clearly indicated.[2] One might observe also that the tuft of hair that arcs from the young woman's head is treated almost as a decorative analogue to the avian crest. In the case of Fragonard, it probably would not be an overstatement to say that the artist intended to suggest a relationship or moral in juxtaposing perched bird and seated woman. Many of his works are rich in allegory, although usually of a base nature.

What is most significant about Fragonard's sanguines and their counterproofs is not their iconography but their consummate draftsmanship. No one better captured the freshness and allure of attractive young women. *Woman with a Parrot* as well as a number of similar figure studies—not to mention his memorable painted sketches—easily support this observation.[3]

J. R. G.

Bequest of Mrs. Henry Potter Russell, 1966.54

44. Maurice Quentin de La Tour *Saint-Quentin 1704-1788 Saint-Quentin*

Self-Portrait, ca. 1760

Pastel on laid paper; 18⅞ × 12⅞ in. (480 × 327 mm).
On cartouche on top of frame: *MATINÉES
LITTÉRAIRES de Mr H. BALLANDE / A Mr TALBOT /
Sociétaire de la Comédie Française / Souvenir Affectueux de
son / Quadruple Succès dans / Lisimon du glorieux 3, 9bre
1872 / Géronte du philosophe Marie 1 Dbr 1872 / Géronte du
Bourru Bienfaisant 22 Dbre 1872 / Ghrysale des Femmes
Savantes 29 Db 1872 / H. BALLANDE.*

PROVENANCE: André Seligmann, Paris, ca. 1928;
Mrs. Alexander Hamilton, Grace Hamilton Kelham and
Leila Hamilton Lewis.
BIBLIOGRAPHY: Phyllis Hattis, *Four Centuries of French
Drawings* (San Francisco: The Fine Arts Museums of
San Francisco, 1977), no. 74, p. 116, repr. p. 119; Robert
Flynn Johnson, "Masterpieces of French Drawing," in
Denys Sutton, ed., "The Fine Arts Museums of San
Francisco," *Apollo* (1980): 130-137, no. 2, repr. p. 130.
EXHIBITIONS: Art Galleries of the University of
California, Los Angeles, *California Collects: North and
South*, 1958, no. 19, repr. (also California Palace of the
Legion of Honor, San Francisco, 1958); California
Palace of the Legion of Honor, The Fine Arts Museums
of San Francisco, *Recent Acquisitions, 1977-1978*, 1978;
idem, *Selected Acquisitions, 1977-1979*, 1979-1980, checklist,
no. 36; idem, *Masterworks from the Achenbach Foundation
for Graphic Arts*, 1981.

Maurice Quentin de La Tour is considered the foremost
pastelist of the eighteenth century. From 1737 until 1773,
he exhibited successfully almost every year at the Salon
du Louvre. La Tour is credited with creating the vogue
for elegant pastel portraiture in which contemporaries
such as François Boucher, Jean-Etienne Liotard, Jean-
Baptiste Perroneau, and Jean-Baptiste-Simeon Chardin
also excelled.

La Tour's ability to capture a true likeness astounded
his sitters and made him the most sought-after portraitist
of his age. Among his subjects were nearly all the
important political, social, and artistic leaders from
Louis XV to Jean-Jacques Rousseau. La Tour balanced
his consummate skill in creating a surface of colorfully
elaborated detail with a subtle probing of the sitter's
character. The artist wrote, "They think that I only
seize upon their features, but without their knowing it,
I reach down into their very depths and grasp them in
their entirety." [1]

Nowhere is La Tour's ability to analyze character
better seen than in his numerous self-portraits, which he
made throughout his career. In our pastel, dated about
1760, the artist has portrayed himself in an engaging,
casual manner. La Tour smiles out at the viewer without
the refined pomposity and high finish that he reserved
for the portrait commissions that made him wealthy and
famous. The lower third of the composition is barely
suggested, but this should not imply that the work is
unfinished. The practice was not an unusual one in
the eighteenth century, and often La Tour intentionally
left his works in this state. In our pastel, it serves to
reinforce the relaxed self-confidence of the artist's
countenance.

This self-portrait is a variant of another work, *La
Tour: Vieux et riant* (Albert Besnard, *La Tour*, Paris,
1928, no. 252, fig. 8).[2] Although more highly finished
another comparable self-portrait, also dated about 1760,
shows the artist at a similar age to that of our sheet
(Geneviève Monnier, *Pastels XVIIᵉ et XVIIIᵉ siècles:
Inventaire des collections publiques françaises, 18, Musée du
Louvre, Cabinet des Dessins*, Paris, 1972, no. 79).[3]
R. F. J.

*Grace Spreckels Hamilton Collection, Bequest of Grace
Hamilton Kelham, 1978.2.13*

45. Hyacinthe Rigaud *Perpignan 1659-1743 Paris*

Sheet of Studies of Hands Playing Bagpipes and Torso View of Man Wearing Robe (study for "Portrait of Gaspard de Gueidan"), 1735

Black chalk with white chalk heightening on blue laid paper; 12 × 18 in. (305 × 458 mm). Inscribed on mount in black ink at lower left: *H. Rigaud.*

PROVENANCE: Cailleux, Paris; Mr. and Mrs. Sidney M. Ehrman; gift to the California Palace of the Legion of Honor.

BIBLIOGRAPHY: Agnes Mongan, "A Drawing by Rigaud," *Bulletin of the California Palace of the Legion of Honor*, no. 10 (1954): n.p.; Thomas C. Howe and James I. Rambo, "Acquisitions from the Ehrman Fund," *Bulletin of the California Palace of the Legion of Honor*, no. 8 (1959): n.p.; Thomas C. Howe, *Handbook of the Collections, California Palace of the Legion of Honor*, 1960, repr. p. 56; Phyllis Hattis, *Four Centuries of French Drawings*, (San Francisco: The Fine Arts Museums of San Francisco, 1977), no. 108, p. 149, repr. p. 151 and cover; Robert Flynn Johnson, "Masterpieces of French Drawing," in Denys Sutton, ed., "The Fine Arts Museums of San Francisco," *Apollo* (1980): 130-137; no. 6, repr. p. 133.

EXHIBITIONS: The Nelson Gallery-Atkins Museum, Kansas City, *The Century of Mozart*, 1956, no. 114, repr.; The University of Minnesota Art Gallery, Minneapolis, *The 18th Century: 100 Drawings by 100 Artists*, 1961, no. 78; California Palace of the Legion of Honor, San Francisco, *Old Master Drawings*, 1966; John and Mable Ringling Museum of Art, Sarasota, *Master Drawings*, 1967; University Art Museum, Berkeley, *Master Drawings from California Collections*, Juergen Schulz, ed., 1968, no. 16, p. 27, pl. 93; Art Gallery of Ontario, Toronto, *French Master Drawings of the 17th and 18th Centuries in North American Collections*, exh. cat. by Pierre Rosenberg, 1972, no. 123, pp. 203-204, repr. (also National Gallery of Canada, Ottawa, 1972; California Palace of the Legion of Honor, The Fine Arts Museums of San Francisco, 1973; New York Cultural Center, New York, 1973); University Art Museum, Berkeley, *Master Drawings: Materials and Methods*, 1972; California Palace of the Legion of Honor, The Fine Arts Museums of San Francisco, *French Eighteenth-Century Drawings from the Permanent Collection*, 1977; idem, *Masterworks from the Achenbach Foundation for Graphic Arts*, 1981.

Awarded the *Prix de Rome* in 1682 at the age of twenty-three, Hyacinthe Rigaud was a young virtuoso eager for fame. He did not travel to Rome for study, as would have been the normal course, but followed the advice of Charles Le Brun instead and remained in Paris. Within six years he had begun to develop an aristocratic clientele, and in 1694 and 1701 he was allowed to paint Louis XIV. The later portrait of the *Roi Soleil* made Rigaud's reputation, and the painting came to represent the king just as its splendid technique and taste for opulent effects assured the artist of a grand career.

A product of the last stage of his career is the portrait of Gaspard de Gueidan, President of the Parliament of Provence, playing the bagpipe. This amusing painting of an ennobled magistrate, signed and dated 1735 and now in the museum at Aix-en-Provence, is of particular interest. As Rigaud's account book reveals, it is entirely by the artist rather than, as was far more common, largely the product of his able assistants. The drawing in our collection is preparatory to this work, and thus with absolute confidence it can be attributed to Rigaud. But this masterpiece of French draftsmanship would be a remarkable achievement even if its attribution were not so unusually secure, for it is a rare and stunning example of perfection in a common medium.

It is hard to trace the origin of the black and white chalk drawing on blue paper to a specific artist, but almost certainly the practice was born in Italy during the early sixteenth century and was used by Northern Renaissance artists as well. The alluring quality of softness and the special mystery that characterizes the finest of such drawings is manifest in Rigaud's masterful sheet. One must also note, however, that the finesse with which he models his forms is uniquely French, and this drawing is one of those special works that can be said to best fulfill the promise of an artist as well as a medium.

J. R. G.

Gift of Mr. and Mrs. Sidney M. Ehrman, 1953.34

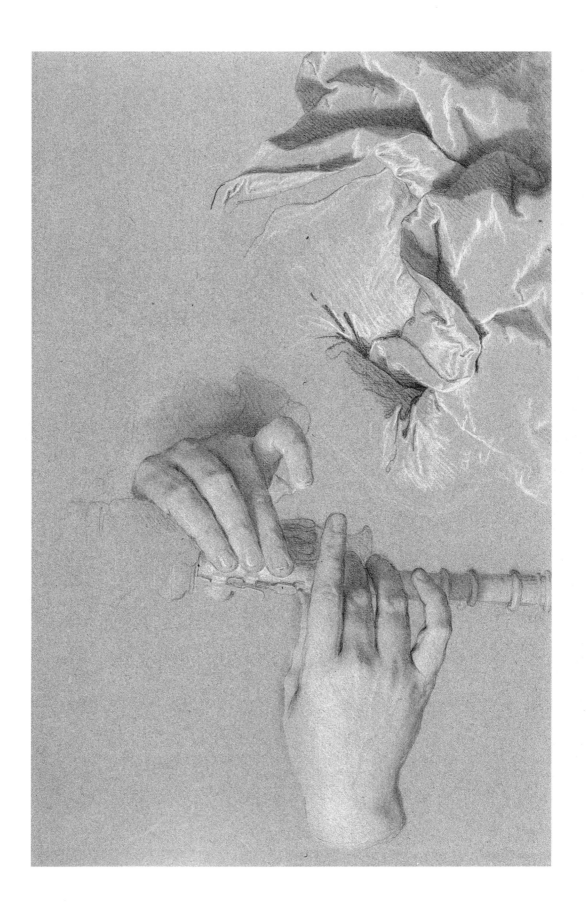

46. Gabriel de Saint-Aubin *Paris 1724-1780 Paris*

Theater Scene (Ernelinde, Princess of Norway), 1767

Watercolor and gouache over pen and black and brown ink and traces of graphite on laid paper; 8¼ × 10⅞ in. (209 × 275 mm). Cropped inscription with date in brown ink, superimposed over one another at lower left: *...filidor... 7bre 1767.*

PROVENANCE: D. David-Weill, Paris; Georges de Batz Collection.

BIBLIOGRAPHY: Gabriel Henriot, *Collection David Weill*, vol. 2 (Paris: Braun & Cie, 1926-1928), pp. 191, 193, repr.; Emile Dacier, *Gabriel de Saint-Aubin*, vol. 2 (Paris, 1931), no. 788 (scène de tragédie); Phyllis Hattis, *Four Centuries of French Drawings* (San Francisco: The Fine Arts Museums of San Francisco, 1977), no. 115, p. 155, repr. p. 162; Robert Flynn Johnson, "Masterpieces of French Drawing," in Denys Sutton, ed., "The Fine Arts Museums of San Francisco," *Apollo* (1980): 130-137, no. 5, repr. p. 132.

EXHIBITIONS: Museum of Fine Arts, Boston, *Chinese Ceramics and European Drawings... in the Home of Georges de Batz...*, 1953, no. 109, repr.; California Palace of the Legion of Honor, San Francisco, *De Batz Collection: Old Master Drawings*, 1968; Art Gallery of Ontario, Toronto, *French Master Drawings of the 17th and 18th Centuries in North American Collections*, 1972, exh. cat. by Pierre Rosenberg, no. 131, pl. 105 (also National Gallery of Canada, Ottawa, 1972; California Palace of the Legion of Honor, The Fine Arts Museums of San Francisco, 1973; New York Cultural Center, New York, 1973); The Denver Art Museum, *Masterpieces of French Art from The Fine Arts Museums of San Francisco*, checklist intro. by Denys Sutton, 1978 (also Wildenstein & Co., New York, 1979; The Minneapolis Institute of Arts, 1979); California Palace of the Legion of Honor, The Fine Arts Museums of San Francisco, *Masterworks from the Achenbach Foundation for Graphic Arts*, 1981.

When confronted with the work of a so-called *petit maître* such as Gabriel de Saint-Aubin, one is truly given to wonder about the appropriateness of the qualification "petit." Much conventional assessment depends on the popularity or rank of an artist's preferred medium rather than on his achievement in that medium. Saint-Aubin was naturally inclined toward graphic art. He rarely painted and apparently never mastered the technical rudiments of the oil medium well enough to create works that were acceptable to the arbiters of painting during the *ancien régime*. Because of his temperamental preference for drawing over painting, an inclination altogether baffling to his peers, Gabriel de Saint-Aubin was essentially ignored by his contemporaries. When his talent was acknowledged, it was the excess of his virtue that was cited, in a comment such as Greuze's that "he had a priapism of drawing."[1]

Since the time of the Goncourt brothers in the nineteenth century, however, the historical and aesthetic value of the artist's work has been discussed, and today it would seem accurate to claim that Saint-Aubin's drawings give us as brilliant a picture of eighteenth-century France as the paintings of Boucher and Fragonard. Certainly, a far less idealized impression of his subjects is gained from the sketches of Saint-Aubin. He has provided us with the "outtakes" of his age. These views of plays, auctions, meetings, feasts, and intimate conversations are convincing glimpses of the events depicted. The rapid but consummate compositions pulsate with activity of every kind and sparkle with an obvious delight in the application of color.

Our drawing of a performance was classified by Dacier as an unidentified theater scene.[2] This was caused by problems in deciphering the inscription at the lower left of the sheet. More recently, reading a portion of the inscription as *filidor* and the cropped date as *7bre 1767*, Phyllis Hattis has convincingly identified the subject of the drawing as a scene from *Ernelinde, Princess of Norway*, an obscure three-act tragic opera with music by Philidor.[3] The moment depicted is probably from act III, scene 4, when the leader of the rebels King Rodoald is hurled into the fire of the sacrificial altar. The artist has conveyed the action with great success. And despite his refusal to be preoccupied with detail, Saint-Aubin, like other great draftsmen, achieves the illusion of detail. We can easily detect the triumphant Ernelinde, with clasped hands and attended by two women, as Sandomir, his dagger raised to attack, confronts the enemy. The action takes place before a large monument, probably a cenotaph, and sailing ships lie at anchor in the right distance.

J. R. G.

Achenbach Foundation for Graphic Arts purchase, Georges de Batz Collection, 1967.17.5

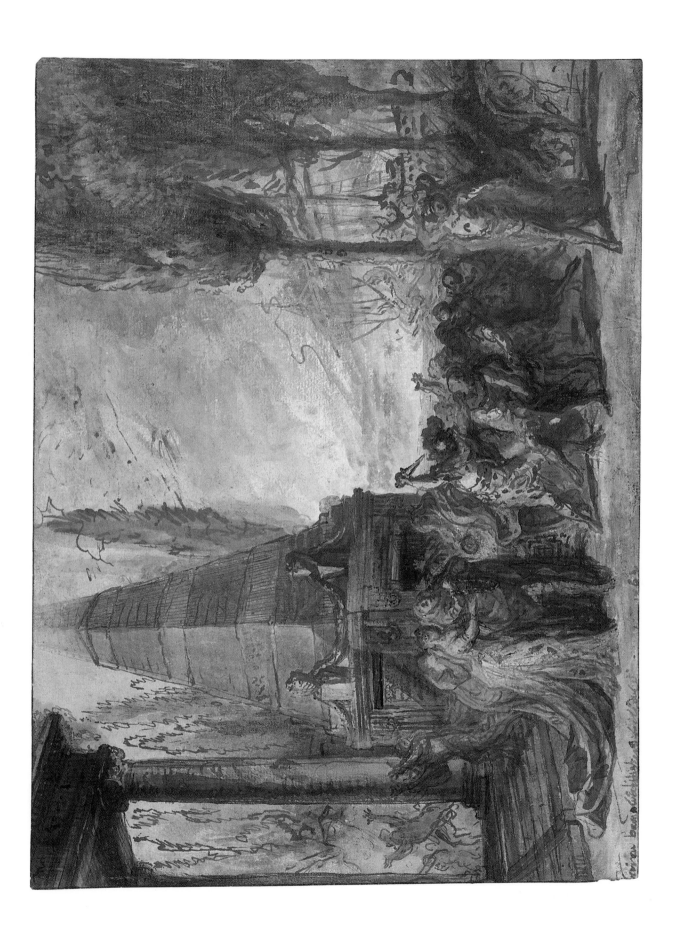

47. Gabriel de Saint-Aubin *Paris 1724-1780 Paris*

A Parisian Fête (L'enlèvement), 1760s
Verso: Landscape with Architectural Ruins

Ink, watercolor, and gouache with traces of charcoal on laid paper; 7⅞ × 5⅜ in. (199 × 135 mm).

PROVENANCE: C.-P., Marquis de Chennevieres (1820-1899), Paris (undocumented); D. David-Weill, Paris; Sturges (according to Slatkin); Georges de Batz Collection.

BIBLIOGRAPHY: Gabriel Henriot, *Collection David-Weill*, vol. 2 (Paris: Braun & Cie, 1926-1928), pp. 187, 189, repr.; Emile Dacier, *Gabriel de Saint-Aubin*, vol. 2 (Paris, 1931), no. 723, pl. 26; Phyllis Hattis, *Four Centuries of French Drawings* (San Francisco: The Fine Arts Museums of San Francisco, 1977), no. 116, p. 155, repr. p. 163.

EXHIBITIONS: Carnegie Institute of Art, Pittsburgh, *French Painting 1100-1900*, 1951, no. 145, repr. (also Toledo Museum of Art, 1951); Museum of Fine Arts, Boston, *Chinese Ceramics and European Drawings... in the Home of Georges de Batz*, 1953, no. 108, repr.; California Palace of the Legion of Honor, San Francisco, *De Batz Collection: Old Master Drawings*, 1968; Art Gallery of Ontario, Toronto, *French Master Drawings of the 17th and 18th Centuries in North American Collections*, 1972, exh. cat. by Pierre Rosenberg, no. 132, p. 209, pl. 12 (also National Gallery of Canada, Ottawa, 1972; California Palace of the Legion of Honor, The Fine Arts Museums of San Francisco, 1973; New York Cultural Center, New York, 1973); California Palace of the Legion of Honor, The Fine Arts Museums of San Francisco, *French Eighteenth-Century Drawings from the Permanent Collection*, 1977; The Denver Art Museum, *Masterpieces of French Art from The Fine Arts Museums of San Francisco*, checklist by Denys Sutton, 1978 (also Wildenstein & Co., New York, 1979; The Minneapolis Institute of Arts, 1979).

After Gabriel de Saint-Aubin's death, his brother Charles-Germain blandly wrote, "Full of erudition, he [Gabriel] failed to fulfill his talent although he drew all the time and everywhere. Eccentric, unsociable, and untidy, it was fortunate that he remained a bachelor... He left a number of drawings in poor conditions."[1] In the light of this appallingly indifferent testimony, it is particularly instructive to look at some of those wonderful sheets drawn "all the time and everywhere." At the very least, their superlative linear summation of an event as well as their lyrical use of color should alert us to the blinding unfairness of aesthetic prejudice that judged them graphic trash.

Like *Theater Scene* (cat. no. 46), the frolicsome episode depicted in *A Parisian Fête* is an excellent example of Saint-Aubin's gift for observation and drawing. An amused young woman is lifted over a balustrade into a musician's gallery, aided by the crowd below. Her apparent enjoyment of the activity, and the crowd's participation, makes one wonder about the appropriateness of the title of *L'enlèvement* (the abduction) recently given to the work by Rosenberg.[2] It hardly appears to be an abduction, at least not in the sense of an unwilling removal or kidnapping.

J. R. G.

Achenbach Foundation for Graphic Arts purchase, Georges de Batz Collection, 1967.17.6

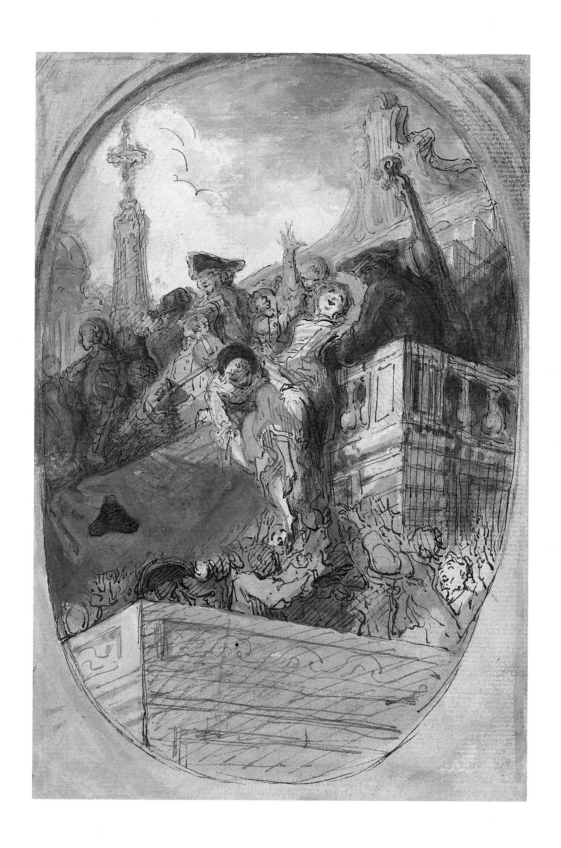

48. Gabriel de Saint-Aubin *Paris 1724-1780 Paris* or
Augustin de Saint-Aubin *Paris 1736-1807 Paris*
The Musical Duo, ca. 1772

Watercolor and gouache, with gum glaze additions, and brown and black ink, over graphite underdrawing on laid paper; 3⅞ × 6¼ in. (100 × 160 mm).

PROVENANCE: Comte de la Béraudière, Paris; M^me Salvator Mayer; A. Bremont, London, 1916; Earl of Carnarvon; Sotheby's, London, 22 March 1923, no. 132; Thos. Agnew & Sons Ltd., London; Walter S.M. Burns; Burns Sale, Sotheby's, London, 6 May 1926, lot 6; Irwin Laughlin, Washington, D.C.; Georges de Batz Collection.
BIBLIOGRAPHY: Phyllis Hattis, *Four Centuries of French Drawings* (San Francisco: The Fine Arts Museums of San Francisco, 1977), no. 119, p. 156, repr. p. 165.
EXHIBITIONS: Burlington Fine Arts Club, London, *French Eighteenth Century Art*, 1913, no. 63, p. 58, pl. 35; M. Knoedler & Co., New York, 1959, *Great Master Drawings of Seven Centuries*, no. 54, pp. 62-63, repr.; California Palace of the Legion of Honor, San Francisco, *De Batz Collection: Old Master Drawings*, 1968.

Dacier did not include *The Musical Duo* in his catalogue of Gabriel de Saint-Aubin's works, and though it remains difficult to attribute this sparkling little sheet to Gabriel with certainty, it is without question by one of the Saint-Aubin family.[1] All seven children were artists or artisans and Gabriel's brother Augustin, in particular, was able to come very close to the style of Gabriel. Frequently, too, the brothers drew side by side, sketching the same subject. Thus the fact that the drawing is a jewel-like creation and successfully conveys a sense of intimacy does not guarantee Gabriel's authorship.

It is the unusual opacity of treatment, obscuring the frequently telltale linear passages, that presents the major difficulty in ascribing this drawing to Gabriel with confidence. And, although the composition effectively dramatizes the musicians in the act of playing, it lacks some of the graphic activity and compositional clutter one expects of Gabriel. An examination of the sheet, including the chair on the left and the wedge of carpet along the bottom, suggests that it may have been cut down somewhat, but even if that were the case the passage remaining is certainly the principal one. Given all of this, along with the knowledge that Augustin was capable of superb work, one must not exclude the possibility that this magical miniature is one of his best.

The delightful moment captured in this drawing is enhanced by details such as the pianist's lifted left hand, poised to resume its accompaniment, and the violinist's pose of relaxed concentration. Both subject and setting are reminiscent of the compositions of Louis de Carmontelle and Jean-Baptiste Mallet. Unlike these exponents of the intimate *en famille* scene, who suffused their compositions with an almost even light, Gabriel de Saint-Aubin and occasionally his brother Augustin were devoted to preserving the selective lighting of the earlier Baroque. Thus all the gestures delineated in *The Musical Duo* are heightened by a dramatic chiaroscuro.

J. R. G.

Achenbach Foundation for Graphic Arts purchase, Georges de Batz Collection, 1967.17.108

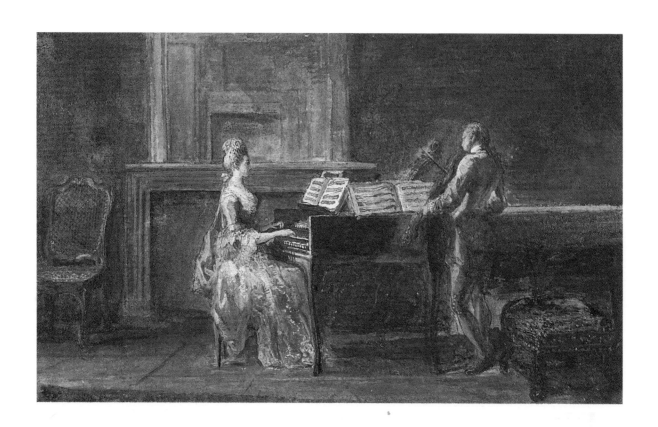

49. (Jean) Antoine Watteau *Valenciennes 1684-1721 Nogent-sur-Marne*

Concert champêtre (Venetian Landscape), ca. 1715

Red chalk on laid paper; 8¾ × 12 in. (223 × 304 mm).
Collector's stamp at lower right: Cailleux.

PROVENANCE: H. Leroux, Versailles, 1957; Cailleux,
Paris.
BIBLIOGRAPHY: K.T. Parker and J. Mathey, *Antoine
Watteau: Catalogue complet de son œuvre dessiné*, vol. 1
(Paris: F. de Nobele, 1957), no. 436, p. 58; Phyllis
Hattis, *Four Centuries of French Drawings* (San Francisco:
The Fine Arts Museums of San Francisco, 1977),
no. 183, p. 206, repr. p. 210.
EXHIBITIONS: Galerie des Beaux-Arts, Bordeaux, *L'art
et la musique*, 1969, no. 154; The Metropolitan Museum of
Art, New York, *Grand Gallery*, 1974; California Palace of
the Legion of Honor, The Fine Arts Museums of San
Francisco, *European Drawings from the Achenbach
Foundation for Graphic Arts*, 1979.

In his important study of Antoine Watteau as a
draftsman, K.T. Parker wrote that "the life of this man
was one of the briefest in which any great artist has
achieved immortality."[1] Indeed, Watteau so influenced
French painting and drawing of his century that it is
inconceivable to examine the art of the period without
considering his contribution first and foremost. Yet
Watteau's early personal life was undistinguished for its
artistic accomplishment and tragic in terms of his
health.[2] It is reported that his personality could be
offensive, though the eminent Count Caylus described
Watteau's traits as "agreeable, tender, and even a little
Arcadian."[3]

Exactly what Caylus meant by "Arcadian" is
unclear, but like some sixteenth-century Venetians,
Watteau made the dreamlike grove or pastoral setting a
specialty. It seems possible, therefore, that Caylus's
term "Arcadian" might imply an inclination toward
detachment or naiveté. Then again, it may have been
intended to suggest a *joie de vivre* bordering on the
irresponsible.

The *Concert champêtre* in the collection of The Fine
Arts Museums is a perfect example of Watteau's
derivative pastoral renderings. Like other drawings of
this type by the artist, it was either wholly or largely
inspired by Venetian drawings and paintings.[4] As
Rubens and Rembrandt copied from admired masters as
well as from nature, so Watteau did not hesitate to draw
from revered examples of the past, especially the works
of Rubens and the Venetians.

An engraving of 1517 by Giulio and Domenico
Campagnola entitled *Shepherds in a Landscape* may be the
main source for the Museums' drawing.[5] However,
landscape drawings by the Campagnolas were to be
found in Pierre Crozat's vast holdings to which Watteau
had access as well as in other collections. A pen and ink
drawing by Domenico in the collection of The Fine
Arts Museums (see cat. no. 8) is exactly the kind of
work that would have interested Watteau. There
were, therefore, many possible sources for the artist's
inspiration, and certainly he was sufficiently inventive
to alter and combine elements to suit his pleasure.
J. R. G.

Achenbach Foundation for Graphic Arts purchase, 1975.2.14

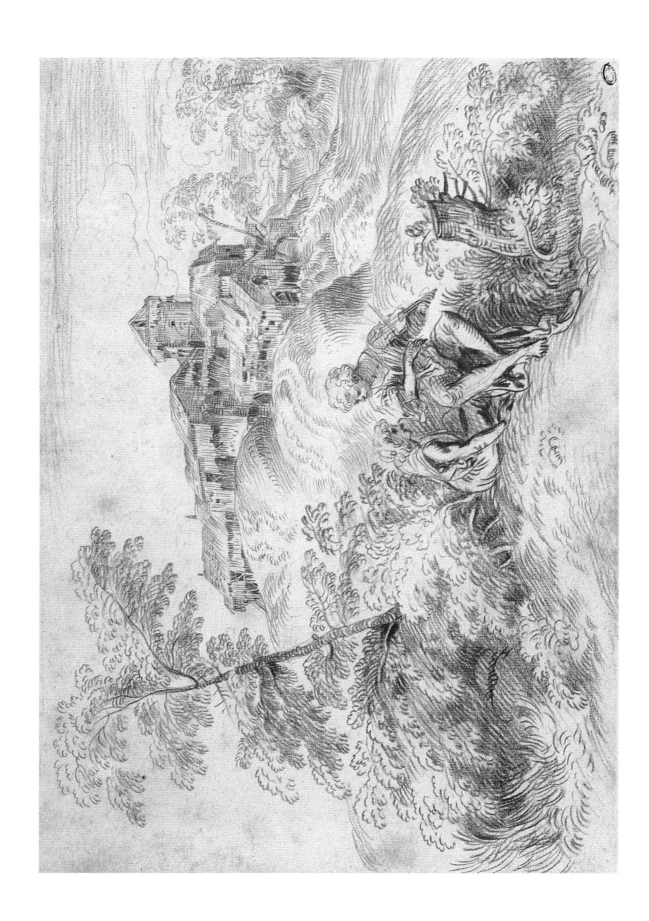

50. Edmond-François Aman-Jean *Chevry-Cossigny 1860-1935 Paris*

Les confidences, ca. 1898

Pastel on blue-gray paper affixed to canvas; 48 × 38 in. (1220 × 965 mm). Signed in brown pastel at lower right: *Aman Jean.*

PROVENANCE: Dr. François Aman-Jean (son of the artist), Essomes-sur-Marne; Lady Jane Abdy, London; Thackrey and Robertson Gallery, San Francisco; Achenbach Foundation for Graphic Arts purchase.
BIBLIOGRAPHY: *Art et Décoration*, 1902 (no further documentation).
EXHIBITIONS: Musée des Arts Décoratifs, Paris, *Souvenir d'Aman-Jean*, 1970; Grand Palais, Paris, *Visionnaires et Intimistes en 1900*, 1973; *Edmond Aman-Jean*, exh. cat. (London: Ferrers Gallery, 1975), no. 4, p. 11, repr.; Thackrey and Robertson Gallery, San Francisco, *Important Art Nouveau and Symbolist Paintings and Drawings from the Collection of Lady Abdy*, 1976; California Palace of the Legion of Honor, The Fine Arts Museums of San Francisco, *Recent Acquisitions 1976-1977*, 1977; idem, *Nineteenth Century French Drawings from the Permanent Collection*, 1978; idem, *Masterworks from the Achenbach Foundation for Graphic Arts*, 1981.

During much of the twentieth century Edmond-François Aman-Jean has been better known as the artist who posed for a celebrated portrait drawing by his friend Georges Seurat, now in The Metropolitan Museum of Art, than for his own considerable artistic accomplishments.[1] Serious reappraisal of French symbolist painting over the past twenty years has rescued Aman-Jean's art from its undeserved obscurity.

Enrolled as a student of Henri Lehmann at the Ecole des Beaux-Arts in 1880, Aman-Jean met and became a close friend of the great pointillist painter Georges Seurat. They even shared a studio for a time, and Seurat's famous portrait drawing of his friend was well received when shown at the Salon of 1883. In 1884, Aman-Jean exhibited his own work at the Salon, and he also worked with Puvis de Chavannes on the large painting *Le bois sacré*, shown at the Salon that year. In 1892 and 1893, Aman-Jean exhibited in the first two Salons de la Rose + Croix, which established Symbolism as a major art movement of the time.
Among his friends were many symbolist poets, notably Mallarmé, Peladan, and Verlaine.

His art shows clear symbolist overtones in its subject matter—beautiful, introspective women predominate—and in its titles, such as *Perfume, Sous les fleurs, La robe rose*.[2] In addition to his skill as a painter, Aman-Jean was an accomplished lithographer. His prints were issued by such publications as *L'Artiste* and *L'Estampe Moderne*. An important aspect of his art, the prints did much to widen his reputation.

As a result of a trip to Italy in 1895, Aman-Jean increasingly turned to a brighter, less moody palette in his works, a palette better attuned to the pastel medium. In *Les confidences*, the softness of the pastel drawing and the subtlety of coloration create a mood of reverie that is the hallmark of Aman-Jean's best work. The placement of the two women forms a rhythmic composition of relaxed intimacy and implied narrative. This large, highly finished pastel is surely one of Aman-Jean's masterpieces.

R. F. J.

Mildred Anna Williams Fund, 1976.7

51. Louis-Léopold Boilly *La Bassée 1761-1845 Paris*

Study for "La vaccine," ca. 1807

Black chalk with white chalk heightening on wove paper; 15¾ × 11¼ in. (401 × 285 mm).

PROVENANCE: Madame R..., at her sale, Galerie Georges Petit, Paris, 14 February 1921, no. 153; George B. Lasquin, at his sale, Galerie Georges Petit, Paris, 7-8 June 1928, no. 11, repr.; Richard M. C. Livingston Estate; Jacques Seligmann & Co., New York; Georges de Batz Collection, San Francisco, 1951.
BIBLIOGRAPHY: Henry Harrisse, *L.-L. Boilly—Peintre, dessinateur et lithographe: Sa vie et son œuvre, 1761-1845,* Paris, 1898, probably no. 1188; Phyllis Hattis, *Four Centuries of French Drawings* (San Francisco: The Fine Arts Museums of San Francisco, 1977), no. 199, p. 223, repr. p. 228; Robert Flynn Johnson, "Masterpieces of French Drawing," in Denys Sutton, ed., "The Fine Arts Museums of San Francisco," *Apollo* (1980): 130-137, no. 7, repr. p. 133.
EXHIBITIONS: Musée Carnavalet, Paris, *La vie parisienne au XVIIIᵉ siècle,* 1928, no. 114; Museum of Fine Arts, Boston, *Chinese Ceramics and European Drawings... in the home of Georges de Batz...,* 1953, no. 123, repr.; California Palace of the Legion of Honor, San Francisco, *De Batz Collection: Old Master Drawings,* 1968; Art Gallery of Ontario, Toronto, *French Master Drawings of the 17th and 18th Centuries in North American Collections,* exh. cat. by Pierre Rosenberg, 1972, no. 7, pl. 141 (also National Gallery of Canada, Ottawa, 1972; California Palace of the Legion of Honor, The Fine Arts Museums of San Francisco, 1973; New York Cultural Center, New York, 1973); California Palace of the Legion of Honor, The Fine Arts Museums of San Francisco, *Nineteenth Century French Drawings from the Permanent Collection,* 1978.

Boilly was an artist's artist. Even if one no longer empathizes with his subjects, selected from the life of Empire Paris, it is hard to remain unmoved by his sensitive command of media, his exquisite orchestration of color, and his frequent success at striking composition.

Boilly came to Paris for the first time in 1785, and he remained there permanently. During the Revolution he was denounced to the *Comité de Salut Public* as a painter of immoral subjects, but he preserved his head by painting a *Triumph de Marat.*

The artist's charm and ability as a draftsman are well shown in the Museums' two drawings, *Study for "La vaccine"* and *Portrait Studies* (cat. no. 52). The former sheet is a study for the right-hand portion of the painting *La vaccine* (also called *Le préjugé vaincu*) of about 1807 and indicates the care that the artist expended in developing his ambitious, painted compositions.[1] Set in a busy physician's office, the ambiance reflects Boilly's enjoyment of crowds as fitting subjects for the painter. In the Museums' preparatory drawing for the painting, the artist has studied composition, gesture, and fabric, and this beautiful, isolated passage stands on its own because of his fine draftsmanship. Boilly's style of drawing is firmly rooted in eighteenth-century French precedent, his grouping and manner of modeling particularly reminiscent of Greuze and Prud'hon respectively.

Vaccination or deliberate infection with strains of smallpox had been introduced in the 1720s by Lady Mary Whortly Montague. In 1798, Edward Jenner, an English country physician, demonstrated that cowpox, a much milder disease, could confer immunity against the deadly smallpox.[2] This cowpox vaccination technique was soon practiced on the continent. In fearful anticipation of the simple procedure, the elder child clings to her mother in Boilly's delightful anecdotal sketch.

J. R. G.

Achenbach Foundation for Graphic Arts purchase, Georges de Batz Collection, 1967.17.3

52. Louis-Léopold Boilly *La Bassée 1761-1845 Paris*

Portrait Studies, ca. 1795

Black, white, and brown chalk on blue-green wove paper, faded to brown; 16 × 18½ in. (406 × 469 mm).

PROVENANCE: Georges de Batz Collection, San Francisco, 1967, reputedly bought from the Boilly family.
BIBLIOGRAPHY: Phyllis Hattis, *Four Centuries of French Drawings* (San Francisco: The Fine Arts Museums of San Francisco, 1977), no. 200, p. 224, repr. p. 229.
EXHIBITIONS: California Palace of the Legion of Honor, San Francisco, *De Batz Collection: Old Master Drawings*, 1968; idem, *Nineteenth Century French Drawings from the Permanent Collection*, 1978; idem, *Masterworks from the Achenbach Foundation for Graphic Arts*, 1981.

Interest in Boilly's work has been revived recently with the appearance of several of his major paintings on the art market and by an audience increasingly receptive to the beauties of the best Empire painting. The most frequently seen pieces by the artist have been small, painted bust portraits of men, women, and children. These are often notable for their austerity of pose, relieved pictorially by judiciously positioned passages of rich color. Thus a waistcoat, scarf, or lapel flower is used to heighten the presentation of carefully observed physiognomy. In effect, these beautiful small portraits are like miniatures inspired by the grand and refined single portraits painted by Jacques-Louis David.

In a similar way, Boilly's drawn portraits reflect a strong eighteenth-century tradition of sensuously modeled heads, often created on colored paper for dramatic contrast. In terms of the tradition of compositions with multiple heads, one thinks immediately of Antoine Watteau whose *trois crayons* and sanguine studies rank among the high achievements of portrait draftsmanship.

Boilly's *Portrait Studies* in the collection of The Fine Arts Museums offers a striking if unintentional tribute to the portrait-head arrangements of Watteau. The specificity of characterization in this drawing also contrasts markedly with the more generalized rendering of heads in *Study for "La vaccine"* (cat. no. 51). Phyllis Hattis has discussed the identification of the various portraits and suggests that the first two heads in the top row are the artist's son Felix and his daughter (name unrecorded) from his first marriage of 1787.[1] Hattis also identifies the handsome head on the extreme right as that of the great sculptor Jean-Antoine Houdon. She postulates that the lower row (left to right) includes the miniaturist, Marie-Gabrielle Capet (1761-1817), one of Boilly's other sons, Marie Simon (b. 1792) or Julien (d. 1804), and finally the sculptor Augustin Pajou. On the basis of the costumes, Hattis proposes a date of 1795.

We may never be certain about the identities of these sitters, but the unmistakable chalk style and compelling characterizations provide positive identification of the hand of Louis-Léopold Boilly, a superb and sensitive draftsman who was probably collecting memories for his own pleasure.

J. R. G.

Achenbach Foundation for Graphic Arts purchase, Georges de Batz Collection, 1967.17.86

53. Rodolphe Bresdin *Ingrandes 1822-1885 Sèvres*

La cavalière orientale dans les montagnes, 1858

Pen and black ink on tracing paper affixed to cardboard;
6¼ × 7⅛ in. (165 × 181 mm). Signed and dated in pen and
ink at lower right: *Rodolphe Bresdin 1858.*

PROVENANCE: H. Shickman Gallery, New York, 1982.
BIBLIOGRAPHY: *Die Weltkunst*, 20a (23 October 1972);
Dirk van Gelder, *Rodolphe Bresdin, Catalogue Raisonné de
l'Œuvre Gravé*, vol. 1 (The Hague: Martinus Nynoff,
1976), fig. 13, p. 25.
EXHIBITIONS: Wallraf-Richartz-Museum, Cologne, *Die
Schwarze Sonne des Traums, Radierungen, Lithographien und
Zeichnungen von Rodolphe Bresdin (1822-1885)*, exh. cat.
by Albert Peters, 1972, no. 34.1, p. 72, repr.; California
Palace of the Legion of Honor, The Fine Arts Museums
of San Francisco, *Recent Acquisitions, Part I*, 1983.

Rodolphe Bresdin as the romanticized hero of
Champfleury's novel *Chien-Caillou*, of 1847, became
the model for the nineteenth-century notion of the
brilliant yet neglected and starving artist working alone
in a garret studio. Bresdin's life, in truth, was an
unfortunate one. It was taken up with the solitary
development of his visionary art, which brought him
little critical or financial success during his lifetime.

Bresdin's archaic romanticism sought inspiration
among earlier masters. We know of his reverence for
Dürer and Rembrandt, although there may also be
influences from early sixteenth-century artists of
the Danube School such as Albrecht Altdorfer and
from Hercules Seghers,[1] Rembrandt's mystical
contemporary. Bresdin, however, did not allow his
respect for the past to cloud his own creativity. His art
consists of intricately detailed compositions of great
virtuosity that describe a dreamlike world of his own
uncharted imagination. That his art was limited to
etchings, lithographs, and drawings in black and white,
makes their importance to the history of nineteenth-
century art even more remarkable. Misunderstood by
critics in his own day, including the noted authority on
printmaking Henri Béraldi who referred to Bresdin's
prints as "extravagantly bad,"[2] he was defended and
appreciated by writers such as Victor Hugo, Charles
Baudelaire, and Théodore de Banville. Living in

Bordeaux during 1864-1865, Bresdin took the young
artist Odilon Redon as a pupil. In later life Redon
acknowledged the inspiration he derived from his
solitary mentor: "His power lay in imagination alone.
He never conceived anything beforehand. He impro-
vised with joy, completing with tenacity the
entanglements of the barely perceptible vegetation of the
forests he dreamt up, which you see now before you."[3]

During the 1850s and 1860s Bresdin created a series
of drawings and prints on the motif of the "oriental
rider," perhaps inspired by earlier use of this subject
matter by romantic artists such as Eugène Delacroix and
Théodore Chassériau.[4] In this drawing, the elegantly
attired female rider, resplendent upon an Arabian horse,
contrasts with the desolate mountain landscape of her
surroundings. The meaning of this work is obscure,
as is often the case in the art of Bresdin.

Odilon Redon has left us an account of Bresdin's
working method. "I see him bent over the window...
bending over the small drawings on bristol paper which
he drew with such careful concentration and of which,
when they were sold, he always kept a tracing done
rapidly, a beautiful tracing enriched by the addition of
new inventions."[5] The Achenbach sheet appears to be
just such a tracing. Previous scholarship has read the
date inscribed on the drawing by the artist as 1856 and
considered it a preliminary drawing for the "oriental
rider" series. The recent publication of a newly
discovered drawing by Bresdin in the collection of Ian
Woodner[6] contradicts these earlier assumptions. The
Woodner drawing, signed and dated 1858, is clearly
the highly finished original from which Bresdin made
the detailed yet animated tracing now in the Achenbach
Foundation. Bresdin often thought enough of his
tracings to sign and date them. In the inscription on the
Achenbach drawing, the final digit in the date should
read as an 8 instead of a 6 as previously published. This
would then align it with the 1858 execution date of the
drawing from which it derives. In 1866 Bresdin again
employed this composition as the basis for the etching *Le
cavalier oriental dans les montagnes* (van Gelder 121).
R. F. J.

Achenbach Foundation for Graphic Arts purchase, 1982.2.46

54. Théodore Chassériau *Sainte-Barbe de Samana, Santo Domingo 1819-1856 Paris*

Alexandre Mourousi, 1855

Soft graphite on wove paper; 10½ × 8⅛ in.
(268 × 206 mm). Inscribed, signed, and dated in
graphite at lower right: *A Madame la Princesse Marie
Cantacuzène / Th. Chassériau 1855.*

PROVENANCE: Princess Marie Cantacuzène (M^me Puvis
de Chavannes); Prince Paul Mourousi, Paris, 1939
(grandson of the sitter); Georges de Batz Collection.
BIBLIOGRAPHY: Léonce Bénédite, *Théodore Chassériau:
Sa vie et son œuvre*, vol. 2 (Paris: André Dezarrois, 1931),
p. 494, repr. p. 481; Phyllis Hattis, *Four Centuries of
French Drawings*, (San Francisco: The Fine Arts
Museums of San Francisco, 1977), no. 217, p. 241, repr.
p. 243; Robert Flynn Johnson, "Masterpieces of French
Drawing," in Denys Sutton, ed., "The Fine Arts
Museums of San Francisco," *Apollo* (1980): 130-137,
no. 9, repr. p. 133.
EXHIBITIONS: Jacques Seligmann & Co., Paris and New
York, *Chassériau*, 1937-1938, no. 368; Museum of Fine
Arts, Boston, *Chinese Ceramics and European Drawings...
in the home of Georges de Batz...*, 1953, no. 130, repr.;
California Palace of the Legion of Honor, San Francisco,
De Batz Collection: Old Master Drawings, 1968; idem,
*Nineteenth Century French Drawings from the Permanent
Collection*, 1978; The Denver Art Museum, *Masterpieces
of French Art from The Fine Arts Museums of San Francisco*,
checklist by Denys Sutton, 1978 (also Wildenstein &
Co., New York, 1979; The Minneapolis Institute of
Arts, 1979); California Palace of the Legion of Honor,
The Fine Arts Museums of San Francisco, *Masterworks
from the Achenbach Foundation for Graphic Arts*, 1981.

The schism between Classicism and Romanticism in
nineteenth-century French art pitted the advocates of
Ingres's glacial ideas of linearity and composition
against Delacroix's advocacy of spirited draftsmanship
and expressive use of color. One artist, however,
Théodore Chassériau, venerated both Ingres and
Delacroix, without allowing either to overwhelm his
own individual talent.

Chassériau was born in Santo Domingo and was
educated in Paris. A precocious student, he entered
Ingres's studio at eleven and by the age of seventeen
was a successful participant in the Salon of 1836.

His early training was based on solid academic
draftsmanship, and Ingres considered him his most
talented pupil. By 1840, however, Chassériau's interest
in the liberating qualities of romantic art was pulling
him away from Ingres as a letter to his brother Frédéric
explains, "After a fairly long conversation with
M. Ingres, I saw that in many respects we could never
agree. He has outlived his prime, and he does not
understand the ideas and changes that have taken place
in the arts in our time...." [1]

In 1846 Chassériau traveled to Constantine
(present-day Algeria), where, like Delacroix, he was
inspired by the light, color, and exoticism of North
Africa. Maintaining a balance between Classicism and
Romanticism, Chassériau continued with great
versatility to work on numerous projects, ranging from
mural decorations and etchings (a series of fifteen
impressive etchings illustrating *Othello*, published in
1844) to paintings and drawings. His sudden death in
1856 at the age of thirty-seven shocked the Parisian art
world.

The Achenbach's sensitive yet penetrating drawing of
the thirteen-year-old *Alexandre Mourousi*, done the year
before Chassériau's death, shows the lasting influence
that Ingres had on Chassériau as a portrait painter and
draftsman. The direct, thoughtful gaze of the sitter
and the elimination of all but essential details are
characteristics of Ingres's methodology. Chassériau,
however, used tonal modeling throughout the drawing
to soften its overall effect and produce a more romantic
rendering of the sitter than one would expect from
Ingres. Sympathetic characterization is a notable trait in
Chassériau's portrait drawings. In the wistful look of
Alexandre Mourousi, who wears a jacket several sizes too
large, the artist has created a memorable vision of a little
boy on the verge of becoming a young man.

The drawing is inscribed to Princess Marie Canta-
cuzène, a Romanian descendant of Byzantine emperors
and the aunt of Alexandre Mourousi. In 1855, the year
the drawing was executed, Chassériau became
romantically involved with her although she was
married. In 1856 she separated from her husband and
later became the wife of the artist Puvis de Chavannes. [2]
R. F. J.

*Achenbach Foundation for Graphic Arts purchase, Georges de
Batz Collection, 1967.17.51*

55. Thomas Couture *Senlis 1815-1879 Villiers-le-Bel*

The Duel after the Masked Ball, 1857

Black and white chalk on blue-green laid paper, faded to green; 19⅛ × 25⅜ in. (492 × 645 mm). Initialed on rock in black chalk at lower right: *T.C.*

PROVENANCE: Galerie Arnoldi-Livie, Munich, 1981; Achenbach Foundation for Graphic Arts purchase.
BIBLIOGRAPHY: Albert Boime, *Thomas Couture and the Eclectic Vision* (New Haven: Yale University Press, 1980), pp. 309-317.
EXHIBITION: California Palace of the Legion of Honor, The Fine Arts Museums of San Francisco, *Recent Acquisitions, Part I*, 1983.

"He is a very complete artist in his own line. I do not think he will ever acquire the qualities he lacks, but on the other hand he is wholly master of what he knows."[1] With these perceptive words, Eugène Delacroix summarized his feelings about Thomas Couture after viewing Couture's celebrated canvas *Romans of the Decadence* at the Salon of 1847. Couture's art is one of contradictions. While it is based on sound academic training with conservative tendencies, his desire to deal with issues of contemporary life through allegory or outright realism placed him among the avant-garde. Couture's belief in an art that sought compromise between Classicism and Romanticism made him the spiritual if not the actual founder of the school of painting known as the "juste milieu." Couture was one of the most influential teachers of the century, and among his pupils were such diverse personalities as Edouard Manet, Puvis de Chavannes, Anselm Feuerbach, Eastman Johnson, and William Morris Hunt.

At the end of the 1850s, Couture embarked on an ambitious series of "realist" paintings. He employed figures dressed as Harlequin and Pierrot from the *commedia dell'arte* to comment on contemporary life in a moralizing and satirical manner. Couture later claimed that this series resulted from seeing the ghost of a recently deceased Harlequin, a vision that occurred to the artist while he was working late one night on the mural decorations of the Chapel of Saint-Eustache.[2]

The Duel after the Masked Ball is considered the most celebrated work in the series. Until our drawing came to light, it was known only through a painted version in the Wallace Collection in London. Unlike the other subjects in the series, it seems that *The Duel* was based on an actual event. During the winter of 1856-1857, according to Albert Boime, "the politicians Deluns-Montaud and Boittelle became so incensed with each other at a masquerade that, without taking time to change their costumes of Harlequin and Pierrot, they hurried to the conventional dueling field in the Bois de Boulogne."[3]

The bravado of this incident moved both Couture and the academic artist Jean-Léon Gérôme to paint the subject. Couture is credited with the earlier version, which probably inspired Gérôme. The popular success of Gérôme's melodramatic treatment, however, overshadowed Couture's work and became a source of rivalry between the two artists. Gérôme emphasized the tragic aftermath of the duel as he showed the departing Harlequin congratulated by his seconds while Pierrot, comforted by his colleagues, lay mortally wounded on the snow-covered ground. Couture, in contrast, chose to dwell on events leading up to the tragedy, on the psychological tension in the gestures of the participants, and the emotions registered on their faces.

Couture unfolds the drama at dawn in a carefully observed landscape. This attention to the reality of setting recalls Delacroix's comment on Couture, "He feels himself to be especially suited to work from nature, and he told me that he makes preparatory studies, so as to learn by heart the subject he wants to paint, and then sets to work on his picture with enthusiasm."[4] The drama is divided between the two rival groups. In the background, a confident Harlequin with his back to us gestures with his rapier. He is being counseled by his seconds, not in gestures of encouragement but in an entreaty to stop the duel. In the foreground, a dispirited and defeated-looking Pierrot listens with downcast eyes as his second instructs him in the use of a double-handed sword. Their companion, who wears Indian feathers, looks on intently. In his inappropriate, loose-fitting clothes and clumsy shoes, Pierrot, who clearly displays no knowledge of swordsmanship, is being handed a weapon far too cumbersome to be effective. If it were not for the deadly seriousness of the ritual, the costumed combatants would seem truly farcical. But it is clear that tragedy is anticipated.

In the mid-nineteenth century, hundreds of middle- and uper-class French youths lost their lives through dueling.[5] For Couture, this bizarre means of defending one's honor was a sign of decadence. Related to an actual event, yet seemingly allegorical, *The Duel after the Masked Ball* displays Couture's sophisticated use of psychological drama to comment on the somber realities of contemporary society.
R. F. J.

William H. Noble Bequest Fund, 1981.2.29

56. Jacques-Louis David *Paris 1748-1825 Brussels*

A Scene of Mourning, 1819

Graphite and black chalk on laid paper; 5⅛ × 7⅞ in. (131 × 200 mm). Signed and dated in graphite at upper right: *L. David Brux. 1819*, and inscribed in brown ink at upper center: *David reconnaissant [sic] à Monsieur Michaud.*

PROVENANCE: Swiss private collection; Adolphe Stein, London, 1973; John and Paul Herring & Co., New York. BIBLIOGRAPHY: Phyllis Hattis, *Four Centuries of French Drawings* (San Francisco: The Fine Arts Museums of San Francisco, 1977), no. 221, p. 245, repr. p. 249. EXHIBITIONS: H. Gerry-Engell Gallery, London, *Master Drawings*, 1973, exh. cat. by Adolphe Stein, no. 18, pl. 11; California Palace of the Legion of Honor, The Fine Arts Museums of San Francisco, *Nineteenth Century French Drawings from the Permanent Collection*, 1978; idem, *Masterworks from the Achenbach Foundation for Graphic Arts*, 1981.

David made this disturbing drawing in Brussels, in 1819, his fourth year of exile from France. It is inscribed "David reconnaissant [sic] à Monsieur Michaud," an inscription that undoubtedly refers to Jean-Baptiste Michaud (1760-1819), a comrade of David's who was a political leader during the Revolution and a member of the National Convention in 1792.[1] In the early days of the Restoration of the Bourbon monarchy, after the fall of Napoleon, Michaud like David left France as an exile and emigrated to Lausanne, where he died in 1819. It appears that David has inscribed this scene of mourning as a tribute after hearing of his friend's death.

David was quite scrupulous about signing and inscribing his later drawings. Our sheet is so inscribed in the upper right in graphite. Since the inscription to Michaud is in brown ink and repeats David's name, it is likely that the artist selected an existing drawing he felt was appropriate and dedicated it in commemoration of his friend's death.

After his exile to Brussels, David increasingly turned to themes of classical mythology. His reverence for the antique, the cornerstone of his Neoclassicism, is evident in this drawing. The four men and a woman are all in classical garb. Four show various degrees of emotional distress in their faces, postures, and gestures; two stare directly out at the viewer; and the strange, fifth figure in the right background stands in profile, oblivious to the emotional outpouring nearby. This confusing drawing is clearly dramatic but without obvious narrative. The psychological stress so apparent in this work recalls Anita Brookner's statement that, "David's activities in Brussels were prolific but obsessional."[2]

Our drawing certainly comes from the same sketchbook as two other drawings, *Bust of a Man*,[3] now in the Cleveland Museum of Art, and *Figures of Men and a Girl*;[4] both are undated but signed and inscribed as executed in Brussels.

R. F. J.

Achenbach Foundation for Graphic Arts purchase, 1974.2.11

David reconnoissant a Monsieur Michaud.

David Bruy. 1810.

57. Edgar Degas *Paris 1834-1917 Paris*

Woman Dressing (La coiffure), ca. 1885

Charcoal and pastel on gray laid paper; 23 × 16⅞ in. (585 × 430 mm). Signed in blue pastel at upper right: *Degas.*

PROVENANCE: Louis de Fourcaud, Paris; Durand-Ruel, Paris, 29 March 1917; Durand-Ruel, New York, 11 November 1920; Dr. T. Edward and Tullah Hanley Collection, 1936; gift to M. H. de Young Memorial Museum.

BIBLIOGRAPHY: Marcel Guérin, ed., *Letters of Degas* (Oxford: Bruno Cassirer, 1947), no. 25, repr.; Phyllis Hattis, *Four Centuries of French Drawings* (San Francisco: The Fine Arts Museums of San Francisco, 1977), no. 222, pp. 245-246, repr. p. 250.

EXHIBITIONS: Wildenstein & Co., New York, *The Dr. T. Edward and Tullah Hanley Collection*, and Fogg Art Museum, Harvard University, 1961-1962, no. 53 (also Gallery of Modern Art, New York, Philadelphia Museum of Art; The Denver Art Museum, 1967-1968; Museum of the Southwest, Midland, 1967, no. 105; Columbus Gallery of Fine Arts, 1968, no. 62; Canisius College, Buffalo, 1969, no. 128, repr.; M. H. de Young Memorial Museum, San Francisco, 1970, no. 90, p. 18, pl. 24, p. 48); California Palace of the Legion of Honor, The Fine Arts Museums of San Francisco, *Nineteenth Century French Drawings from the Permanent Collection*, 1978; Kunsthalle, Tübingen, and Nationalgalerie, Berlin, *Edgar Degas. Pastelle*, Ölskizzen, Zeichnungen, 1984, exh. cat. by Götz Adriani, no. 156, p. 382, repr.

In the mid-1880s, when this pastel was executed, Degas's drawing style was undergoing a transformation. Over the previous thirty years, sharp, incisive draftsmanship had been the hallmark of his art. Beginning in the mid-1870s, however, Degas turned increasingly to charcoal or black chalk as his favored drawing medium in place of graphite. As a result, his drawings became bolder and more monumental in scale. The earlier intensity of delineation was now overshadowed by a new awareness of structural form.

As early as 1872, Degas had begun to complain about his eyes and their sensitivity to light.[1] Rather than succumb to gradually failing eyesight, by the mid-1880s Degas adjusted his art to the new situation with more vigorous draftsmanship. The Achenbach drawing is an interesting transitional work. It contains a complex pose and a strong element of portraiture that links it to earlier works such as *Study for "La chanson du chien"* of about 1877.[2] At the same time, it is executed in a bold, simplified, almost rough manner that prefigures the aggressive abstracted figure studies of later years.

The image of a woman adjusting her hair before an unseen mirror is the type of natural, unposed "keyhole" picture that Degas was to take to even greater extremes in his series of ten pastels exhibited in the eighth and last Impressionist exhibition of 1886. In our sheet, he drew the figure in black charcoal with additions of reddish-brown chalk for the hair and touches of white to indicate the clothing. Pink pastel has been employed by Degas in a dramatic manner on her bodice, neck, face, and arms to indicate the reflection of artificial light cast from outside the picture. The indistinct nature of the hands arranging the hair and the bold charcoal strokes surrounding the upper body give the drawing a sense of dynamic action. Degas, in such a pastel, has created a realist work of startlingly modern conception.

Unlike the majority of Degas drawings that remained in the artist's studio until his death, the Achenbach sheet is a signed work that Degas either gave or sold to his friend Louis de Fourcaud, the critic who wrote for journals such as the *Gazette des Beaux-Arts, Figaro*, and *Le Gaulois*. The drawing was later bought by Degas's dealer Durand-Ruel, at the second de Fourcaud sale in 1917, while Degas was still alive.[3] Although P. A. Lemoisne knew the pastel, he did not include it in his volume *Degas et son œuvre* (Paris, 1946) because he considered it a drawing, rendered primarily in charcoal.[4]

R. F. J.

Memorial gift from Dr. T. Edward and Tullah Hanley, Bradford, Pennsylvania, 69.30.42

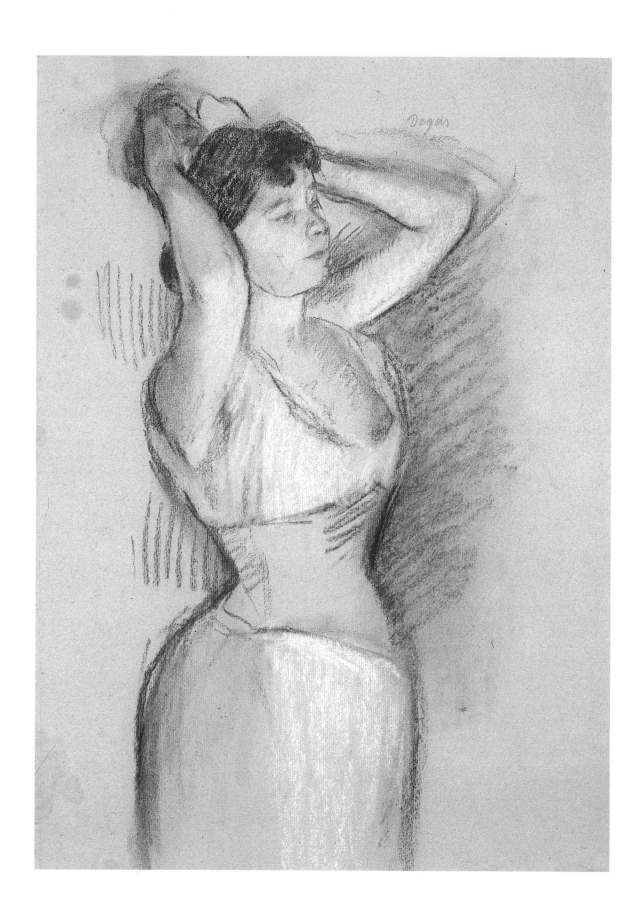

58. Eugène Delacroix *Charenton-Saint-Maurice 1798-1863 Paris*

Arabs and Horses near Tangiers, ca. 1832

Watercolor, gouache, and graphite on wove paper;
6⅝ × 10½ in. (167 × 265 mm). Signed in brown ink at
lower left: *Eug Delacroix*.

PROVENANCE: Gift of Delacroix to Count de Mornay;
Count de Mornay's sale, 29 March 1877, lot 13; Jacques
Seligmann & Co., New York, 1951; California Palace of
the Legion of Honor purchase.

BIBLIOGRAPHY: Phyllis Hattis, *Four Centuries of French
Drawings* (San Francisco: The Fine Arts Museums of
San Francisco, 1977), no. 224, p. 246, repr. p. 251; Robert
Flynn Johnson, "Masterpieces of French Drawing," in
Denys Sutton, ed., "The Fine Arts Museums of San
Francisco," *Apollo* (1980): 130-137, no. 10, repr. p. 134.

EXHIBITIONS: California Palace of the Legion of Honor,
San Francisco, *Drawings, Watercolors, and Prints by
Eugène Delacroix in West Coast Collections*, 1963, no. 10, pl. 7
(also Mills College Art Gallery, Oakland, 1963); Arts
Council of Great Britain, *Delacroix*, exh. cat. by Lorenz
Eitner, 1964, no. 126, p. 54; The Santa Barbara Museum
of Art, *The Horse in Art*, 1974; California Palace of the
Legion of Honor, The Fine Arts Museums of San
Francisco, *Nineteenth Century French Drawings from the
Permanent Collection*, 1978; idem, *Masterworks from the
Achenbach Foundation for Graphic Arts*, 1981.

In 1832, Delacroix traveled to Morocco under the
patronage of the Count de Mornay. In a series of
sketchbooks and a diary, the artist recorded the sights
and sensations of this exotic region, which were to
inspire him for the remainder of his career. This
watercolor is a carefully finished work that undoubtedly
was made after his trip but that employed sketches and
color notes made on the spot. It is one of a group of
eighteen elaborate, signed watercolors that Delacroix
made for the Count to commemorate their trip together.[1]
They were probably done in Toulon in July 1832, while
the de Mornay mission passed a fortnight in quarantine
after its return from Morocco.[2] The descriptive title
listed in Robaut is assuredly correct, because it is the
same as that listed in Count de Mornay's sale (29 March
1877, lot 13).[3]

This watercolor is an example of Delacroix's ability
to channel his artistic energy into a controlled and
realistic depiction of a romantic locale. Expecting a
sensual world of color and exoticism, Delacroix instead
was surprised by the classical simplicity and dignity of
Moroccan life. In his journal of 28 April 1832 he wrote,
"In many ways they are closer to nature than we–their
clothes, for instance, and the shape of their shoes.
Hence there is beauty in everything they do. But we,
with our corsets, narrow shoes, and tubular clothing, are
lamentable objects. We have gained science at the cost of
grace."[4]

R. F. J.

Mildred Anna Williams Fund, 1951.35

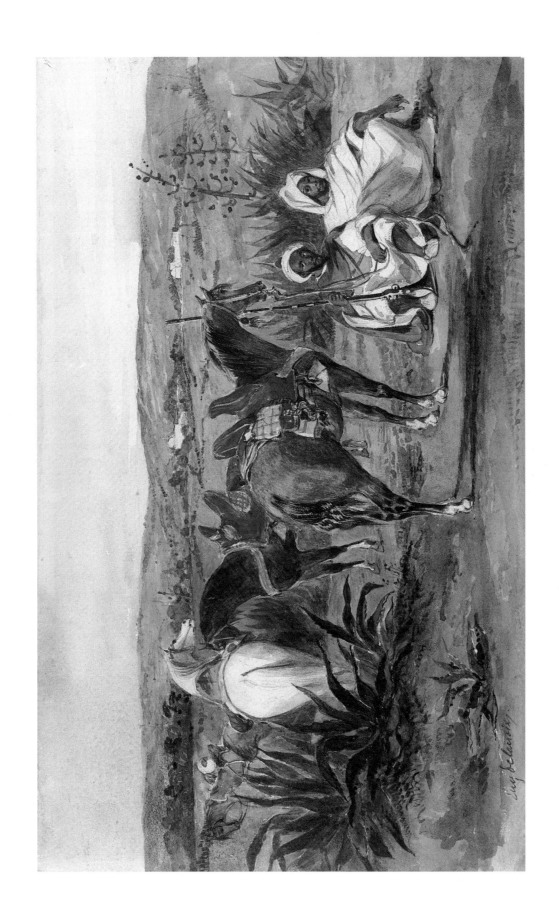

59. Paul Gauguin *Paris 1848-1903 Atuana, Marquesas*

L'arlésienne, M^{me} Ginoux, 1888

Colored chalks and charcoal with white chalk heightening on wove paper; 22⅛ × 19⅜ in. (561 × 492 mm). Inscribed in charcoal at upper right: *L'œil moins a costé du | nez | arête vive | à la naissance.*

PROVENANCE: Vincent van Gogh (?); F. H. Hirschland, New York; H. Bakwin, New York; Dr. T. Edward and Tullah Hanley Collection (before 1946); gift to the M. H. de Young Memorial Museum.
BIBLIOGRAPHY and EXHIBITIONS: For extensive bibliography and exhibition history, see notes for this entry, pp. 224-225.

The ill-fated artistic friendship of Paul Gauguin and Vincent van Gogh resulted in the creation of one of the most powerful and famous drawings of the late nineteenth century. Gauguin made this drawing during his stay with van Gogh at Arles in the fall of 1888.

After arriving in Arles from Pont-Aven in October, Gauguin found that, unlike van Gogh, he was not overly inspired by the countryside and its people. He was attracted, however, by the women of Arles in their picturesque yet severe black costumes. Gauguin wrote, "The women here have elegant headdresses and a Greek beauty. Their shawls fall into folds as in primitive paintings...."[1] Gauguin was impressed by van Gogh's recently completed painting, *The Night Café* (de la Faille 463; Yale University Art Gallery) and set about painting his own version of the scene with the looming figure of a woman dominating the foreground (Pushkin Museum, Moscow). M^{me} Ginoux, the wife of the proprietor of the café, posed for the Museums' drawing of *L'arlésienne*, which served as a preparatory study for Gauguin's painting. Except for a few notebook studies, *L'arlésienne: M^{me} Ginoux* is one of the few drawings that survived Gauguin's two-month stay in Arles.[2]

A few months before he executed this drawing, Gauguin wrote to van Gogh, "I believe that in my figures I have achieved a great simplicity, which is both rustic and superstitious."[3] In this sculptural drawing Gauguin employed the artistic concepts of "Synthetism" that were emerging in his work. These included reduction of forms to their essential outlines, avoidance of shadows as much as possible, flattening of planes, and simplification of modeling. According to John Rewald, the drawing of *L'arlésienne* is the most representative example of Gauguin's new synthetist style and it "expresses all the startling features of his recent evolution."[4]

It seems that at some point van Gogh expressed a liking for the drawing and borrowed or was given it. It is possible that Gauguin inscribed the drawing at that time *L'œil moins a costé du | nez | arête vive | à la naissance* (the eye should be placed further away from the ridge of the nose) to aid van Gogh in utilizing the work. In May or April 1889 in Arles van Gogh painted his first version of *L'arlésienne* after Gauguin's drawing.[5]

Three other painted versions of *L'arlésienne* were completed by van Gogh between January and April 1890 in the asylum of Saint-Rémy. In all four paintings (de la Faille 540, 541, 542, 543) van Gogh represents the woman leaning on a table. Although no table is indicated in the drawing, van Gogh would have known how Gauguin had placed M^{me} Ginoux at a café table with glasses and a siphon in his painting *The Night Café*. In van Gogh's painted versions, however, there are two books on the table: *Uncle Tom's Cabin* by Harriet Beecher Stowe and *A Christmas Carol* by Charles Dickens. It is difficult to discern a symbolic meaning for these books except that at the time van Gogh had read and admired both authors.[6]

Van Gogh sent at least one version of *L'arlésienne* to his brother Theo and was eager to find out Gauguin's reaction to his treatment of the subject. Van Gogh regarded his paintings based on the Gauguin drawing as a joint effort. In an unfinished letter to Gauguin, found among van Gogh's papers after his suicide, van Gogh had written: *And it gives me enormous pleasure when you say the Arlésienne's portrait, which was based strictly on your drawing, is to your liking. I tried to be religiously faithful to your drawing, while nevertheless taking the liberty of interpreting through the medium of color the sober character and the style of the drawing in question. It is a synthesis of the Arlésiennes, if you like; as syntheses of the Arlésiennes are rare, take this as a work belonging to you and me as a summary of our months of work together. For my part I paid for doing it with another month of illness, but I also know that it is a canvas which will be understood by you, and by a very few others, as we would wish it to be understood. My friend Dr. Gachet here has taken to it altogether after two or three hesitations, and says, "How difficult it is to be simple." Very well—I want to underline the thing again by etching it, then let it be. Anyone who likes can have it.*[7]

This monumental drawing and the paintings by both Gauguin and van Gogh that were inspired by it are a reminder of the creative yet short-lived interplay that occurred between these two troubled geniuses.
R. F. J.

Memorial gift from Dr. T. Edward and Tullah Hanley, Bradford, Pennsylvania, 69.30.78

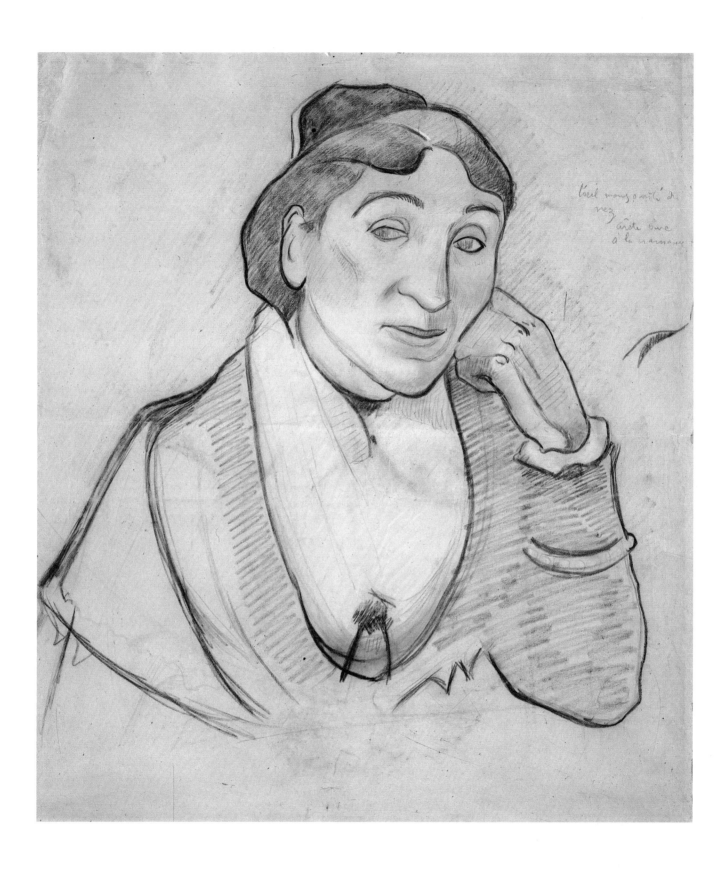

60. Henri Harpignies *Valenciennes 1819-1916 Saint Privé*

Landscape with an Artist Sketching, 1885

Watercolor over graphite underdrawing on wove paper; 11¹⁄₁₆ × 15⁹⁄₁₆ in. (280 × 395 mm). Signed and dated in black watercolor at lower left: *H. Harpignies 1885*.

PROVENANCE: David Tunick, Inc., New York, 1979; Achenbach Foundation for Graphic Arts purchase.
EXHIBITIONS: California Palace of the Legion of Honor, The Fine Arts Museums of San Francisco, *Selected Acquisitions, 1977-1979*, 1979-1980, checklist, no. 27; idem, *19th Century French Landscapes: Prints and Drawings from the Permanent Collection*, 1984.

Henri-Joseph Harpignies was the most skillful and prolific, if not the most inspired, of the second generation of French landscape watercolorists that emerged in the 1850s. This group also included Gustave Doré, Louis Français, Jean-François Millet, and Théodore Rousseau. In an extraordinarily long career that stretched from the 1840s until his death in 1916, Harpignies concentrated on depicting the countryside in France and Italy.

Although there are fewer examples compared with the vast number of landscape watercolors of the English School, the nineteenth-century French contribution to this genre is nevertheless considerable. In England, there was an emphasis on naturalism rather than classicism in the paintings and watercolors of the Norwich School early in the century, exemplified by the works of John Sell Cotman. This was followed by the use of

brilliant plein-air effects in the watercolors of Richard Parks Bonington, Thomas Shotter Boys, and John Constable. These developments had a profound effect on young Parisian artists of the 1820s and 1830s such as Eugène Isabey, Paul Huet, and Eugène Delacroix.

Harpignies, like the English artists, thought of watercolor as a major art form and his greatest works are in that medium. His early watercolors derived their color, composition, and subject matter from the Barbizon School. Jean-Baptiste Camille Corot, whom he met in 1853, was another influence on Harpignies with his simplified light-filled Italian landscapes.[1] Through the 1870s the work of Harpignies continued to be solidly structured, although it began to give way in the 1880s to more fluid light-filled compositions that echoed the effects of Impressionism. The Achenbach's fresh watercolor of 1885 is a transitional work. Though he maintains the structural solidity of his earlier style, Harpignies silhouettes the tree branches and contrasts the foreground shadows to the brightly sunlit distance in a dynamic scene of impressionistic realism. The subject is brought into even greater focus by the appearance of an artist sketching. By the inclusion of this figure, Harpignies not only gives scale to the two massive trees but in a sense he celebrates the liberation of the nineteenth-century artist to be at one with nature.

R. F. J.

William H. Noble Bequest Fund, 1979.2.4

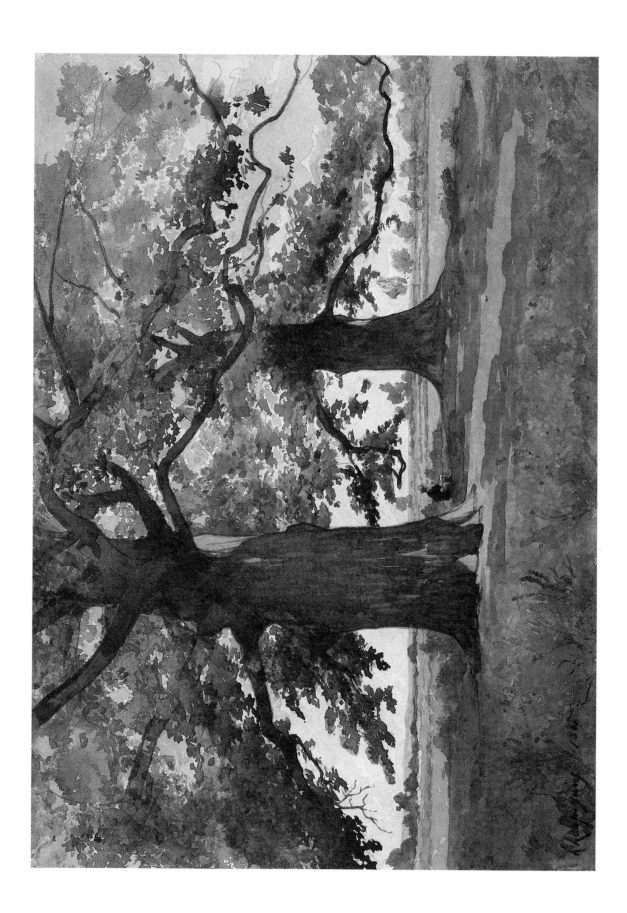

61. Jean-Auguste-Dominique Ingres *Montauban 1780-1867 Paris*

Portrait of Maria Maddalena Magli, 1806

Graphite on cream wove paper; 8⅛ × 6¼ in.
(208 × 159 mm). At lower right, inscribed in graphite,
probably by the artist: *javanni (?) magnani Peintre de
carrosse.*

PROVENANCE: Bartolini family, Florence, 1806; to
Lorenzo, until 1850; to his daughter, Signora Lorenzo
Luchi; to her daughter, Marchesa Bernardo Pianetti
della Stufa, until 1956; Feilchenfeldt, Zurich; Paul
Kantor, Los Angeles; Norton Simon, Los Angeles,
1963; Christie's, London, 1971; Wildenstein & Co.,
New York, 1973.
BIBLIOGRAPHY: M. Tinti, *Lorenzo Bartolini* (Rome, 1936),
no. 18, pp. 81-82; Hans Naef, "Ingres als Porträtist
im Elternhause Bartolinis," *Paragone* 7, no. 83
(Florence, November 1956): pp. 31-38, repr. fig. 23;
Juergen Schulz, ed., *Master Drawings from California
Collections*, exh. cat. (Berkeley: University Art Museum,
1968), no. 11, p. 23, repr. p. 86; Hans Naef,
J. A. D. Ingres, vol. 4 (Bern: Benteli Verlag, 1977),
no. 38, p. 72, repr. p. 73; Phyllis Hattis, *Four Centuries
of French Drawings* (San Francisco: The Fine Arts
Museums of San Francisco, 1977), no. 240, p. 267, repr.
p. 270; Robert Flynn Johnson, "Masterpieces of French
Drawing," in Denys Sutton, ed., "The Fine Arts
Museums of San Francisco," *Apollo* (1980): 130-137,
no. 8, repr. p. 133.
EXHIBITIONS: Kunsthaus, Zurich, *Rome vue par Ingres*,
1958, no. B1-b; Wildenstein & Co., New York,
Masterworks on Paper, 1975; California Palace of the
Legion of Honor, The Fine Arts Museums of San
Francisco, *Recent Acquisitions*, 1976; The Denver Art
Museum, *Masterpieces of French Art from The Fine Arts
Museums of San Francisco*, checklist by Denys Sutton,
1978 (also Wildenstein & Co., New York, 1979; The
Minneapolis Institute of Arts, 1979); California Palace of
the Legion of Honor, The Fine Arts Museums of San
Francisco, *Nineteenth Century French Drawings from
the Permanent Collection*, 1978; idem, *Masterworks from
the Achenbach Foundation for Graphic Arts*, 1981.

Jean-Auguste-Dominique Ingres is considered one of the
most refined and insightful portrait draftsmen of all
time. His large œuvre of over four-hundred-fifty portrait

drawings, meticulously catalogued by Hans Naef,[1]
spans the years from before his apprenticeship in the
studio of David in the early 1790s to his death in 1867.

In 1806 Ingres traveled from Paris to Rome to take up
residency at the French Academy as a *Prix de Rome*
recipient. Accompanying him was his friend, the neo-
classical sculptor Lorenzo Bartolini (1777-1850), who was
a fellow student in David's studio. The two travelers
spent the week of 2 October 1806 in Florence at the
home of Bartolini's parents, where Ingres drew this
sympathetic portrait of Lorenzo Bartolini's mother,
Maria Maddalena Magli (1751-1831). During the same
visit Ingres also drew pencil portraits of Bartolini's
father, Liborio, and two younger brothers, Francesco
and Leopoldo.[2]

The depiction of M^me Bartolini by Ingres, however, is
the most striking and intense of the group. Her features
are precisely rendered in a direct yet simplified manner.
Only her face and her bodice are delineated, while her
hands and the chair she sits on are sketchily drawn. It is
apparent from the lack of finish that the drawing was
made along with the others as a token of friendship in
recognition of their hospitality to the artist.

Much justifiable praise has centered on the highly
finished portrait drawing commissions of Ingres, often
with elaborate landscape backgrounds, which he made
later in his Roman stay as a means of livelihood. The
sitters were usually visitors or tourists, often
Englishmen who took their Ingres portraits home as
artistic souvenirs, much as an earlier generation of
Englishmen took home Canaletto's shimmering images
of Venice. Many of these beautiful commissioned
drawings are devoid of psychological insight, probably
because the majority of the sitters were virtual strangers
to Ingres and his emotional investment in them was
slight. Indeed, his psychological insight was usually in
proportion to his knowledge of and association with the
sitter. In the case of M^me Bartolini, he found a woman of
quiet, dignified beauty whom he has viewed with
obvious sympathy and pathos. The result is one of the
most subtly powerful drawings of Ingres's early career.
R. F. J.

Achenbach Foundation for Graphic Arts purchase, 1976.2.4

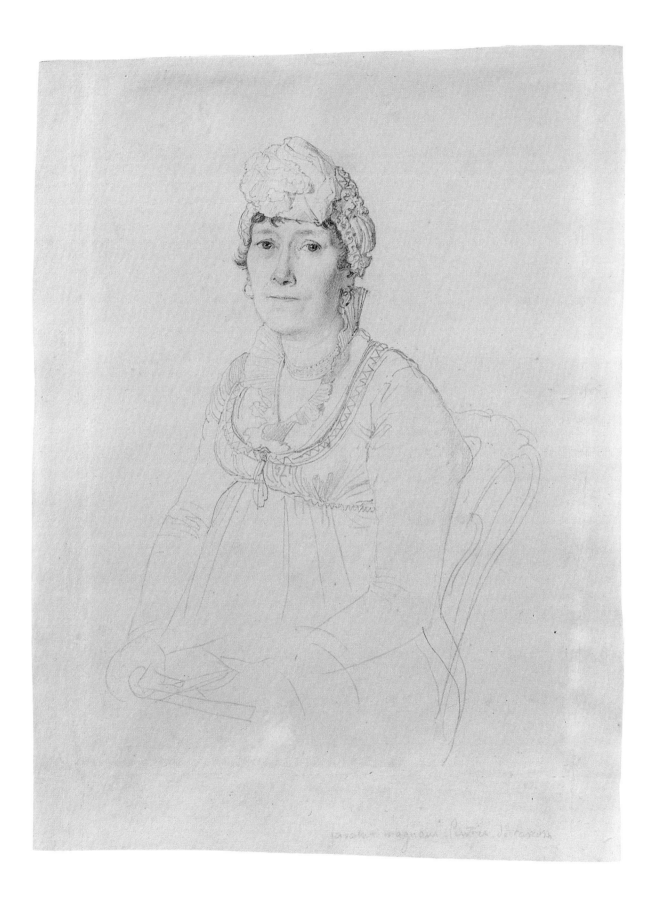

62. Eugène Isabey *Paris 1803-1886 Paris*

Le naufrage, 1858

Watercolor and gouache over graphite underdrawing on wove paper affixed to cardboard; 13 × 17⅝ in. (333 × 448 mm). Signed and dated at lower right: *E. Isabey 1858.*

PROVENANCE: Robert Noortman Gallery, London, 1978.
EXHIBITIONS: Robert Noortman Gallery, London, *Third Exhibition of Nineteenth-Century French Watercolours and Drawings,* 1978, no. 37; California Palace of the Legion of Honor, The Fine Arts Museums of San Francisco, *Selected Acquisitions, 1977-1979,* 1979-1980, checklist, no. 34.

Eugène Isabey was the son and pupil of Jean-Baptiste Isabey (1767-1855), a miniaturist at the Napoleonic Court. Eugène had an early success in the Salon of 1824, where he exhibited landscape and marine paintings and was awarded a first class medal. About this time Isabey became a friend of Eugène Delacroix and came under the influence of Delacroix's circle of romantic artists, which included the Englishman Richard Parks Bonington. In 1825 Isabey traveled to London where he was further exposed to English landscape art, especially the works of J. M. W. Turner. Isabey accompanied a French expeditionary force to Algeria in 1830, as an official artist, but his experience there did not have the lasting effect it had on artists such as Delacroix and Chassériau. Isabey preferred to work

around the coast of Normandy. He used this harsh windblown environment as the subject of numerous paintings, watercolors, and lithographs executed in a dynamic and painterly style.

Eugène Isabey's interest in nautical disasters is in line with Lorenz Eitner's observation that "the storm-tossed boat...chiefly attracted artists representing the dramatic and essentially 'baroque' strain in romantic art."[1] *Le naufrage* was executed in 1858, the same year as Isabey's celebrated painting *Burning of the Steamer Austria* (Musée des Beaux-Arts, Bordeaux), which dramatically recounts the sinking of that ship on 13 September 1858, with a loss of over 500 lives.[2] Although there are similarities between these two works, such as the position of the stern of the sinking ships, they represent entirely different subjects. The painting seeks to document a historical event, while our watercolor is a more generalized reflection on the perils of the sea.

Carefully working over the drawing in watercolor washes, Isabey has skillfully added highlights in blue, green, red, and white gouache to further heighten the drama. In this work he reveals his debt to English art and particularly to Turner in his treatment of similar subject matter.[3]

R. F. J.

Elizabeth Ebert and Arthur W. Barney Fund and Achenbach Foundation for Graphic Arts purchase. 1979.2.43

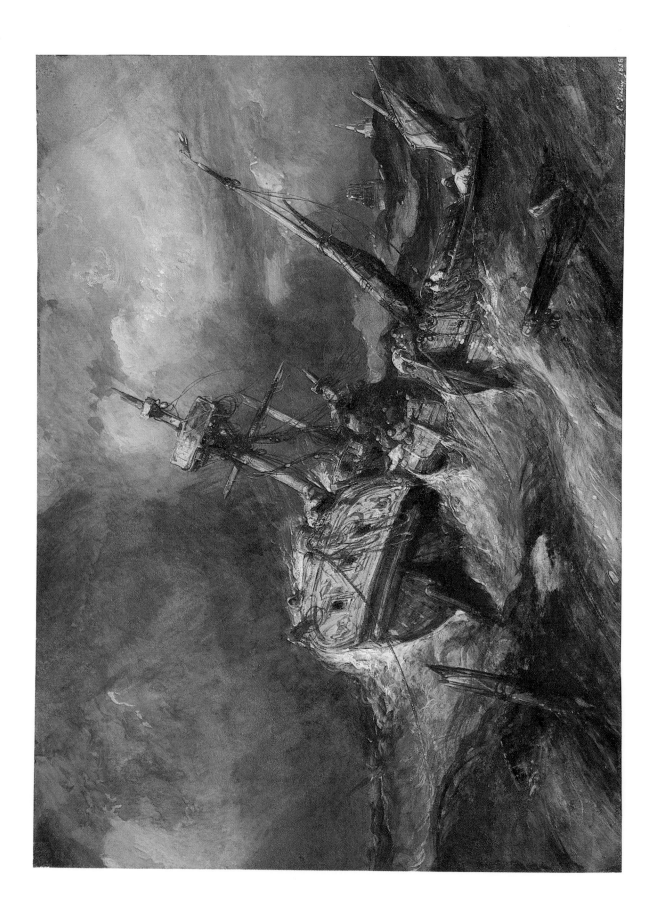

63. Edouard Manet *Paris 1832-1883 Paris*

Seated Woman Wearing a Soft Hat, ca. 1875

Graphite and ink wash on wove graph paper;
7⅜ × 4¼ in. (186 × 120 mm). Stamp of 1884 atelier sale
in faded red ink at lower right: E.M. (Lugt 880).

PROVENANCE: Edgar Degas; his sale, Galerie Georges
Petit, Paris, 26 and 27 March 1918, lot 224;
J. K. Thannhauser, Berlin-Lucerne, 1931 (unverified);
Howard Swope (unverified); Justin Thannhauser,
New York, 1941; Marie Harriman Gallery, New York,
1941; Mr. and Mrs. Philip N. Lilienthal; Bequest of
Ruth Haas Lilienthal to The Fine Arts Museums
of San Francisco.
BIBLIOGRAPHY: Adolphe Tabarant, *Manet, histoire
catalographique* (Paris: Editions Montaigne, 1931), no. 62,
pp. 540-541; A. Tabarant, *Manet et ses œuvres*, 2d ed.
(Paris: Gallimard, 1947), pp. 259-260, p. 614; Denis
Rouart and Daniel Wildenstein, *Manet*, vol. 2 (Paris-
Lausanne: Bibliothèque des arts, 1975), no. 393, p. 146;
Phyllis Hattis, *Four Centuries of French Drawings* (San
Francisco: The Fine Arts Museums of San Francisco,
1977), no. 248, p. 274, repr. p. 278.
EXHIBITIONS: Museum of Art, Toledo, *French Drawings
and Watercolors*, 1941, no. 78, California Palace of the
Legion of Honor, The Fine Arts Museums of San
Francisco, *Nineteenth Century French Drawings from the
Permanent Collection*, 1978.

Edouard Manet was not a great draftsman in the
traditional sense. Many of the great artists of his own
century, such as Prud'hon, Delacroix, Daumier, and
Degas, often made superbly finished drawings that were
conceived as works of art in themselves. Manet, by
contrast, generally regarded drawing as a means to an
end. Except for a number of watercolors, some made as
replicas of larger oils, he used drawing primarily as a
tool of personal visual exploration. It was a means of
notation that recorded his immediate sensations for
future deliberation and development. A large number of
Manet's spontaneous yet often fragmented drawings
served as first ideas or working studies for his paintings,
etchings, and lithographs. Ultimately, his skills as a
draftsman are best seen in these paintings and prints,
premeditated works that allowed the artist to develop his
ideas in a careful manner.

Seated Woman Wearing a Soft Hat is a fine example of
Manet's ability to summarize the essential characteristics
of his subject. Executed on a standard-size graph paper
that the artist often used, it undoubtedly once formed
part of a sketchbook. Manet quickly jotted down the
basic outlines of his drawing in graphite, followed by
the confident application of wash. Referring to the

numerous wash drawings of women that Manet made
from the mid-1870s onward, Alain de Leiris wrote,
"They are done in a swift brush technique in ink with
occasional use of watercolor. They constitute a distinct
genre within the general category of portraiture. The
artist emphasizes the formal values of pattern and color
and almost entirely disregards character analysis and
expression."[1] Except for the direct, attentive look in
her eyes, all other aspects of the personality of the
woman in our drawing are obscured by the informal
pose of her hand against her face. Manet has lavished the
greatest care in depicting the woman's hat, building up
the volumes of fabric through the application of delicate
brushstrokes of wash. Regarding the abstract quality of
these drawings of women, de Leiris wrote, "The dot of
an eye, the curve of a nose, the silhouette of a lost
profile, the shape of a collar, or the texture of a veil are
merely graphic elaborations of a single pattern—the
'object-image' which Manet created from them."[2]

This drawing was once owned by Edgar Degas, one
of the greatest artist-collectors of the nineteenth century.
Manet and Degas first met when they were in their
thirties. As personalities they were quite different:
Manet was gregarious, extroverted, and eager for recog-
nition while Degas was sarcastic, introverted, and
shunned critical acclaim. Over the years they
maintained a warm friendship, occasionally marked by
quarrels. On leaving Manet's funeral Degas remarked,
"We never knew how great he was."[3]

Degas owned eight paintings and twelve drawings
and watercolors by Manet.[4] Although Manet and Degas
are known to have exchanged works of art, this drawing
would have been acquired by Degas after Manet's
death, since it bears the Manet atelier mark (Lugt
880). The drawing was included in the 1918 sale of
Degas's private art collection,[5] although its
identification as the one in Degas's collection was
questioned at one time. Our sheet does not bear the
Degas estate stamp on the verso, and the measurements
in the auction catalogue differ (the catalogue gives a
size of 175 × 115 mm, while the drawing is actually
186 × 120 mm). Ronald Pickvance, however, has made
the interesting observation that the mat burn on the
drawing exactly coincides with the measurements given
in the Degas sale catalogue.[6] If the drawing had been
framed, it is logical that sight measurements would have
been given. The atelier stamp that would have been
affixed to the backboard of the framed drawing must
have been lost in subsequent reframing.

R. F. J.

Bequest of Ruth Haas Lilienthal, 1975.2.6

seul

64. Jean-François Millet *Gruchy 1814-1875 Barbizon*

Return of the Flock, ca. 1860-1865

Black chalk on laid paper; 11⅜ × 12⅞ in. (288 × 326mm). Signed in chalk at lower right: *J F M.* Inscribed in graphite on verso: *W.C. 1459 / 101 38.*

PROVENANCE: Emanuel Walter (late 19th c.); willed to the San Francisco Art Association (later the San Francisco Art Institute); Emanuel Walter Collection sale, Butterfield & Butterfield, San Francisco, 8 March 1971, no. 180.
BIBLIOGRAPHY: Lorinda M. Bryant, *French Pictures and Their Painters* (London, 1923), p. 124, pl. 82; Phyllis Hattis, *Four Centuries of French Drawings* (San Francisco: The Fine Arts Museums of San Francisco, 1977), no. 251, p. 275, repr. p. 280.
EXHIBITIONS: California Palace of the Legion of Honor, The Fine Arts Museums of San Francisco, *The Barbizon Tradition*, 1977; idem, *Nineteenth Century French Drawings from the Permanent Collection*, 1978.

The casual student of nineteenth-century French art, who has accepted the usual stylistic progression from Barbizon to Impressionism, will find the work of Jean-François Millet an unexpected source of precedent and influence.

Millet has been commonly regarded as a passionate but sentimental commentator who subordinated media to meaning. Yet he was responsible for evolving some of the more adventurous painterly and graphic styles before those of Seurat and Cézanne, rich with qualities of mystery and abstraction that are usually associated with an orientation toward pure art rather than subject. An artist remembered primarily as the poet-recorder of the agrarian condition and the peasant's daily round, Millet also emerges as one of the more important portraitists of his century. His flair for exploration was far more influential than is generally recognized, and artists as diverse in their approach to technique and composition as van Gogh, Seurat, and Redon in varying degrees were indebted to the Barbizon master.

The fine chalk sheet in the Museums' collection provides an example of a typical Millet subject as well as an indication of the quality and potential of the artist's draftsmanship. Even in the later nineteenth century, astute observers perceived the excellence of such drawings. Camille Pissarro, bemoaning the deleterious effects of eighteenth-century sentimentality on art and finding fault with Millet's paintings on these grounds, stated that people "do not realize that certain of Millet's drawings are a hundred times better than his paintings which are now dated."[1] In fact, Pissarro felt that "Millet's whole value is in his drawings."[2]

The *Return of the Flock* is composed of woven patches of parallel lines within and around simply delineated forms. By this technique, the heightening effects of light could be presented–such as the backs of the sheep and the side of the shepherdess–without hardening the composition with a more forthright chiaroscuro. The style of the drawing suggests a date of the early to mid-1860s.[3]

J. R. G.

Achenbach Foundation for Graphic Arts purchase, 1971.18

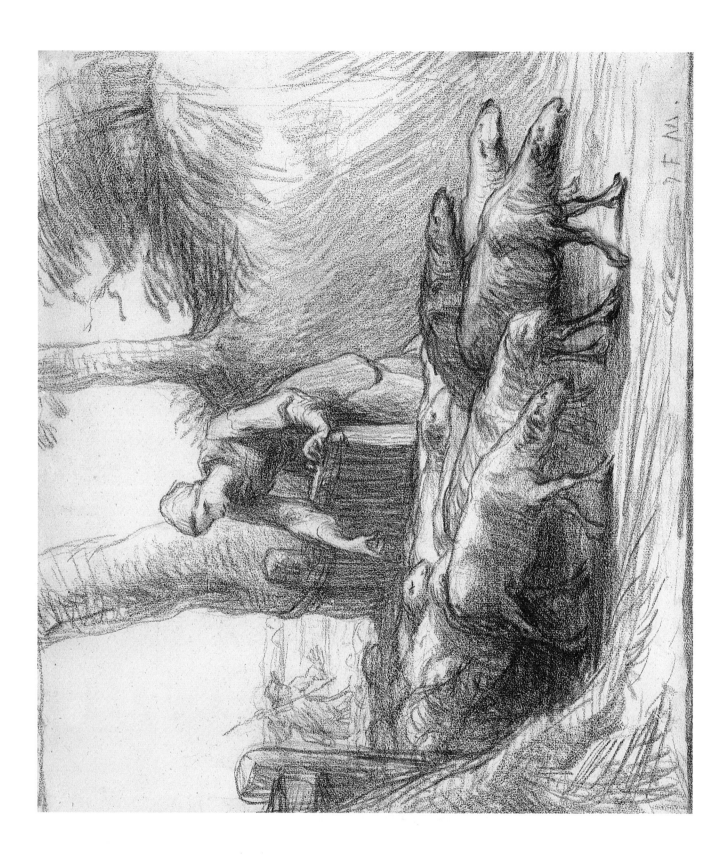

65. Claude Monet *Paris 1840-1926 Giverny*

The Coast of Normandy Viewed from Sainte-Adresse, ca. 1864

Black chalk on laid paper; 6⅞ × 12⅛ in. (175 × 308 mm). Signed in black chalk at lower left: *Cl. Monet.*

PROVENANCE: Sagot, Paris; A. Conger Goodyear; John Rewald, New York, ca. 1943; M. Knoedler & Co., New York, ca. 1953; A. E. Goldschmidt, Stamford, 1960; Dr. T. Edward and Tullah Hanley Collection; gift to M. H. de Young Memorial Museum.
BIBLIOGRAPHY: John Rewald, *History of Impressionism* (New York: The Museum of Modern Art, 1946), p. 113 repr.; Regina Shoolman and Charles E. Slatkin, *Six Centuries of French Master Drawings in America* (New York: Oxford University Press, 1950), p. 196, pl. 111; William C. Seitz, *Claude Monet* (New York: Harry N. Abrams, 1960), p. 49, fig. 74; Phyllis Hattis, *Four Centuries of French Drawings* (San Francisco: The Fine Arts Museums of San Francisco, 1977), no. 253, p. 276, repr. p. 281; Robert Flynn Johnson, "Masterpieces of French Drawing," in Denys Sutton, ed., "The Fine Arts Museums of San Francisco," *Apollo* (1980): 130-137, no. 111, repr. p. 134.
EXHIBITIONS: Wildenstein & Co., New York, *Monet*, 1945, no. 83; idem, *Dr. T. Edward and Tullah Hanley Collection*, and Fogg Art Museum, Harvard University, 1961-1962, no. 93, repr. p. 38 (also Gallery of Modern Art, New York; Philadelphia Museum of Art; The Denver Art Museum, 1967-1968, p. 64; Museum of the Southwest, Midland, 1967, no. 21; Columbus Gallery of Fine Arts, 1968, no. 91; Canisius College, Buffalo, 1969, no. 175; M. H. de Young Memorial Museum, San Francisco, 1970, no. 124, pl. 26); University of Michigan Museum of Art, Ann Arbor, *A Generation of Draughtsmen*, 1962; California Palace of the Legion of Honor, The Fine Arts Museums of San Francisco, *Nineteenth Century French Drawings from the Permanent Collection*, 1978; Stanford University Museum of Art, *Personality of the Artist in Handwriting and Drawing*, 1981; California Palace of the Legion of Honor, The Fine Arts Museums of San Francisco, *19th Century French Landscape: Prints and Drawings from the Permanent Collection*, 1984.

Because he was blessed by a unique gift for painting as well as by a long, productive life, Claude Monet's achievement could be considered the most important of the major Impressionists. From the sparkling early works done at Sainte-Adresse and Argenteuil and the inspired serial imagery of his middle years to the triumphant, color-field, waterlily panoramas of his old age, Monet sustained an inventive, color-oriented approach to everything he painted. And like many painters who primarily explored color, from the time of Titian to the present, Monet employed monochromatic drawing infrequently.[1]

The artist spent his youth at Le Havre, and there he met the painter Boudin and observed his masterful renditions of the coast. Another sea painter, the important Dutch artist Jongkind, spent much time with the young Monet and was responsible for an important aspect of his education in painting. Monet also admired Daubigny, a leading Barbizon artist who already was referred to as "chief of the school of impression" in 1865. Daubigny's influence on the work of Monet was far more significant than is generally appreciated.[2]

The style of Monet's *Coast of Normandy Viewed from Sainte-Adresse* in the collection of The Fine Arts Museums very probably was inspired by the landscape drawings of Daubigny, which are rarely seen now. The Barbizon painter executed very similar studies in charcoal that were notable for their rough darks and lights and that emphasized a faceted simplification of the terrain. Essential structure rather than detail was stressed, and charcoal was the usual medium.

Viewing this drawing by Monet brings to mind the artist's remark that "I have never isolated drawing from color."[3] Though, in fact, that is a reasonable statement, indicative of his solid training, in practice Monet's growth as a painter of color structure was not accompanied by an impressive corpus of independent drawings. Nevertheless, the artist undoubtedly did many more drawings than are extant, for he was an accomplished draftsman and caricaturist as a youth.

The Coast of Normandy Viewed from Sainte-Adresse dates to about 1864, and the title of the work is based on Raoul Dufy's apparent identification of the site as the *roches noires* of Sainte-Adresse.[4]

J. R. G.

Memorial gift from Dr. T. Edward and Tullah Hanley, Bradford, Pennsylvania, 69.30.141

66. Pierre-Paul Prud'hon *Cluny 1758-1823 Paris*

"Je ne me bats point contre un insensé," from Jean-Jacques Rousseau's *La nouvelle Héloïse* (1804)

Black and gray ink with white gouache heightening on wove paper; 4¾ × 3¼ in. (120 × 80 mm).

PROVENANCE: Alexis Godillot; Sotheby's London, 4 July 1977, no. 198, repr. p. 43; Sven Bruntjen, Woodside, California.

BIBLIOGRAPHY: Jean Guiffrey, *Catalogue de l'œuvre peint et dessiné de Pierre-Paul Prud'hon* (Paris: Morancé, 1924), no. 1070.

EXHIBITIONS: Paris, *Exposition P. P. Prud'hon*, 1922, no. 162; California Palace of the Legion of Honor, The Fine Arts Museums of San Francisco, *Recent Acquisitions, 1977-1978*, 1978; idem, *Selected Acquisitions, 1977-1979*, 1979-1980, checklist, no. 47.

The last child in a large family, Prud'hon was raised by the monks of Cluny until he was placed under the care of the painter Antoine Devosges of Dijon. Subsequently, he studied with Wille and Pierre and went on to win the *Prix de Rome*, which enabled him to travel to Italy and to observe firsthand the works of artists such as Raphael and Correggio. This proved to be an indelible experience, and Prud'hon's mature style never abandoned its Correggesque orientation towards soft delineation and sensuous modeling.

To those familiar with Prud'hon's arresting, academic nudes and his larger, more ambitious compositions, the delicacy he is capable of may come as a surprise. A superb example of his talent for detail is the drawing in the collection of The Fine Arts Museums, one of five tiny works engraved as vignettes to illustrate Jean-Jacques Rousseau's *Julia* or *La nouvelle Héloïse*.[1]

What is initially striking about all of these miniatures is their concentration on physiognomy and the portrayal of emotion. But equally impressive and significant is the artist's exceptional sensitivity to the dramatizing quality of light. As we examine just how Prud'hon achieves the effect of light, it is appropriate to recall the critical commentary of the Goncourts who stated that "it is the drawing of light which he seeks above all else."[2]

In the Museums' sheet, the artist has chosen to illustrate the moment in Part II, Letter X when Saint-Preux bursts into Lord Edouard's room and challenges him to a duel.[3] Two flickering candles on Edouard's desk reflect in the eye of Saint-Preux and illuminate his sword, enhancing the mood of tension and alarm. From the edges of the floor tiles to the sheen on waistcoats, the artist's rendering has observed the behavior of weak, scattered light, and thus his entire composition has gained in both unity and mystery. The scene is crafted with fine parallel lines, and the strong delineation is softened by the artist's furlike arrangement of parallel and interwoven strokes.

The Museums' miniature was engraved for the 1804 edition of Rousseau's work published by Bossange, Masson, and Besson. An earlier edition of 1761 had included illustrations by Gravelot.

J. R. G.

Achenbach Foundation for Graphic Arts purchase, 1977.2.13

67. Odilon Redon *Bordeaux 1840-1916 Paris*

Orpheus, ca. 1905

Pastel on laid paper, affixed to canvas mount;
23⅜ × 18⅜ in. (595 × 468 mm). Signed twice: in red
crayon at lower right, *ODILON REDON*; and in graphite
at left of red signature, *Odilon R.*

PROVENANCE: Wildenstein & Co., New York, ca. 1955;
Frederick J. Hellman; bequest to California Palace of
the Legion of Honor.
BIBLIOGRAPHY: Phyllis Hattis, *Four Centuries of French
Drawings* (San Francisco: The Fine Arts Museums of
San Francisco, 1977), no. 308, p. 312, repr. p. 319;
Robert Flynn Johnson, "Masterpieces of French
Drawing," in Denys Sutton, ed., "The Fine Arts
Museums of San Francisco," *Apollo* (1980): 130-137,
no. 13, repr. p. 135.
EXHIBITION: California Palace of the Legion of Honor,
The Fine Arts Museums of San Francisco, *Selected
Acquisitions, 1977-1979*, 1979-1980, checklist, no. 48.

If it is considered poetic excess to label Redon's mature
work sublimely primitive and uniquely magical, it must
be regarded as fact that his use of pastel expanded the
potential of the medium beyond the realms of
portraiture, landscape, and still life to include the
depiction of mystical, dreamlike visions. Only in
eighteenth-century French drawings and watercolors by
artists such as Fragonard, Saint-Aubin, and Prud'hon
do we see some hint of Redon's approach to the
vaporous presentations of imaginary episodes. In
contrast, sixteenth- and seventeenth-century Italian art
gives us such stories without ever abandoning linear
definition: tightly rendered clouds like so many large
cotton balls and mystical light that usually travels in
beams.

But Redon employed pastel to do what it does best:
crumble and smudge, fuse and fade. Thus his
flamboyantly colored veils of smoke are virtually
amorphous, and they glow with an inner light,
fabricating a kind of sonorous sfumato to present and
envelop his gods and mythical scenes.

Odilon Redon was the pupil of the enigmatic
Rodolphe Bresdin, but almost certainly the startling
and often jewel-like paintings and watercolors of
Gustave Moreau (1826-1898) encouraged Redon's
more refined, more abstract color. From a technical
point of view, the artist's experimentation with clouds
of color recalls Turner, whose work Redon admired
greatly. But while Turner evolved a watercolor
technique that captured observed but evanescent
atmospheric effects, Redon developed his pastel style
to help conjure imaginary atmospheres and mystical
light.

In considering Redon's pioneering pastel technique, it
is important to realize that his drawings and prints were
much admired by the French symbolist circle of artists
and writers even before his novel pastels were known.
The subjects of his pastels, with the exception of
flowers, were well established in his earlier black and
white work.

The pastel in The Fine Arts Museums' collection is
one of Redon's numerous explorations of the Orpheus
theme, one especially suited to the tastes of symbolist
writers and painters.[1] The artist has shown the head of
Orpheus floating in a space behind his lyre. According
to the Greek myth, Orpheus, a worshipper of Apollo,
was killed by maenads at the urging of Dionysus,
Apollo's rival. Orpheus's head and lyre, still singing
bewitching music, floated to Lesbos where a shrine to
Orpheus was founded.

The style and palette suggest that the Museums'
pastel was executed circa 1905.

J. R. G.

Bequest of Frederick J. Hellman, 1965.29

68. Auguste Rodin *Paris 1840-1917 Meudon*

Nu aux jambes écartées, ca. 1900-1914

Graphite and watercolor on wove paper; 7¾ × 8¼ in. (197 × 210 mm). Signed at lower right: *A Rodin.*

PROVENANCE: Huguette Berès, Paris; Thackrey and Robertson Gallery, San Francisco, 1980.
EXHIBITION: California Palace of the Legion of Honor, The Fine Arts Museums of San Francisco, *Recent Acquisitions*, 1981.

Auguste Rodin, considered today to be the greatest sculptor since Michelangelo, was also a prolific and skilled draftsman. The Rodin Museum alone has approximately 7,200 works on paper. Drawings and watercolors were a vital part of Rodin's creative production. They were not used as studies for sculptures but existed separately, as independent works of art.[1]

"The sight of human forms feeds and comforts me. I have infinite worship for the nude."[2] With these words, Auguste Rodin expressed his obsessive desire to explore artistically the human body in all manner of poses. Spare yet expressive works, such as the watercolor *Nu aux jambes écartées*, sprang from Rodin's spontaneity and candor. Its speed and sureness of execution recall the sculptor Antoine Bourdelle's remark that Rodin's drawings "are always the expression of essential impulses."[3] Rodin has extended the outstretched woman, who balances on a single leg, until she challenges the borders at the top and sides of the sheet. Although she is in a reclining position, Rodin has created the illusion of an acrobatic standing pose. The figure is confidently delineated in sinuous pencil lines enriched by delicate watercolor washes.

Rodin's late drawings and sculptures that display genitalia are sometimes viewed as openly erotic and provocative, but this is inaccurate. Albert Elsen wrote of this watercolor, "The reclining figure may be construed by some as 'erotic' but I do not share that opinion. Rodin drew his models from all perspectives and you can see how in the reclining figure the model's form fills the field, and the pose gives Rodin a marvelous arabesque in depth. I do not believe Rodin was out to shock or titillate with this drawing. He was always searching for fresh movement and poses... Rodin did not shy from showing a woman's sex. Rodin's candor is that of modernism."[4]

R. F. J.

Achenbach Foundation for Graphic Arts purchase, 1980.2.18

69. Georges Seurat *Paris 1859-1891 Paris*

Woman Bending Viewed from Behind, ca. 1881-1882

Black crayon on laid paper; 12¼ × 9½ in. (311 × 242 mm).

PROVENANCE: Stephen Bourgeois Gallery, New York;
Marie Steiner, New York; American Art Association-
Anderson Galleries, New York, 1929; Rains Galleries,
New York, 1936; Henry Sykes, Chicago; Dr. T.
Edward and Tullah Hanley Collection; gift to
M. H. de Young Memorial Museum.
BIBLIOGRAPHY: Germain Seligman, *The Drawings of
Georges Seurat* (New York: Curt Valentin, 1947), no. 55,
pl. 43; D. C. Rich and R. L. Herbert, eds., *Seurat,
Paintings and Drawings*, exh. cat. (The Art Institute of
Chicago, 1958), no. 24; César de Hauke, *Seurat et son
œuvre*, vol. 2 (Paris, 1961), repr., no. 494; Phyllis Hattis,
Four Centuries of French Drawings (San Francisco: The
Fine Arts Museums of San Francisco, 1977), no. 263,
p. 284, repr. p. 289.
EXHIBITIONS: American Art Association-Anderson
Galleries, New York, 26 November 1929, no. 220; Rains
Galleries, New York, 23 April 1936, no. 74; M. Knoedler &
Co., New York, *Seurat 1859-1891*, 1949, no. 46; The
Art Institute of Chicago, *Seurat, Paintings and Drawings*,
1958, no. 24 (also The Museum of Modern Art, New
York, 1958); Wildenstein & Co., New York, *The
Dr. T. Edward and Tullah Hanley Collection*, and Fogg Art
Museum, Harvard University, 1961-1962, no. 110,
repr. p. 45 (also Gallery of Modern Art, New York;
Philadelphia Museum of Art; The Denver Art
Museum, 1967-1968, repr. p. 43; Museum of the
Southwest, Midland, 1967, no. 27; Columbus Gallery of
Fine Arts, 1968, no. 106; Canisius College, Buffalo, 1969,
no. 193; M. H. de Young Memorial Museum, San
Francisco, 1970, no. 132, pl. 29, p. 53); California Palace
of the Legion of Honor, The Fine Arts Museums of San
Francisco, *The Barbizon Tradition*, 1977; idem, *Nineteenth
Century French Drawings from the Permanent Collection*,
1978; idem, *Masterworks from the Achenbach Foundation
for Graphic Arts*, 1981; Kunsthalle, Bielefeld, *Georges
Seurat, Zeichnungen*, exh. cat. by Erich Franz and Bernd
Growe, 1983, no. 29, p. 184, repr. (also Staatliche
Kunsthalle, Baden-Baden, 1984).

During the time from 1881 to 1884, after his return
from military service at Brest, Georges Seurat's

draftsmanship underwent a profound transformation. In
these years he began to use conté crayon applied in
built-up layers of tonal shading on thick, rough-textured
Michallet paper. The subjects of these radically
rendered drawings are revealed in terms of light and
shadow, rather than line.

Instead of the often random jottings of his early
sketchbooks, Seurat began to focus on the creation of
austere yet intense landscapes and figurative
compositions. These drawings are carefully balanced
and methodically composed. No matter how indistinct
the subject, they evoke a sense of completeness. John
Russell writes that this rapid maturation of artistic
sensibility is exemplified by the way in which Seurat
"learned to take a small fragment of everyday life and
isolate and simplify it." [1]

The subject of our drawing is a woman with her back
to us, bending over before what appears to be a
grillwork fence. Shrubbery is indicated at the lower left
and right. The figure's contour is emphasized through
Seurat's use of what he called "irradiation," surround-
ing dark objects with light tones or light objects with
dark tones to create a greater dynamic within the
drawing. In our sheet, he has accomplished this by
putting an aura of light tonality around the dense
silhouette of the woman.

This work is related to a series of early drawings and
small oil studies of bending figures. They derive in part
from Seurat's interest in Jean-François Millet's
paintings of toiling farmworkers. Despite previous
dating of this drawing to about 1886,[2] it clearly should
be placed among a group of austere, moody
compositions of single figures from the years 1881 and
1882.[3] The depiction of solitary figures, often evoking
an air of subdued alienation, is present, however,
throughout Seurat's œuvre. It is remarkable that this
artist, whom Germain Seligman referred to as "a poet of
the light," should have produced so many visions of
detached isolation.[4]

R. F. J.

*Memorial gift of Dr. T. Edward and Tullah Hanley,
Bradford, Pennsylvania, 69.30.187*

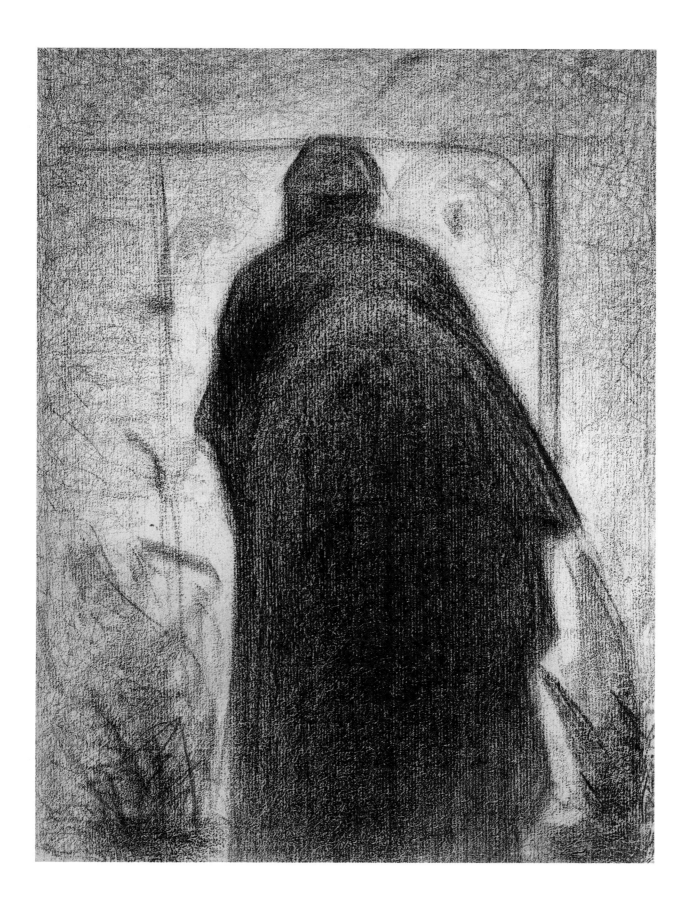

70. Georges Seurat *Paris 1859-1891 Paris*

Study for "La parade de cirque," ca. 1887

Black crayon on laid paper; 9⅛ × 12⅛ in. (233 × 308 mm). Inscribed in graphite on verso: *G. Geffroy* [Gustave Geffroy, the critic]; in blue crayon: *G. Seurat / B* [Maximilien Luce]; in orange chalk: *281* [estate number].

PROVENANCE: Estate of the artist; Félix Fénéon, Paris; Wildenstein & Co., New York; California Palace of the Legion of Honor purchase.
BIBLIOGRAPHY: P. Mabille, "Dessins inédits de Seurat," *Minotaure*, 3rd ser., 5, no. 11 (15 May 1938): 3, repr.; Umbro Apollonio, *Disegni de Georges Seurat* (Venice, 1947), p. 12, pl. XX entitled "Saltimbanchi;" Jermayne MacAgy, "Seurat: Master-Draftsman," *Bulletin of the California Palace of the Legion of Honor* (July 1947): 19-23; Robert L. Herbert, *Seurat's Drawings* (New York: Shorewood Publishers, 1962), p. 123, no. 107, repr.; César de Hauke, *Seurat et son œuvre* (Paris: Gründ, 1962), no. 675, repr.; André Chastel and F. Minervino, *L'opera completa di Seurat* (Milan: Rizzoli, 1972), pp. 106-107, D. 55, repr.; Phyllis Hattis, *Four Centuries of French Drawings* (San Francisco: The Fine Arts Museums of San Francisco, 1977), no. 264, p. 285, repr. p. 290; Robert Flynn Johnson, "Masterpieces of French Drawing," in Denys Sutton, ed., "The Fine Arts Museums of San Francisco," *Apollo* (1980): 130-137, no. 17, repr. p. 137.
EXHIBITIONS: For extensive exhibition history, see notes for this entry, p. 226.

This drawing is from a series of studies that Seurat made during the winter of 1886-1887 for the canvas *La parade*, completed in 1888, now in The Metropolitan Museum of Art, New York. Like many other Parisian artists and poets of his generation, Seurat was attracted to street fairs, circuses, café-concerts, and other forms of urban entertainment.[1] In an earlier drawing, *Clowns at Poney* (CdH 668), 1882-1883, now in the Phillips Collection, Washington, D.C., Seurat first developed the motif of clowns on a stage that suggested spatial recession, with a foreground crowd

and architectural backdrops. In our drawing, however, the composition has been reduced to the barest essentials. As Robert Herbert observed, "There are no diagonal movements; the individual forms are flat, and stand against the single plane of the background; their edges are smooth and unbroken, like those of Egyptian bas-relief. Space is further reduced...by the elimination of any foreground."[2]

The abstract tonality of this drawing recalls John Rewald's comment that Seurat's "vision always made him perceive values before lines, that it would never occur to him to start a canvas with a line."[3] Despite the universalization of the figures, only the shadowy figure on the right is clearly not in circus garb. Because focus and detail are excluded, the personalities of these performers are revealed through shape and pose alone.

The light clothing and dark, rounded hat of the clown on the right are in contrast to the dark trousers and white, conical hat of his partner. As Herbert has observed, the two central figures are a study in tonal and structural opposites forming a balance of contrasts.[4] The outstretched arm linking the two clowns is a rare example of the depiction of physical contact in Seurat's œuvre. Except for another study of *La parade* that shows dancers with linked hands (CdH 384), Seurat allowed the intimacy of touch only in those scenes that depict women (mothers or nursemaids) and children.[5] It is not that Seurat allowed the cerebral nature of his art to exclude the emotional, but rather that his view of the world was one of order and rationality, which tended to exclude warm emotion in favor of cool detachment.

George Seurat's drawings stand on their own as one of the significant artistic achievements of the nineteenth century. His friend Paul Signac called them "the most beautiful painter's drawings that ever existed."[6] In developing a new way of drawing, utilizing a concentration on tonality and interplay of structure, Seurat is revealed as a precursor of the great modern movements of twentieth-century art.

R. F. J.

Archer M. Huntington Fund, 1947.1

71. Henri de Toulouse-Lautrec *Albi 1864-1901 Malromé*

Au cirque: Cheval pointant, 1899

Black chalk with orange and yellow crayon additions on wove paper; 14 × 10 in. (357 × 254 mm). Inscribed with monogram in chalk at lower left. Stamp of atelier in pale red ink at lower right (Lugt 1338).

PROVENANCE: Maurice Joyant; M. Knoedler & Co., New York; Charles F. Fuller, 1937; Jane Canfield, 1940; Blair Fairfield Fuller, San Francisco; Hansen-Fuller Gallery, San Francisco; Achenbach Foundation for Graphic Arts purchase.

BIBLIOGRAPHY: Arsène Alexandre, *Au Cirque* (Paris, Manzi-Joyant, 1905), no. 12, repr.; M. G. Dortu, *Toulouse-Lautrec et son œuvre*, vol. 6 (New York, Collectors Editions, 1971), p. 834, no. D.4.533; Robert Flynn Johnson, "Masterpieces of French Drawing," in Denys Sutton, ed., "The Fine Arts Museums of San Francisco," *Apollo* (1980): 130-137, no. 15, repr. p. 136.

EXHIBITIONS: Musée des Arts Décoratifs, Paris, 1931, no. 253; M. Knoedler & Co., New York, *Toulouse-Lautrec, Paintings, Drawings, Posters*, 1937, no. 48; California Palace of the Legion of Honor, The Fine Arts Museums of San Francisco, *Recent Acquisitions, 1976-1977*, 1977; The Denver Art Museum, *Masterpieces of French Art from The Fine Arts Museums of San Francisco*, checklist by Denys Sutton, 1978 (also Wildenstein & Co., New York, 1979; and The Minneapolis Institute of Arts, 1979); California Palace of the Legion of Honor, The Fine Arts Museums of San Francisco, *Nineteenth Century French Drawings from the Permanent Collection*, 1978; idem, *Masterworks from the Achenbach Foundation for Graphic Arts*, 1981; idem, *Animals Real and Imagined*, 1982.

In 1899 Henri de Toulouse-Lautrec suffered a series of attacks of partial amnesia along with other ailments brought on by alcoholism. In early March that year his mother had him committed to the Saint James Clinic, a sanitarium in Neuilly outside of Paris, where he remained for seventy-one days. By the end of March, Lautrec had recovered his faculties and, through the aid of his friends Maurice Joyant and Joseph Albert, transformed his hospital room into a studio with paper, pens, crayons, watercolors, and even lithographic stones.

Joyant recounts that he and the artist conspired to convince the doctors that Lautrec was well enough to leave.[1] Joyant's plan was that Lautrec execute a series of highly finished drawings, based on his memories of the circus, that would display his full recovery. The result was a series of thirty-nine drawings (Dortu 4522-4560) that are considered among the most brilliant examples of Lautrec's draftsmanship. Lautrec's friend Arsène Alexandre wrote of this series in 1905 that "the circus scenes presented here are among his most extraordinary works, executed altogether from memory, without documentation, without preliminary sketches, without notes, references, or models of any kind; they are a real miracle of plastic intelligence.... Composition, the characterization of various types, humour, breadth of execution, everything that entered into Lautrec's talent, are all found or rather refound in these drawings, in which certain exaggerations in proportion only confirm the sincerity and intention of this venture, the triumph of this memory, the soundness of this painter's faculties."[2]

Lautrec was introduced to the world of the circus at an early age, and throughout his career he returned to it as subject matter, always infusing these works with a sense of fresh, childlike fascination. Among the popular Parisian circuses of the day, Lautrec preferred the Cirque Fernando in Montmartre and the more chic Cirque Nouveau on the rue Saint-Honoré, although he also attended performances at the Cirque d'Hiver and the private Cirque Molier.[3] In addition to their aesthetic merit, Lautrec's circus drawings and paintings provide an invaluable record of an extraordinary facet of *fin de siècle* Parisian life.

Au cirque: Cheval pointant is one of the most dramatic works of the series. In a spotlighted circus ring before empty bleachers, a diminutive ringmaster theatrically goes to one knee as the obedient horse rears to the snap of his whip. The preliminary black chalk *pentimenti* surrounding the horse's legs gives an added touch of motion to this work. In a display of admirable restraint, Lautrec has employed only subtle touches of orange and yellow crayon to complement the black chalk that defines this powerful drawing. Like the other circus drawings, Lautrec signed our sheet with his monogram, and in this case, he placed it in the lower left corner. Lautrec could not resist the temptation of adding his monogram again by scratching it into the dust in the center of the circus ring.

R. F. J.

Elizabeth Ebert and Arthur W. Barney Fund, 1977.2.5

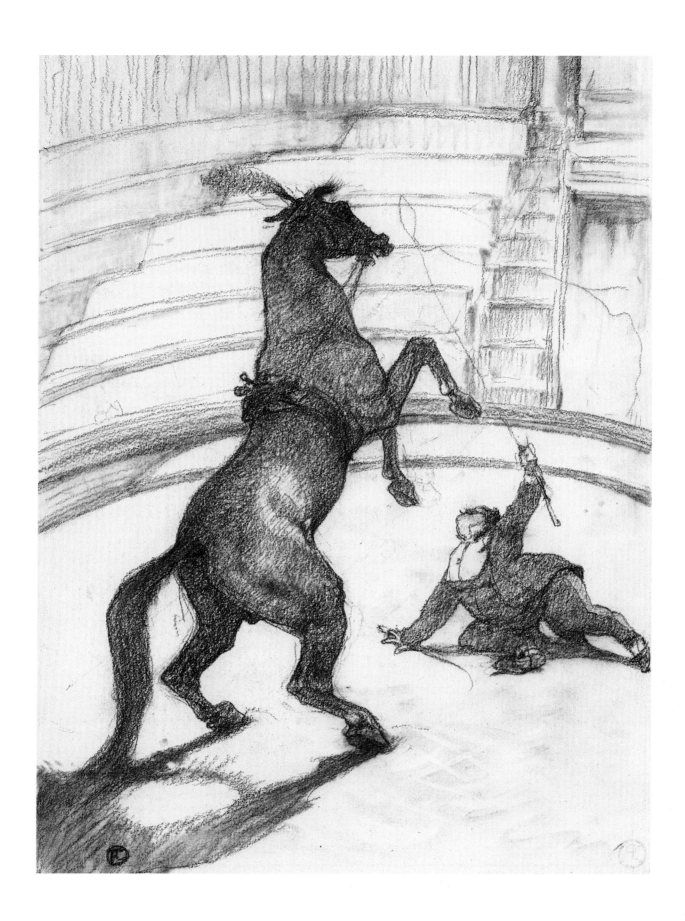

72. Henri de Toulouse-Lautrec *Albi 1864-1901 Malromé*

Au cirque: Ecuyère de haute école – Le salut (The Bow), 1899

Black chalk on wove paper; 14 × 10 in. (357 × 254 mm).
Inscribed with monogram in graphite at upper right.
Stamp of atelier in pale red ink at lower right
(Lugt 1338).

PROVENANCE: Maurice Joyant, Paris; M^{me} Dortu,
Paris; Gerstenberg, Berlin; M. Knoedler & Co., Berlin,
1931; Mr. and Mrs. Frederick Beckman, New York,
1944; M. Knoedler & Co., New York, 1953; Dr. T.
Edward and Tullah Hanley Collection; gift to
M. H. de Young Memorial Museum.
BIBLIOGRAPHY: Arsène Alexandre, *Au Cirque* (Paris,
Manzi-Joyant, 1905), no. 17, repr.; M. G. Dortu,
Toulouse-Lautrec et son œuvre, vol. 6 (New York: Col-
lectors Editions, 1971), p. 844, no. D.4.538; Phyllis
Hattis, *Four Centuries of French Drawings* (San Francisco:
The Fine Arts Museums of San Francisco, 1977), no. 267,
p. 291, repr. p. 294; M. Moskowitz and M. Sérullaz,
Drawings of the Masters: French Impressionists (New York,
1962), p. 113, repr.
EXHIBITIONS: Knoedler Galleries, New York, *The Circus
by Toulouse-Lautrec*, 1931, no. 16; Louvre, Paris, *Toulouse-
Lautrec Exhibition*, 1931, no. 258; Wildenstein & Co.,
New York, *The Dr. T. Edward and Tullah Hanley Col-
lection*, and Fogg Art Museum, Harvard University,
1961-1962, no. 116, repr. p. 43 (also Gallery of Modern Art,
New York; Philadelphia Museum of Art; The Denver
Art Museum; and Museum of the Southwest, Midland,
1967-1968, no. 29; Columbus Gallery of Fine Arts, 1968,
no. 107; Canisius College, Buffalo, 1969, no. 195;
M. H. de Young Memorial Museum, San Francisco,
1970, no. 133, pl. 28, p. 52); for additional exhibitions,
1937-1964, see bibliography: M. G. Dortu; The Denver
Art Museum, *Masterpieces of French Art from The Fine Arts
Museums of San Francisco*, checklist by Denys Sutton,
1978 (also Wildenstein & Co., New York, 1979; The
Minneapolis Institute of Arts, 1979); California Palace of
the Legion of Honor, The Fine Arts Museums of
San Francisco, *Nineteenth Century French Drawings from
the Permanent Collection*, 1978; idem, *Masterworks from the
Achenbach Foundation for Graphic Arts*, 1981.

Although less dramatic than the Achenbach's other
work from this series (cat. no. 71), *Au cirque: Ecuyère de
haute école – Le salut (The Bow)* is more radical in its
composition, and its spare linearity has psychological
overtones.

In all but one of the thirty-nine drawings of the circus
series, the performers are depicted either in isolation or
before empty stands.[1] One explanation for this is that
Lautrec, working from memory, concentrated on the
main characters and background and could not be
bothered to fill the stands with a repertoire of spectators.
Nevertheless, the absence of spectators gives our sheet a
stark, surreal quality. For whom has the equestrienne
just performed and who is receiving her bow? This is
not the circus as public spectacle but a private command
performance. Although these drawings are thought to
have been done completely from memory, William Seitz
has suggested that during his medical treatment Lautrec
may have been allowed to visit the private Cirque Molier
on the rue Bénouville.[2] Founded in 1880 by Ernest
Molier, the circus was noted for its trained horses, and
its famous leading equestrienne, Blanche Allarty, who
later became M^{me} Molier. It is possible that Lautrec has
made her the subject of our drawing.

Unlike most of the other drawings in the series, which
are heightened with watercolor, pastel, or colored
crayon, Lautrec has restricted himself to black chalk in
our sheet. The absence of color heightens the severe
linearity of the work.

The expanse of the ring (traditionally, thirteen meters
wide) is suggested by the emptiness of the foreground.
The curvilinearity of the empty stands is abruptly cut
off by the entryway, which leads the eye directly
to the imposing amazonlike equestrienne bending in an
awkward bow. In the background, a beautifully
delineated horse is led away by a groom whose figure is
radically cropped. This work is both plausible in its
reality and mysterious in its vacuity. Disturbing over-
tones in these drawings were also noticed by Lautrec's
contemporaries, including his friend Yvette Guilbert,
who said the circus drawings "give one a feeling of
nightmare... the ring has become a tragic circle where
howling madness leads the game of beasts and men."[3]
Nevertheless, these *tour de force* circus drawings were
largely responsible for the doctors' decision to release
the artist. "I have purchased my liberty with my
drawings," Lautrec exclaimed to his friend, Joyant.[4]
Tragically, however, the artist soon reverted to his
dissolute habits and died twenty-eight months later on
9 September 1901.

R. F. J.

*Memorial gift from Dr. T. Edward and Tullah Hanley,
Bradford, Pennsylvania, 69.30.118*

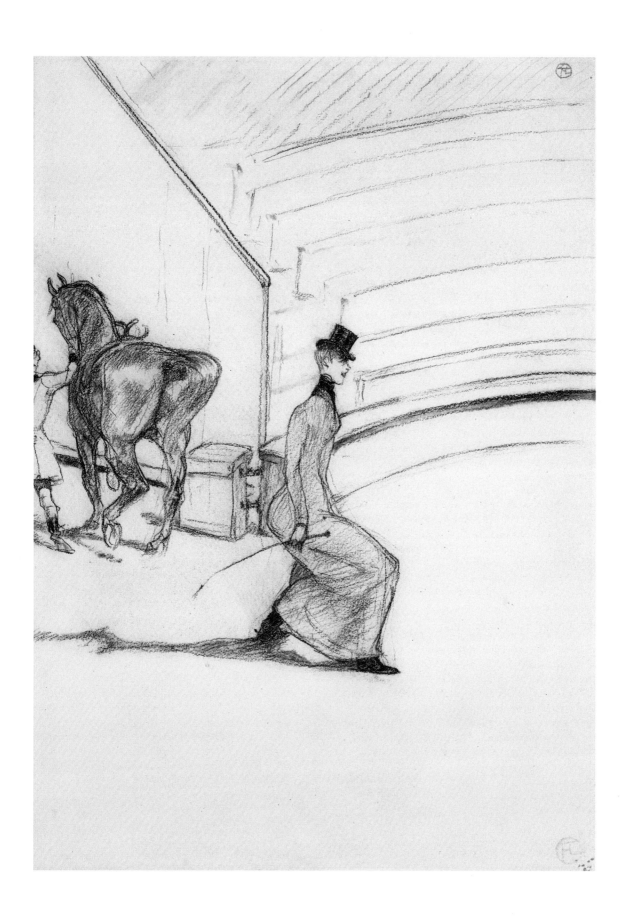

73. William Blake *London 1757-1827 London*

The Complaint of Job, ca. 1786

Gray wash on thin wove paper; 12¼ × 18⅞in.
(324 × 480mm).

PROVENANCE: Mrs. Blake; Frederick Tatham;
Sotheby's, 29 April 1862, lot 164; F. T. Palgrave;
E. Parsons; W. Graham Robertson, 1906; Christie's,
22 July 1949, lot 17; Schwartz; Dr. T. Edward and
Tullah Hanley Collection; gift to M. H. de Young
Memorial Museum.
BIBLIOGRAPHY: Joseph R. Goldyne, "British Art at San
Francisco," in Denys Sutton, ed., "The Fine Arts
Museums of San Francisco," *Apollo* (1980): 122-129,
no. 8, repr. p. 126; Martin Butlin, *The Paintings and
Drawings of William Blake*, (New Haven: Yale
University Press, 1981), no. 164, p. 62, pl. 201.
EXHIBITIONS: Carfax Galleries, 1906, no. 63B;
Manchester, 1914, no. 15; Tate Gallery, 1947, no. 77;
Bournemouth, Southhampton, and Brighton, 1949,
no. 24; Washington, D.C., 1957, no. 11; Philadelphia,
1957; Buffalo, 1960, no. 34; Wildenstein & Co., New
York, *The Dr. T. Edward and Tullah Hanley Collection*,
and Fogg Art Museum, Harvard University, 1961-1962,
no. 35 (also Gallery of Modern Art, New York and
Philadelphia Museum of Art, 1967; Columbus Gallery of
Fine Arts, 1968, no. 114; M. H. de Young Memorial
Museum, San Francisco, 1970, no. 169, p. 24);
University Art Museum, Berkeley, *William Blake:
Graphic Works*, 1974; California Palace of the Legion of
Honor, The Fine Arts Museums of San Francisco,
Masterworks from the Achenbach Foundation for Graphic Arts,
1981; idem, *William Blake and His Followers*, 1982-1983.

During the last quarter century an avalanche of books,
exhibitions, and symposia devoted to William Blake as
poet, watercolorist, and printmaker has given the artist
an aura of rather intimidating proportions. In the San
Francisco Bay Area alone, his sincere admirers have
included some of our most noted poets. Allen Ginsberg
even reported a Blake-like eidetic event in which a vision
of the artist came to him and sang his songs, inspiring
Ginsberg himself to sing the *Songs of Innocence and
Experience*, both in public and on records. Robert
Duncan and Gary Snyder also have been influenced by
the English poet-painter and Duncan has stated that
"Blake is father of us all."[1]

Despite his following, embarrassingly swollen by
throngs of sixties "flower children" in search of materia
psychedelica, Blake is not an easy artist to know. His
pictorial works by no means speak for themselves,
except insofar as his unique color sense and mannered
drawing can be delightful and occasionally wondrous.

For many artists those qualities are sufficient, but
Blake sometimes demands more serious regard for
his subject. When that subject is of Blake's invention,
considerable study might be essential. The magnif-
icent grisaille watercolor belonging to The Fine Arts
Museums, however, does not present this problem. *The
Complaint of Job* is derived from the Book of Job 7:17-18.
After losing his children and his possessions and then
enduring an attack of boils, Job begs God for jus-
tification: "What is man that thou...shouldest try him
every moment?"

One of Blake's most impressive and highly finished
early drawings, *The Complaint* is most notable for
its flowing composition, established by curvilinear
passages of light and line. These passages produce a
dynamic equilibrium in which tension and movement
are orchestrated to provide balance and focus. Like the
Book of Tobit for Rembrandt, the Book of Job was for
Blake a splendid source of pictorial inspiration, and the
artist used it throughout his career. His most perfect
graphic work in many ways was the *Book of Job*
comprised of twenty-one etchings commissioned by
John Linnell in 1823.

An engraving based on either the Museums' *Complaint
of Job* or a related painting, now lost, was made by
Blake, and only the single, known impression of the first
state of the print retains the emotional intensity of the
drawing. Regrettably, that impression has been trimmed
along its lower margin so that there is now no indication
of a date; had a date existed, it might have helped to
substantiate the dating of our sheet.[2] On stylistic
grounds, our drawing appears to have been done from
about 1786 to 1790. The second state of the print, though
completely reengraved and devoid of the concentrated
vigor of the first-state engraving, is dated 1793 and titled
*JOB / What is Man that Thou Shouldest Try him Every
Moment?*

J. R. G.

*Memorial gift from Dr. T. Edward and Tullah Hanley,
Bradford, Pennsylvania, 69.30.215*

74. Thomas Shotter Boys *London 1803-1874 London*

Landscape with a Lockgate, ca. 1833

Watercolor over graphite underdrawing and scraping out on wove paper; 6½ × 6 in. (165 × 153 mm).

PROVENANCE: Private collection; Morton Morris & Co. Ltd., London; Davis and Langdale, Inc., New York.

Thomas Shotter Boys was a brilliant topographical watercolorist and an innovative force in the history of lithography. His reputation, however, only now is emerging properly in histories of nineteenth-century English art.

Little is known of Boys's personal life and character. At fourteen he began his training as an engraver. He traveled to France in 1825, and in Paris met the brilliant and influential artist Richard Parkes Bonington who, in the last three years of his short life, became a friend and mentor to Boys. Bonington encouraged Boys to take up watercolor, and he advised him to forego graphite underdrawing for direct line drawing with a brush as well as to lay down washes of broken granular color. Boys's reputation has suffered from the misconception that he was merely an imitator of Bonington. Clearly, Boys was influenced by Bonington at the time but so also were other artists, such as William Callow, James Holland, Eugène Delacroix, and Camille Corot.

Only after Bonington's death in 1828 did Boys enter his most creative period, which lasted until 1839. Working on a small scale, as he did best, Boys produced at this time a series of crisply executed watercolor views of Paris and its environs and scenes of rural England. In 1839 he published the superb series of twenty-six color lithographs *Picturesque Architecture in Paris, Ghent, Antwerp, and Rouen*. These works mark Boys as the first artist to utilize registered stones for printing lithographs in complicated color arrangements. These prints are considered an original and innovative development in the history of lithography. Nothing comparable was produced in color printing until the revival of lithography in France at the end of the century by artists such as Chéret and Toulouse-Lautrec. Boys followed up the success of that series with the publication of *Original Views of London As It Is* in 1842. In this series he abandoned color printing because of its expense and instead produced monochrome lithographs that were then hand-colored. From the mid-1840s, Boys's career declined precipitously, and he was forced to take hack-

work engraving commissions, including work on John Ruskin's *Modern Painters* and *The Stones of Venice*. Ruskin, however, never mentioned Boys in his critical writings, and, as H. Stokes commented, "his word was law to the wealthy collectors of the 'fifties and 'sixties. The word was not given, and Thomas Shotter Boys passed slowly into oblivion."[1] Boys died in London in 1874 with less than one hundred pounds to his name, a tragic victim of critical neglect and shifting fashions in art.

Landscape with a Lockgate, dated by James Roundell about 1833, is an example of Boys at the height of his creative powers. With minimal underdrawing, the artist has applied multiple, thin washes in building up the structure of the work. Boys habitually used his thumb to give texture to the surface, as he did in the trees at the right and middle of the landscape. The single flash of red applied to one of the figures adds a dynamic element to a work that is otherwise restrained in tone. Although intimate in scale, this watercolor is broadly conceived with an extensive landscape on the right opposed by a dark clump of trees on the left. The lockgate is central to the composition, and beyond it the mast of a small boat indicates a lower water level. An animal and two indistinct figures enliven and give scale to the work. All are exquisitely mirrored in the foreground water as birds fly through an uncertain sky. Boys has created a subtle evocation of pastoral England. James Roundell could have been referring to this watercolor when he wrote, "He concentrates his attention on the portrayal of the atmosphere of the scene at a precise moment; the forms of the figures have been stopped for an instant in their passage across the picture, the scudding clouds he has captured in a few quick and fluid washes of blue. His style is one of instinct; he paints what his highly sensitive emotions register."[2]

R. F. J.

Purchase, gift of Ardys and Robert Allport, Mr. and Mrs. Harry W. Anderson, Innis Bromfield, Mrs. Alexander de Bretteville, Mr. and Mrs. Charles D. Field, the Goldyne family, Mrs. Covington Janin, Mr. and Mrs. John Lowell Jones, Mr. and Mrs. Walter S. Newman, Mrs. Ernst Ophuls, Mrs. Julian L. Peabody, Mr. and Mrs. Adolph S. Rosekrans, Mrs. Martin Skewes-Cox, Mrs. Louis Sloss, Elizabeth S. Tower, and Achenbach Foundation for Graphic Arts, 1983.2.47

75. Edward Burne-Jones *Birmingham 1833-1898 London*

The Tree of Forgiveness–A Mosaic in Rome (design for The Tree of Life mosaic in the American Church, Rome), 1891

Black, blue, gray, and white chalk with metallic paint on green wove paper; left panel, 15⅞ × 8 in. (415 × 203 mm); center panel, 17⅞ × 12¼ in. (453 × 311 mm); right panel, 16½ × 8⅛ in. (420 × 206 mm). Inscribed in graphite: on left panel *ADAM*; on center panel, *THE TREE OF FORGIVENESS*; on right panel, *A MOSAIC IN ROME, EVE*, and initialed and dated, *EBJ 1891*.

PROVENANCE: Christie's, London, 16 and 18 July 1898; Dr. T. Edward and Tullah Hanley Collection: gift to M. H. de Young Memorial Museum.
EXHIBITIONS: Fine Arts Society Gallery, London, *Drawings and Studies by Sir Edward Burne-Jones, Bart.*; Wildenstein & Co., New York, *The Dr. T. Edward and Tullah Hanley Collection*, and Fogg Art Museum, Harvard University, 1961-1962 (also Gallery of Modern Art, New York; Philadelphia Museum of Art; The Denver Art Museum; and Museum of the Southwest, Midland, 1967-1968; Columbus Gallery of Fine Arts, 1968; Canisius College, Buffalo, 1969; M. H. de Young Memorial Museum, San Francisco, 1970, no. 59, p. 16); California Palace of the Legion of Honor, The Fine Arts Museums of San Francisco, *Masterworks from the Achenbach Foundation for Graphic Arts*, 1981.

Edward Burne-Jones was one of the most successful and acclaimed artists in England, yet he died a disillusioned man. His art was inspired by dreamlike visions of mythology, Christianity, and the Arthurian legends, and his works were an obsessive glorification of languid beauty. Burne-Jones, however, felt that his idealized art had become obsolete in a world increasingly devoted to science, reason, and materialism. He lamented, "A pity it is I was not born in the Middle Ages. People would then have known how to use me."[1]

The early works of Burne-Jones show heavy Pre-Raphaelite influence, notably that of Dante Gabriel Rossetti with whom he studied in 1855 and 1856. On the recommendation of Rossetti, Burne-Jones traveled to Italy in 1859 to widen his artistic experience, and he accompanied John Ruskin on another visit there in 1862. As a result of these trips, Burne-Jones became devoted to the art of the *quattrocento*, especially the works of Mantegna, Michelangelo, and above all Botticelli. From the early 1860s until the end of his career, the spirit of their examples infused his art, which was notable for its complex compositions, degree of finish, color, subtlety, and air of melancholy.

In 1891, recovering from a serious illness, Burne-Jones finished a series of designs that he began in 1882

for mosaic decorations of the American Church in Rome. Enthusiastic about the project, he said, "It is to be in Rome, and it is to last for eternity."[2] *The Tree of Forgiveness* is a preliminary drawing for *The Tree of Life* mosaic, referred to in contemporary accounts of the designs as "the most beautiful of all, and the most stamped with Burne-Jones's individuality–executed in the space above the chancel arch."[3]

Burne-Jones was a prolific draftsman who recognized his best drawings as a significant aspect of his creativity, carefully signing and dating many of them. Our elaborately finished drawing is signed, dated, and inscribed with the identification of Adam and Eve, and titled *The Tree of Forgiveness–A Mosaic in Rome*. Only the squaring of the drawing behind the figure of Adam marks this a working design for the mosaic. The three sheets consist of a praying Adam on the left, Christ in the center, and Eve on the right holding a child, and they form a triptych linked by the outstretched arms of Christ in an act of benediction. A curvilinear Tree of Life drawn in gold metallic ink flows from one sheet to the other in an Art Nouveau stylization.

For Burne-Jones, human beauty was always embodied in female characteristics. Consequently, the figures of Christ and Adam are decidedly effeminate. There is, however, a curious lack of sexuality in the androgynous nudity of all three elongated figures that is typical of Burne-Jones. Although beautifully drawn and composed, the essential meaning of this religious idealization ultimately wavers between profundity and decoration.

Highly influential in Germany and France as well as in his native England during the 1880s and 1890s, Burne-Jones served as a link between the earlier Pre-Raphaelites and the contemporary exponents of Symbolism and Art Nouveau. In the twentieth century, his reputation has undergone a series of critical setbacks and rejuvenations, based in part on the difficulty art historians have had in reconciling the obvious sincerity of Burne-Jones's artistic ideals and admirable mastery of drawing and composition with the skepticism of our age toward an art based on rarefied depictions of an escapist world of myth and dream. The artist William Rothenstein, who knew Burne-Jones in his later years expressed this dichotomy when he wrote, "I, too, was aware of certain weaknesses; but no man who can draw and design so nobly and thereby impress his vision on the world is to be swept aside."[4]

R. F. J.

Memorial gift from Dr. T. Edward and Tullah Hanley, Bradford, Pennsylvania, 69.30.18 a-c

76. John Sell Cotman *Norwich 1782-1842 London*

Tower of Tilney, All Saints' Church, Norfolk, ca. 1818

Watercolor over graphite underdrawing on textured wove paper; 11⅛ × 8¼ in. (282 × 210 mm). Signed and numbered in brown ink at lower left: *467 Cotman*, and inscribed in graphite at bottom center: *Tilney*.

PROVENANCE: Reverend James Bulwer (?); Walker's Galleries, London, 1922, no. 26; Mr. H. M. Horsley; Anthony Reed, London; Achenbach Foundation for Graphic Arts purchase.
BIBLIOGRAPHY: Joseph R. Goldyne, "British Art at San Francisco," in Denys Sutton, ed., "The Fine Arts Museums of San Francisco," *Apollo* (1980): 122-129, no. 10, repr. p. 128.
EXHIBITIONS: California Palace of the Legion of Honor, The Fine Arts Museums of San Francisco, *Selected Acquisitions, 1977-1979*, 1979-1980, checklist, no. 18; idem, *Masterworks from the Achenbach Foundation for Graphic Arts*, 1981.

John Sell Cotman created a style that is one of the most recognizable in the history of English watercolor.[1] Like that of Francis Towne (ca. 1739-1816), it appeals to modern sensibilities that have absorbed the analytic vision of Cézanne's watercolors. This does not suggest that Cotman or Towne were English prophets of Cézanne, but rather it recognizes their concern at an earlier time for the evaluation and clarification of structure. Cézanne certainly had sufficient French examples, such as Poussin, to turn to in this regard, yet no earlier French artist seemed directed toward the degree of simplification or sense of clarity achieved by Towne and Cotman.

Towne and Cotman, of course, differ in many ways. Most significant are their differing attitudes toward composition. Towne stresses the sweep of the landscape and almost always gives a secondary role to man-made structures. In contrast, Cotman concentrates on more confined vistas that very often include buildings, bridges, and figures. In his own time he achieved a degree of fame because of his unique approach to architectural compositions, and he attracted many followers.[2]

Tower of Tilney, All Saints' Church, Norfolk is a striking example of John Sell Cotman's architectural rendering in watercolor. The stepped tower is centrally located and dramatically presented, which emphasizes its looming presence in the meadow. The man sitting on the foreground bank as well as the little dog and its reflection in the water are used for contrast. Foliage encircling the tower is treated as a series of subtly colored flat masses, as are the clouds, arranged in patterns calculated to stress the position and height of the tower.

Executed toward the middle of Cotman's career, the Museums' sheet was etched by him as part of the ambitious *Antiquities of Norfolk* published in 1838. This etching was one of fifty plates that comprised the third series of the *Antiquities*, subtitled "Specimens of Castellated and Ecclesiastical Remains in the County of Norfolk."[3] In his well-known prints, the artist chose short, fine lines to fill the areas so simply indicated by wash in the watercolors.

J. R. G.

Elizabeth Ebert and Arthur W. Barney Fund, 1977.2.11

77. David Cox *Birmingham 1783-1859 Harborne*

Stonehenge–A Storm Coming On, ca. 1825

Watercolor over traces of graphite underdrawing on
wove paper; 9½ × 14⅛ in. (243 × 361 mm). Watermark: *?
& Allnut 1823*. Inscribed on verso: *DC* and *Stonehenge*.

PROVENANCE: H. C. Green; his sale, Sotheby's,
London, 18 October 1961, lot 179; Rev. E. P. Baker,
F.S.A.; Society of Antiquaries, London; Sotheby's,
London, 19 November 1981, lot 196; Andrew Wyld,
London, 1981.
EXHIBITION: California Palace of the Legion of Honor,
The Fine Arts Museums of San Francisco, *Recent
Acquisitions, Part I*, 1983.

The correct attribution of many nineteenth-century
English watercolors is often made more challenging
because of the considerable influence of certain teachers
of this medium. The Museums' *Stonehenge–A Storm
Coming On* illustrates the point well. Recently attributed
to William Turner of Oxford (1789–1862), so-called to
distinguish him from the renowned J. M. W. Turner,
the dramatic view of the great megalithic circle, north of
Salisbury, Wiltshire, can be given quite assuredly to
David Cox.

One of the leading figures of the English School, Cox
learned much from his teacher, John Varley. Varley's
style, somewhat like that of Francis Towne before him,
emphasized the simplification of landscape forms by
establishing essential masses with delicate washes of
color. The most successful examples of this approach
treated broad vistas with an emphasis on atmospheric
perspective and subtle texture.

David Cox built quite directly on Varley's method in
the watercolors of his early maturity, but unfortunately
this period remains little known in Cox's development.
It may be exemplified best by the Museums' recently
acquired *Stonehenge*.

The attribution of this sheet to William Turner of
Oxford, also a Varley pupil, was probably based more
on the subject of the work than on its style, for, like
others, Turner painted the celebrated Neolithic or
Bronze Age site numerous times. The handling of the
medium, however, is contrary to what one expects of his
work. Rather, it accords perfectly with the Varleyesque
spirit of David Cox's watercolors of the 1820s. Further-
more, a large exhibition watercolor of 1824 by Cox,
Shepherds Collecting their Flocks, Herefordshire, recently
seen by this writer, provides excellent evidence to
support Cox's authorship of *Stonehenge*.[1] The cloud
passages and foreground details of vegetation, in
particular, demonstrate identical treatment–a com-
bination of blotting, scraping, and wet-color removal
by means of a moist, clean brush.

Best known for his later, feathery technique, some-
times referred to as an impressionist style, Cox also was
esteemed for the clear, sparkling manner seen in the
Museums' *Calais Pier* (cat. no. 78). Without question,
his was a problematic versatility, for too many of his
works succeeded in achieving only competent results, in
either their conception or treatment. Nevertheless, when
inspired David Cox created memorable watercolors and
oils, among which *Stonehenge* should be included.

J. R. G.

Achenbach Foundation for Graphic Arts purchase, 1982.2.60

78. David Cox *Birmingham 1783-1859 Harborne*

Gray Day, Calais Pier, ca. 1845

Watercolor over graphite underdrawing on wove paper;
7⅝ × 11⅛ in. (192 × 287 mm). Signed at lower left:
David Cox.

PROVENANCE: Sir Hugh Walpole; Miss P. A. Gardner;
Anthony Reed, London.
EXHIBITION: California Palace of the Legion of Honor,
The Fine Arts Museums of San Francisco, *Recent
Acquisitions, 1976-1977*, 1977.

One of the most delightful English artists of the
nineteenth century, David Cox, like J. M. W. Turner
(see cat. no. 87) was well-known during his lifetime.
But the similarity ends there, for the work of Cox more
properly fits our general expectations for the English
School. Comparison with Turner is unfair, of course, in
the sense that sustained experiment and innovation on
Turner's level are rare, nor are they necessarily
prerequisites for achieving brilliant pictures. At his best
David Cox was an inspired painter, especially when he
worked on a subject he loved, such as the pier at Calais.
And, not uncommonly, he made more than one version
of his favorite subjects.

Cox trained with another well-known watercolorist,
the noted teacher John Varley. Like Varley, he became
a celebrated teacher and published several successful

books on painting. Though Cox's tutorial disposition
sometimes stultified his approach to his own work,
he was almost always liberated by confronting a view
rich in sky, sand, and wind. His choice of scenery was
not unlike that of many Dutch seventeenth-century
masters in its avoidance of the more dramatic, sublime
possibilities of mountains, ravines, and heavenly
pyrotechnics. Instead, like these artists, Cox achieved
memorable results by celebrating the effects of light and
wind on land and water.

David Cox traveled to Holland, Belgium, and France,
and his French pieces, such as our watercolor of *Calais
Pier*, constitute some of his best work. Among the other
versions of this subject, all dating to about 1845, are
those at Birmingham, the British Museum, and the
Whitworth Art Gallery, University of Manchester.
There is also a single oil of *Calais Pier* now at the Walker
Art Gallery, Liverpool. Mary Bennett has called
attention to the fact that the popularity of the subject
can be traced to Turner's painting of 1803.[1] This
precedent also may explain the inspiration for Cox's
single oil painting of Calais Pier, for no oil of any of his
other continental subjects seems to have been painted.[2]
J. R. G.

*Gift of Mrs. Alexander de Bretteville and Achenbach
Foundation for Graphic Arts purchase, 1976.2.26*

79. Richard Dadd *Chatham, Kent 1817-1886 Broadmoor*

Bearded Man with a Pipe, 1842-1843

Watercolor on wove paper; 9¾ × 7¾ in. (247 × 196 mm).

PROVENANCE: J. S. Maas & Co., Ltd., London.
EXHIBITION: California Palace of the Legion of Honor,
The Fine Arts Museums of San Francisco, *Recent
Acquisitions, 1976-1977*, 1977.

Richard Dadd was one of the most unusual and
eccentric artists of his day. His early artistic training
took place at the British Museum, after his family
moved to London in 1834. He entered the Royal
Academy schools in 1837, and he earned three silver
medals before 1840. He exhibited at the Royal Academy
from 1839 to 1842.

Dadd accompanied Sir Thomas Phillips (1801-1867)
on an extended tour of Europe and the Near East in
1842 to gather material for his art. During the latter part
of the tour Dadd began to show signs of severe mental
disorder. On 28 August 1843 Dadd lured his devoted
father to a park in Cobham and murdered him with a
knife under the delusion that his father was the devil.
Dadd fled to France, where he was arrested two days
later for attempting to slay a complete stranger.
Eventually Dadd was returned to England, where he
was certified insane. He was placed first in Bethlem
Hospital, Saint George's Fields, Lambeth, and in
1864 was transferred to Broadmoor Criminal Lunatic
Asylum, where he died in 1886. Throughout his years
of incarceration, the no-longer-violent artist produced
a large body of highly personal work, including the
famous fairy paintings, *Contradiction: Oberon and Titania*
(1854-1858; private collection) and *The Fairy Feller's
Master Stroke* (1855; Tate Gallery, London), and a

bizarre series of approximately twenty-nine watercolors,
Sketches to Illustrate the Passions (1853-1856).

According to Patricia Allderidge, the Achenbach
watercolor dates from Dadd's journey to the Near East
in 1842-1843.[1] Two similar, highly finished portraits of
Dadd's companion, Sir Thomas Phillips, were done
at this time.[2] In another Dadd watercolor of 1845,
Allderidge comments about a curious working method
of the artist that also is present in our sheet: "One of
Dadd's favourite devices, of exactly repeating the same
line throughout the smaller details, can be seen here....[3]
In our work, the vertical elements of the pole at the left
are repeated by the window frames above, the pipe in
the man's hand, the palm trees, and the lances held by
the riders, ending in the arched doorway in the upper
right. Because the robed figure in the watercolor bears a
strong resemblance to a photograph of the artist, there
has been speculation that our sheet is a self-portrait.[4]
Dadd was wearing a full mustache and beard at this
time, and he undoubtedly wore the native clothes of the
Near East, as was the custom of travelers in this period.
In addition, the watercolor's size and finish make it
almost a pendant to the watercolor Dadd made of Sir
Thomas Phillips. Nevertheless, the face looks older than
that of a man of twenty-five, Dadd's age when this
watercolor was done. Without further documentation,
whether or not this work is a self-portrait is still an open
question. Not in question is its power as a work of art
created when the shadow of madness was beginning to
engulf the artist.

R. F. J.

Achenbach Foundation for Graphic Arts purchase, 1976.2.20

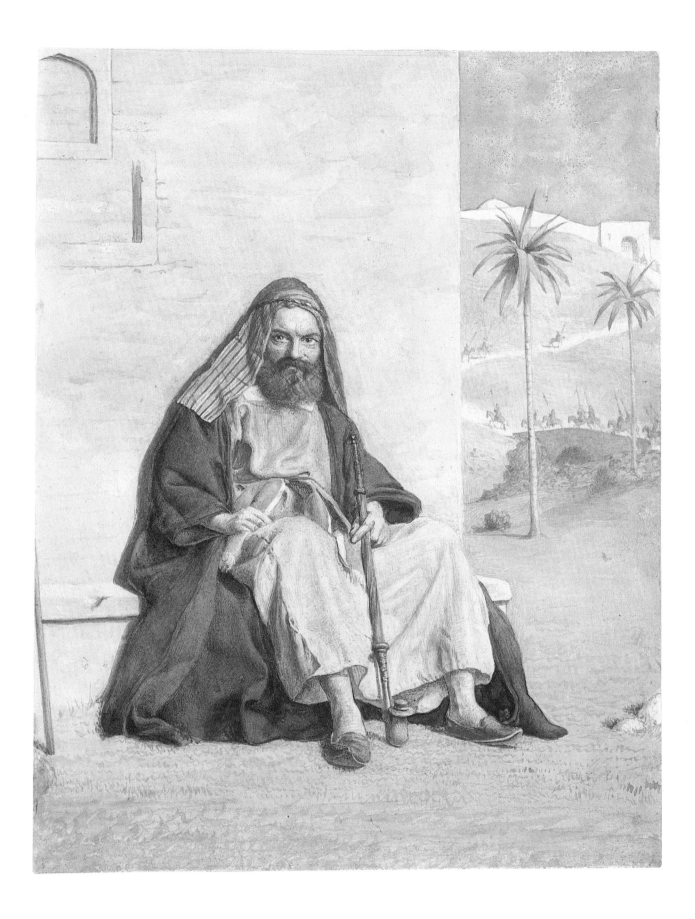

80. Thomas Gainsborough *Sudbury 1727-1788 London*

Upland Landscape with Figures, Riders, and Cattle, 1780s

Varnished watercolor with oil paint additions on laid paper; 8½ × 12¼ in. (216 × 310 mm).

PROVENANCE: Henry J. Pfungst; his sale, Christie's, London, 15 June 1917, lot 1; Seligmann; M. Knoedler & Co., New York; Colnaghi, London; Thomas Partridge; Colnaghi, London; Mr. and Mrs. Sidney M. Ehrman; gift to California Palace of the Legion of Honor.

BIBLIOGRAPHY: Mary C. Woodall, *Gainsborough's Landscape Drawings* (London, Faber and Faber, 1939), no. 68; John Hayes, *The Drawings of Thomas Gainsborough* (New Haven: Yale University Press, 1971), no. 732, p. 276.

EXHIBITIONS: Colnaghi, London, 1906, no. 69; M. Knoedler & Co., New York, 1923, no. 12; Ipswich Museum and Art Galleries, Suffolk, 1927, no. 147; The Phoenix Art Museum, *English Landscape Painters*, 1962, no. 3; The Santa Barbara Museum of Art, *Painted Papers*, 1962, no. 91; Munson-Williams-Proctor Institute, Utica, New York, *Masters of Landscape–East and West*, 1963, no. 39, repr. p. 45 (also Rochester Memorial Art Gallery, 1963); California Palace of the Legion of Honor, San Francisco, *Old Master Drawings*, 1966; idem, *English Master Drawings*, 1970; University Art Museum, Berkeley, *English Graphics of the Eighteenth Century*, 1974; Montgomery Art Gallery, Pomona College, Claremont, *18th Century Drawings from California Collections*, exh. cat. by David W. Steadman and Carol M. Osborne, 1976, no. 25, p. 21, repr. p. 89 (also E. B. Crocker Art Gallery, Sacramento, 1976).

"There is a place up the river side... where he often sat to sketch, on account of the beauty of the landscape, its extensiveness, and richness in variety, both in the fore and back grounds." [1] So John Constable wrote in 1797 of one of the locations preferred by the young Gainsborough in Suffolk. Today, Thomas Gainsborough like Constable and Turner is an artist known even to those who are not particularly familiar with English art. Gainsborough's fame rests principally on his portraits rather than his landscapes, because his wonderfully wistful portrait style ennobled some of the most prominent people of his age. While his talents in portraiture were in great demand, Gainsborough truly coveted the moments he spent drawing landscape. John Hayes, discussing the artist's landscapes, has written that "drawing, for Gainsborough, was always more an act of love than a means of storing up ideas and information." [2]

Because Gainsborough was prolific and often gave his work away, what remains of his œuvre in landscape drawing has been judged to be a small fraction of what was produced. The landscape drawings that remain, nevertheless, tell us that the artist's abilities as a landscapist were as impressive as those that brought him prominence as a portraitist. These drawings provide the best evidence of his reported passion for the genre, and in themselves constitute a major statement in the history of landscape.

The beautiful *Upland Landscape* in the collection of The Fine Arts Museums is a rapidly executed pastorale, employing dilute oil color, and the effect is calculated more to produce a successful sketch than to achieve an accurate sense of nature. [3] As a landscape draftsman, Gainsborough acquired a repertoire of forms while a young man and gradually relaxed his technique to allow these rapid renderings. Indeed, his manner of sketching with chalk and paint on paper had profound influence on the remarkable freedom of his later oil painting technique. From a technical point of view, a key element in assessing Thomas Gainsborough's achievement must be that unlike most eighteenth-century English artists, he displayed a painterly approach to draftsmanship and a draftsmanly approach to painting, thus contributing a sense of freshness even to his more formal subjects.

It is impossible to be precise about the date of the Museums' landscape, but it is certainly a sheet dating to the last years of the artist's life. John Hayes relates it to several other fine late drawings.

J. R. G.

Gift of Mr. and Mrs. Sidney M. Ehrman, 1952.63

81. Thomas Heaphy *London 1775-1835 London*

Still Life with Mallard and Rabbits in a Basket, 1806

Watercolor with gum glaze additions over graphite underdrawing on wove paper; 5⅞ × 7¼ in. (150 × 195 mm). Signed and dated at lower right: *T. Heaphy 1806.*

PROVENANCE: Andrew Wyld, London.

The Museums' recently acquired watercolor by Thomas Heaphy is an example of the exceptional talent of certain forgotten watercolorists of the English School. The Royal Academician Richard Redgrave, who was Heaphy's contemporary, wrote that Heaphy "went to nature both for his character and expression and did not scruple to represent her as he found her."[1] Redgrave also commented that "his work won upon the public by its truthfulness and direct reference to nature."[2] Other contemporary writers noted and appreciated Heaphy's exquisite finish but took him to task repeatedly for his disagreeable subjects who that included hoodlums, gamblers, and vulgar comic scenes.

Writing in 1808 in the *Review of Publications of Art,* John Landseer suggested that it was not easy to gather an idea of Heaphy's abilities without seeing his work. About a depiction of game he wrote that it was "grouped with much art and coloured and finished with excellent taste and precision. It is saying a great deal, but we conceive that if the game of Gerard Dou (a Dutch seventeenth-century master renowned for superbly finished still-life passages) were placed beside it, his hares and wild ducks would appear mere efforts of patient labour compared to Mr. Heaphy's."[3]

As one examines the Museums' *Still Life* by Heaphy, one sees an excellent example of the type of work praised by Landseer. The subject is treated with compassion and composed with obvious sensitivity to refinement of color and preservation of detail. The placement of the mallard's orange feet along with the colors of its plumage produce a lyrical counterpoint to the more neutral tones of the straw, basket, and barrel.

Given such talent, it is not surprising to find that Heaphy exhibited at the Royal Academy for the first time in 1797, at the age of twenty-two. In 1803 he was appointed Portrait Painter to the Princess of Wales; in 1805 he became one of the founding members of the Water Colour Society; and in 1824 he was chosen first president of the Royal Society of British Artists.[4] Benjamin West, President of the Royal Academy, much admired Heaphy's ability, and his encomiums together with the obvious technical prowess of the young artist resulted in the enormously high prices paid for many of Heaphy's watercolors. A figure of four hundred guineas was recorded for one work, at a time when many artists were selling their smaller sheets for a guinea.[5] To gain an idea of this extravagant indication of regard for Heaphy, one might consider that in his lifetime Turner never received as much for a watercolor and rarely gained that amount for a painting.

J. R. G.

Joseph M. Bransten Fund, gift of Mr. and Mrs. Robert Bransten, 1984.2.43

82. Alfred William Hunt *Liverpool 1830-1896 Campden Hill*

A Panoramic View over Moorland

Watercolor and gouache over traces of graphite underdrawing on wove paper; 15¾ × 26⅜ in. (400 × 670 mm).

PROVENANCE: Somerville & Simpson, London.
EXHIBITION: California Palace of the Legion of Honor, The Fine Arts Museums of San Francisco, *Recent Acquisitions, Part I*, 1983.

Although they have been out of favor with art historians and collectors for much of the twentieth century, large, highly finished, "exhibition" watercolors of the Victorian era have undergone a revival of interest.[1] Alfred William Hunt was one of the most popular and skillful practitioners of this style in the second half of the nineteenth century. Other leading English artists who produced works in this manner were William Henry Hunt, Samuel Palmer, John Frederick Lewis, and Myles Birket Foster.

Victorian patrons were not the cultured aristocracy who promoted the arts in the eighteenth century. Martin Hardie writes that "they were mostly men of industry whose own fortunes depended upon impeccable craftsmanship and machine-made exactness. They understood what they would have called honest-to-God workmanship. They were prepared to make a lavish expenditure upon art so long as the pictures they bought displayed the high polish and precision which in their eyes was a sign of the best quality."[2]

At exhibitions in the gallery of the Society of Painters in Water-Colours, artists would display their finest works in ornate gold frames. The often large size and high finish of the works exhibited was an effort by the artists to attract attention and to please the public's taste by rivaling oil painting in exactitude, scale, and surface richness. Although elaborate figurative pieces centering on rural genre or literary themes were common, the most typical subject for an "exhibition" watercolor was the topographical landscape.

The reputation of Alfred William Hunt rests on his superb watercolor landscapes. Born in Liverpool in 1830, Hunt learned the rudiments of art at an early age from his father who was an accomplished landscape artist. By 1854, after a successful education at Liverpool College and Corpus Christi College, Oxford, Hunt decided to devote himself to art. J. M. W. Turner was his strongest early influence. From 1854 until the late 1880s, Hunt exhibited at the Royal Academy thirty-seven times and at the Society of Painters in Water-Colours on three hundred thirty-four occasions.[3] Sympathetic to Hunt's refined technique and powers of observation, Ruskin in 1856 praised one of his watercolors for "uniting most subtle finish and watchfulness of nature with real and rare power of composition."[4]

Hunt's watercolors, such as *A Panoramic View over Moorland*, are characterized by a decidedly Pre-Raphaelite meticulousness. As in the Museums' work, the surfaces of his watercolors are often scrubbed and scraped to achieve an atmospheric perspective. The critic of *The Spectator* wrote in 1897 of a Hunt watercolor, "In no other picture here is there a better example of the peculiar power of this painter who could make a range of mountains look solid and vast, and yet only put on the paper the faintest possible stain of colour."[5] Another feature of Hunt's style in our work is the placement of a portion of the landscape prominently in the foreground, contrasting with a broad, receding view.[6] As in our watercolor, this detailed foreground was usually worked over with gouache highlights.

Alfred William Hunt was able to fuse his poetic imagination with a truthful perception of nature that resulted in some of the most beautiful watercolors of the Victorian era. *A Panoramic View over Moorland* was unattributed when acquired by the Achenbach Foundation in 1981. Evelyn Joll was the first to suggest that it was created by Hunt. Subsequent comparison with other works by Hunt, such as *The Tarn of Watendlath, between Derwentwater and Thirlmere* of 1858 in the British Museum and numerous works in the Newall Collection, confirm the attribution.[7] Our work is unsigned, not an uncommon occurrence for Hunt's watercolors, even for those as large and finished as ours. Of the thirty-nine Hunt watercolors in the Newall Collection sold at auction in 1979, nineteen were unsigned.[8]

R. F. J.

Achenbach Foundation for Graphic Arts purchase, 1981.2.30

83. Sir Thomas Lawrence *Bristol 1769-1830 London*

Portrait of Mrs. Sarah Siddons, ca. 1790

Graphite on wove paper affixed to thicker paper mount; 7½ × 4⅞ in. (190 × 124 mm).

PROVENANCE: From the artist to Samuel Lysons; Lysons's family sale, 21 April 1887, lot 322; presumably to Mrs. W. E. Price; W. R. Price; Mrs. Alan Davidson sale, London, 2 March 1976, lot 142; The Leger Galleries, Ltd., London.
BIBLIOGRAPHY: Kenneth Garlick, *A Catalogue of the Paintings, Drawings, and Pastels of Sir Thomas Lawrence*, vol. 39 (London: Walpole Society, 1964), p. 229.
EXHIBITIONS: The Leger Galleries, Ltd., London, *Exhibition of English Watercolours*, 1976, no. 1, repr.; California Palace of the Legion of Honor, The Fine Arts Museums of San Francisco, *Recent Acquisitions, 1976-1977*, 1977; National Portrait Gallery, London (exh. at 15 Carlton House Terrace), *Sir Thomas Lawrence, 1769-1830*, exh. cat. by Michael Levey, 1979-1980, no. 57, p. 88, repr.

Since his death, Sir Thomas Lawrence's reputation as a portraitist of considerable sensitivity and skill has suffered from unfavorable art historical judgment. The artist's fondness for surface flash in his brushwork and the general unevenness of his art has denied him a place in the front rank of early nineteenth-century European painters. In 1855, twenty-five years after Lawrence's death, Eugène Delacroix wrote in his journal that Lawrence's portrait paintings had "a kind of originality" but that "exaggeration for the sake of effect and, indeed, the utterly false effects which result therefrom, has decided the style of all his disciples and gives the whole school an appearance of artificiality which its other fine qualities cannot redeem."[1] One must turn to Lawrence's drawings to see his insight as a portraitist. This was convincingly demonstrated in the National Portrait Gallery's 1979 Lawrence retrospective

in London, where our drawing of Sarah Siddons was featured.[2]

During the last quarter of the eighteenth century, Sarah Siddons (1755-1831) became the most famous English actress of her day. Beginning with a picture done in Bath in 1783, Lawrence painted and drew Mrs. Siddons several times during his long career. She and her family became close friends of the artist, although problems later were to arise. At one time Lawrence was engaged to marry one of Mrs. Siddons's five daughters, Sally (1775-1803), only to become romantically involved with another daughter, Marie (1779-1798). Before her death, Marie received Sally's agreement never to marry the artist. In later life, Mrs. Siddons eventually reconciled with Lawrence.

The discovery that the Achenbach drawing is of Mrs. Siddons was made by Dr. Kenneth Garlick, who corrected the previous identification as Lady Hamilton. An etching by Lawrence in the British Museum is based on the drawing.[3] The sheet can be documented and dated about 1790, according to a letter from Daniel Lysons to Thomas Campbell in April 1830, which mentions that the etching was made from "the beautiful drawing of Mrs. Siddons... before August 1790."[4] Further evidence to date the drawing is the mobcap that Mrs. Siddons is wearing.[5]

Lawrence has given Mrs. Siddons an intense, yet thoughtful countenance. Her fashionable and carefully delineated headgear is in contrast to the slight execution of her arm and body. There is often both intimacy and insight in Lawrence's best portrait drawings, such as the Achenbach sheet, that is lacking in the grandiose oils for which he was famous.

R. F. J.

Gift of the Goldyne Family in memory of Dr. Alfred J. Goldyne, 1977.2.1

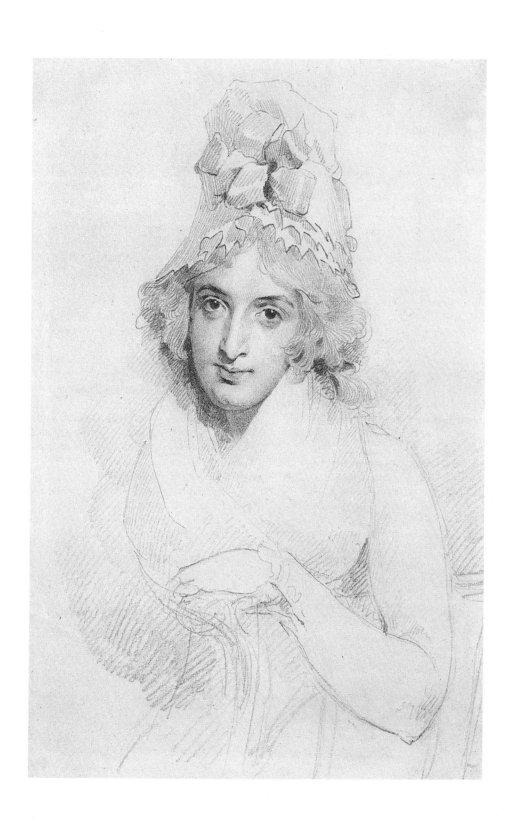

84. Edward Lear *Highgate 1812-1888 San Remo*

Saint Peter's from the Arco Oscuro, 1842

Graphite with white gouache heightening on green wove paper; 10 × 15¾ in. (254 × 400 mm). Inscribed at lower left: *St. Peter's, from Arc'oscuro*, and signed and dated at lower right: *Edward Lear. del. 1842*.

PROVENANCE: Presumably from the family of Robert Hornby; Mrs. Edmund Hornby; Hazlitt, Gooden & Fox, London, 1980.
EXHIBITIONS: Hazlitt, Gooden & Fox, London, *The Lure of Rome*, 1979, no. 81, pl. 86; California Palace of the Legion of Honor, The Fine Arts Museums of San Francisco, *Recent Acquisitions*, 1981.

While Lear is world-famous for his *Nonsense Verse* and children's poems, such as *The Owl and the Pussy Cat*, and is one of the most endearing personalities of nineteenth-century English art and literature, he also must be recognized as one of the greatest English draftsmen and watercolorists. Such acknowledgment has not been fully granted yet for the same reasons that explain the tardy esteem bestowed on Ruskin's art (see cat. no. 86). Each of these artists made numerous works and at the same time achieved fame in another field. It is time, however, to view Lear as an inspired creator who was ingeniously playful in verse and caricature but who was seriously poetic in his drawings, watercolors, and paintings. Lear's mature style as a landscape draftsman can be best characterized by the touching lines of his friend Alfred Lord Tennyson, which were recorded on

Lear's gravestone at San Remo: "With such a pencil, such a pen/You shadowed forth to distant men/I read and felt that I was there."[1]

Edward Lear was trained in his youth as a lithographer, and he excelled at conveying depth through the use of grays. Because he also had a predilection for great vistas, precipitous drops, and foliage used to offset his pallid distances, Lear succeeded in producing many finished works of compelling composition with splendid atmospheric effects.

He first traveled to Rome in 1837 because of his health. In England again in 1841, he published a volume of lithographs called "Rome and its Environs." He then returned to Rome, where he gave drawing lessons and made many drawings, one of them the beautiful study *Saint Peter's from the Arco Oscuro* in the collection of The Fine Arts Museums. This sheet reveals the artist at his best as a monochrome draftsman. Presumably, it descended in the family of Robert Hornby, one of Lear's patrons who helped to finance his trip of 1837. There is a similar view with slight variations, dated 4 March 1840, in the Tate Gallery.

With a finish typical of tone-plate lithographs of the period, Lear transmits the sense of reverent nostalgia that other English artists, such as Wright of Derby and Samuel Palmer, felt for Rome and the warm and ancient lands of classical history and mythology.
J.R.G.

Achenbach Foundation for Graphic Arts purchase, 1980.2.6

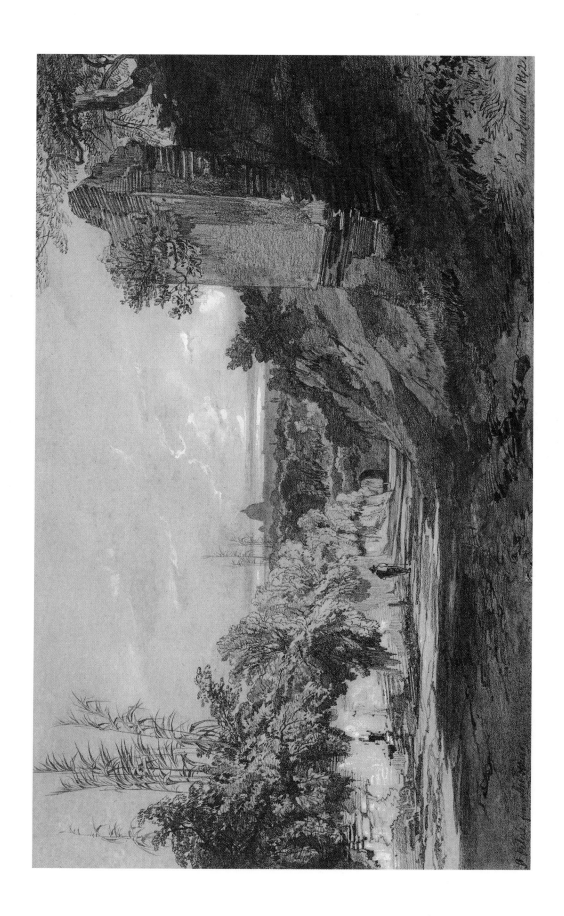

85. Thomas Rowlandson *London 1756 -1827 London*

Grotesque Heads

Pen and brown ink and watercolor over traces of
graphite underdrawing on wove paper; 8⅞ × 7⅛ in.
(227 × 181 mm). Signed in brown ink at lower left:
T. Rowlandson.

PROVENANCE: David Ashley, Inc., New York; Moore
S. Achenbach, 1940.
EXHIBITION: California Palace of the Legion of Honor,
San Francisco, *Watercolor Drawings by Thomas
Rowlandson*, 1957.

Thomas Rowlandson was the most talented and versatile
of the group of late eighteenth- and early nineteenth-
century British artists who specialized in caricature.
Also notable among them were George Cruikshank and
James Gillray. From 1775 until 1787 Rowlandson
regularly exhibited watercolors at the Royal Academy.
In the 1790s he began his long association with the
publisher Rudolph Ackermann. Their major publica-
tions were *The Microcosm of London* (1808-1810), *The
Tours of Dr. Syntax* (1812-1821), and *The English Dance of
Death* (1814-1816). Through these publications and the
hundreds of other plain and hand-colored etchings of
varying quality, Rowlandson became famous for his
artistic skill and wit.

Although his fame rests on his large body of humor-
ous, often risqué watercolors and etchings, Rowlandson
was also a versatile draftsman, capable of accomplished
portraits, and landscapes, as well as urban and rustic
genre scenes.

This disturbing yet powerful watercolor displays
a darker side of Rowlandson's nature.[1] Gone is the
extroverted, almost frivolous quality usually associated
with the artist, to be replaced by a terrifying introverted
vision of human emotion.

Rowlandson's art was influenced by the caricatures of
the Italian Pier-Leone Ghezzi (1674-1755; see cat. no. 11),
and among the English by artists such as William
Hogarth (1697-1764) and George Morland (1763-1804).
In this sheet of faces, Rowlandson may have been
influenced by Leonardo da Vinci's famous caricature
heads now in Windsor Castle. They would have been
accessible to Rowlandson through the reproductive
etchings by Wenceslaus Hollar (1607-1677).

The twelve heads in our watercolor do not evoke a
wide range of emotions. They seem restricted to fear
(the two heads in the upper right), anger (the two
heads in the upper left, the main head in the middle,
and the one to the right), and general madness (the
remaining six heads). The purpose of this watercolor is
unclear: whether it was intended as a sketch sheet to
experiment with various facial emotions or as a fully
unified work is unknown. The composition centers
around a single angry face, which suggests the
possibility that the other heads are figments of the
central figure's imagination, in short, the visualization
of that man's nightmare.

The end of the eighteenth century saw the emer-
gence of Romanticism as a major artistic force and the
increased preoccupation with psychological themes.
Francisco Goya's famous print *The Sleep of Reason
Produces Monsters* of 1799, from *Los Caprichos*, is an
obvious example. Rowlandson was an intelligent, well-
traveled man, and it is not surprising that his art
reflected an awareness of these growing artistic trends.
He undoubtedly knew the physiognomic writings of
Johann Caspar Lavater (1741-1801), the Swiss pastor and
scholar who was a close friend of the artist Henry
Fuseli.[2] Lavater's widely read studies of human
physiognomy could have influenced Rowlandson to
create this curious watercolor.

Because the artist rarely dated his watercolors and
drawings, it is difficult to assign a date of execution to
them, and this sheet is no exception. The Achenbach
Foundation possesses a collection of one hundred
twenty-five Rowlandson drawings and watercolors,
which cover a wide variety of subject matter.
R.F.J.

Achenbach Foundation for Graphic Arts, 1963.24.541

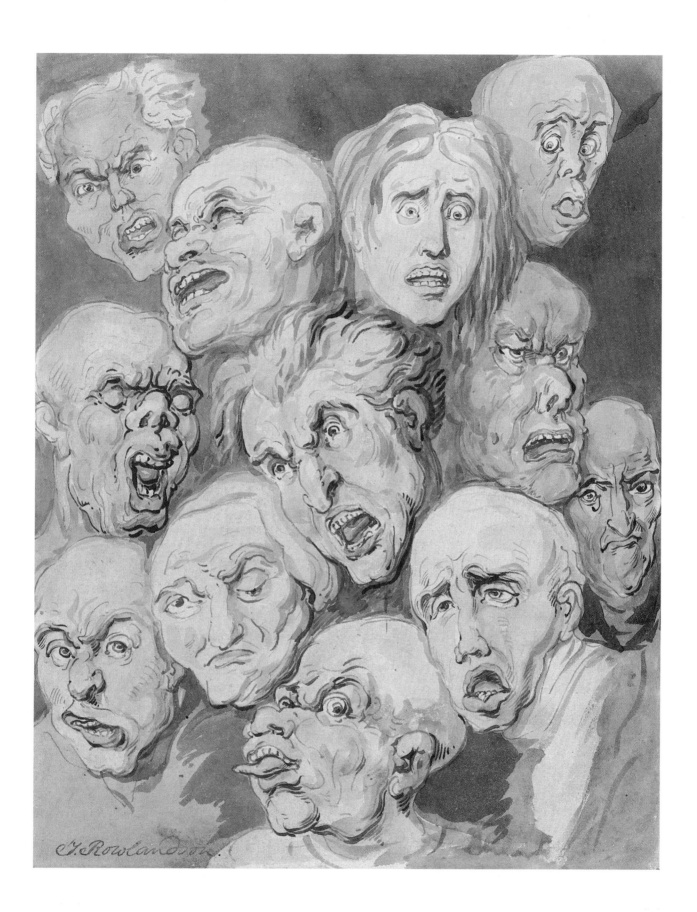

86. John Ruskin *London 1819-1900 Coniston*

A River in the Highlands

Watercolor over graphite underdrawing on thick wove paper; 7⅜ × 10⅞ in. (189 × 275 mm).

PROVENANCE: Gift of John Ruskin to Mrs. M. B. Thomas Hayes, née Sidney; Mrs. J. N. Moore; Mrs. J. Vandeleur; Christie's, London, 8 June 1976, lot 178; The Fine Art Society Ltd., London.
EXHIBITION: California Palace of the Legion of Honor, The Fine Arts Museums of San Francisco, *Selected Acquisitions, 1977-1979*, 1979-1980, checklist, no. 50.

John Ruskin's lifelong belief was that his art, although important to his development as a writer, was simply that of an amateur. Art history has taken his prolific and intensely observed drawings and watercolors far more seriously than he did himself. Ruskin may be ranked with William Blake and Victor Hugo as one of the significant literary figures of the nineteenth century who also produced a notable body of creative art.

At twenty-one, Ruskin realized that he did not have the talent to become an important artist: "The end of study in us who are not to be artists is... to receive what I am persuaded God means to be the *second* source of happiness to man–the impression of that mystery which... we call 'beauty'."[1] Ruskin determined that, unlike his great hero J. M. W. Turner, he did not possess a sufficient combination of truth, poetry, and emotion to produce what he called "imaginative topography." At the same time, he rejected the lesser creative efforts of artists, such as his teachers A.V. Copley-Fielding and J. D. Harding, whose mechanical rules for picturesque effect he labeled "conventional topography." Rather, he chose the direction of an observer who faithfully records his immediate impressions of nature. He labeled this type of artistic expression "'historical topography,' where 'not a line is to be altered, not a stick nor stone removed....' The picture is to be, as far as possible, the reflection of the place in a mirror, and the artist is to consider himself only as a sensitive and skilful [sic] reflector."[2]

A River in the Highlands probably was painted in 1847 during a Scottish holiday. Ruskin's geological interests were inspired by what he saw at the time. He later described Scotland as "one magnificent mineralogical specimen."[3] This interpretation of nature can be seen in Ruskin's rendering of a boulder in the lower left of the composition, which is drawn with fanatical care for accuracy. On the left of the composition, the foreground and middle distance are dominated by an obsessive attention to detailing the natural forms. In contrast, a more subjective treatment of the river, the far shore, and the distant mountains is apparent on the right, although even here, great emphasis has been placed on atmospheric perspective. Despite his avowed belief in the depiction of the beauty found in nature as opposed to the beauty imposed on nature by art, it is clear that a sensitive and poetic imagination is present in Ruskin's conception of this Scottish scene.

For John Ruskin, the greatest English art critic of his age, truth and beauty in art were one and the same. His art, based on a deeply felt yet rational view of the world, has begun to be fully appreciated only in the twentieth century.

R. F. J.

Gift of the Graphic Arts Council, 1978.2.34

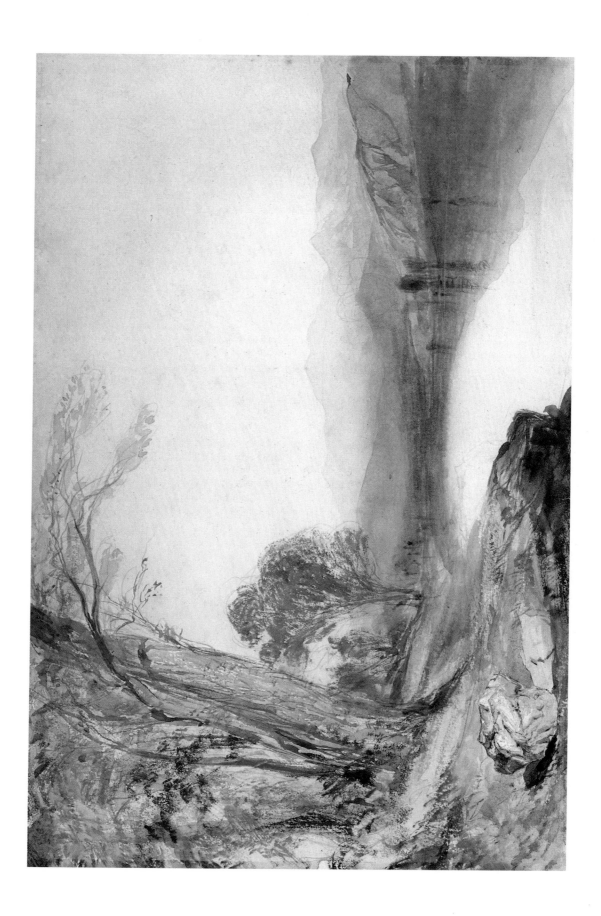

87. Joseph Mallord William Turner *London 1775-1851 Chelsea*

View of Kenilworth Castle, ca. 1830

Watercolor and gouache on wove paper; 11½ × 17⅞ in.
(292 × 454 mm).

PROVENANCE: Messrs. Noon, Boys, and Graves, 1833;
John Ruskin, ca. 1860; H. A. J. Munro of Novar; his
sale, Christie's, 2 June 1877, lot 41; Thomas Agnew &
Sons, London; W. Tattersall, Quarry Bank, Black-
burn; Thomas Agnew & Sons, London; Mrs. W. H.
Crocker, Burlingame, California; Mrs. Henry Potter
Russell, San Francisco; Osgood Hooker, San Fran-
cisco; gift to the California Palace of the Legion of
Honor.

BIBLIOGRAPHY: Engraved by T. Jeavons for Charles
Heath, ed., *Picturesque Views in England and Wales, from
Drawings by J. M. W. Turner, Esq., R. A.*, vol. 2
(London, 1832), pl. 58; republished by H. E. Lloyd
(London, 1838), vol. 2, pl. 10; Sir Walter Armstrong,
Turner (London: Agnew, 1902), p. 260, repr.; Cook and
Wedderburn, eds., *The Complete Works of John Ruskin,*
Library Edition, 39 vols. (London, 1903-1912), vol. 35,
p. 305; A. J. Finberg, *The Life of J. M. W. Turner, R. A.*,
2d ed. (Oxford Clarendon Press, 1961), p. 380; Andrew
Wilton, *J. M. W. Turner, His Art and Life* (New York:
Rizzoli, 1979), no. 842, p. 398, repr.; Eric Shanes,
*Turner's Picturesque Views in England and Wales 1825-
1838* (London: Chatto & Windus, 1979), no. 51, p. 37,
repr.; Joseph R. Goldyne, "British Art at San
Francisco," in Denys Sutton, ed., "The Fine Arts
Museums of San Francisco," *Apollo* (1980): 122-129,
pl. 23, repr. p. 127.

EXHIBITIONS: Noon, Boys, & Graves Gallery, London,
1833, no. 22; California Palace of the Legion of Honor,
San Francisco, *English Master Drawings*, 1970; University
Art Museum, Berkeley, *Master Drawings: Materials and
Methods*, 1972; idem, *J. M. W. Turner, Works on Paper
from American Collections*, exh. cat. by Joseph R.
Goldyne, 1975, no. 26, p. 116, repr.; California Palace of
the Legion of Honor, The Fine Arts Museums of San
Francisco, *Masterworks from the Achenbach Foundation for
Graphic Arts*, 1981; Grand Palais, Paris, *J. M. W.
Turner*, exh. cat., 1984, no. 203, p. 261, repr.

Never in the history of Western art was any artist's
initial reputation so associated with the praise and
defense of a single critic as Turner's was with John
Ruskin. *View of Kenilworth Castle* is particularly
noteworthy from this viewpoint, for it was one of the
Turners seen by Ruskin on the evening when he first
met the artist. The event was recorded by Ruskin as
having taken place at the home of the dealer Griffith on
22 June 1840. He recalled that "the drawing of
Kenilworth was one of those that came out of Mr. Grif-
fith's folio after dinner; and I believe I must have
talked some folly about it, as being a leading one of the
England series, which would displease Turner greatly.
There were few things he hated more than hearing
people gush about particular drawings. He knew it
merely meant they could not see the others." [1]

Kenilworth is, indeed, one of the most beautiful sheets
that were made to be engraved for Charles Heath's
publication *Picturesque Views in England and Wales*. This
fine series was issued in twenty-four parts over an
eleven-year period, from 1827 to 1838. Like many
lavish publishing efforts in the nineteenth century, the
venture failed and the publisher declared bankruptcy.
Turner, a wealthy artist by this time, bought back the
plates and unsold prints for the reserve price of £3000.

The stately castle-fortress of Kenilworth, laid to ruin
by Oliver Cromwell's troops, was the setting for Sir
Walter Scott's novel of the same name (1821), and it
was the perfect subject for Turner's brush. Certainly
the greatest of what may be called the romantic
topographers, Turner was able to endow such a subject
with an aura of grandeur beyond even its imposing
physical stature. He accomplished this by bathing the
ruin in light and atmosphere, created technically with
passages of glazing, dry brush, scraping, and stippling.

View of Kenilworth Castle dates to about 1830, and the
engraving after the watercolor was published in 1832.
J. R. G.

Gift of Osgood Hooker, 1967.4

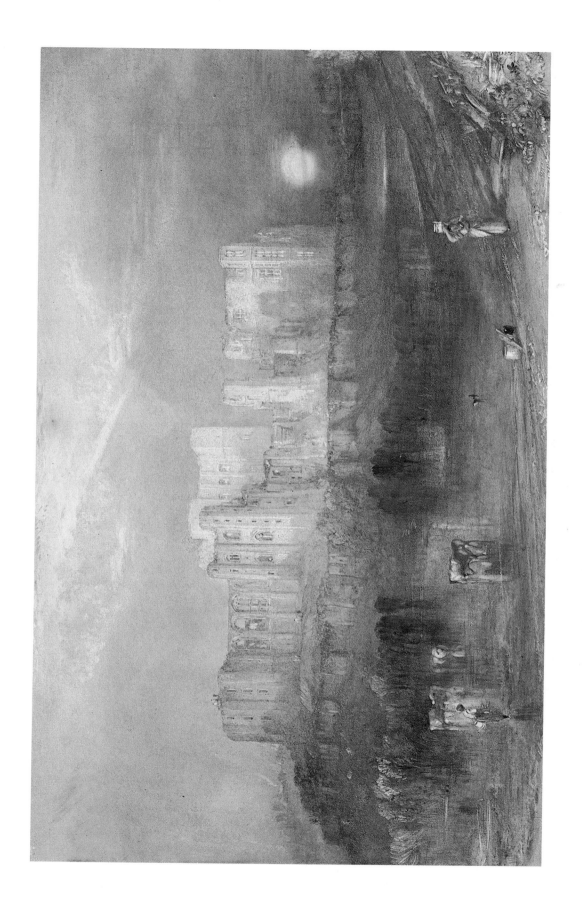

88. Sir David Wilkie *Cults, Fifeshire 1785-1841 at sea off Gibraltar*

The Arrival of the Rich Relation, ca. 1820

Pen and brown ink on wove paper; 10 × 12½ in.
(254 × 317 mm).

PROVENANCE: Wilkie's sale, Christie's, 25 April 1842,
lot 66; Collins; Squire Gallery, London; Collis
P. Huntington; California Palace of the Legion of
Honor purchase.
BIBLIOGRAPHY: *Portfolio* 18 (1877), opp. p. 92; Joseph
R. Goldyne, "British Art at San Francisco," in Denys
Sutton, ed., "The Fine Arts Museums of San
Francisco," *Apollo* (1980): 122-130, no. 14, repr. p. 129.
EXHIBITIONS: University Art Museum, Berkeley, *Master
Drawings from California Collections*, 1968, ed. by Juergen
Schulz, no. 3, p. 17, repr. p. 80; California Palace of
the Legion of Honor, San Francisco, *English Master
Drawings*, 1970.

Born near Edinburgh, Sir David Wilkie came to London
in 1805, already quite an experienced young painter.
He first showed at the Royal Academy in 1806, and
after Sir Henry Raeburn's death in 1823 he was
appointed King's Limner for Scotland. Much
appreciated by Queen Victoria and the Royal Family,
he was knighted in 1836.

Wilkie was one of the great names of his age, and
shortly after his unexpected death he was included in
the mightiest of pantheons. In John Martin's enormous
canvas of the *Last Judgment*, Wilkie was ranked with
Michelangelo, da Vinci, Raphael, Titian, and Dürer.
But the greatest tribute by a fellow painter to his
memory is Turner's masterpiece *Peace, Burial at Sea*, one
of the supreme paintings of the romantic era. Turner, an
admirer and sometime rival of Wilkie, showed the
funeral of the painter off Gibraltar aboard the *Oriental*
on its return from the Middle East.

The studies that Wilkie completed on his fateful
trip to the exotic East are today some of his best-
known works. Yet during his lifetime his most
famous paintings–commissioned by some of the
greatest collectors of the period, including the Prince
Regent–were the chamber-size narrative compositions
that represented primarily scenes of everyday English
life. Wilkie's drawings for these subjects are among the
finest examples of British draftsmanship of the first
quarter of the nineteenth century, and they offer
an inventive amalgam of Dutch and English precedent.
In such works one recognizes the inspiration of Rem-
brandt's etching style and Ostade's drawings and
prints. Julius Angerstein, founder of England's
National Gallery of Art, and one of the artist's patrons,
correctly observed that Wilkie's subjects were in the
tradition of Teniers and Hogarth.[1]

The Arrival of the Rich Relation in the collection of The
Fine Arts Museums is one of the masterpieces of
Wilkie's drawing style. This domestic narrative that
features the welcome of a stodgy dowager by a gathering
of her relatives is as redolent of English humor as it is of
Dutch style. Dramatically lit by contrasting areas of
free, open penwork and passages of heavier cross-
hatching, the composition beautifully presents the
essentials of a popular farce.

There is no known painting related to our drawing,
although it is likely that a subject so carefully studied
would have been intended for canvas.[2] Although one
cannot pinpoint the date of this work, composition and
pen style suggest a time about 1820. A similarly
finished and developed composition for the *Entry of
George IV into Holyrood House* is inscribed and dated
1822.[3]

J.R.G.

Archer M. Huntington Fund, 1952.82

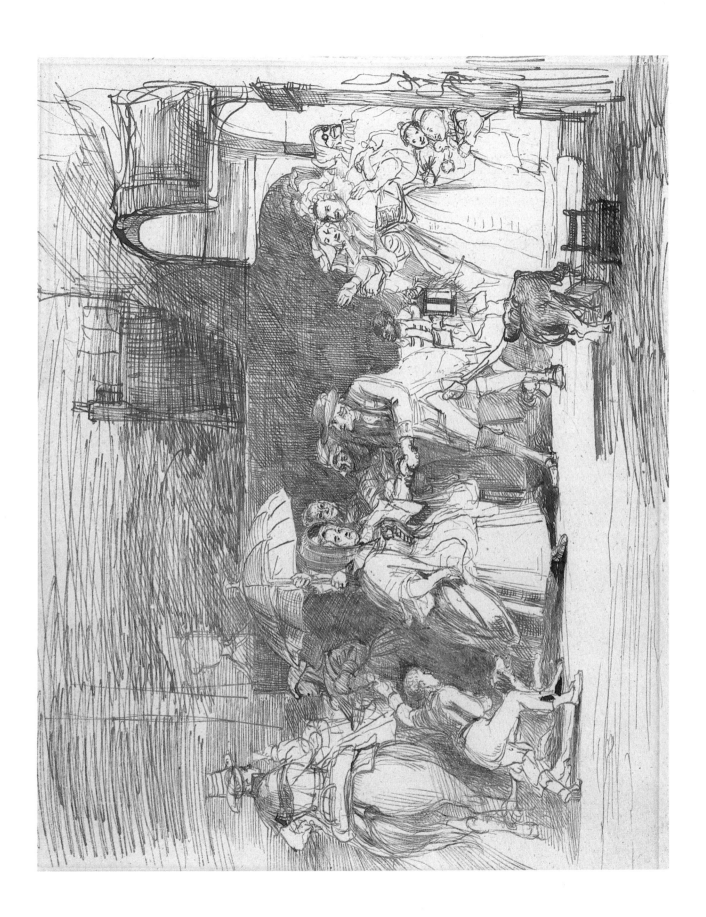

89. John James Audubon *Haiti 1785-1851 New York*

Douglass or Chickaree Squirrel, ca. 1841-1843

Pen and black ink, graphite, and watercolor with gum glaze additions on wove paper; 12¼ × 9½ in. (310 × 242 mm). Inscribed in graphite at lower left: *Douglass' Squirrel.*

PROVENANCE: Mr. and Mrs. Lawrence A. Fleischman, Detroit; Kennedy Galleries, New York, 1967; Mr. and Mrs. John D. Rockefeller 3rd.

EXHIBITIONS: Pennsylvania Academy of Fine Arts, *Small Paintings of Large Importance from the Collection of Lawrence A. and Barbara Fleischman*, 1961, no. 1; Kennedy Galleries, New York, *American Drawings, Pastels and Watercolors*, 1967, exh. cat., no. 70, repr.; M. H. de Young Memorial Museum, The Fine Arts Museum of San Francisco, *American Art: An Exhibition from the Collection of Mr. and Mrs. John D. Rockefeller 3rd*, exh. cat. by E. P. Richardson, 1976, no. 23, p. 68; California Palace of the Legion of Honor, The Fine Arts Museums of San Francisco, *Selected Acquisitions, 1977-1979*, 1979-1980, checklist, no. 4; idem, *Masterworks from the Achenbach Foundation for Graphic Arts*, 1981; The National Museum of Western Art, Tokyo, *American Painting 1730-1960: A Selection from the Collection of Mr. and Mrs. John D. Rockefeller 3rd*, exh. cat. by Margaretta M. Lovell, 1982, no. 21, repr.; California Palace of the Legion of Honor, The Fine Arts Museums of San Francisco, *Animals Real and Imagined*, 1981-1982.

As the biological sciences advanced beyond gross description to the realm of biochemical structure and function, the accurate anatomical depiction of animals came to be an archaic means of conveying knowledge about the natural world. But pictorial art of exceptional quality created to examine and document aspects of natural history remains timeless and appealing, for it tells as much of the sensibilities of the artist and his age as about the structure of the depicted specimen.

In the nineteenth century America's philosophers, poets, and artists were inclined to investigate and celebrate the wonders of their environment and, like the poet William Cullen Bryant, to admonish their countrymen to do likewise. Certain artists, such as Peale, Wilson, and Eakins, were scientifically inclined, but the most notable artist to study the fauna of the United States was John James Audubon. Because of his dedication to depicting natural history and the magnificence of his results, he has become one of America's favorite nineteenth-century artist-personalities.

Audubon's highly defined and beautifully composed images of North American birds and quadrupeds constitute one of the last grand applications of art to the service of science. His four hundred thirty-five aquatint plates comprise the glorious elephant folios *Birds of America* published from 1826 to 1838. Audubon was assisted by Robert Havell in creating one of the great monuments in the history of scientific illustration.

His next project, executed in lithography rather than aquatint, was the three-volume folio *Viviparous Quadrupeds of North America* published between 1845 and 1848. Audubon did preparatory watercolors for this project, as he had done for the *Birds of America*. These original drawings and watercolors are the finest statement of his technical prowess and his talent for revitalizing dead specimens, and it is unfortunate that they are not better known to admirers of his prints.

Audubon's *Douglass or Chickaree Squirrel*, a study for plate 66 of the *Viviparous Quadrupeds*, came to The Fine Arts Museums as part of the Rockefeller bequest, and it provides us with a beautiful example of the artist's watercolor technique. Though his sons, Victor Gifford and John Woodhouse, contributed watercolor studies for plates in the *Viviparous Quadrupeds*, John James himself concentrated on the small mammals, such as this squirrel. Its fine coat and alert pose are sensitively rendered by the artist who spent much time studying mammalia in their natural environment. Audubon's best works reveal his observations of structure, surface, movement, habit, and habitat. His result is a convincing and sympathetic representation of the living creature.
J. R. G.

Gift of Mr. and Mrs. John D. Rockefeller 3rd, 1979.7.5

Douglass' Squirrel.

90. Mary Cassatt *Pittsburgh 1844-1926 Château de Beaufresne*

Head of a Woman, ca. 1885

Pastel on brown wove paper; 16⅞ × 15¼ in.
(429 × 386 mm). Inscribed in red chalk on verso: *Degas*
and in graphite: *S.V.*

PROVENANCE: M^me Brière, Paris, 1951; Dr. T. Edward
and Tullah Hanley Collection, Bradford; gift to
M. H. de Young Memorial Museum.
BIBLIOGRAPHY: Adelyn D. Breeskin, *Mary Cassatt:
Catalogue Raisonné of the Oils, Pastels, Watercolors, and
Drawings* (Washington, D.C.: Smithsonian Institution
Press, 1970), no. 168, repr.
EXHIBITIONS: Wildenstein & Co., New York,
Dr. T. Edward and Tullah Hanley Collection, and Fogg Art
Museum, Harvard University, 1961-1962 (also Gallery of
Modern Art, New York; Philadelphia Museum of Art;
The Denver Art Museum, 1967-1968, repr.; Museum of
the Southwest, Midland, 1967, no. 96; Columbus Gallery
of Fine Arts, 1968, no. 5; Canisius College, Buffalo,
1969, no. 7, repr.; M. H. de Young Memorial Museum,
San Francisco, 1970, no. 7, pl. 16, p. 40); M. H. de
Young Memorial Museum, The Fine Arts Museums of
San Francisco, *Faces and Figures: 19th Century Works on
Paper from the Permanent Collection*, 1984.

Much has been written about the influence on Mary
Cassatt of her friend and mentor Edgar Degas. This
mutually beneficial artistic association should not,
however, obscure Cassatt's openness to other influences
and styles. It appears that the art of Edouard Manet has
influenced her approach to this pastel portrait of a young
woman, completed about 1885.[1] From the late 1870s
until his death in 1883, Manet produced more than
seventy pastels of women, many of them bust- or half-
length portraits using neutral backgrounds.[2] These fresh
charactcrizations executed in vibrant pastel hues surely
had an impact on Cassatt. As Adelyn Breeskin has

written, "Her vision was definitely that of a realist....
In her painting style she actually accepted more from
Manet than from Degas. Like Manet, she was only
an Impressionist in the high key and luminosity of
her palette and in her insistence on the importance of
light as it plays on objects."[3] In Cassatt's pastel, the
startling acidic green and yellow background colors and
the vivid red touches of the chair back demonstrate
Manet's influence. The forthright frontal pose of the
woman is frequently seen in the art of both Manet and
Degas, but it is also characteristic of the majority of
eighteenth-century pastel portraits by such masters as
Maurice Quentin de La Tour and Jean-Baptiste
Perroneau. Cassatt's restrained, taut draftsmanship in
the delineation of the face, however, owes a debt to
Degas. Indeed, this unsigned Cassatt at one time was
thought to be by Degas because his name is inscribed in
red chalk on the verso.

Paul Gauguin accurately summed up the weakness
and strength of Cassatt's art when he remarked, "Mary
Cassatt has...charm, but she also has force."[4] The
fact that Cassatt's work seldom attains the heights of
Degas's and Manet's should not lessen her obvious
achievements. Gaining the respect of the Parisian avant-
garde in the late nineteenth century was a remarkable
achievement for any artist. To have done so as both an
American and a woman was almost unbelievable.

There is another version of this pastel (Breeskin,
no. 167) which is considered the earlier of the two.
Breeskin, however, notes that "she repeated it as no. 168
(the Achenbach version) giving more height to the head
and the toque and more clarity to the features. I think
that no. 168 is therefore the better of the two pastels."[5]
R.F.J.

*Memorial gift from Dr. T. Edward and Tullah Hanley,
Bradford, Pennsylvania, 69.30.22*

91. Jasper Francis Cropsey *Rossville, New York 1823-1900 Hastings-on-Hudson, New York*

The Gates of the Hudson, 1891

Watercolor over graphite underdrawing on thick-textured wove paper; 17⅞ × 27 in. (454 × 686 mm). Signed at lower left: *J. F. Cropsey.*

PROVENANCE: Henry F. Dickinson, Carmel, California.
BIBLIOGRAPHY: William S. Talbot, *Jasper F. Cropsey 1823-1900* (New York: Garland Publishing, 1977), no. 232, p. 475.
EXHIBITION: National Collection of Fine Arts, Smithsonian Institution, Washington, D.C., *Jasper F. Cropsey 1823-1900*, exh. cat. by William S. Talbot, 1970, no. 79, pp. 107-108, repr. (also The Cleveland Museum of Art, and Munson-Williams-Proctor Institute, Utica, New York, 1970).

Jasper Francis Cropsey was one of the most talented artists of the second generation of the Hudson River School. His earlier work is almost exclusively landscape, reflecting vestiges of the strong Romanticism of Washington Allston and Thomas Cole, while his later work shows a greater concern for the naturalist vision as championed by Asher B. Durand. Cropsey's art was characterized by fluid brushwork and the use of brilliant colors. His later art, however, did not keep pace with the newer movements of Impressionism and Tonalism, and Cropsey's reputation declined after 1870. He died in near obscurity in 1900.

Cropsey was a founding member of the American Watercolor Society in 1867, and he continued to exhibit with the group until his death. In his later years he increasingly turned to watercolor as his preferred medium. *Gates of the Hudson* can be dated to 1891, based on comparison with a dated work it closely resembles.[1] In a letter of that year Cropsey described this landscape as "a careful view from the West bank of the Hudson River–South from Newburgh–looking down the River toward the Highlands, or as they are sometimes called 'The Gates of the Hudson.' The high mountain to the right is the 'Storm King.' The small island at the entrance of the narrow part of the River is now called Iona–a favorite place for picnic Parties in the Summer time; but once was known as Polly-pell in Revolutionary times."[2]

In this imposing watercolor, Cropsey took full advantage of the drama presented by the natural panorama. The work is composed of vivid yet controlled colors. From the 1850s, autumnal scenery had become Cropsey's favorite seasonal motif and the hallmark of his art to the public. Within this sylvan landscape Cropsey has nevertheless documented the intrusion of late nineteenth-century American industrial society by including telephone poles along a road and a steamboat among the sailing vessels.

American art historians have criticized Cropsey's watercolor technique for not being fluid and transparent.[3] It is true that Cropsey emphasized detailed underdrawing; consequently these works look more like tinted drawings than watercolors in the tradition of Homer and Sargent. This can be explained by Cropsey's considerable time in England, where he was influenced by Victorian watercolors. In an ambitious work such as *Gates of the Hudson*, the carefully composed and highly detailed style is reminiscent of the large "exhibition watercolors" of such artists as George Fennel Robson and Alfred William Hunt. Another highly finished Cropsey watercolor, *Under the Palisades*, of about 1891, is also in the Museums' collection.[4]

R. F. J.

Gift of Henry F. Dickinson to the M. H. de Young Memorial Museum, 60.9.1

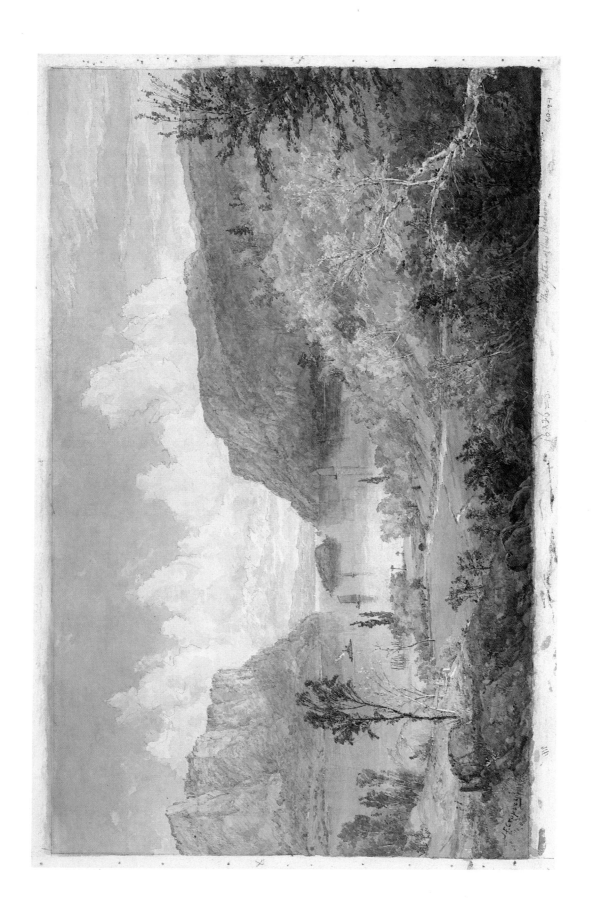

92. Thomas Eakins *Philadelphia 1844-1916 Philadelphia*

Man in a Turban, 1866-1867

Graphite over charcoal on blue-green laid paper;
23⅛ × 16⅞ in. (586 × 428 mm). Inscribed by Charles
Bregler in black ink at the upper right corner: *Drawing
by Thomas Eakins.*

PROVENANCE: Babcock Galleries, New York, 1939
(agent for Eakins Estate); Dr. T. Edward and Tullah
Hanley Collection; gift to M. H. de Young Memorial
Museum.
BIBLIOGRAPHY: Lloyd Goodrich, *Thomas Eakins, His Life
and Work* (New York: Whitney Museum of American
Art, 1933), no. 13; Roland McKinney, *Thomas Eakins*
(New York: Crown Publishers, 1942), repr. p. 105;
Gordon Hendricks, *The Life and Work of Thomas Eakins*
(New York: Grossman Publishers, 1974), no. 5,
p. 316, repr.
EXHIBITIONS: E. C. Babcock Art Galleries, New York,
*Exhibition of Sketches, Studies and Intimate Paintings by
Thomas Eakins*, 1939, no. 38; Wildenstein & Co., New
York, *The Dr. T. Edward and Tullah Hanley Collection*,
and Fogg Art Museum, Harvard University, 1961-1962
(also Gallery of Modern Art, New York; Philadelphia
Museum of Art; The Denver Art Museum; and
Museum of Southwest, Midland, 1967-1968; Columbus
Gallery of Fine Arts, 1968; Canisius College, Buffalo,
1969; M. H. de Young Memorial Museum, San
Francisco, 1970, no. 12, p. 13, pl. 15, p. 39); M. H. de
Young Memorial Museum, The Fine Arts Museums of
San Francisco, *Faces and Figures: 19th Century Works on
Paper from the Permanent Collection*, 1984.

Thomas Eakins's reputation as one of America's greatest
artists rests largely on his abilities as a portraitist. His
interest in portraiture was fostered by an academic
training that stressed drawing from the model as a key
element of an artist's development. Because of its
relative naïveté, this stumped drawing has been dated
early in Eakins's career. Lloyd Goodrich dates it to the
years 1863-1866, when Eakins attended the Pennsylvania
Academy of Arts.[1] It is more probable, however, as
Gordon Hendricks stated, that the work was executed in
1866-1867, during Eakins's first months of study in
Paris.[2] There are three reasons for this conclusion: the
drawing is on French paper, its general bust-length
portrait style coincides with a number of similar
paintings made in Paris at that time, and the model is
an exotically turbaned black or Arab.

The unusual three-quarter rear view of the model,
which adds a dynamic element to the drawing, could
have been chosen by Eakins as an exercise in drawing
from extreme angles. A simpler explanation might be
that all the prime spots for drawing the model were
taken that day in the crowded Ecole des Beaux-Arts life
class, so that Eakins was forced to draw from a location
behind the model.

The interest of the pose and the vigorous execution of
this drawing are balanced against the coarseness of
Eakins's technique. However, as Goodrich has stated,
"This is no reflection on its characteristic strength and
massiveness, and its command of light and shadow—
qualities revealed in Eakins's works from the first."[3]
R.F.J.

*Memorial gift from Dr. T. Edward and Tullah Hanley,
Bradford, Pennsylvania, 69.30.58*

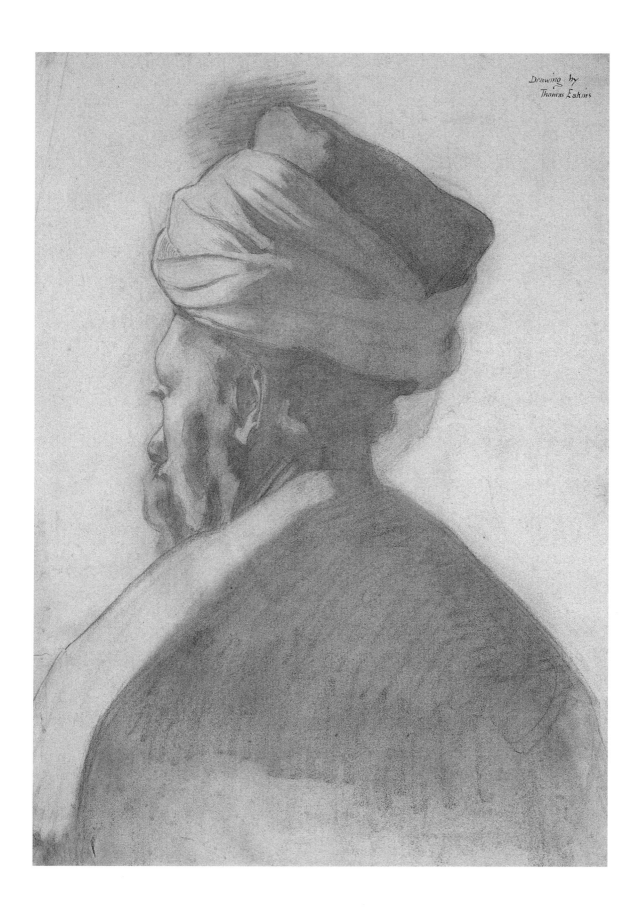

Drawing by
Thomas Eakins

93. Frederick Childe Hassam *Dorchester, Massachusetts 1859-1935 East Hampton, New York*

Rainy Night, ca. 1895

Watercolor and gouache over graphite underdrawing on wove paper; 11¼ × 8¼ in. (285 × 210 mm). Signed in red ink at lower left: *Childe Hassam.*

PROVENANCE: Bernard Danenberg Galleries, New York; Mrs. Frederick J. Hellman, San Francisco.
BIBLIOGRAPHY: This work will be included in the forthcoming catalogue raisonné on Childe Hassam by Stuart T. Feld and Kathleen M. Burnside.
EXHIBITIONS: California Palace of the Legion of Honor, The Fine Arts Museums of San Francisco, *Selected Acquisitions, 1977-1979*, 1979-1980, checklist, no. 28; idem, *Masterworks from the Achenbach Foundation for Graphic Arts*, 1981.

Frederick Childe Hassam, like many young artists in Boston in the late 1870s, was an admirer of the Barbizon School of painting. As a result of his travel throughout Europe in 1883 and his three-year sojourn in Paris from 1886 to 1889, however, Hassam rapidly became well versed in the more progressive art movements of the day. His own art evolved toward a form of Impressionism, while it maintained a realist mode in retaining the clear identity of his subjects. Although this style remained constant throughout the rest of his long career, art historians agree that his works of the 1890s, such as the watercolor *Rainy Night*, are his finest achievements.

Watercolor was a favorite medium of Hassam's from an early age. By 1882 he had produced a series of pure landscapes of the environs of Boston. They were executed in bold, transparent washes reminiscent of the work of the English School, notably J. M. W. Turner.[1] As Hassam's art matured, so did his watercolor technique. By the time he moved to New York in 1889, after three years in Paris, his watercolors had become the most advanced and sophisticated aspect of his art. Typical of his preference for small-scale watercolors, *Rainy Night* of about 1895 exemplifies Hassam's confidence in his ability to manipulate this volatile medium.

In this glistening nocturne, Hassam, through his virtuoso handling of veils of transparent washes, has not only captured the look but also the damp atmosphere of a rain-drenched New York street. The play of artificial light on the wet pavement and onto the blue-black sky creates an unreal quality of excitement and expectation. Hassam later went over the work with selective touches of white and yellow gouache to strengthen the illusion of reflected light.

Hassam may have been inspired by the earlier nocturnes of his countryman James A. McNeill Whistler. In his famous *Ten O'Clock* lecture Whistler stated that as night falls upon the city "the poor buildings lose themselves in the dim sky, and the tall chimneys become campanili, and the warehouses are palaces in the night, and the whole city hangs in the heavens, and fairy-land is before us...."[2] Hassam's watercolor, with its glimpse of pedestrians crowded under umbrellas and busy horse-drawn cabs, was not meant to document a particular place or time. Instead, the artist created a romantic vision of the modern metropolis that was only as real as his imagination.

R. F. J.

Gift of Louise H. Felker and Margery H. Strass in memory of Rosalie G. Hellman, 1978.2.30

94. Winslow Homer *Boston 1836-1910 Prout's Neck, Maine*

Burnt Mountain, 1892

Watercolor with traces of graphite underdrawing on wove paper; 13⅞ × 20 in. (358 × 518 mm). Signed and dated in dark blue watercolor at lower left: *Homer 1892*.

PROVENANCE: J. R. Andrews, Bath, Maine, 1916; Mr. and Mrs. Charles R. Henschel, New York; M. Knoedler & Co., New York; Mr. and Mrs. John D. Rockefeller 3rd, 1970.

BIBLIOGRAPHY: *Illustrated Catalogue of Valuable Paintings... belonging to the Estates of the late J. R. Andrews...* (New York: The American Art Association, 1916), no. 108, repr.; Nathaniel Pousette-Dart, *Winslow Homer* (New York: Frederick A. Stokes Co., 1923); Lloyd Goodrich, "Winslow Homer," *The Arts* (October 1924): 202; Theodore Bolton, "Water Colors by Homer: Critique and Catalogue," *The Fine Arts* (April 1932): 52; "The Henschel Homers: A Collector's Picking of the Watercolors," *Art News* (July 1941): 21; James W. Fosburgh, "Winslow Homer–Artist," *The New York State Conservationist* (August-September 1948), repr. on cover; Lloyd Goodrich, *Winslow Homer in the Adirondacks*, exh. cat. (New York: Adirondack Museum, Blue Mountain Lake, 1959), fig. 22; Albert Ten Eyck Gardner, *Winslow Homer* (New York: C. N. Potter, 1961), p. 179.

EXHIBITIONS: Museum of Modern Art, New York, *Homer/Ryder/Eakins*, 1930, no. 31; The Art Institute of Chicago, *A Century of Progress, Exhibition of Paintings and Sculpture*, 1934, no. 470; M. Knoedler & Co., New York, *Winslow Homer, Artist: Loan Exhibition of Water Colours*, 1936, no. 18; Musée du Jeu de Paume, Paris, *Trois Siècles d'Art aux Etats-Unis*, 1938, 2d ed., no. 85; Institute of Modern Art, Boston, *Watercolors by Winslow Homer from the Collection of Mr. and Mrs. Charles R. Henschel*, checklist, 1941, no. 11 (also California Palace of the Legion of Honor, San Francisco, 1941); Wildenstein & Co., New York, *A Loan Exhibition of Winslow Homer*, 1947, no. 69; National Gallery of Art, Washington, D.C., *Winslow Homer, A Retrospective Exhibition*, exh. cat. by Albert Ten Eyck Gardner, 1958-1959, no. 145 (also The Metropolitan Museum of Art, 1959); idem, *Water Colors by Winslow Homer from the Collection of Mrs. Charles R. Henschel*, 1962, no. 10, repr.; Albright-Knox Art Gallery, Buffalo, New York, *Watercolors by Winslow*

Homer, 1966, no. 30; M. H. de Young Memorial Museum, The Fine Arts Museums of San Francisco, *American Art: An Exhibition from the Collection of Mr. and Mrs. John D. Rockefeller 3rd*, exh. cat. by E. P. Richardson, 1976, no. 73, pp. 174-175; California Palace of the Legion of Honor, The Fine Arts Museums of San Francisco, *Selected Acquisitions, 1977-1979*, 1979-1980, checklist, no. 33; idem, *Winslow Homer, Wood Engravings: Visions and Revisions*, 1983.

Winslow Homer began to explore the medium of watercolor in 1873 with scenes of Gloucester Harbor. After only a short tentative period, he developed a mastery of technique and a freshness of vision that made his watercolors superior to any others in America up to that time. An artistic breakthrough began, however, with the watercolors made after Homer's trip to the Bahamas and Cuba in the winter of 1884-1885. This can be seen in the freer and more liquid use of washes and in a bolder use of color and composition. His greatest watercolors, created in the 1890s, were the climax of this development. They fall into two groups: the sun-drenched scenes of Florida, the Bahamas, and Bermuda; and the more introverted wilderness scenes of the Adirondacks and Québec. *Burnt Mountain*, dated 1892, is characteristic of the latter group.

A somber mood pervades this scene, and it is punctuated by the skillfully rendered, leaden storm clouds and the barren tree roots silhouetted against the sky. The strong diagonal of the fallen tree leads the viewer to the resting hunter and his guide, and it separates them further from the distant landscape and the patch of lake far below on the right. Despite the ominous mood, there is no human drama. The posture of the men is one of experience and acceptance of the wilderness. Winslow Homer continually turned to the theme of man against the elements of nature. His solitary, unsentimental, masculine sensibility joined with his artistic creativity to give us vivid images of the resourcefulness of the human spirit.

R. F. J.

Gift of Mr. and Mrs. John D. Rockefeller 3rd, 1979.7.55

95. Winslow Homer *Boston 1836-1910 Prout's Neck, Maine*

Sunrise, Fishing in the Adirondacks, 1892

Watercolor on wove paper; 13½ × 20½ in.
(343 × 522 mm). Signed at lower right: *Homer*.

PROVENANCE: William F. Ewing, New York; Colonel
Edgar William Garbisch, New York; Hirschl & Adler
Galleries, New York.
BIBLIOGRAPHY: Lloyd Goodrich, *Winslow Homer in the
Adirondacks*, exh. cat. (Blue Mountain Lake, New York:
Adirondack Museum, 1959), p. 25.
EXHIBITIONS: Museum of Fine Arts, Boston, 1944;
National Gallery of Art, Washington, D.C., *Winslow
Homer, A Retrospective Exhibition*, exh. cat. by Albert Ten
Eyck Gardner, 1958-1959, no. 141, p. 125, repr. p. 72
(also The Metropolitan Museum of Art, New York,
1959); University of Arizona Art Gallery, Tucson,
Winslow Homer, 1963; California Palace of the Legion of
Honor, The Fine Arts Museums of San Francisco,
Masterworks from the Achenbach Foundation for Graphic Arts,
1981; idem, *Winslow Homer, Wood Engravings:
Visions and Revisions*, 1983.

In watercolors such as *Sunrise, Fishing in the Adirondacks*,
Winslow Homer places himself among the finest
American watercolorists of his day. His considerable
achievement in mastering this difficult medium ranks
him with other great nineteenth-century watercolorists
including William Blake, J. M. W. Turner, Honoré
Daumier, Rudolf von Alt, Paul Cézanne, and his
compatriot John Singer Sargent.

In his Adirondack scene, Homer has emphasized
mood over narrative in depicting a fisherman casting his
line in the early dawn. The quiet of the scene,
emphasized by the stillness of the lake surface, is only
slightly broken by the wake of the gliding canoe in the
water and the whirling of the fishing line. Homer has
delighted in scratching into the still-wet paper his almost
calligraphic rendering of the impossibly long cast of the
fisherman. The bold placement of the fisherman with-
in the extremely dense nocturnal blues and greens is
contrasted with the brilliantly handled, blood red
washes in a sky that promises dawn.

In his old age, Homer told his dealer Charles R.
Henschel of Knoedler's, "You will see, in the future I
will live by my watercolors."[1] With the passage of
years and growing recognition of his accomplishment,
Homer's prophetic assessment of his watercolors is in
large part correct.
R. F. J.

*Achenbach Foundation for Graphic Arts purchase, Mildred
Anna Williams Fund, 1966.2*

96. John La Farge *New York 1835-1910 Providence, Rhode Island*

The Great Buddha, 1886

Watercolor over traces of graphite underdrawing on wove paper; 15⅞ × 19¼ in. (404 × 491 mm).

PROVENANCE: R. P. Tolman; Stephen C. Clark; Kennedy Galleries, New York; Mr. and Mrs. John D. Rockefeller 3rd, 1968.

EXHIBITIONS: Kennedy Galleries, New York, *John La Farge: Oils and Watercolors*, 1968, no. 15; California Palace of the Legion of Honor, The Fine Arts Museum of San Francisco, *Selected Acquisitions, 1977-1979*, 1979-1980, checklist, no. 35; The National Museum of Western Art, Tokyo, *American Painting 1730-1960: A Selection from the Collection of Mr. and Mrs. John D. Rockefeller 3rd*, exh. cat. by Margaretta Lovell, 1982, no. 36, repr.

As a result of his experiences as a traveler, writer, lecturer, teacher, and theorist, John La Farge was considered the most erudite American artist of his age. The eclectic nature of his art is exemplified by the fact that it ranged at times from strict academicism to realism, Symbolism, and even Impressionism. An accomplished painter, draftsman, and muralist, La Farge was also, along with Louis Comfort Tiffany, the most innovative American practitioner in stained glass.

Although he was intrigued with the medium of watercolor, La Farge had great difficulty mastering its unforgiving subtleties. He first exhibited at the Water Color Society in 1876, and he frequently worked in the medium in the late 1870s. On his travels in subsequent decades he found watercolor the most accessible method of capturing his artistic impressions. His frequent problem with it, however, was his own inability to reconcile the inherent improvisational fluidity of the medium with his need to rework, correct, and "finish." As Theodore Stebbins wrote of La Farge's watercolors, "Though he demonstrates at times a great sensitivity to color values, an understanding of pigments and paper, a willingness to take chances, and a knowledge of composition, these are seldom found together in one work."[1]

The Great Buddha is an exception. In this work, La Farge has been able to balance spontaneity in depicting atmospheric effects and overall mood with accuracy in depicting the reality of the site. This work resulted from his extended trip to Japan in 1886, which he later chronicled in a series of published letters.[2] On 2 September 1886 La Farge and his companion, Henry Adams, traveled to Kamakura, a coastal town twelve miles south of Yokohama where the great bronze Buddha, commonly known as Daibutsu, sits. Then as now, it is one of the most venerated sites in Japan. This great statue and its surroundings had an immediate effect on La Farge as he approached the site: "From the side one can see how it bends over, and rough as it is from behind, the impression of something real was strong as its gray form moved through the openings of the trees."[3] This is the viewpoint the artist adopted in our watercolor. La Farge recounted that he attempted to record his impressions of the scene accurately: "I painted also, more to get the curious gray and violet tone of the bronze than to make a faithful drawing, for that seemed impossible in the approaching afternoon.... The clouds had begun to open, and a faint autumnal light filled the little hollow, which has only small trees...."[4]

Our detailed watercolor was clearly made at a later date, based on memory and on the above-mentioned watercolor sketches made at the site. Nevertheless, it succeeds to an amazing degree in capturing the wonder La Farge felt in experiencing this great work of art.

La Farge made another watercolor of the statue seen from its base, but it is far more conventional and static.[5] The Achenbach sheet is a contemplative, sophisticated work. La Farge has caught the impressionistic shifting of light over the natural surroundings, while maintaining his accurate record of the scene even to noting the greenish corrosion on the head and chest of the ancient bronze.

R. F. J.

Gift of Mr. and Mrs. John D. Rockefeller 3rd, 1979.7.70

97. Thomas Moran *Bolton, England 1837-1926 Santa Barbara, California*

View of New York from Across the Harbor, ca. 1883-1885

Graphite, pen and brown and black inks, gray and brown washes, with white and cream gouache heightening on wove paper; 10¼ × 17 in. (260 × 433 mm). Signed in brown ink with monogram at lower left and inscribed in brown ink at lower right: *New York from the Bay.*

PROVENANCE: James Graham Gallery, New York, 1973; Mr. and Mrs. John D. Rockefeller 3rd, 1973. EXHIBITION: M. H. de Young Memorial Museum, The Fine Arts Museums of San Francisco, *American Art: An Exhibition from the Collection of Mr. and Mrs. John D. Rockefeller 3rd*, exh. cat. by E. P. Richardson, 1976, no. 87, p. 202.

Thomas Moran became one of the most famous American painters of the nineteenth century principally because of his celebration of the grandeur of Western scenery. Unlike Bierstadt, Moran liked to employ a Turneresque palette. This inclination toward spectacular color and effects was cultivated since childhood because of his fascination with Turner. As an apprentice engraver in the early to mid-1850s, he had traded his watercolors for volumes of Turner's engravings, such as *The Rivers of France.* Later in 1861, Moran traveled to England especially to see Turner's pictures as well as the sites that the English artist had painted.[1] In 1871 the artist accompanied F. V. Hayden on a pioneering geological expedition to Yellowstone, and the watercolors that resulted from that now celebrated trip are Moran's first truly inventive expressions based on the lessons learned from Turner a decade earlier.

The Museum's exquisite topographical study of the New York skyline from the Hudson River centers on the southern tip of Manhattan Island. It cannot be dated before the early 1880s, for the Brooklyn Bridge appears finished (it was completed in 1883).[2] Although the study is in black and white, the panoramic view reveals Moran's feeling for the transitory but strong effects of light. In this sense, it still pays a debt to Turner's watercolors and their skies, rivers, and seas, which were studied and occasionally copied by Moran in early 1862 at the National Gallery in London. *View of New York from Across the Harbor* not only suggests Moran's mastery of watercolor but it also speaks for Moran's experience in preparing works for engraved illustration. During his career Moran probably designed more than fifteen hundred illustrations for magazines such as *Scribner's Monthly,* which began publication in 1870 and that year included a work by the artist.[3] Other magazines that eagerly sought and published his drawings for engraving include *Harper's Monthly,* the *Aldine,* the *Art Journal,* and the *Illustrated London News.* The painter also contributed illustrations for books and government documents.[4] We have not yet been able to identify an engraving related to our study, but there is a good chance that one exists.

J. R. G.

Gift of Mr. and Mrs. John D. Rockefeller 3rd, 1979.7.74

98. Albert Pinkham Ryder *New Bedford, Massachussetts 1847-1917 Elmhurst, New York*

Untitled (landscape), ca. 1880

Watercolor over graphite underdrawing on wove paper; 10 × 14⅛ in. (255 × 360 mm). Signed in graphite at lower right: *A P Ryder*.

PROVENANCE: From the artist to Colonel C.E.S. Wood, Portland, Oregon, later San Francisco; to his stepdaughter, Katherine Field Caldwell, Berkeley, California.
EXHIBITIONS: San Francisco Museum of Art, *Twentieth Anniversary Exhibition: The Museum and its Collections, Collections of Modern Art in the Bay Area*, checklist, 1955; California Palace of the Legion of Honor, The Fine Arts Museums of San Francisco, *Recent Acquisitions, Part I*, 1983.

This restrained and curiously modern-looking composition could be mistaken for a work by a twentieth-century artist such as Edwin Dickinson. Instead, it is an accomplished, yet totally atypical, watercolor by the nineteenth-century visionary artist Albert Pinkham Ryder. Although he is widely considered one of the great nineteenth-century American artists along with Thomas Eakins and Winslow Homer, Ryder's works on paper are virtually nonexistent, and he was not even mentioned in Theodore E. Stebbins's landmark publication of 1977, *American Master Drawings and Watercolors*.[1]

Most of Ryder's works are imaginative landscapes, seascapes, and biblical or poetic subjects. They are executed on wood, canvas, or gilded leather, in oils applied so thickly and in so many layers that subsequent cracking and discoloration has disfigured most of them.

Ryder preferred to depict ethereal dawn, evening, or night scenes. In this unidealized watercolor, however, drawn in sharp, clear daylight, his art shows realist tendencies that are barely suggested in his oil paintings. Ryder's works are difficult to date, since he himself never dated them. Often they are unsigned as well. Because his interests turned from naturalistic subjects to more literary and poetic themes about 1880, our watercolor should be dated about this time.[2] As a young artist, Ryder was often frustrated by his inability to work naturalistically: "Nature is a teacher who never deceives. When I grew weary with futile struggle to imitate the canvases of the past, I went out into the fields, determined to serve nature as faithfully as I had served art. In my desire to be accurate I became lost in a maze of detail. Try as I would, my colors were not those of nature. My leaves were infinitely below the standard of a leaf, my finest strokes were coarse and crude...."[3] Our watercolor offers one of those rare instances in which Ryder fulfilled his desire to capture observed rather than imagined nature.

Carefully signed in the lower right corner, this watercolor was originally a gift from Ryder to friend and patron Colonel Charles Erskine Scott Wood (1852-1944) of Portland, Oregon. They became friends in the early 1880s, while Wood was attending Columbia University Law School. On the backboard of the frame there is an inscription in Wood's handwriting: "Albert Pinkham Ryder/who told me it was one of about five watercolors he had ever done–C.E.S.W."

R. F. J.

Gift of Mrs. Katherine Caldwell, 1982.2.55

99. John Singer Sargent *Florence 1856-1925 London*

A Note (The Libreria, Venice), ca. 1902-1908

Watercolor over graphite underdrawing on wove paper;
14 × 20⅛ in. (356 × 510 mm).

PROVENANCE: Sold by Knoedler & Co., New York, for
Sargent to The Brooklyn Museum, 1909; sold by The
Brooklyn Museum to Knoedler & Co., New York, 1926;
George Hopper Fitch, 1956.
BIBLIOGRAPHY: William Howe Downes, *John S. Sargent:
His Life and Work* (Boston: Little, Brown & Co., 1925),
no. 596, p. 271.
EXHIBITIONS: Brooklyn Institute of Arts and Sciences
(no further documentation); M. Knoedler & Co., New
York, 1909; The Cleveland Museum of Art, *Fourth
Exhibition of Watercolors and Pastels*, 1927; Columbus
Gallery of Fine Arts (no further documentation);
California Palace of the Legion of Honor, The Fine Arts
Museums of San Francisco, *Recent Acquisitions 1976-1977*,
1977; idem, *Masterworks from the Achenbach Foundation for
Graphic Arts*, 1981; idem, *Venice: The American View,
1860-1920*, exh. cat. by Margaretta M. Lovell, 1984,
no. 61, repr. (also The Cleveland Museum of Art,
1985).

By the year 1900, John Singer Sargent was considered
the most fashionable and skillful portrait painter on
either side of the Atlantic. However, the unending
stream of wealthy clients who came to his London
studio to commission portraits began to wear down his
creative energy and tax his patience. Sargent
increasingly traveled abroad at this time to escape the
monotony of portraiture that pleased the client but not
the artist. It freed him to explore diverse subject matter
and to work in a spontaneous and personal manner. The
greatest manifestation of this new artistic freedom is
seen in his remarkable watercolors. Donelson Hoopes
has written, "The watercolors are free of the taint of
servitude to the demands of international society, and
possess a powerful technique which cannot be faulted
for superficiality—objections which Sargent's critics
have always pointed to as the fatal flaws of his
art...."[1] Sargent's achievements in watercolor rank
him with Winslow Homer as one of America's two
great practitioners of this seductive yet unforgiving
medium.

Sargent had explored the technique of watercolor as a
student, but it was not until 1887, possibly through
meeting the English artist Hercules Brabazon Brabazon
(1821-1906), that his interest in the medium was
reawakened.[2] Sargent's efforts at this time, however,
were tentative, and it was not until after 1900 that he
seriously concentrated on mastering its nuances. Hoopes
observed, "Very quickly, Sargent was applying a
vigorous brush to paper with a *brio* that is unmatched.
Watercolor seemed to release him from constraints about
pictorial 'manners'."[3]

Like many artists before him, Sargent found in the
city of Venice a bountiful source of creative inspiration
that was to nurture him throughout his career. *A Note
(The Libreria, Venice)* is a stunning example of Sargent's
ability to bring new energy to the depiction of a
Venetian monument so famous that it had become
almost a cliché. In this watercolor he has employed a
low viewpoint, restrained color, fragmentation of the
monument by radical cropping, and the demateri-
alization of structure by deft application of washes to
produce a vision of stunning originality. The result is a
work that is subtle in overall appearance yet dramatic in
effect—making us "see" this monument
in a new light.

It is interesting to note that Sargent rethought the
composition and drew a line at the base of the visible
molding with the notation "cut off." It is fortunate that
his instructions were not carried out and that our work
survives as a graphic illustration of Sargent's working
method of cropping his compositions.[4]

Sargent himself had a modest opinion of his
watercolors. When collectors insisted that he title them,
he would amusingly choose such bland descriptions as
"Blokes," "Dried Seaweed," or "Vegetables."[5] The
title of the Museums' work, *A Note*, may be no more
than a quick invention by Sargent to please a dealer. Its
lyrical connotation, however, reminiscent of Whistler's
Nocturne and *Harmony* series of paintings, suggests that it
was possibly a more carefully considered choice.[6]

Our watercolor was painted between 1902, when the
Campanile fell, and 1908 when it would have been
rebuilt enough to appear above the balustrade in the
background.[7] This work was included in the landmark
exhibition of Sargent watercolors at M. Knoedler & Co.,
New York, in 1909, and was part of the group of eighty-
three watercolors wisely purchased by The Brooklyn
Museum at that time. Unfortunately for that Museum,
it was also in the large group of Sargent watercolors that
the Museum decided to sell back to Knoedler in 1926, as
a result of escalating prices following the artist's death a
year earlier.

R. F. J.

Gift of Mr. and Mrs. George Hopper Fitch, 1976.2.21

Cut off

100. James Sharples *Lancashire, England ca. 1751-1811 New York*

Catherine Thorn Johnson, ca. 1796

Pastel on paper affixed to cardboard; 9¼ × 7⅜ in. (235 × 187 mm).

PROVENANCE: Mr. and Mrs. Lawrence A. Fleischman, Detroit, Michigan; Kennedy Galleries, New York, 1967; Mr. and Mrs. John D. Rockefeller 3rd.

EXHIBITIONS: Kennedy Galleries, New York, *American Drawings, Pastels and Watercolors*, exh. cat., 1967, no. 8, p. 10; California Palace of the Legion of Honor, The Fine Arts Museums of San Francisco, *Selected Acquisitions, 1977-1979*, 1979-1980, checklist, no. 52; M. H. de Young Memorial Museum, The Fine Arts Museums of San Francisco, *Faces and Figures: 19th Century Works on Paper from the Permanent Collection*, 1984.

Before the invention of the daguerreotype and other forms of photographic reproduction, there was a great demand for affordable portraiture in America. After the Revolutionary War this demand was met by an untold number of itinerant draftsmen who were usually foreign born. For a modest fee they would produce a good likeness, usually a profile, in a matter of hours. Their preferred media were chalk, pastel, and watercolor. Charles Balthazar Julien Févret de Saint-Mémin (French, 1770-1852) was the best known and most prolific portraitist of this period with over eight hundred known likenesses to his credit.[1] A more refined and painterly talent, however, is found in the pastel portraiture of the English-born artist James Sharples.

Sharples, a native of Lancashire, trained for the priesthood in France before returning to England to study art. By 1782 he had established himself in Bath as a teacher of drawing. The following year he moved to London, and during the next decade he exhibited several times at the Royal Academy. About 1793 Sharples and his family (his wife also was an accomplished portraitist) moved to New York. Over the next seventeen years, interrupted by a sojourn in England, Sharples became one of the more popular portraitists of the Federal Period. One measure of his success was that he left an estate of thirty-five thousand dollars, derived from his drawing commissions earned at a rate of fifteen dollars for a profile and twenty dollars for a full-face likeness.[2]

Using a thin, gray paper with surface texture to hold the pastel, Sharples invariably worked on an intimate scale of approximately nine-by-seven inches. To secure a fast and accurate representation, he employed a well-known device of the day called the physiognotrace. This machine aided the artist in copying the profile of a sitter, after which modeling could be added. Brushes were then used to apply the pastel in powdered form over the profile tracing. Sharples estimated that it took him two hours to complete an average portrait.[3]

Catherine Thorn Johnson is an especially fine and delicate example of Sharples's talent. The beauty of the sitter is matched but not overwhelmed by the artist's rendering of her simple yet fashionable ruffled dress, the pearls that adorn her ears, and her elaborately coiffured hair. The use of a Prussian blue pastel background to highlight the sitter was a specialty of Sharples's elegant neoclassical portraiture.

R. F. J.

Gift of Mr. and Mrs. John D. Rockefeller 3rd, 1979.7.92

Notes

1. Giovanni Francesco Barbieri (Il Guercino)
Saint John the Evangelist Meditating the Gospel

1. Our thanks to Mr. Nicholas Turner of the British Museum for this information.

2. Giovanni Francesco Barbieri (Il Guercino)
A Kneeling Nun

1. "Dono poi suo particolare fu ancora il fare certi ritratti, che Noi Pittori chiamiamo Caricature, nel qual genere di cose egli fu uno di quei pochi dotati di quella vivacità, e mente, che a ciò fare abbisogna, e da locare trà più Eccelenti...." See Jacob Bean, *Italian Drawings in the Art Museum/Princeton University* (New York: October House, 1966), p. 35.

4. Stefano della Bella
Marine Battle

1. Alexandre de Vesme, *Le Peintre-Graveur Italien* (Milan, 1906), p. 211, no. 816. One of eight marine subjects dedicated to Prince Lorenzo of Tuscany.

5. Giuseppe Galli Bibiena
Design for a Castrum Dolores to the Holy Roman Emperor, Leopold Joseph

1. The more complete title of the volume is *Architetture e Prospettive / dedicate / alla Maestà / di / Carlo Sesto / Imperador de' Romani / da / Giuseppe Galli Bibiena / Suo Primo Ingegner Teatrale, ed Architetto, etc.* The illustrations include fifty engravings of architectural and perspective scenes designed and drawn by Bibiena and engraved by or under the supervision of Andreas Pfeffel. The volume has been published by Dover in its Pictorial Archive Series (New York, 1964).

2. Ibid., part 5, pls. 1 and 2.

6. Pietro Buonaccorsi (Il Perino del Vaga)
Landscape with a Ruin and Study of Arms

1. Vasari, *Lives*, translated by Gaston du C. de Vere, vol. 6 (London: Medici Society, 1912-1914), p. 194.

2. Sometime before 1968, the Museums' drawing probably was affixed to another drawing by Perino featuring a group of figure studies. It was stated that the two drawings were split from a single sheet, although judging from an examination of the verso of the Museums' drawing, it appears more likely that the two works were simply glued together as recto and verso. See H. Schickman Gallery, New York, *Old Master Drawings*, 1968, no. 23.

7. Carletto Caliari
Bearded Man Wearing a Ruff

1. Mary Lee Bennett and Agnes Mongan, *Drawings from the Daniels Collection* (Cambridge: Harvard University, Fogg Art Museum, 1968), no. 1. Hans Tietze and Erica Tietze-Conrat, *The Drawings of the Venetian Painters* (New York: J. J. Augustin, 1944; republished 1970, by Collectors Editions Ltd., New York), vol. 1, no. 235, p. 58 (as Leandro); but also see pp. 352-359 for a discussion of the "Haeredes Paoli" and Carletto Caliari.

2. Alessandro Ballarin, "Introduzione a un catalogo dei disegni di Jacopo Bassano–II," in *Studi di storia dell'arte in onore di Antonio Morassi* (Venice: Alfieri, 1971), pp. 144-151.

W. R. Rearick, *Maestri Veneti del Cinquecento* (Florence, 1980), p. 58, under no. 34. Discussions of the recent change of attribution of the Marignane group of heads usually neglect to mention a much earlier attribution to Carletto Caliari made by K. T. Parker. This was a similar head formerly given to Paolo Veronese. See K. T. Parker, *Old Master Drawings* (London: Batsford, 1936; republished 1970, by Collectors Editions Ltd., New York), vol. 11, p. 27, pl. 22.

3. For a discussion of this painting and another drawing from the Marignane group see Jacob Bean, *15th and 16th Century Italian Drawings in the Metropolitan Museum of Art* (New York: The Metropolitan Museum of Art, 1982) no. 36, pp. 50-51.

8. Domenico Campagnola
Hilly Landscape with Woman and Donkey

1. Konrad Oberhuber, "Domenico Campagnola," in Jay A. Levenson et al., *Early Italian Engravings from the National Gallery of Art*, exh. cat. (Washington, D.C.: National Gallery of Art, 1973), p. 414.

2. James Byam Shaw, *The Italian Drawings of the Frits Lugt Collection* (Paris: Institut Néerlandais, 1983), vol. 1, p. 237.

3. Hans Tietze and E. Tietze-Conrat, *The Drawings of the Venetian Painters* (New York: J. J. Augustin, 1944), p. 123.

4. Ibid., p. 124.

5. Compare with *Callisto's Transformation into a Bear after Giving Birth to Arcas* (The Detroit Art Institute); *Fantastic Coastal Landscape* (H. Shickman Gallery catalogue, 1968, no. 11); and *Landscape with a Group of Trees on a Hillock* (Paris: Frits Lugt Collection, Institut Néerlandais).

6. Tietze, *Drawings*, p. 124.

7. Oberhuber, "Domenico," p. 417.

8. Elizabeth Mongan, "Domenico Campagnola," in Agnes Mongan, ed., *One Hundred Master Drawings*, exh. cat. (Cambridge: Harvard University Press, 1949), p. 50.

9. Giovanni Antonio Canal (Il Canaletto)
View of the Arch of Constantine and Environs, Rome

1. Letter from James Byam Shaw to a previous owner.

2. Ibid.

10. Francesco Fontebasso
Male Nude Floating Upward, His Arms Outstretched; A Bust of a Young Woman

1. Michael Levy, *Painting in XVIII Century Venice* (London: Phaidon, 1959), p. 47.

2. Terisio Pignatti, *Venetian Drawings from American Collections*, exh. cat. (Washington, D.C.: International Exhibitions Foundation, 1974), cat. no. 86, pp. 42-43. The drawing was also published by Mary Lee Benett and Agnes Mongan, *Drawings from the David Daniels Collection* (Cambridge: Harvard University, Fogg Art Museum, 1968), no. 17.

11. Pier-Leone Ghezzi
Doctor Fossambroni

1. *Caricature Drawings by Pier-Leone Ghezzi* (London: Sotheby's, 10 December 1979).

2. Ibid.

12. Ottavio Leoni
Portrait of Franco Tenturcine

1. *Italian Drawings, Selections from the Collection of Esther S. and*

Malcolm W. Bick, entry by Peter C. Sorlien, exh. cat. (New
Hampshire: Hopkins Center, Dartmouth College, 1971), no. 20.
2. Ibid.
3. Jacob Bean, *17th Century Italian Drawings in The Metropolitan
Museum of Art* (New York: Harry N. Abrams, Inc., 1979),
nos. 263 and 264, p. 198.

13. Pier Francesco Mola
Conversion of Saint Paul
1. For the best discussion of the conflicting evidence regarding
Mola's training, as well as a catalogue raisonné of his painted
work and related drawings, see: Richard Cocke, *Pier Francesco
Mola* (Oxford: Clarendon Press, 1972).
2. As Cocke explains (ibid., p. 59), the frescoes in the
Ravenna chapel are undocumented but are mentioned in the
early sources. Unfortunately, Cocke was unaware of the
existence of this sheet, for in his catalogue raisonné he states
that no drawing related to the fresco at Il Gesù (ibid., p. 52)
has been identified (ibid., p. 59).

14. Jacopo Negretti (Il Palma Giovane)
Recto: *Studies of the Transfiguration, Saint John
the Baptist*
Verso: *Horsemen in Combat*
1. Ivanoff and Zampetti, *Palma Il Giovane* (Bergamo:
Poligrafiche Bolis Bergamo, 1980), no. 232, p. 561, ill. p. 692,
no. 5.
2. A. Rizzi, *La Galleria d'Arte Antica e i Musei Civici di Udine*
(Udine, 1969), p. 36.

15. Giovanni Battista Piazzetta
Bust of a Girl Holding an Apple
1. Terisio Pignatti, *Venetian Drawings from American Collections*
(Washington, D.C.: International Exhibitions Foundation,
1974), p. 34.
2. Ibid.
3. Otto Benesch, *Venetian Drawings of the Eighteenth Century in
America* (New York: H. Bittner & Co., 1947), p. 29.

16. Bernardo Strozzi (Il Cappuccino Genovese)
Temperance
1. Opinions recorded during visits of these scholars to the
Achenbach Foundation.
2. The Achenbach Foundation has a group of six drawings by
Ventura Salimbeni.
3. Figurative drawings by Vanni and Salimbeni that may serve
for comparison can be seen in *Disegni dei Barocceschi Senesi
(Francesco Vanni e Ventura Salimbeni)*, introduction and
catalogue by Peter Riedel (Florence: Olschki, 1976). *Temperance*
was attributed to Giovanni Battista Spinelli by Alfred Moir and
published as such in Moir's catalogue *Regional Styles of Drawing
in Italy: 1600-1700* (Santa Barbara: University of California,
1977), no. 67, p. 108-109.
4. For a good, brief discussion of Strozzi as a draftsman,
including a selected bibliography, see Mary Newcome, *Genoese
Baroque Drawings* (Binghamton: University Art Gallery, State
University of New York, 1972), nos. 25 and 26, pp. 10-11.

17. Giovanni Battista Tiepolo
The Crucifixion
1. George Knox, *Tiepolo/A Bicentenary Exhibition*, exh. cat.
(Cambridge: Fogg Art Museum, Harvard University, 1970),
no. 59.
2. Ibid.

18. Giovanni Domenico Tiepolo
The Head of an Old Man
1. George Knox, *Tiepolo/A Bicentenary Exhibition*, exh. cat.
(Cambridge: Fogg Art Museum, Harvard University, 1970),
no. 92.
2. George Knox, *Domenico Tiepolo/Raccolta di Teste* (Udine,
1970), Head I, 22 (illustrates both drawing and print). Knox
(*Tiepolo/A Bicentenary*) mentions that the drawing is close in
style to a study by Giambattista, now at the Ashmolean
Museum, Oxford, for the altarpiece at Mirano (illus. in
Antonio Morassi, *A Complete Catalogue of the Paintings of
G. B. Tiepolo* [London: Phaidon, 1962], pl. 132). This work is
dated 1754-1760, and Knox dates the San Francisco drawing
accordingly. As the *Raccolta* was published between 1770 and 1774
and the print derived from the San Francisco drawing was
included in part one, an attribution of the drawing to
Domenico would probably place its date closer to 1770.

19. Giovanni Domenico Tiepolo
*Punchinello Series: Punchinello's Children Begging
for Treats*
1. *Balli di Sfessania*, ca. 1622 (Lieure 379-402).
2. James Byam Shaw, *The Drawings of Domenico Tiepolo*
(London: Faber and Faber, 1962), p. 53.
3. Marcia E. Vetrocq, *Domenico Tiepolo's Punchinello Drawings*,
exh. cat. (Bloomington: Indiana University Art Museum,
1979), p. 21.
4. Shaw, *Drawings of Domenico*, pp. 58-59.
5. Vetrocq, *Tiepolo's Punchinello Drawings*, p. 37.
6. Ibid., p. 22.
7. Ibid., p. 139, no. 54.

20. Giovanni Domenico Tiepolo
Punchinello Series: La Furlana
1. The others are no. 6, *The Country Dance* (Museum of Art,
Rhode Island School of Design, Providence); no. 22,
Punchinello with Dancing Dogs (Fogg Art Museum, Harvard
University, Cambridge).
2. Marcia E. Vetrocq, *Domenico Tiepolo's Punchinello Drawings*,
exh. cat. (Bloomington: Indiana University Art Museum,
1979), p. 76.
3. Actually, there were 103 drawings, since the title page was
not counted. One sheet, *Punchinello with Elephant* (The Pierpont
Morgan Library, New York), had been separated from the
group at an earlier date.
4. Janos Scholz, *Italian Master Drawings, 1350-1800, from the
Janos Scholz Collection* (New York: Dover Publications, 1976),
p. vii.
5. Vetrocq, *Tiepolo's Punchinello Drawings*.

21. Workshop of Pieter Brueghel the Elder
The Beekeepers
1. Ludwig Münz, *Brueghel, The Drawings* (London: Phaidon
Press, 1961), no. 154, p. 230.

2. Entry by Konrad Renger, *Pieter Brueghel d. Ä als Zeichner* (Kupferstichkabinett, Berlin, 1975), no. 100, pp. 86-87.

3. A. E. Popham, *Catalogue of Drawings by Dutch and Flemish Artists in the British Museum* (London, 1932), vol. 5, no. 7, p. 145.

4. Translation by Maxine Rosston and Pauline Jacobson.

5. Renger, pp. 86-87.

6. Ibid.

22. Gillis Neyts
View of a City with Ruined Arch

1. Eight works by Neyts of varying style are illustrated and discussed by Leo Van Puyvelde in *The Flemish Drawings in the Collection of His Majesty the King at Windsor Castle* (New York: Oxford University Press, 1942), nos. 264-271, pp. 43-44. Also see Walter Bernt, *Die Niederländischen Zeichner des 17. Jahrhunderts* (Munich: Verlag Bruckmann, 1958), vol. 2, nos. 436-441, illus.

2. The artist also signed and initialed drawings using the Latin equivalent, Aegidius, of his Flemish Christian name, Gillis.

23. Ferdinand Bol
The Return of the Prodigal Son

1. For excellent essays on Rembrandt as a teacher see E. Haverkamp-Begemann, "Rembrandt as Teacher," in *Rembrandt After Three Hundred Years* (The Art Institute of Chicago, 1969), pp. 21-29, and Otto Benesch, "Rembrandt's Artistic Heritage" in *Otto Benesch/Collected Writings* (London: Phaidon, 1970), pp. 57-82.

2. Joachim von Sandrart, *Teutsche Akademie*, Peltzer, ed., 1925, p. 203 (passage quoted in English in Horst Gerson, "Rembrandt as a Teacher" in his *Rembrandt Paintings* [New York: Reynal, 1968], p. 62).

3. Gerson, p. 66.

4. Werner Sumowski, "Ferdinand Bol," in *Drawings of the Rembrandt School* (New York: Abaris, 1979), p. 197.

5. For a discussion of the attribution of *The Return of the Prodigal Son*, see Sumowski, no. 206ˣ, p. 436.

6. See Otto Benesch, *The Drawings of Rembrandt*, (London: Phaidon, 1973), vol. 4, no. A40a and illus. 1105 (attributed to Rembrandt in the style of the early 1640s).

24. Ferdinand Bol
Bearded Old Man with Beret

1. For a discussion of the Bol painting on which *Bearded Old Man with Beret* is based see Werner Sumowski, *Gemälde der Rembrandt Schüler* (Germany, Edition PVA, 1983), cat. no. 132, p. 304, illus. A discussion of the drawing is to be found in Sumowski, "Ferdinand Bol," in *Drawings of the Rembrandt School* (New York: Abaris, 1979), vol. 1, cat. no. 143ˣ, pp. 310-311. Sumowski notes that this drawing is identical in style to Bol's copy after a Rembrandt self-portrait of 1640 (National Gallery of London), Sumowski cat. no. 142ˣ. Other drawings related stylistically or in feeling include Sumowski nos. 128ˣ, 129ˣ, and 138ˣ.

25. Johannes Bronkhorst
Study of Lepidopterans (Five Adults and a Caterpillar)

1. For the most splendid and ambitious publication on Merian to date, see: Ullmann, Beer, and Lukin, *Maria Sibylla Merian/Leningrad Watercolours* (New York: Harcourt, Brace, Jovanovitch, 1974). In two volumes, it contains facsimiles and color plates of the largest collection of Merian watercolors in existence.

2. There have been a number of Bronkhorsts on the market in recent years. This writer has seen several that are initialed, but most of them are not.

26. Jan van Goyen
River Landscape with Farm Buildings, Bridge, and Three Boats

1. Our drawing is listed but not illustrated by Beck. For similar works catalogued according to date, see Hans Ulrich Beck, *Jan van Goyen* (Amsterdam: Van Gendt, 1972), vol. 1.

27. Marten van Heemskerck
Joseph and Potiphar's Wife

1. The most fascinating evidence for Heemskerck's Roman sojourn is provided by the so-called Roman sketchbooks in the Print Room of West Berlin. See Christian Hulsen and Hermann Egger, *Die Römischen Skizzenbücher von Marten van Heemskerck, etc.* (Berlin, 1913-1916; Soest, Holland: Davaco, 1975, reprint).

2. Some of Heemskerck's early drawings have been attributed to Giulio Romano. For a discussion of this, see K. G. Boon, *Netherlandish Drawings of the Fifteenth and Sixteenth Centuries* (The Hague: Government Printing Office, 1978), no. 312, p. 110.

3. See Wolfgang Stechow, "Heemskerck, the Old Testament and Goethe," *Master Drawings* 2, no. 1 (1964): 37.

4. Ibid., p. 38.

5. See F. W. H. Hollstein, *Dutch and Flemish Etchings, Engravings and Woodcuts ca. 1450-1700* (Amsterdam, n. d.), vol. 8, p. 238, cat. no. 48; also see *Master Drawings from California Collections*, Juergen Schulz, ed. (Berkeley: University Art Museum, University of California, 1968), cat. no. 68, p. 70.

6. Hollstein, no. 400. The related engraving of *Joseph and Potiphar's Wife* illustrates the ninth commandment, "Thou shalt not bear false witness."

7. Similar griffin or grotesque supports are to be found in several other drawings by Heemskerck. See Jan Garff, *Tegninger af Maerten Van Heemskerck* (Copenhagen: Statens Museum for Kunst, 1971), pls. 77 and 83.

28. Pieter Jansz Quast
A Skater

1. B. A. Stanton-Hirst, "Pieter Quast and the Theatre," *Oud Holland* 96, no. 4 (1982): 234-235.

2. Ibid., p. 234.

3. Franklin W. Robinson, *Seventeenth-Century Dutch Drawings from American Collections* (Washington, D.C.: International Exhibitions Foundation, 1977), p. 31.

4. *Fine Dutch, Flemish and German Drawings* (Amsterdam: Sotheby Mak van Waay B.V., 16 November 1981), lots 1-23.

5. In the collection of the Achenbach Foundation for Graphic Arts: *A Jester*, graphite on vellum, 196 × 147 mm, AFGA purchase, 1982.2.54.

6. Stanton-Hirst, "Pieter Quast," pp. 213-237.

30. Johann Wolfgang Baumgartner
Elementum Terrae (Allegory of Earth)

1. Bernard S. Meyers, ed., *McGraw-Hill Dictionary of Art*, vol. 1 (New York: McGraw-Hill, 1969), p. 269.

2. Thieme-Becker, *Künstler Lexikon*, vol. 20 (Leipzig: E. A. Seemann, 1930), pp. 411-412.

3. David W. Steadman and Carol M. Osborne, *18th Century Drawings from California Collections*, exh. cat. (Claremont: Pomona College, 1976), no. 4, pp. 8-9.

31. **Barbara Regina Dietzsch**
A Dandelion (Taraxacum officinale) with a Tiger Moth, a Butterfly (Lycaenid sp.), a Snail, and a Beetle
1. See David Scrase, *Flowers of Three Centuries: One Hundred Drawings and Watercolors from the Broughton Collection* (Washington, D.C.: International Exhibitions Foundation, 1983), nos. 20-26.

32. **Adolph von Menzel**
Study of a Tree
1. Degas and Menzel were in contact in Paris in 1867-1868. During that period Degas saw and then copied Menzel's painting of 1856 *Théâtre Gymnase*. From Menzel's exhibition at Goupils Gallery in Paris in 1883, Degas made a copy of *A Supper Ball*, a painting of 1878.
2. *Adolph von Menzel: Das graphische Werk*, vol. 2, compiled by Heidi Ebertshäuser (Munich: Rogner & Bernhard, 1976), pp. 1266, 1270.
3. Ibid., pp. 1257, 1266, 1270, 1283.
4. Ibid., pp. 1218, 1277.
5. Irmgard Wirth, "Adolph Menzel Drawings," in *Drawings and Watercolours by Adolph Menzel 1815-1905* (Arts Council of Great Britain, 1965), unpaginated.

33. **Gerhardt Wilhelm von Reutern**
Anne Lies Stamm and Anne Kathring
1. Stefanie Maison, *Gerhardt Wilhelm von Reutern*, exh. cat. (London: Hazlitt, Gooden & Fox, 1978), p. 7.
2. *Aquarelle und Zeichnungen der deutschen Romantik*, exh. cat. (Munich: Galerie Arnoldi-Livie, 1980), no. 49. A sketchbook by Ludwig Emil Grimm, containing a watercolor by von Reutern, is now in The Pierpont Morgan Library, New York.
3. Anne Kathring probably refers to Anne Kayhrin Ort whom von Reutern is known to have drawn.
4. Wilhelm Schoof, "Wie die Malerkolonie Willingshausen entstand" and "Goethe und Willingshausen," *Hessische Heimat* 7, no. 3, new series (1957-1958), pp. 6-13.
5. *Gerhardt Wilhelm von Reutern*, exh. cat. (Paris: Galerie Fischer-Kiener, 1977).
6. Maison, *Von Reutern*. The exhibition contained six watercolors and thirty-one drawings.

34. **Philipp Veit**
Study for "Die beiden Marien am Grabe"
1. There are two related, less finished studies for these figures. See Martin Spahn, *Philipp Veit* (Bielefeld und Leipzig: Velhagen & Klasing, 1901), pp. 54-55, figs. 49 and 50.

35. **Melchior Lorch**
The Prophet Jeremiah Exhorts the King of Judah and Other Kings to Submit to Babylon
1. Sotheby's, London, 15 March 1966; also see Peter Ward-Jackson, "Some Rare Drawings by Melchior Lorchis," *Connoisseur* 135 (1955): 83-93.

2. Thomas DaCosta Kaufmann, *Drawings from the Holy Roman Empire/1540-1680* (Princeton: The Art Museum, Princeton University, 1982), pp. 62-63.

36. **Mariano José María Bernardo Fortuny y Carbó**
Italian Woman
1. Robert Rosenblum and H. W. Janson, *19th-Century Art* (New York: Harry N. Abrams, 1984), p. 376.
2. Mary Lee Bennett and Agnes Mongan, *Drawings from the Daniels Collection*, exh. cat. (Cambridge: Harvard University, Fogg Art Museum, 1968), no. 42.

37. **Jusepe de Ribera**
Study of a Man with Upraised Hand (Orator?)
1. See Michael Mahoney, "The Drawings of Salvator Rosa" (Ph.D. diss., Courtauld Institute, University of London, 1965), and Jonathan Brown, *Jusepe de Ribera/Prints and Drawings*, exh. cat. (Princeton: Princeton University Press, 1973).
2. Brown, no. 16, p. 164.
3. Walter Vitzthum, *A Selection of Italian Drawings from North American Collections* (Toronto: Mackenzie Art Gallery, 1970), no. 39.

38. **Jacques Callot**
Two Studies of a Standing Man
1. Associated stylistically with Ternois nos. 311, 326, 363, 424, and 425; see Ternois, *Jacques Callot, Catalogue complet de son œuvre dessiné* (Paris: F. de Nobele, 1961).

39. **Circle of François Quesnel**
Portrait of a Lady
1. Given the subtleties of draftsmanship that must be differentiated to make a secure attribution in this complex area, it is fitting to recall the comment of Anthony Blunt with regard to a group of eleven drawings originally attributed to Dumonstier and reattributed by him to Quesnel. He stated that "it is impossible without a careful comparison with other sixteenth-century chalk portraits in the original to arrive at any definite conclusion about their authorship." See Anthony Blunt, *The French Drawings in the Collection of His Majesty the King at Windsor Castle* (Oxford and London: Phaidon, 1945), pp. 17-18.
2. Phyllis Hattis, *Four Centuries of French Drawings in The Fine Arts Museums of San Francisco* (San Francisco: The Fine Arts Museums of San Francisco, 1977), no. 7, pp. 45-46.
3. Ibid., p. 45.

40. **Edme Bouchardon**
Design for a Token for the Royal Treasury
1. Erwin Gradmann, *French Master Drawings of the Eighteenth Century* (London: A. Zwemmer, 1949), p. 29.
2. Pierre Rosenberg, *French Master Drawings of the 17th and 18th Centuries in North American Collections*, exh. cat. (Kent, England: Westerham Press, 1972), p. 136.
3. Correspondence from Jean-Pierre Selz, 1978.

41. **François Boucher**
Minerva
1. Regina Shoolman and Charles E. Slatkin, *Six Centuries of French Master Drawings in America* (New York: Oxford University Press, 1950), p. 62.

2. Kenneth Clark, *The Nude: A Study in Ideal Form* (New York: Doubleday & Co., 1956), p. 211.

3. E. and J. de Goncourt, *French XVIII Century Painters*, trans. Robin Ironside (New York: Oxford University Press, 1948), p. 72, cited from Agnes Mongan, ed., *One Hundred Master Drawings* (Cambridge: Harvard University Press, 1949), p. 114.

42. Jean-Honoré Fragonard
Artist in the Studio

1. John Canaday, *The Lives of the Painters* (New York: W. W. Norton & Co., 1969), vol. 2, pp. 577-578.

2. Eunice Williams, *Drawings by Fragonard in North American Collections*, exh. cat. (Washington, D.C.: National Gallery of Art, 1978), p. 86.

3. Phyllis Hattis, *Four Centuries of French Drawings* (San Francisco: The Fine Arts Museums of San Francisco, 1977), no. 51, p. 92.

4. Williams, *Drawings by Fragonard*.

43. Jean-Honoré Fragonard
Woman with a Parrot

1. See *The Painterly Print / Monotypes from the Seventeenth to the Twentieth Century* (New York: The Metropolitan Museum of Art, 1980).

2. It was published as a parakeet, *La femme au perroquet*, in 1913 (Galerie Georges Petit, *Catalogue de Dessins de l'Ecole française du dix-huitième siècle, provenant de la Collection Heseltine* [Paris, 1913], p. 21, no. 34), and as a macaw in 1977 (Phyllis Hattis, *Four Centuries of French Drawings* [San Francisco: The Fine Arts Museums of San Francisco, 1977], no. 53, p. 93).

3. *Woman with a Parrot* is catalogued and reproduced in Alexandre Ananoff, *L'œuvre dessiné de Jean-Honoré Fragonard* (Paris: F. de Nobele, 1961), vol. 1, no. 187, fig. 73. For similar figures, also see Ananoff, vol. 1, nos. 163, 165, 173, and 182; and vol. 2, nos. 726, 727, and 729.

44. Maurice Quentin de La Tour
Self-Portrait

1. A. Leroy, *La Tour* (Paris, 1933), cited from Regina Shoolman and Charles E. Slatkin, *Six Centuries of French Master Drawings in America*, (New York: Oxford University Press, 1950, p. 70.

2. Phyllis Hattis, *Four Centuries of French Drawings* (San Francisco: The Fine Arts Museums of San Francisco, 1977), no. 74, p. 116.

3. Ibid.

46. Gabriel de Saint-Aubin
Theater Scene (Ernelinde, Princess of Norway)

1. Greuze is quoted by Charles-Germain de Saint-Aubin in his *Livre des Saint-Aubin*. The complete text may be found in Emile Dacier, *Gabriel de Saint-Aubin, peintre, dessinateur et graveur*, vol. 1, *L'Homme et l'œuvre* (Paris, 1929), pp. 14-15.

2. Emile Dacier, *Gabriel de Saint-Aubin* (Paris, 1931), vol. 2, no. 788.

3. Phyllis Hattis, *Four Centuries of French Drawings* (San Francisco: The Fine Arts Museums of San Francisco, 1977), no. 115, p. 155. repr. p. 162.

47. Gabriel de Saint-Aubin
A Parisian Fête (L'enlèvement)

1. Charles-Germain de Saint-Aubin's complete texts are quoted in Emile Dacier, *Gabriel de Saint-Aubin*, (Paris, 1929),

pp. 14-15. Also, many passages have been translated into English by Ellen D'Oench in her essay "Gabriel de Saint-Aubin and his Time," in *Prints and Drawings by Gabriel de Saint-Aubin*, exh. cat. (Baltimore: Davison Art Center, Baltimore Museum of Art, 1975), pp. 5-13.

2. Pierre Rosenberg, *French Master Drawings of the 17th and 18th Centuries in North American Collections*, exh. cat. (Toronto: Art Gallery of Ontario, 1972), no. 132, p. 209, pl. 12.

48. Gabriel de Saint-Aubin *or* Augustin de Saint-Aubin
The Musical Duo

1. During the early part of this century, *The Musical Duo* appeared at auction catalogued as the work of Augustin, and Phyllis Hattis suggests that Dacier did not include it in the catalogue of Gabriel's work for that reason. Cautioning that it is premature to exclude a possible attribution to Augustin, she reappraises the work as by Gabriel. The present cataloguer senses that Dacier was hesitant about the attribution to Gabriel on stylistic grounds and is inclined to weigh the attribution towards Augustin. See Emile Dacier, *Gabriel de Saint-Aubin*, catalogue raisonné (Paris, 1931) and Phyllis Hattis, *Four Centuries of French Drawings* (San Francisco: The Fine Arts Museums of San Francisco, 1977), no. 119, p. 156.

49. (Jean) Antoine Watteau
Concert champêtre (Venetian Landscape)

1. K. T. Parker, *The Drawings of Antoine Watteau* (London, 1931; New York: Hacker, 1970, reprint), p. 1.

2. He was fired by Rubens while an apprentice in the studio of Claude Audran and failed to win the *Prix de Rome* in 1709. He suffered from tuberculosis—*la maladie de langueur*—for which he was treated in London in 1719 and to which he eventually succumbed. See Parker, pp. 1-2.

3. Parker, pp. 1-2.

4. K. T. Parker and J. Mathey, *Antoine Watteau: Catalogue complet de son œuvre dessiné* (Paris: F. de Nobele, 1957), vol. 1, no. 436.

5. Konrad Oberhuber, *Early Italian Engravings from the National Gallery of Art*, exh. cat. (Washington, D.C.: National Gallery of Art, 1973), no. 150.

50. Edmond-François Aman-Jean
Les confidences

1. Jacob Bean, *100 European Drawings in the Metropolitan Museum of Art* (Greenwich: New York Graphic Society, 1964), no. 78, repr.

2. *French Symbolist Painters* (London: Hayward Gallery, 1972), pp. 22-23.

51. Louis-Léopold Boilly
Study for "La vaccine"

1. The present location of the painting is unknown. It was published by Paul Marmottan, *Le peintre Louis Boilly* (Paris: H. Gateau, 1913), pp. 121-122, pl. 38. At least ten studies related to the painting are mentioned by Pierre Rosenberg in his entry on the Museums' *Study* (see Pierre Rosenberg, *French Master Drawings of the 17th and 18th Centuries in North American Collections*, [Toronto: Art Gallery of Ontario, 1972], no. 7, p. 133).

2. See Stephen F. Mason, *A History of the Sciences* (New York: MacMillan, 1962), p. 519.

52. Louis-Léopold Boilly
Portrait Studies

1. Phyllis Hattis, *Four Centuries of French Drawings* (San Francisco: The Fine Arts Museums of San Francisco, 1977), no. 200, p. 224.

53. Rodolphe Bresdin
La cavalière orientale dans les montagnes

1. John Rewald, Dore Ashton, and Harold Joachim, *Odilon Redon, Gustave Moreau, Rodolphe Bresdin*, exh. cat. (New York: The Museum of Modern Art, 1961), p. 14.
2. Ibid., pp. 150-152.
3. Ibid., p. 163, from the Preface for the catalogue of a Bresdin retrospective, Salon d'Automne, Paris, 1908.
4. Albert Peters, *Die Schwarze Sonne des Traums, Radierungen, Lithographien und Zeichnungen von Rodolphe Bresdin (1822-1885)*, exh. cat. (Cologne: Wallraf-Richartz-Museum, 1972), pp. 42, 72-74.
5. Rewald et al., *Odilon Redon*, p. 163.
6. George R. Goldner, *Master Drawings from the Woodner Collection*, exh. cat. (Malibu, California: The J. Paul Getty Museum, 1983), no. 64, p. 158.

54. Théodore Chassériau
Alexandre Mourousi

1. Robert Goldwater and Marco Treves, eds., *Artists on Art*, (New York: Pantheon Books, 1972), p. 238.
2. Robert J. F. Kashey and Martin L. H. Reymert, *Ingres & Delacroix Through Degas & Puvis de Chavannes*, exh. cat. (New York: Shepherd Gallery, 1975), p. 211.

55. Thomas Couture
The Duel after the Masked Ball

1. Hubert Wellington, ed., *The Journal of Eugène Delacroix* (New York: Cornell University Press, 1980), p. 77.
2. Robert J. F. Kashey and Martin L. H. Reymert, *Ingres & Delacroix Through Degas & Puvis de Chavannes*, exh. cat. (New York: Shepherd Gallery, 1975), p. 183.
3. Albert Boime, *Thomas Couture and the Eclectic Vision* (New Haven: Yale University Press, 1980), p. 313.
4. Wellington, p. 66.
5. Boime, pp. 315-316.

56. Jacques-Louis David
A Scene of Mourning

1. Phyllis Hattis, *Four Centuries of French Drawings* (San Francisco: The Fine Arts Museums of San Francisco, 1977), no. 221, p. 245.
2. Anita Brookner, *Jacques-Louis David* (New York: Harper & Row, 1980), p. 180.
3. Adolphe Stein and Lorna Lowe, *Old Master Drawings*, exh. cat. (London: H. Terry-Engell Gallery, 1972), no. 74, p. 9, pl. 51.
4. Adolphe Stein, *Master Drawings*, exh. cat. (London: William Drummond, Covent Garden Gallery, 1977), no. 31, pl. 30.

57. Edgar Degas
Woman Dressing (La coiffure)

1. Marcel Guérin, ed., *Letters of Degas* (Oxford: Bruno Cassirer, 1947); letter no. 4 to Lorenz Frölich, 27 November 1872; letter no. 6 to James Tissot, 18 February 1873.
2. Jean Sutherland Boggs, *Drawings by Degas*, exh. cat. (Saint Louis: City Art Museum of Saint Louis, 1967), no. 81, p. 128, repr.
3. Phyllis Hattis, *Four Centuries of French Drawings* (San Francisco: The Fine Arts Museums of San Francisco, 1977), no. 222, pp. 245-246, repr. p. 250.
4. Correspondence from Charles Durand-Ruel, Paris, to Dr. Phyllis Hattis, 18 November 1975.

58. Eugène Delacroix
Arabs and Horses near Tangiers

1. For another watercolor from the series see *Fantasia devant la porte de Mequinez* (Musée du Louvre, RF 3372), in *Mémorial de l'Exposition Eugène Delacroix* (Paris, 1963), no. 189.
2. Lorenz Eitner, *Delacroix* (London: Arts Council of Great Britain, 1964), no. 126, p. 54.
3. Ibid.
4. Hubert Wellington, ed., *The Journal of Eugène Delacroix* (New York: Cornell University Press, 1980), p. 54.

59. Paul Gauguin
L'arlésienne, M^{me} Ginoux

1. John Rewald, *Post-Impressionism from van Gogh to Gauguin* (New York: The Museum of Modern Art, 1962), p. 254.
2. Ronald Pickvance, *Van Gogh in Arles*, exh. cat. (New York: Harry N. Abrams, 1984), p. 210.
3. Daniel Guerin, ed., *The Writings of a Savage, Paul Gauguin* (New York: Viking Press, 1978), p. 25.
4. John Rewald, *Gauguin Drawings* (New York: Thomas Yoseloff, 1958), p. 12.
5. Guerin, *Paul Gauguin*, note 51a, p. 385.
6. *The Complete Letters of Vincent Van Gogh* (Greenwich: New York Graphic Society, 1958), vol. 3, letter 605, p. 208.
7. Ibid., letter 643, pp. 284-286.

BIBLIOGRAPHY: John Rewald, *Gauguin Drawings* (New York: Thomas Yoseloff, 1958), pp. 12 and 25, no. 15, repr.; John Canaday, *Mainstreams of Modern Art* (New York: Holt, 1959), p. 379, pl. 455; Jean Leymarie, *Paul Gauguin* (Basel: Phoebus-Verlag, 1959, and London, 1961), p. 8, repr.; John Rewald, *Post-Impressionism from van Gogh to Gauguin* (New York: The Museum of Modern Art, 1962), pp. 252, 355, 385, 397-398, repr., pp. 251, 356; René Huyghe, *Gauguin* (New York: Crown Publishers, 1959), p. 28, repr.; J.-B. de la Faille, *The Works of van Gogh: His Paintings and Drawings*, 2d. ed. (Amsterdam: Reynal, 1970), p. 286; *Vincent van Gogh Catalogue* (Otterlo: State Museum Kröller-Müller, 1970), p. 103; Robert Goldwater, *Paul Gauguin* (New York: Harry N. Abrams, 1972), p. 33, repr.; Jean-Luc Bordeaux, "Un musée français en Californie," *Connaissance des arts* 299 (January 1977), repr., p. 36; Phyllis Hattis, *Four Centuries of French Drawings* (San Francisco: The Fine Arts Museums of San Francisco, 1977), no. 230, p. 254, repr. p. 260; Robert Flynn Johnson, "Masterpieces of French Drawing," in Denys Sutton, ed., "The Fine Arts Museums of San Francisco," *Apollo* (1980): 130-137, no. 14, repr. p. 135.

EXHIBITIONS: Museum of Modern Art, New York, *Modern Drawings*, 1944, p. 19, repr.; Wildenstein & Co., New York, *Paul*

Gauguin, 1946, no. 52; California Palace of the Legion of Honor, San Francisco, *19th Century French Drawings*, 1947, no. 141, repr.; Wildenstein & Co., New York, *Gauguin*, 1956, no. 58; The Art Institute of Chicago, *Gauguin*, 1959, no. 78, repr. (also Museum of Modern Art, New York, 1959); Wildenstein & Co., New York, *The Dr. T. Edward and Tullah Hanley Collection*, and Fogg Art Museum, Harvard University, 1961-1962, no. 65, repr. p. 42 (also Gallery of Modern Art, New York; Philadelphia Museum of Art; The Denver Art Museum; Museum of the Southwest, Midland, 1967-1968, no. 110; Columbus Gallery of Fine Arts, 1968, no. 74; Canisius College, Buffalo, 1969, p. 10, repr.; M. H. de Young Memorial Museum, San Francisco, 1970, no. 104, cat. cover); California Palace of the Legion of Honor, The Fine Arts Museums of San Francisco, *Nineteenth Century French Drawings from the Permanent Collection*, 1978; The Denver Art Museum, *Masterpieces of French Art from The Fine Arts Museums of San Francisco*, checklist by Denys Sutton, 1978 (also Wildenstein & Co., New York, 1979; The Minneapolis Institute of Arts, 1979; California Palace of the Legion of Honor, The Fine Arts Museums of San Francisco, *Masterworks from the Achenbach Foundation for Graphic Arts*, 1981; The Metropolitan Museum of Art, New York, *Van Gogh in Arles*, exh. cat. by Ronald Pickvance, 1984, no. 122, p. 210, repr.

60. Henri Harpignies
Landscape with an Artist Sketching
1. Alain de Leiris and Carol Hynning Smith, *From Delacroix to Cézanne, French Watercolor Landscapes of the Nineteenth Century*, exh. cat. (College Park: The University of Maryland Art Gallery, 1977), p. 134.

61. Jean-Auguste-Dominique Ingres
Portrait of Maria Maddalena Magli
1. Hans Naef, *J. A. D. Ingres*, 5 vols. (Bern: Benteli Verlag, 1977).
2. Ibid., vol. 4, no. 37, p. 70; no. 39, p. 74; no. 40, p. 76.

62. Eugène Isabey
Le naufrage
1. Lorenz Eitner, "The Open Window and the Storm Tossed Boat: An Essay in the Iconography of Romanticism," *Art Bulletin* 37, no. 4 (December 1955): 289.
2. Jean Clay, *Romanticism* (New York: Chartwell Books, 1981), p. 94.
3. Martin Butlin and Evelyn Joll, *The Paintings of J. M. W. Turner*, 2 vols. (New Haven: Yale University Press, 1977), no. 54, pl. 49, *The Shipwreck*, ca. 1805 (Tate Gallery, London), and no. 210, pl. 215, *The Wreck of a Transport Ship*, ca. 1810 (Fundaçao Calouste Gulbenkian, Lisbon).

63. Edouard Manet
Seated Woman Wearing a Soft Hat
1. Alain de Leiris, *The Drawings of Edouard Manet* (Berkeley: University of California Press, 1969), p. 74.
2. Ibid., p. 37.
3. Daniel Halévy, *My Friend Degas*, translated and edited by Mina Curtiss (Middletown, Connecticut: Wesleyan University Press, 1964), p. 92, note.
4. Galerie Georges Petit, Paris, *Collection Edgar Degas*, 26 and 27 March 1918; Paintings, lots 72-79; Drawings and Watercolors, lots 218-229.

5. Ibid., lot 224.
6. Conversation between the author and Ronald Pickvance, October, 1984.

64. Jean-François Millet
Return of the Flock
1. Camille Pissarro, *Camille Pissarro/Letters to His Son Lucien* (New York: Pantheon, 1943), p. 110.
2. Ibid., p. 111.
3. For a pastel of a similar subject in the same period, see Alexandra Murphy, *Jean-François Millet* (Boston: Museum of Fine Arts, 1984), no. 114, pp. 170-171.

65. Claude Monet
The Coast of Normandy Viewed from Sainte-Adresse
1. For a brief illustrated review of Monet's technique as a draftsman, including mention of the Museums' sheet, see William Seitz, *Monet* (New York: Harry N. Abrams, 1960), p. 49, fig. 74.
2. See John Rewald, *The History of Impressionism* (New York: The Museum of Modern Art, 1961), p. 101.
3. Seitz, p. 49.
4. Reported to Phyllis Hattis by John Rewald. See Hattis, *Four Centuries of French Drawings* (San Francisco: The Fine Arts Museums of San Francisco, 1977), p. 276. Regardless, one should be cautious about the identification of the site of this drawing on the basis of its internal evidence alone. Though it is not a study for a signed and dated painting, it does relate to certain painted compositions such as Wildenstein nos. 26 and 27.

66. Pierre-Paul Prud'hon
"Je ne me bats point contre un insensé," from Jean-Jacques Rousseau's La nouvelle Héloïse
1. See information provided by Helen Weston and David Wakefield for entry, lot 198, Sotheby's, London, 4 July 1977.
2. Quoted in Maurice Serullaz, "Introduction," *French Drawings from Prud'hon to Daumier* (Greenwich, Connecticut: New York Graphic Society, 1966), p. 15.
3. See note 1.

67. Odilon Redon
Orpheus
1. The most notable treatment of the theme by a contemporary was undoubtedly Gustave Moreau's Salon painting of 1866: *Young Thracian Woman Bearing the Head of Orpheus*; Redon's first rendering of the subject was a charcoal composition of 1881 (Rijksmuseum Kroller-Muller 648). The severed head as a theme was not uncommon in art and literature of the period. Various cephalic apparitions, the head of John the Baptist, the Winged Head, etc., were subjects treated by Redon (see Richard Hobbs, *Odilon Redon* [Boston: New York Graphic Society, 1977], p. 24). For a discussion of and further references to this pastel, see Hattis, *Four Centuries of French Drawings* (San Francisco: The Fine Arts Museums of San Francisco, 1977), no. 308, p. 312.

68. Auguste Rodin
Nu aux jambes écartées
1. Albert Elsen and J. Kirk T. Varnedoe, *The Drawings of Rodin* (New York: Praeger, 1971), p. 19.
2. Ibid., p. 20.

3. Elisabeth Chase Geissbuhler, *Rodin's Later Drawings*
(Boston: Beacon Press, 1963), p. 71.
4. Correspondence with Albert Elsen, 22 August 1980.

69. Georges Seurat
Woman Bending Viewed from Behind
1. John Russell, *Seurat* (New York: Praeger, 1965), p. 65.
2. Germain Seligman, *The Drawings of Georges Seurat* (New
York: Curt Valentin, 1947), no. 55, p. 81; also Phyllis Hattis,
Four Centuries of French Drawings (San Francisco: The Fine Arts
Museums of San Francisco, 1977), no. 263, p. 284.
3. Erich Franz and Bernd Growe, *Georges Seurat, Zeichnungen*,
exh. cat. (Munich: Prestel-Verlag, 1983), nos. 22-37.
4. Seligman, *Seurat*, p. 37.

70. Georges Seurat
Study for "La parade de cirque"
1. Robert L. Herbert, *Seurat's Drawings* (New York:
Shorewood Publishers, 1962), pp. 121-122.
2. Ibid., p. 124.
3. John Rewald, *Post-Impressionism from Van Gogh to Gauguin*
(New York: The Museum of Modern Art, 1962), p. 80, cited
in *The Academic Tradition* (Bloomington: Indiana University Art
Museum, 1968), p. 34.
4. Herbert, p. 125.
5. César de Hauke, *Seurat et son œuvre* (Paris: Gründ, 1962),
CdH 162, 213, 486, 488, 631.
6. John Russell, *Seurat* (New York: Praeger, 1965), pp. 65-66.
EXHIBITIONS: Royal Scottish Academy, Edinburgh, *Scottish
Fine Arts and Print Club Loan Exhibition*, 1937; California Palace
of the Legion of Honor, San Francisco, *19th Century French
Drawings*, 1947, no. 152, repr.; Scripps College, Claremont, 1949,
(no further documentation); Venice, *XXV Biennale di Venezia*,
exh. cat., 1950, p. 179; Galleria dell'Obelisco, Rome, *Georges
Seurat*, 1950, exh. cat. by Umbro Apollonio, no. 8;
Wildenstein & Co., New York, *Seurat and his Friends*, 1953, no.
33; Contemporary Arts Museum, Houston, *Shadow and
Substance*, 1956; The Art Institute of Chicago and The Museum
of Modern Art, New York, *Seurat*, 1958, no. 131; Museum
Boymans-van Beuningen, Rotterdam, and Musée de
l'Orangerie, Paris, *De Clouet à Matisse, dessins français des
collections américaines*, 1958-1959, no. 190, pl. 189;
Montgomery Art Gallery, Pomona College, Claremont, *Salon
and Independent Artists of the 1880s*, 1963; The Santa Barbara
Museum of Art, *European Drawings 1450-1900*, 1964, no. 28; Art
Gallery, University of New Mexico, Albuquerque, *Art Since
1889*, 1964, no. 105, p. 18; John and Mable Ringling Museum
of Art, Sarasota, *Master Drawings*, 1967; Indiana University,
Bloomington, *The Academic Tradition: An Exhibition of 19th
Century French Drawings*, 1969, no. 96, p. 34; University Art
Museum, Berkeley, *Master Drawings: Materials and Methods*,
1972; California Palace of the Legion of Honor, The Fine Arts
Museums of San Francisco, *Nineteenth Century French Drawings
from the Permanent Collection*, 1978; The Denver Art Museum,
*Masterpieces of French Art from The Fine Arts Museums of San
Francisco*, checklist by Denys Sutton, 1978 (also Wildenstein &
Co., New York, 1979; and The Minneapolis Institute of Arts,
1979); National Gallery of Art, Washington, D.C., *Picasso: The*

Saltimbanques, 1980-1981; Kunsthalle, Bielefeld, *Georges Seurat,
Zeichnungen*, exh. cat. by Erich Franz and Bernd Growe, 1983,
no. 80, p. 193, repr. (also Staatliche Kunsthalle, Baden-Baden,
1984).

71. Henri de Toulouse-Lautrec
Au cirque: Cheval pointant
1. P. Huisman and M. G. Dortu, *Lautrec by Lautrec*
(New York: Viking Press, 1964), p. 202.
2. Gerstle Mack, *Toulouse-Lautrec* (New York: Alfred
A. Knopf, 1938), pp. 219-220.
3. Ibid., p. 215.

72. Henri de Toulouse-Lautrec
Au cirque: Ecuyère de haute école–Le salut (The Bow)
1. *Au cirque: entrée en piste* (Dortu 4530).
2. William C. Seitz, *Henri de Toulouse-Lautrec at the Circus*
(New York: Harry N. Abrams, 1967), unpaginated.
3. Ibid.
4. Gerstle Mack, *Toulouse-Lautrec* (New York: Alfred
A. Knopf, 1938), p. 347.

73. William Blake
The Complaint of Job
1. See Martin K. Nurmi, *William Blake* (Canton, Ohio: Kent
State University Press, 1976), p. 13.
2. See Geoffrey Keynes, *Engravings by William Blake: The
Separate Plates*, catalogue raisonné (Dublin: Walker, 1956),
pp. 10-12.

74. Thomas Shotter Boys
Landscape with a Lockgate
1. Hugh Stokes, "Thomas Shotter Boys," *Walker's Quarterly*
18 (1926), cited by Alastair Smart in James Roundell, *Thomas
Shotter Boys* (London: Octopus Books, 1974), p. 11.
2. Roundell, *Boys*, p. 25.

75. Edward Burne-Jones
*The Tree of Forgiveness–A Mosaic in Rome
(design for the Tree of Life Mosaic in the American
Church, Rome)*
1. David Cecil, *Visionary and Dreamer*, Princeton University
Press: The A.W. Mellon Lectures in the Fine Arts
(Washington, D.C.: The National Gallery of Art, 1969), p. 153.
2. Fortunée De Lisle, *Burne-Jones* (London: Methuen & Co.,
1907), p. 145.
3. Ibid., p. 146.
4. William Rothenstein, *Men and Memories* (New York:
Coward-McCann, Inc., 1931), p. 258.

76. John Sell Cotman
Tower of Tilney, All Saints' Church, Norfolk
1. Currently the best introduction to the artist is *John Sell
Cotman/1782-1842*, edited by Miklos Rajnai (Ithaca: Cornell
University Press, 1982).
2. Because of Cotman's following, attribution is occasionally a
problem. *Tower of Tilney* has been seen and authenticated by
Dr. Miklos Rajnai.
3. *Specimens of Castellated and Ecclesiastical Remains in the County of
Norfolk*. A third series of etchings by John Sell Cotman, Esq.
Architectural descriptions by Thomas Rickman, Esq.
(London, 1838), pp. 18-19.

77. David Cox

Stonehenge–A Storm Coming On

1. This watercolor has not been reproduced in the literature, but it is listed in Neal Solly, *Memoir of the Life of David Cox* (Radart Reproductions, 1973; originally published in 1873), p. 319.

78. David Cox

Gray Day, Calais Pier

1. Mary Bennett, *The Emma Holt Bequest, Sudley*, ill. cat. (Liverpool: Walker Art Gallery, pp. 21-22, pl. 34. Also see Stephen Wildman, *David Cox/1783-1859, A Bicentenary Exhibition* (Birmingham Museums and Art Gallery, 1983), p. 82, no. 65.
2. See Wildman.

79. Richard Dadd

Bearded Man with a Pipe

1. Correspondence with Patricia Allderidge on 22 June and 6 August 1981.
2. Patricia Allderidge, *The Late Richard Dadd, 1817-1886*, exh. cat. (London: The Tate Gallery, 1974), nos. 83 and 84, p. 75.
3. Ibid., no. 101, p. 79.
4. Ibid., frontispiece.

80. Thomas Gainsborough

Upland Landscape with Figures, Riders, and Cattle

1. From a letter by Constable to J. T. Smith, East Bergholt, 7 May 1797. See "John Constable's Correspondence II," *Suffolk Records Society* (London: Her Majesty's Stationery Office, 1964), vol. 6, p. 11. Also quoted in John Hayes, *The Drawings of Thomas Gainsborough*, (New Haven: Yale University Press, 1971), vol. 1, p. 26.
2. Hayes, p. 27.
3. The Museums' drawing is listed by Hayes as no. 732, p. 276.

81. Thomas Heaphy

Still Life with Mallard and Rabbits in a Basket

1. Quoted in William T. Whitley, "Thomas Heaphy (1775-1835)," Royal Society of British Artists' Art Club Publications, no. 1 (London, 1933), p. 13. This reference constitutes the main source of our information on Heaphy who was the first president of the Royal Society of British Artists.
2. Ibid.
3. Ibid., p. 15.
4. Ibid., p. 24.
5. Ibid., p. 16.

82. Alfred William Hunt

A Panoramic View over Moorland

1. Jane Bayard, *Works of Splendor and Imagination: The Exhibition Watercolor, 1770-1870* (New Haven: Yale Center for British Art, 1981).
2. Martin Hardie, *Water-Colour Painting in Britain*, (London: B.T. Batsford Ltd., 1979), vol. 3, p. 150.
3. *Bryan's Dictionary of Painters and Engravers*, (London: G. Bell & Sons, 1927), vol. 3, p. 87.
4. Ibid.
5. Cited in *The Newall Collection*, Christie's, London, 13 and 14 December 1979, lot 178, p. 131.
6. Ibid., lots 161, 164, 167, 170, 171, 178, 182, 194, 205.

7. John Rowlands, ed., *Master Drawings and Watercolours in the British Museum* (London: British Museum Publications Ltd., 1984), no. 187, p. 188.
8. *The Newall Collection*, Christie's, London, 13 and 14 December 1979, lots 161-206.

83. Sir Thomas Lawrence

Portrait of Mrs. Sarah Siddons

1. Hubert Wellington, ed., *The Journal of Eugène Delacroix* (New York: Cornell University Press, 1980), p. 291.
2. Michael Levey, *Sir Thomas Lawrence, 1769-1830*, exh. cat. (London: National Portrait Gallery, 1979-1980), pp. 88-90, no. 57, repr. p. 88.
3. Kenneth Garlick, *A Catalogue of the Paintings, Drawings and Pastels of Sir Thomas Lawrence* (London: Walpole Society, 1964), vol. 39, p. 243.
4. D. E. Williams, *Life and Correspondence of Sir Thomas Lawrence, Kt.* (1831), vol. 1, pp. 101-102.
5. Levey, p. 90.

84. Edward Lear

Saint Peter's from the Arco Oscuro

1. From the second stanza of Alfred Lord Tennyson's poem *To E. L. on his Travels in Greece.*

85. Thomas Rowlandson

Grotesque Heads

1. John Baskett has kindly pointed out two similar Rowlandson sheets: a drawing of bullbaiting in the Ashmolean Museum, Oxford, and the watercolor *Serving Punch* in the Mellon Collection (Baskett and Snelgrove 241).
2. Johann Caspar Lavater, *Physiognomische Fragmente zur Beförderung der Menschenkenntnis und Menschenliebe*, 4 vols. (1775-1778); English trans., *Essays on Physiognomy* (1789-1798).

86. John Ruskin

A River in the Highlands

1. John Baskett and Dudley Snelgrove, *English Drawings and Watercolors 1550-1850 in the Mellon Collection* (New York: Harper & Row, 1972), p. 106.
2. E. T. Cook and A. Wedderburn, eds., *The Complete Works of John Ruskin* (London, 1903-1912), cited from Paul H. Walton, *The Drawings of John Ruskin* (Oxford: Clarendon Press, 1972), p. 121.
3. Ibid., p. 72.

87. Joseph Mallord William Turner

View of Kenilworth Castle

1. A. J. Finberg, *The Life of J. M. W. Turner, R.A.*, 2d. ed., revised (Oxford: Clarendon Press, 1961), p. 380.

88. Sir David Wilkie

The Arrival of the Rich Relation

1. T. S. R. Boase, "The Age of Wilkie," in his *English Art/1800-1870* (London: Oxford University Press, 1959), pp. 154-155.
2. That there was more than one study of the subject is indicated by the mention of a chalk rendition sold with the Museums' version at Christie's (Wilkie's sale) in April 1842. See *The Art Union* 4 (1842): 159-160.
3. In the collection of The National Gallery of Canada, Ottawa.

90. Mary Cassatt
Head of a Woman

1. Although Breeskin dates the pastel about 1890, the solidity of the draftsmanship indicates an earlier date.
2. Charles Moffett, *Manet*, exh. cat. (New York: The Metropolitan Museum of Art, 1983), pp. 439-440.
3. Adelyn D. Breeskin, *The Graphic Art of Mary Cassatt*, exh. cat. (New York: The Museum of Graphic Art, 1967), p. 10.
4. Norman Schlenoff, *Encyclopedia of World Art* (New York: McGraw-Hill, 1960), vol. 3, p. 143.
5. Correspondence with Adelyn D. Breeskin, 3 November 1981.

91. Jasper Francis Cropsey
The Gates of the Hudson

1. William S. Talbot, *Jasper F. Cropsey 1823-1900* (New York: Garland Publishing, 1977), no. 232, p. 475.
2. William S. Talbot, *Jasper F. Cropsey 1823-1900*, exh. cat. (Washington, D.C.: Smithsonian Institution Press, 1970), no. 79, pp. 107-108.
3. Talbot, *Cropsey*, 1977, pp. 241-242; also Theodore E. Stebbins, Jr., *American Master Drawings and Watercolors* (New York: Harper & Row, 1976), pp. 150-151.
4. Talbot, 1977, no. 233.

92. Thomas Eakins
Man in a Turban

1. Lloyd Goodrich, *Thomas Eakins* (Cambridge: Harvard University Press, for the National Gallery of Art, Washington, D.C., 1982), pp. 314-315, notes 10:36-11:6.
2. Gordon Henricks, *The Life and Work of Thomas Eakins* (New York: Grossman, 1974), p. 316, no. 5.
3. From a letter sent by Lloyd Goodrich to Robert Flynn Johnson, dated 8 December 1983.

93. Frederick Childe Hassam
Rainy Night

1. Donelson F. Hoopes, *Childe Hassam* (New York: Watson-Guptill, 1979), p. 11.
2. Ibid., p. 54.

95. Winslow Homer
Sunrise, Fishing in the Adirondacks

1. Lloyd Goodrich, *Winslow Homer* (New York: Macmillan, for the Whitney Museum of American Art, 1944), p. 159.

96. John La Farge
The Great Buddha

1. Theodore E. Stebbins, Jr., *American Master Drawings and Watercolors* (New York: Harper & Row, 1976), p. 238.
2. John La Farge, *An Artist's Letters from Japan* (New York: Kennedy Graphics, Da Capo Press, 1970).
3. Ibid., p. 225.
4. Ibid., p. 226.
5. Ibid., frontispiece.

97. Thomas Moran
View of New York from Across the Harbor

1. Joseph Goldyne, "Criticism and Collecting: Nineteenth Century American Response to Turner's Achievement," in *J. M. W. Turner/Works on Paper from American Collections*, exh. cat., (Berkeley: University Art Museum, University of California, 1975), pp. 32-33.
2. A more thorough study of the skyline, including identification of buildings, might help to establish the date of this work more precisely.
3. Thurman Wilkins, *Thomas Moran/Artist of the Mountains*, (Norman: University of Oklahoma Press, 1966), pp. 256-257. The artist's daughter estimated that her father made at least 1500 illustrations over a period of thirty years—approximately two-thirds for wood engravings—usually in India ink and Chinese white on the block to be engraved.
4. Ibid., p. 258.

98. Albert Pinkham Ryder
Untitled (landscape)

1. Theodore E. Stebbins, Jr., *American Master Drawings and Watercolors*, exh. cat. (New York: Harper & Row, 1976).
2. Lloyd Goodrich, *Albert P. Ryder* (New York: George Braziller, Inc., 1959), p. 18.
3. Ibid., p. 13.

99. John Singer Sargent
A Note (The Libreria, Venice)

1. Donelson F. Hoopes, *Sargent Watercolors* (New York: Watson-Guptill Publications, 1976), p. 20.
2. Ibid., p. 15.
3. Ibid., p. 19.
4. Margaretta M. Lovell, *Venice: The American View, 1860-1920* (San Francisco: The Fine Arts Museums of San Francisco, 1984), no. 61, p. 109, repr. p. 108.
5. Hoopes, *Sargent*, p. 19; Carter Ratcliff, *John Singer Sargent* (New York: Abbeville Press, 1982), p. 185.
6. Lovell, p. 109.
7. Ibid.

100. James Sharples
Catherine Thorn Johnson

1. Theodore E. Stebbins, Jr., *American Master Drawings and Watercolors* (New York: Harper & Row, 1976), p. 45.
2. "American Drawings, Pastels, and Watercolors," in *Works of the Eighteenth and Early Nineteenth Centuries*, exh. cat. (New York: Kennedy Galleries, 1967), p. 11.
3. Ibid.

Index of Artists